NATIONAL GEOGRAPHIC
PHOTOGRAPHY
FIELD GUIDE

NATIONAL GEOGRAPHIC
PHOTOGRAPHY
FIELD GUIDE

SECRETS TO MAKING GREAT PICTURES

PETER K. BURIAN
and ROBERT CAPUTO

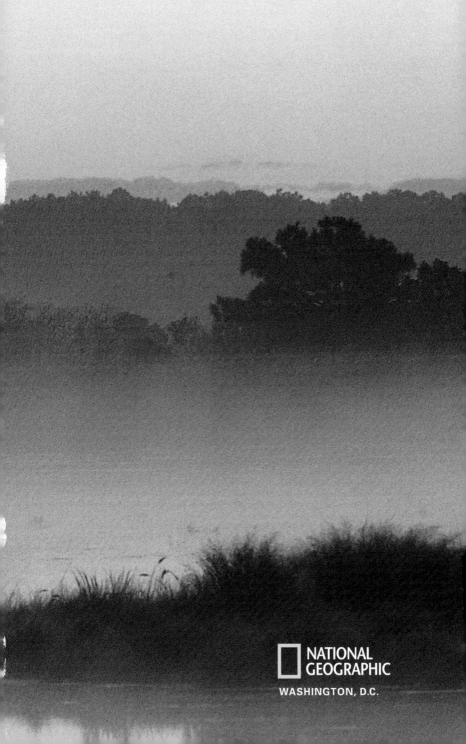

NATIONAL
GEOGRAPHIC

WASHINGTON, D.C.

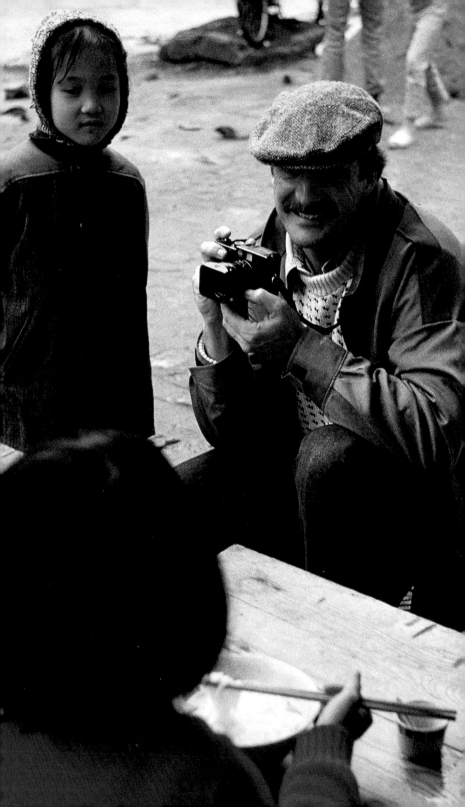

CONTENTS

Pages 2-3: Mist, color, and silhouettes combine to convey the serenity and beauty of this deer's habitat at the Chincoteague National Wildlife Refuge, Virginia.
James P. Blair

Opposite page: A sincere smile and easy manner are essential tools when photographing people, as shown by David Alan Harvey on assignment in Hanoi.
Kenneth Garrett

Library of Congress Control Number 2003104002

INTRODUCTION

by Robert Caputo

WE ARE INUNDATED with photographs every day—pictures of war and famine, victory and defeat, of famous and infamous people, of goods we are enticed to buy, gorgeous models, ideal homes, microscopic organisms and distant stars, of important moments from history and moments that are important only to us. Photographs bring faraway places into our living rooms and time past into the present. We all have albums (or, for the less organized, drawersful) of pictures of loved ones and of ourselves when we were younger. Photographs provide the pleasures of art and information about things we will never actually see. And they are our personal memories made real.

But of the countless photographs our eyes pass over, only a small number arrest our attention and stick in our memories. Just what is it that separates these images from the rest?

Although great photographs come in many different forms, they all have one thing in common: Each conveys a strong feeling, be it joy, sadness, compassion, revulsion, or the simple but indescribable pleasure of looking at something that our eyes and brains find appealing. The photographer communicates this feeling by successfully combining his sensibility—his eye—with knowledge of the tools and techniques. To get an image that is both of and about the subject, the photographer looks, thinks, chooses the right equipment, and then presses the shutter button.

In this guide, we will explore and explain the elements of composition, lighting, and exposure that go into the thinking part of

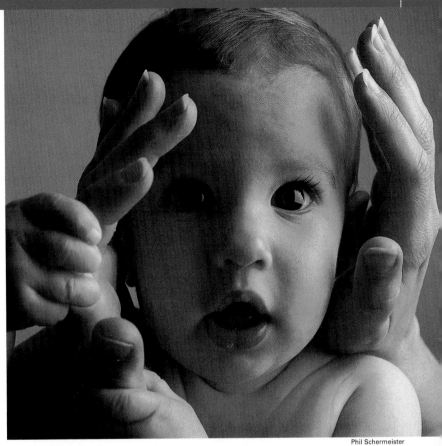

Phil Schermeister

Embraced by Mom's loving hands, an infant stares wide-eyed at her new world. Window light and a soft box combine to cast the warm tones that enhance this image of our most popular subject—our children.

image making, and the cameras, lenses, film, and other hardware that are our tools. We will then look at all sorts of situations— from landscapes to people, from underwater photography to aerials. We'll get tips and tricks of the trade from experienced NATIONAL GEOGRAPHIC photographers. And we'll explore the world of computers and photography.

You don't have to be a professional to make good photographs, but you do have to spend a lot of time with your camera. We hope you will use this guide to learn useful tips and techniques, and then go out and make lots of pictures. That is, after all, the fun part.

ESSENTIAL BASICS

by Peter K. Burian

When musician Scott Smith wanted a picture for the cover of his new CD, *Wish*, he photographed this young girl using an $80 autofocus camera with a fixed, wide-angle lens. Despite the simple equipment, he was able to create an effective image by planning the composition—including the background and camera perspective—and by carefully considering the direction of the light and its effect on the subject. He asked the girl to make a wish as she blew the seeds from the dandelion flower.

Scott Smith

THE WORD "PHOTOGRAPHY," as literally translated from the Greek, means "light drawing." Photography is indeed mostly concerned with light. Light reflecting from a scene creates an image. While the camera's shutter is open, light enters through the lens and exposes the light-sensitive grains in the film. Then the film is processed in chemicals to produce a negative (or a positive, in the case of a slide or transparency). When the negative is projected onto a sheet of light-sensitive paper, an image forms, creating a print in color or in black and white.

In addition to understanding this basic process, an aspiring photographer must understand and control several factors in order to advance beyond taking snapshots. Although these factors can consume an entire semester in a college course on photography or form the basis of a career, we'll cover them briefly here and feature practical reference information you can use to make better photographs.

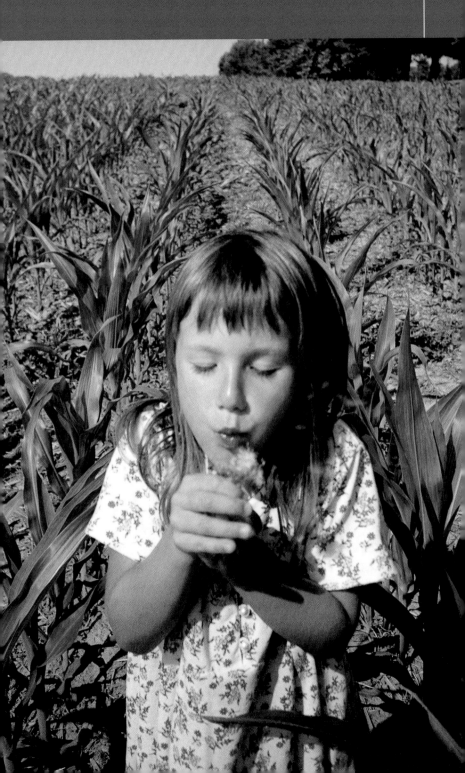

GETTING STARTED WITH PHOTOGRAPHY

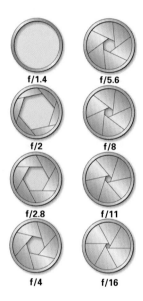

f/1.4 f/5.6

f/2 f/8

f/2.8 f/11

f/4 f/16

A smaller f/number denotes a wider aperture, and a larger f/number denotes a smaller aperture. **Each increment represents one "stop,"** which means a doubling or a halving of the area of the opening and of the amount of light that will pass during any given amount of time.

Slim Films

Light and Exposure

The amount of light striking a subject varies according to the time of day, the weather, and other factors. With the right amount of light, you'll get a clear picture overall, and each subject tone, from white to black, will be rendered as your eye saw it. The exposure depends on the brightness level of the scene—how much light passes through the lens and for how long. More specifically, the following factors are involved.

Film Speed

An ISO (International Standards Organization) number denotes the film's speed, or its sensitivity to light. The higher the number, the more sensitive the film. An ISO 1600 film, for example, requires very little light to form a correct exposure, whereas an ISO 25 film requires 64 times more.

Aperture

The aperture is the size of the opening in the diaphragm mechanism of the lens. The larger the aperture selected (by you or an automatic camera), the more light there will be to expose the film in any given amount of time. The aperture size is adjustable on all but very basic camera equipment. A series of f/numbers is used to denote aperture size, and these are marked on a ring on the lens. (Some high-tech camera systems require you to select the aperture with a dial on the camera.)

These settings, called f-stops, run in a series from the largest to the smallest: f/1.4, f/2, f/2.8, f/4, f/5.6, f/8, f/11, f/16, and f/22 are the most common.

Open up one f-stop—from f/8 to f/5.6, for example—and the aperture is twice as large in area; it allows double the amount of light to pass. Stop down one f-stop—from f/16 to f/22, for example, and the aperture size is only half as large; you have cut in half the amount of light that will reach the film while the picture is being made.

Shutter Speed

The shutter speed controls the amount of time the curtain in the camera (or overlapping metal leaves in some lenses) will remain open. This too is adjustable. You can select a shutter speed, or allow an automatic mode of the camera to do so. The longer the shutter speed, the more light will reach the film at any given aperture size. Shutter speeds are indicated in seconds and fractions of a second on the camera's dial. (Many high-tech cameras no longer have such a mechanical control. Their shutter speeds are selected with an electronic dial and displayed on an LCD data panel.)

Common shutter speeds include the following, from slow to fast: 1 second, 1/2 , 1/4, 1/8, 1/15, 1/30, 1/60, 1/125, 1/250, 1/500, and 1/1000 of a second. (Some cameras allow you to select intermediate shutter speed steps such as 1/350 of a second. Many have longer and shorter settings than those listed.) Just as with f-stops, a change of one setting either doubles or halves the exposure.

Aperture Size and Time Combination

The wider the aperture selected—the less time, i.e.—faster shutter speed, is necessary to correctly expose the film. Conversely, the longer the shutter is open, the smaller the required aperture size. As you may have guessed by now, any of numerous different—but equivalent—combinations of f-stop and shutter speed will produce the same exposure. Lenses with wide maximum apertures are called "fast" because they allow faster shutter speeds to be selected.

Example: A small aperture such as f/16 at a long shutter speed such as 1/2 second will produce the

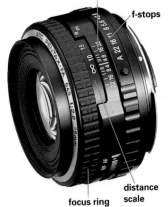

depth of field marks

f-stops

distance scale

focus ring

Although the controls and markings on lenses vary, traditional models include a scale for checking the focused distance, a ring for changing focus, markings for estimating depth of field, and a ring for adjusting the aperture size, or f-stop.

Courtesy Pentax Corporation

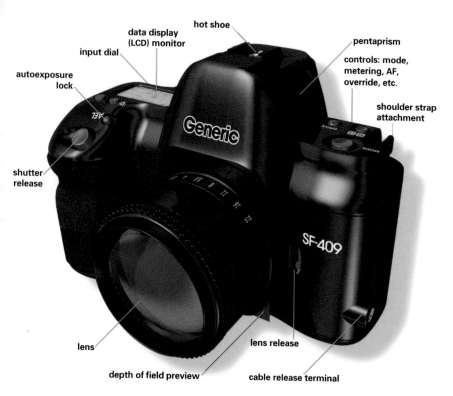

autoexposure lock

input dial

data display (LCD) monitor

hot shoe

pentaprism

controls: mode, metering, AF, override, etc.

shoulder strap attachment

shutter release

Generic

SF-409

lens

lens release

depth of field preview

cable release terminal

A great variety of camera types are available to photographers, with the **35mm SLR (single lens reflex)** being the choice for those who want a broad selection of lenses and other accessories, and through-the-lens metering and framing. In the example above, the operating features of a high-tech SLR are labeled. Slim Films

same exposure as a wider aperture such as f/11 at a faster shutter speed—1/4 second in this case. (Here you doubled the size of the aperture so you could cut the time in half.) The diagram on page 15 illustrates this concept—called "reciprocity" or "equivalent exposure"—in more detail.

If this concept still seems confusing, consider this analogy. You want to fill a one-quart jug with water. If you use a garden hose, it may take a few seconds. Switch to a fire hose with a very wide diameter, and the jug will be full in a split second. As you try it with hoses of smaller and smaller diameter, the process takes progressively longer. Any equivalent combination—of time and the size

of the opening—produces the "correct" result: a full quart jug in this case, or—in photography—a correctly exposed frame of film.

Exposure Meter

Guidance as to the amount of light needed in any situation is provided by the exposure meter built into all modern cameras. (You can also buy accessory handheld meters.) Think of the exposure meter as a computer—in some high-tech cameras, it truly is. The system assesses the brightness of the scene and indicates whether the setting you have made will provide a correct exposure. In automatic modes, the camera will make some or all of the settings for you, as discussed later.

Common Camera-Operating Modes

Most current cameras—except the point-and-shoot models—offer at least two options for settings that will provide a good exposure. It is important to understand the difference.

Manual Mode

When you select the camera's manual operating mode, the exposure meter offers guidance only—you can accept it or ignore it. You must change the f-stop and the shutter speed using two separate controls until you get an indication of correct exposure. Change the shutter speed, and you must also change the f-stop and vice versa. This is a bit slow, and you must remember to do both.

Semiautomatic Mode

Most cameras offer at least one operating mode in which you need to set only one of the factors—usually the f-stop. The camera will automatically respond with an appropriate shutter speed for correct exposure. (This is called aperture-priority automatic.) Many models offer another option in which you set the desired shutter speed and the camera sets the corresponding f-stop (shutter-

Tip

Cameras rarely show the full fractions numerals, such as 1/250 or 1/8 second. Instead, they are abbreviated—usually as "250" and "8" in these examples. If you have a high-tech camera that allows for very long shutter speeds, other abbreviations may be used; check your owner's manual.

With the advent of numerous new high-tech features and computerized capabilities, many cameras now use electronic buttons, dials, and readouts (below, left). These differ noticeably from models that use the old-style, conventional mechanical knobs and rings.

priority automatic). Working in semiautomatic mode is quicker than shooting in manual mode.

Program Mode

Today's high-tech 35mm cameras offer a fully automatic operating mode too, usually designated by a "P" for programmed exposure. When this is selected, the camera's computer chooses both the f-stop and the shutter speed for correct exposure. The combination may not meet your creative intentions, however.

Program Controls

Some high-tech cameras also have additional options. Most common is program shift. Turn a dial, and the camera shifts among the various combinations of shutter speed and f-stop that will provide a correct exposure. Shoot when you reach

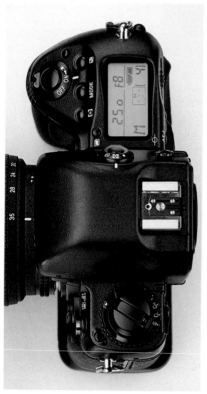

National Geographic Society Photographer Mark Thiessen (above, both)
Slim Films (opposite)

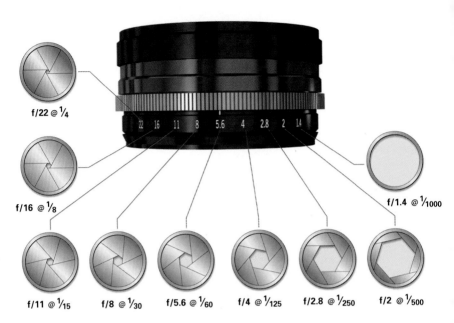

f/22 @ ¼

f/16 @ ⅛

f/1.4 @ ¹⁄₁₀₀₀

f/11 @ ¹⁄₁₅ f/8 @ ¹⁄₃₀ f/5.6 @ ¹⁄₆₀ f/4 @ ¹⁄₁₂₅ f/2.8 @ ¹⁄₂₅₀ f/2 @ ¹⁄₅₀₀

Many combinations of aperture and shutter speed produce an **equivalent exposure**: The same amount of light exposes the film. With a wide aperture and fast shutter speed, depth of field is shallow and motion stopped. With a small aperture and slow shutter speed, depth of field is great but motion is harder to stop.

one that you feel is appropriate. For example, the camera may set f/8 at 1/125. You may want more depth of field for a hillside of flowers, so you may shift to f/16 at 1/30. Or, you may want to "freeze" a high-speed motorcyclist, so you'll shift to f/4 at 1/500. Since all the combinations are equivalent, the exposure will not change—only the depth of field and the rendition of motion will be affected. Both concepts are described later.

Subject-Specific Programs
Many, but not all, high-tech cameras have programs designed for common subject types: landscapes (favoring depth of field), sports (favoring high shutter speeds), portraits (favoring moderately wide apertures), and so on. These programs select the f-stop and shutter speed that an experienced photographer might choose for a suitable rendering of motion and range of sharpness in a

Tip

For now, we are assuming that a camera's exposure meter will always provide (or recommend) settings for correct exposure. This is not always true for very dark or very light subject matter. See the chapters on exposure and on film for tips on how to use overrides for better results.

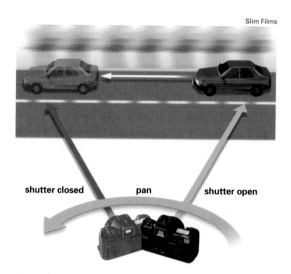

Slim Films

shutter closed pan shutter open

Panning with a moving subject can be a highly effective technique for creating a sense of motion in still photography (opposite). Panning requires some trial-and-error practice using a slow shutter speed and trying to pan at exactly the same speed as the subject. Shoot many frames until you achieve success.

scene. If you do not agree with these settings, simply switch to one of the other modes that allows you greater control.

Motion and Shutter Speed

As the previous section implied, the shutter speed determines how motion will be interpreted on film. You have two basic options: Freeze the subject or allow some blur to give a feeling of motion. For a cyclist, you may decide to shoot at a 1/500- or a 1/30-second shutter speed depending on the effect you want to convey: a cyclist frozen in time or in fluid motion. The shutter speed needed to stop motion depends on a number of factors; the chart provided on page 262 offers some suggestions as a starting point for your own experimentation.

For a moving subject traveling across your path—the cyclist, for example—try panning. Move the camera, following the subject's progress smoothly, and trip the shutter at some point. (Continue to follow through even after you have taken the picture. The results are better, just as they are with a golf swing.) The subject will be fairly sharp, but the background will be blurred. Try this

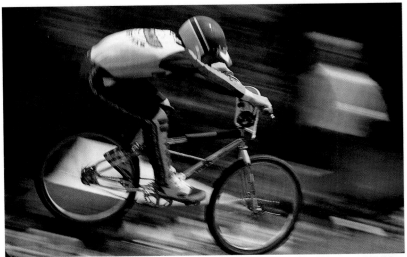

Keith Philpott

technique at several shutter speeds—from 1/4 to 1/30—and one of the pictures should give the effect you are trying to achieve. Remember that if the shutter speed is very long, camera shake may be a problem; try using a monopod.

Depth of Field and F-stop

We have all seen pictures in which everything in the scene is rendered quite sharply: the subject, the background, and the foreground. In other pictures, exactly the opposite effect was achieved by the photographer: Only the subject is sharp, while its surroundings are out of focus—a soft wash of color. One way to produce such different effects is to vary the amount of "depth of field," which we will discuss in an upcoming section.

Assuming a fixed distance of, say, 15 feet, depth of field is affected by changing apertures. At f/2, for example, only the subject will be fully sharp. Stop down to f/22, however, and foreground and background elements will be brought into focus.

The Technical Dilemma

When you select a faster shutter speed to freeze

Peter K. Burian

Several technical factors affect the range of sharp focus in a photograph. For the image above, the photographer selected a long lens (280mm), moved in very close to the subject, and set a wide aperture (f/4) to achieve a shallow depth of field.

motion, the camera's exposure meter will recommend a wider aperture. You'll get shallow depth of field—a narrow zone of sharp focus—so important elements of the scene may not appear sharp. (This may or may not be the effect you want.) Conversely, as you switch to a longer shutter speed, you'll need to stop down to a smaller aperture for a correct exposure. Now, extraneous clutter in the scene—perhaps cars in the distance—will be fairly sharp too. (Panning with a moving subject will blur the background, however.)

This technical factor limits your creative options. You cannot always get just the right combination of shutter speed and f-stop to meet your desire for a specific rendition of motion and a specific depth of field plus a sharp picture. This is a fact of life in photography, although depth of field can be controlled—increased or decreased—in other ways too, as we'll see.

When shutter speed is the most important consideration, such as for action photography, the camera's shutter priority semiautomatic mode is a suitable choice. In other situations, such as for landscapes or portraits, the right f-stop for appropriate depth of field is more important, and the aperture priority mode is a better choice. Subject-specific programs can be useful too, but they make you rely on the manufacturer's opinion as to what is the right shutter speed and f-stop for any particular subject type.

Depth of Field Demystified

The ability to control depth of field is one of the factors that separates the snapshooter from the advanced photographer. Photography textbooks often include long chapters on depth of field. For a full appreciation of all of the factors, we recommend further study, especially for scientific photography. Here, we will cover only the most practical aspects, step by step, sticking to the basics. Since the following information will be relevant to

other chapters in this book, it is worth considering at this time.

The Concept

Simply stated, depth of field is "the zone of acceptably sharp focus in a photograph." In truth, only the subject that you have focused on—and anything else at the same distance from the camera—will be razor sharp. Still, other elements in the picture—in front of the subject and behind it—will usually be somewhat sharp. The extent of depth of field in a photograph is controlled by the following factors.

Focal Length

As noted in the upcoming subchapter on lenses, you can vary the depth of field from any shooting position by using different focal lengths. Long lenses—such as 300mm to 600mm—produce pictures with shallow depth of field. Short lenses—such as 28mm or 35mm—produce extensive depth of field.

Subject Distance

The closer you get to the subject, the less depth of field in your pictures. In extreme close-up photography the zone of acceptably sharp focus is measured in mere millimeters. On the other hand, if you photograph a distant city skyline, depth of field is extensive.

The Focused Point

Depth of field extends about one-third in front of the point you focus on, and two-thirds behind it. (This applies to most photography, except at extremely high magnification, which is beyond the scope of this book.) For extensive depth of field, say in a picture of a field of poppies, focus at a point roughly one-third of the way from the bottom of the frame using a relatively small aperture.

The Aperture (f-stop)

As mentioned earlier, large apertures (small f/numbers) produce limited depth of field while small apertures (large f/numbers) increase the zone

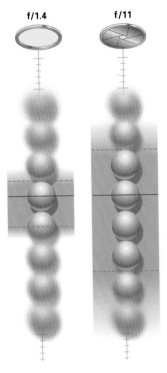

f/1.4 **f/11**

Although only the focused plane is truly sharp in any photograph, the **zone of acceptable sharpness** (depth of field) is greater. At a wide aperture (left) the depth of field is shallow. When a small aperture is selected, depth of field expands: More of the foreground and background is rendered as acceptably sharp.

Slim Films

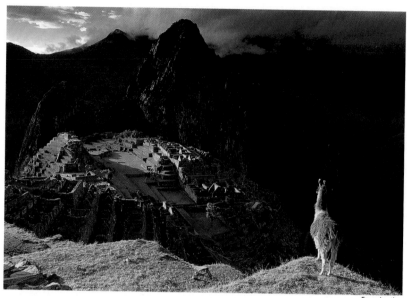

Frans Lanting

In landscape photographs we generally expect extensive depth of field, with sharp focus from the foreground to the background. To achieve this effect, select a wide-angle lens (wide-angle lenses inherently have greater depth of field at a given f-stop), set a small aperture (perhaps f/11 or higher), and focus about one-third of the way into the scene. If your camera has a depth-of-field preview control, check it before you shoot.

of acceptably sharp focus. As you stop down from f/5.6 to f/8 and so on, depth of field becomes more and more extensive. By f/22, you get great depth of field: The amount depends on the other factors mentioned previously, of course.

Check Depth of Field

Modern cameras allow you to view the scene at the maximum aperture of the lens where the view is brightest. This makes viewing and focusing easier. Since the camera stops the aperture down an instant before the shutter opens, you will not be able to see the depth of field change as the lens switches from a wide aperture to a small aperture. And it will differ in the pictures you take at each f-stop.

Some cameras (or lenses) include a control called "depth-of-field preview" that permits you to visually assess the range of sharp focus at any aperture. You may view the scene at several different f-stops and take the picture at the one with the right depth of field. The focusing screen

will darken as you stop down, so do it slowly—one f/stop at a time—to give your eye time to get accustomed to the dimmer screen. There are also other ways to evaluate the amount of depth of field.

Manufacturers' Charts

Lens manufacturers often publish a chart in the owner's manual that indicates depth of field at different apertures and subject distances. You may find similar charts in books and magazines about photography.

Lens Markings

Some lenses have scales next to the aperture ring for estimating the depth of field at each f-stop. This is becoming less common, however, especially with autofocus lenses, particularly zooms. And in some brands, the lenses do not even have aperture rings. Check your camera's owner's manual to determine exactly how to estimate depth of field if your lenses have aperture rings and a depth-of-field scale.

Hyperfocal Charts

In photo magazines, some companies advertise charts that help you to maximize depth of field. They list a number of focal lengths and indicate the optimum focused distance. For example, such charts may indicate: With a 20mm lens set to f/11, focus the lens at 5 feet and depth of field will extend from 2.5 feet to infinity. Similar information is provided for other f-stops—usually from f/8 to f/32. Such charts are useful for landscapes and cityscapes and other static subject matter that will "hold still" for a relatively long shutter speed.

Shutter Speed or F-stop?

Since you can get a correct exposure at many equivalent combinations of f-stop and shutter speed, which should you select? Is it better to use a wide aperture and a fast shutter speed, or a small aperture and a long shutter speed? It depends on two factors, one technical and the other creative.

Tip

The zone of acceptably sharp focus will seem more extensive in small prints than in enlargements. A foreground object that appears sharp in a 4x6 print may look partly blurred in a 16x20 blowup and even in an 8x10 when you view the picture closely.

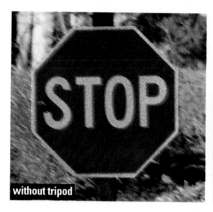

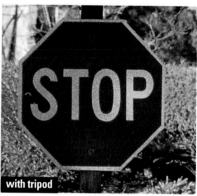

without tripod

with tripod

John G. Agnone, NGS Staff (both)

When shooting at long shutter speeds with a handheld camera, image blur is common. The photo on the left was made at 1/30 of a second with a 200mm lens. To ensure sharp pictures, use a firm support or faster shutter speed.

Avoid Unsharp Pictures

Photo finishers report that lack of sharpness is the most common reason for unsatisfactory pictures. Aside from errors in focusing, the cause is usually camera shake or subject motion. If you are hand-holding the camera, you will need a shutter speed fast enough to counter natural body tremors. And a moving subject, such as a child on a bike, will be blurred unless you use a fast shutter speed.

You can use a tripod, monopod, or some other support—even brace your elbows on a rock or the roof of a car—to counter camera shake. At the very least, use a correct holding position to keep the camera steady; cradle the lens in one hand and hold the camera with the other. For faster shutter speeds—to increase the odds of a razor-sharp picture—load a more light-sensitive or faster film, such as ISO 400 instead of ISO 100. This will allow you to select a broader combination of f-stop and shutter speed.

Note that the longer the lens, the faster the shutter speed needed for sharp pictures if you are hand-holding the camera equipment. The rule of thumb is to shoot at a shutter speed "at least one over the reciprocal of the focal length." For example, with a 28mm lens, shoot at 1/30; with a 50mm lens, at 1/60; with a 200mm telephoto, at 1/250 or faster. In low light, you rarely get high shutter speeds, so use a firm support to avoid blur.

Slim Films

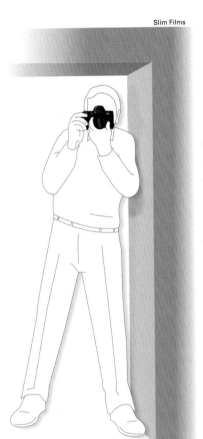

To increase the odds of making a sharp picture without blur caused by hand or body shake, use the correct **camera holding and posture techniques**. Tuck in your elbows, cradle the lens, and use either a standing or kneeling shooter's stance. For greater stability, lean against something solid whenever possible. These recommendations are especially important when shooting at slow shutter speeds in low light without flash.

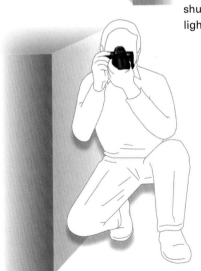

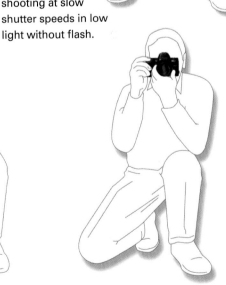

COMPOSITION

For vertical subjects, vertical framing is usually appropriate. Use the rule of thirds—or at least off-center composition—and leave space in front of an animate or moving subject. In this photograph, the egret's reflection adds a subtle element of depth.

Peter K. Burian

TODAY's sophisticated cameras, lenses, and color print films permit almost anyone to produce sharp pictures with correct exposure. On the other hand, very few of these technically acceptable photos should satisfy the creative standards of the serious photographer. Photographic excellence, like beauty, may be in the eye of the beholder, but most of us would agree on certain criteria. Cluttered backgrounds, partially blurred foreground objects, or tiny subjects dead center in the frame and over-powered by irrelevant space are not the ingredients for appealing pictures.

Composition is a primary factor in successful photography and deserves serious consideration. Despite a backlash against rigid rules, suitable composition remains essential for effective image design. A badly composed photograph will lessen appreciation of your work—even if the viewer does not recognize the reason. Today's "intelligent" SLR cameras can almost take the picture for you, but they have yet to be programmed to seek out and arrange the visual elements for well-balanced images. The following guidelines have proved very useful for achieving pleasing composition.

The Rule of Thirds

The rule-of-thirds guideline for off-center subject placement is the traditional way to create a well-balanced picture and has been used by painters for centuries. The center of any picture is not a satisfying resting place for the eye, and a central composition is static, not dynamic. To follow the

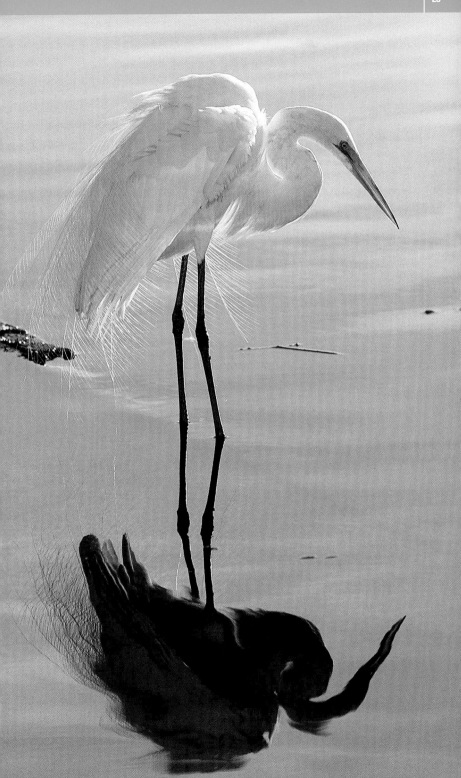

Susie Post

The rule of thirds is a guideline developed by artists centuries ago. When the subject—or its most important element—is placed near one of the intersecting points of an imaginary grid, the viewer's eye is led through the frame. The result is an aesthetically strong image.

rule of thirds, imagine that your camera's viewing screen is etched with grid lines, resembling a tic-tac-toe game. As you view the scene—be it a snow-covered tree, a distant lion on a plain, or a prairie farmhouse—place the subject at one of the intersecting points. This technique works equally well with a horizontal or a vertical framing and is far more effective than a dead center, bull's-eye composition. Here are a few examples to consider when composing in this manner.

Dramatic Skies

Emphasize dramatic skies by placing the horizon low in the frame, along the lower line in your imaginary grid. If the sky is dull, but important to the story, place it at the higher line.

Large Subject

In a close-up portrait, for example, place the most important subject element—the closest eye, perhaps—at an intersecting point in the frame. This should be one of the two top points so as to avoid excessive empty space above the subject.

Moving Subject

Leave space for a moving subject to "travel into"; if it's an animate subject at rest—such as an animal or person—leave space for it to gaze into if it is not looking into the lens.

Left to Right

In Western cultures we read from left to right and also tend to scan a picture the same way. For this reason, it is usually appropriate to place the primary subject closer to the left side of the frame. If the subject is in the exact center, we are less likely to explore the other areas. You may want to center the subject first for focusing, but then recompose; with most autofocus cameras, slight pressure on the shutter-release button will lock and hold focus.

Intentionally breaking the rule of thirds, the photographer decided to center the primary subject in the image below. The picture remains successful, however, because of the balance provided by other elements within the frame.

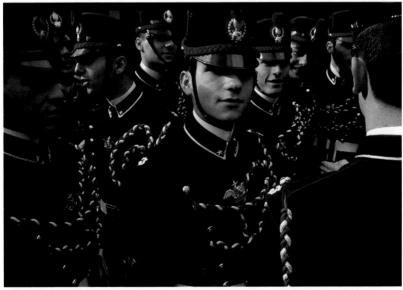

NGS Photographer David Alan Harvey

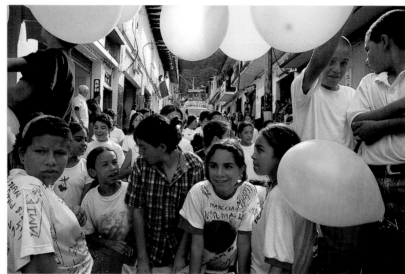

Susie Post

One way to create a three-dimensional effect within the two-dimensional photograph is to use a frame—in this case, colorful balloons. When you find a suitable framing device that is in motion, try to maneuver into position to take advantage of this depth-enhancing element.

Move the Subject

If you can, move the subject to a more appropriate spot in order to carry out any of the previous suggestions. Otherwise, simply move yourself and the camera. That may mean moving to the left a few feet, shooting from ground level, or driving a few miles to a more appropriate vantage point.

Off-Center Composition

In any off-center composition with a small center of interest, there will be some empty space in the frame. Compose the image so that there is something of interest—or a secondary, perhaps more distant subject—to satisfy the viewer's eye as it explores the picture. If you want to emphasize isolation, leave the space empty.

Foreground Frames

Often, especially in landscape and architectural photography, the empty space will be sky. Although a deep, azure-blue expanse can add to the appeal of an image, a pale sky can be distracting. You can eliminate much of the sky by moving closer, switch-

ing to a longer lens, or cropping the image when making or ordering a print. If none of these is feasible, try to find an object in the foreground to use as a frame above the primary subject. The archway, gate, door, or window of a more distant building, or a branch covered with leaves or blossoms are some commonly used framing devices. When using this technique, consider the following points.

Change Position
You may need to explore the area to find a suitable vantage point for your frame and change your position before making the picture.

Sharply Render or Blur Frames
The framing device should be sharply rendered or completely blurred away. For architecture, it's best to keep the frame sharp. Use a small aperture (perhaps f/22) and a wide-angle lens. For natural objects such as foliage, you may wish to completely blur away the frame into a soft wash of color; use a wide aperture, such as f/4, and a telephoto lens. Decisive tactics like these help create stronger pictures than those the f/8 setting often selected by a camera's program mode can produce.

Framing Objects
A framing object should have some aesthetic value on its own. Shapes such as archways, interesting brickwork, colorful doorways, or overhanging branches with brilliant fall colors or ripening fruit are but some of the possibilities. The framing object should not be so large, stunning, or colorful that it draws the viewer's eye away from the center of interest. If it is much darker than the subject, or in deep shade, it may be rendered as a silhouette. If it is fairly close to you, a bit of flash can provide a brighter effect; try shooting the situation with and without flash.

Appropriate Frame
The frame should complement the subject. A centuries-old mosque, for example, is unlikely to benefit from a frame provided by a new concrete

Melissa Farlow

Instead of taking a documentary photograph of this building, the photographer scouted the location to find a suitable frame and tilted the camera up at an angle. An imaginative approach can take even a frequently photographed subject into a new visual dimension.

structure covered with graffiti, unless you're trying to make a specific point such as architectural or social contrast in the image.

Frame the Bottom

A framing subject near the bottom of a picture can be equally useful to fill in empty expanses of grass or clutter. Boldly colored flowers, the rocks of an ancient farm fence, a small hill, shrubs, or farm implements are all possibilities. Make sure they are appropriate for the primary subject. To avoid a partially blurred foreground—which can be distracting—use care with depth of field.

Don't Overuse Framing

Avoid framing every subject because this device can

Raymond Gehman

A leading line—effectively employed here to draw the viewer's eye through the scene—is not used frequently by most photographers because it can be difficult to locate. When you notice a subject that might be suitable for a leading line, it's worth exploring the area to find the best position to take advantage of the potential it offers.

become clichéd if used excessively. Imagine a travelogue slide show of Greece in which every building, person, and landscape image is framed; you would soon find this technique forced and repetitious.

Leading Lines

For landscapes and other panoramic scenes, try to find a subject element that will lead the viewer's eye into the image—from left to right or bottom to top. Such an element might be a road receding into the distance toward a mountain, ice floes in water leading to a glacier, the graceful S curve of a river flowing from a mountain, or a series of fishing boats or rocks in the background at various

distances from a village. Refer to the suggestions in the section on framing regarding complementary subject matter and depth of field since these may affect the successful use of leading lines.

Other Compositional Techniques

In addition to the primary guidelines for composition already discussed, there are others that can help to create well-balanced, interesting images.

Find a Clear Point of Interest

Don't force the viewer's eye to roam around the picture, searching for a resting place or something to observe. Include a subject that will provide a point of interest—preferably not centered in the frame.

Fill the Frame

"If your pictures aren't good enough, you're not close enough." These wise words from World War II photojournalist Robert Capa are probably the most useful photographic advice. If you cannot walk up to the subject, switch to a longer lens to shoot portraits instead of snapshots. When the situation presents vertical lines, use a matching camera orientation to avoid wasted space at the edges of a frame. Otherwise, crop the photograph when making, ordering, or matting a print.

Present a Clear Message

In wide-angle compositions, exclude superfluous elements, especially very bright areas that will pull the viewer's eye from the primary subject. Crop competing subject matter in the viewfinder by changing your shooting position.

Compose Boldly

Consider other artistic components when looking for a picture in any vast scene. Look for the rhythm of repetitive elements, a dynamic diagonal, contrasting color, texture, or shape, or a unity of design. These are advanced techniques you can develop by studying the work of the masters of art and photography.

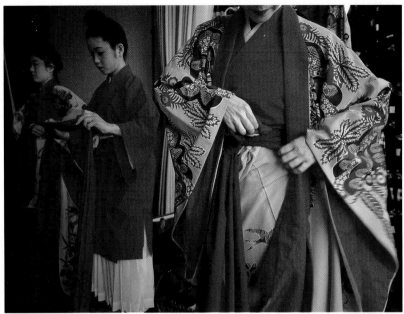

Karen Kasmauski

Create Depth

Use a wide-angle lens and include subjects in the foreground, middle ground, and background to give a three-dimensional feel to a two-dimensional image. A leading line, plus some overlap of elements such as buildings or mountains, can help.

Conclusion

Experienced photographers will often break the rules to make a point or create a mood. Before breaking the rules, it is important to know and practice the basics. After they have become second nature to you, begin to experiment. For example, you might try placing a circular subject in the center for formal symmetry, include urban clutter around an ancient monument, place the horizon line near the very bottom of the frame to empha- size dramatic clouds, or place a person so he is looking out of the frame for a sense of tension. But do so knowingly and intentionally, showing only your successes to others, and you will develop a reputation as an accomplished photographer.

The rules of composi- tion are not rigid, as this photographer proved when she created a powerful image by cropping the subject's head. The photograph remains successful, however, because it adheres to the rule of thirds and has a balanced composition and a strong center of interest.

CAMERAS

A single lens reflex (SLR) camera uses the same lens to view the scene and to make the picture. As the shutter-release button is pressed, the **reflex mirror,** which had been reflecting light to the viewfinder (via the pentaprism), moves upward, allowing the image to reach the film plane; the shutter curtain opens so that light can expose the film and then closes; the mirror automatically returns to its original position.

Slim Films

STILL PHOTOGRAPHY was invented more than 170 years ago, but it is in the past 25 years that the most significant advances have been made in the development of the camera itself. And in the past decade, the technology has advanced by quantum leaps. Today, many models incorporate powerful microcomputers with artificial intelligence. They are designed to make sharp, well-exposed pictures automatically. Despite these advances, the camera's basic features remain the same: The camera body holds the film in a lighttight chamber, the shutter opens for a specific time, and light exposes the film through a lens mounted to the camera.

Within this broad description there are several types and formats of cameras. Most use film, although there are digital models that don't use film. We'll review the most common types of cameras and the advantages of each, with emphasis on the full-size 35mm cameras that accept interchangeable lenses, since these are still the cameras most frequently used by serious photographers—at least those who work outside a studio.

Camera formats are based on the size of the film frame. The frames vary substantially, ranging from small in the Advanced Photo System (APS), to extremely large—up to 11x14-inch sheets—in cameras still used by some professional photographers for formal landscape and architectural photography. Although camera design has generally determined the film size that will be used, some cameras are adaptable to several formats, thereby giving photographers additional creative options.

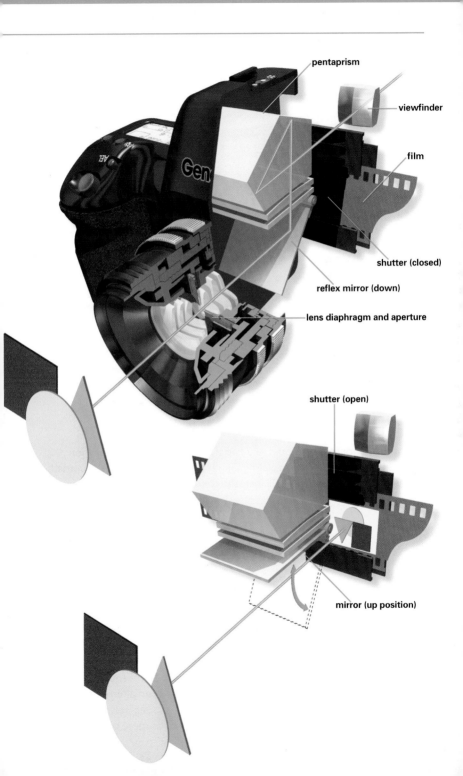

pentaprism

viewfinder

film

shutter (closed)

reflex mirror (down)

lens diaphragm and aperture

shutter (open)

mirror (up position)

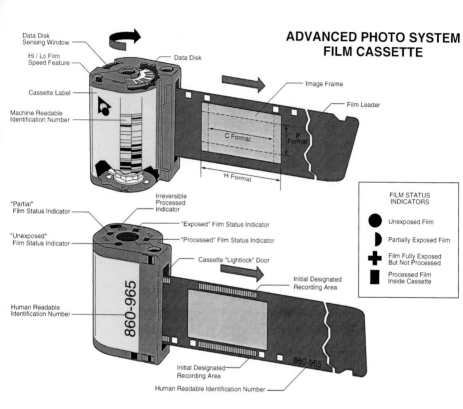

ADVANCED PHOTO SYSTEM FILM CASSETTE

Data Disk Sensing Window
Hi / Lo Film Speed Feature
Cassette Label
Machine Readable Identification Number
Data Disk
Image Frame
Film Leader
C Format
P Format
H Format

"Partial" Film Status Indicator
Irreversible Processed Indicator
"Unexposed" Film Status Indicator
"Exposed" Film Status Indicator
"Processed" Film Status Indicator
Cassette "Lightlock" Door
Human Readable Identification Number
860-965
Initial Designated Recording Area
Initial Designated Recording Area
Human Readable Identification Number
860-965

FILM STATUS INDICATORS

Unexposed Film
Partially Exposed Film
Film Fully Exposed But Not Processed
Processed Film Inside Cassette

Most film companies now offer **APS-format film**, designed specifically for APS cameras. Manufacturers claim that the wealth of information recorded on the film and the cassette will increase picture quality and convenience for photographers.

Courtesy Eastman Kodak Company

The Advanced Photo System

Most people are familiar with the 35mm format (with negatives and slides 24x36mm in size) that has been the industry standard for many years. Several smaller formats were offered in the past, but the latest (since 1996) is APS, sometimes called 24mm format, in which a frame of film is 17x30mm—almost 42 percent smaller than the 35mm frame. Intended as an alternative to 35mm photography, and not as a replacement, it offers several advantages such as more compact cameras;

virtually foolproof film loading; technology for better print quality; three distinct picture formats (4x6, slightly longer 4x7, and panoramic 4x10 or 4x11.5); and negatives that are returned in the film cartridge for storage and protection.

Although APS is available mostly in the compact point-and-shoot cameras, you'll find a few full-size APS cameras too. They include a full range of capabilities and accept interchangeable lenses and other accessories.

The Verdict on APS

Refer to the chart on page 40 comparing 35mm and APS format for additional specifics on the pros and cons of each. At the time of this writing, nearly half of all new compact cameras sold were of the smaller format. Although APS is very appropriate for point-and-shoot cameras, most serious photographers have remained loyal to the full-size SLR cameras because of their larger image size, the broader variety of available films, and the vast selection of models. If you regularly order 8x10 or larger prints, stick with a 35mm camera; otherwise, either format should meet your demands in terms of camera versatility and image quality.

Basic Camera Types

For the most popular types of film formats there are three primary types of cameras. Each has its own set of advantages and drawbacks, and there is no single type that is ideal in every respect.

(1) Lens-Shutter Compacts

The small (pocket-size) cameras incorporate a built-in lens with a shutter mechanism that opens to allow light to expose the film. You view the scene through a second lens—not through the lens that takes the picture. Also called a point-and-shoot camera, this type is generally fully automatic, with features from autofocus to camera-controlled exposure (picture brightness). Available for 35mm

> **Tip**
>
> The term "panoramic" is often used today to denote the "stretch format": a long, narrow image on a single frame of film. (The top and bottom of the frame are masked and print as black strips that are then cut off.) A few 35mm and medium-format SLR cameras also offer this option, sometimes with an accessory.

©1996 P. Burian

ISO 400

Peter K. Burian (above); John G. Agnone, NGS Staff (right, both)

Photo finishers provide an index print (above) for pictures on a roll of APS film, making it easy to select a frame when ordering prints. You don't see APS negatives, which are about 42 percent smaller than 35mm, because they are kept inside the film cassette after processing for storage and protection.

and APS film, compacts range from very inexpensive to prestige models with premium-grade lenses and magnesium alloy bodies. Today, most models include a built-in flash, and many have a zoom lens that ranges from wide-angle to telephoto, such as a 38-120mm or 38-160mm.

Pros and Cons

These lightweight cameras will fit into a jacket pocket, so they have a lot of appeal as take-anywhere models. They're self-contained

so you do not need to buy any extras. As a general rule, they are simple to operate. All but the very cheap models (which have poor lenses and unsophisticated automation) take good pictures, at least in terms of technical quality.

On the other hand, compact cameras are not intended for serious photography for three reasons. Most do not include even limited override of the automation; they do not accept other lenses or accessories, and, therefore, are limited in their scope; framing is inaccurate because, in close-up work, what you see through the viewfinder is not exactly what the lens sees.

The Verdict on Compacts
Good for traveling light and shooting quickly, compact cameras are extremely convenient,

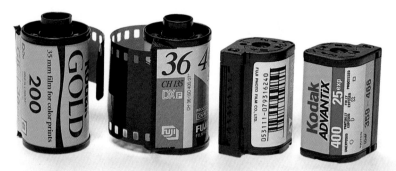

Compared with the 35mm rolls (left) the APS rolls are smaller and designed for automatic loading. Although fewer film types are available in APS, the variety is broad enough to satisfy most photographers. NGS Photographer Mark Thiessen

35mm Versus Advanced Photo System (APS)

35mm Format	Advanced Photo System
Larger negative produces better picture quality, especially noticeable in 8x10 and larger prints	Some APS cameras are smaller. Very good image quality in prints to 5x7 and good in 8x10 due to new film technology, especially from ISO 100 and 200 film
With modern cameras, film is quite easy to load	Foolproof, drop-in film loading
More camera, lens, and film types for serious photography	Mid-roll change capability (some models) makes switching film (at any time) extremely convenient; most SLRs accept lenses from 35mm systems
Superior APS film technology is already being employed in some 35mm films for even higher image quality	The film cartridge indicates whether the roll is new, used, partially exposed, or fully processed; you cannot accidentally reload a finished film
Well-equipped labs produce excellent prints; lower film and processing costs; both are universally available.	Information Exchange (IX) in top-of- the-line cameras can result in better print quality (if the lab uses a high-tech printing system)
Negative strips are flat, more compact to store	Negatives are returned in the cassette, reducing the risk of scratches
Some labs offer index prints for 35mm film	The lab provides an index print of all pictures on the roll so you can easily select those you want reprinted
Some 35mm cameras include a panorama frame feature, but prints can always be cropped to any shape desired	Choice of three picture formats can be selected in the camera or when reprints are ordered
Cameras with a data back can print date and time	Title, date, time, and print quantity features can be selected (high-end models only)
More film types universally available; usually less expensive	Most popular film types (including black-and-white) available; cassette is 25 percent smaller

and are a suitable backup to a more serious camera. Buy a mid-priced model of a familiar brand and you'll get a zoom lens with good optics, effective autofocus, built-in flash with red-eye reduction, and acceptable viewfinder quality. Avoid models with an excessive number of features and buttons. Compact cameras are ideal for family vacation activities such as canoeing or trekking because of their small size, low weight, and decent picture quality. If you often shoot in rain or around sand and water, look for weather-resistant models, which are well sealed against moisture and dust.

The APS-format camera below has advanced features and capabilities and is comparable to the 35mm model shown below it. Externally, APS cameras are not always smaller, especially those with broad-range zoom lenses.

Courtesy Eastman Kodak Company (top);
Courtesy Pentax Corporation (lower)

(2) The Single Lens Reflex (SLR)

Despite the convenience of point-and-shoot compact cameras, most serious photographers prefer a single lens reflex camera. Often abbreviated to SLR, the name refers to the fact that you view and take the picture through one lens. Available in APS, 35mm, and the larger medium format, SLR cameras range from very basic (fully manual) to extremely advanced with "intelligent" automation, which allows even the novice to produce technically

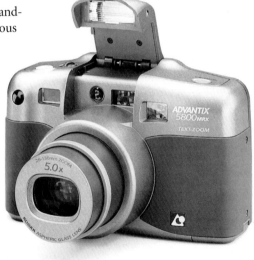

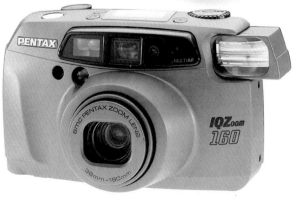

good pictures. All current models include overrides, allowing the camera to grow in versatility as the owner's skills and demands increase.

Pros and Cons

Viewing the subject through the lens will actually make the picture more accurate in framing. Thanks to the internal mirror and prism system, what you see is what you get. Most SLR systems include a broad range of lenses, flash units from small to powerful, and accessories for advanced applications. You can see exactly what is (and is not) in focus; you can adjust the shutter speed to vary the depiction of motion; and you can set the aperture (f-stop) to vary the range of sharp focus. In automatic modes the camera will provide correct exposure, although you can override the system at any time for a brighter, darker, or more aesthetically creative picture. Or you can switch to the fully manual mode for complete control of all aspects of picture-making.

Intended for advanced hobbyists and professional photographers, the full-featured 35mm SLR cameras (below) are large, heavy, and expensive. Most manufacturers offer smaller, lighter, and more affordable models (opposite) as well; many of these include the essential automatic, semi-automatic, and manual features discussed in the text.

Courtesy Nikon, Inc. (both)

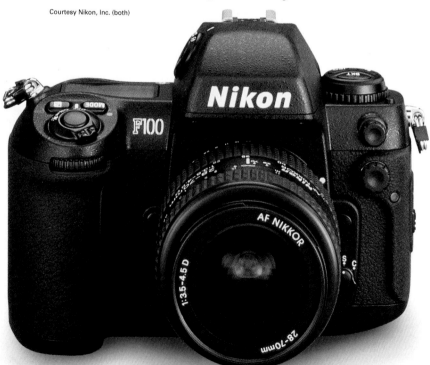

The Verdict on SLRs

The 35mm single lens reflex models are by far the most popular among serious photographers. Available models range from basic-inexpensive to full-featured-pricey, and you'll find many in every price category. Some photographers prefer a medium-format SLR camera because of the larger size of the negative or transparency—4.5x6cm, 6x 6cm, and 6x7cm are most common. (Even the smallest negative is nearly three times larger than its 35mm counterpart.) Note, however, that medium-format cameras tend to be more expensive, larger, heavier, and usually less automated. The larger image size is a definite advantage when oversize prints are required.

(3) The Rangefinder Camera

In both 35mm and medium format, there's another type of camera that accepts interchangeable lenses: the rangefinder with a viewing system above or beside the lens. In the latest models, the view is quite accurate. You see what will be recorded on film, thanks to a sophisticated viewfinder that adjusts to the lens and the focused distance. Some models have lines in the finder that allow nearly accurate framing in close-up photography.

Tip

Very few SLR cameras show 100 percent of the actual image area in the viewing screen. Hence, more of the scene will be recorded on the slide or negative than you can see. For slides, this makes little difference since the slide mount covers some of the image area around the edges of the frame. When prints are made from negatives—especially with automated photo finishing equipment—an even larger area is cropped.

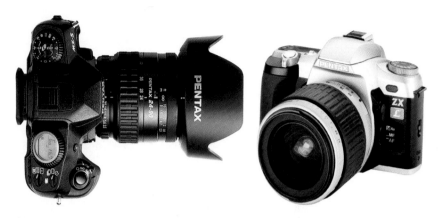

SLR cameras with autofocus and high-tech features such as intelligent light-metering systems and advanced program capabilities have differing types of controls: Most current models have fewer buttons, because "command" or "input" dials are quicker and more convenient.

Courtesy Pentax USA (both)

Pros and Cons

A rangefinder camera allows you to see the subject at all times, because the view does not black out when the image is being made. The cameras (and lenses) are usually small, inconspicuous, and virtually silent in operation. Most models are elegant, offering a prestige look and feel; superb mechanical components and optics are a bonus. In comparison to SLR systems the drawbacks, however, are notable: generally less automation, higher price considering the capabilities, few accessories and lenses (usually from ultrawide to short tele-photo), plus a view that is not quite clear with tele-photo lenses or 100 percent accurate in close-ups.

The Verdict on Rangefinders

Most of the benefits described are useful for photographing people, when capturing the right gesture or the decisive moment is important. Hence, it's no surprise that rangefinders are the preferred cameras of many photojournalists as well as travel photographers. The Contax G2 system is competitive with some high-tech SLR cameras because it includes autofocus, built-in film advance motor,

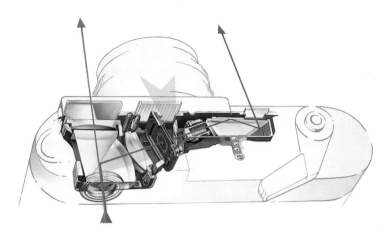

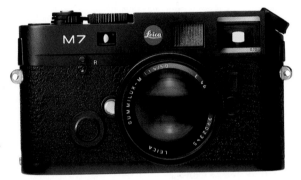

and the basic automatic modes in addition to fully manual operation. Although most rangefinder owners also own a full SLR system (often including longer telephoto lenses), few would ever switch entirely.

Larger-Format Cameras

Medium-Format

Although the 35mm systems have numerous advantages, some photographers prefer a larger negative. Many camera systems accept roll films larger than 35mm. The most common formats produce a negative or transparency that is 5.6x4.2cm (called "645," because the image size is close to 6x4.5cm), 6x6cm (or 2 ¼ inches square), or 6x7cm in size; larger formats are available too.

Larger-format cameras have several advantages. Their larger negatives can be more easily retouched (blemishes removed by an artist); they produce sharper images in enlargements; and the 645 and 6x7 formats are more closely proportional to standard-size printing papers and magazine pages.

The Leica M7 is a sophisticated rangefinder. Utilizing prisms, it superimposes a portion of two nearly identical images, one on top of the other. When the lens is accurately focused on the subject, the small, central field-measuring rectangle—which is slightly lighter in tone than the surrounding image—appears as a single image.

Courtesy Leica Camera, Inc.

35mm SLR Cameras Versus 35mm Rangefinders

Subject/Situation	SLR Pro and Con	Rangefinder Pro and Con
People: candids, family events, weddings	**Pro:** High levels of automation and many zoom lenses also allow for quick shooting **Con:** Viewfinder blacks out while photo is taken; most SLRs are not as quiet	***Pro:** Nearly silent shutter release; subject is visible in the finder at all times **Con:** No zoom lenses; some models are less automated, especially the flash
Wildlife	***Pro:** Availability of long lenses for distant subjects **Con:** Cameras can be noisy	**Pro:** Quieter operation **Con:** Longest lenses are only 135mm, too short for wildlife
Travel	***Pro:** Zoom lenses reduce number of lenses needed; autoexposure and autofocus are readily available **Con:** Greater weight and size	**Pro:** Very portable and inconspicuous
General flash photography	***Pro:** TTL flash, sophisticated automatic fill-in flash available; built-in flash is common **Con:** N/A	**Pro:** Some of the latest models include TTL flash **Con:** Few high-power flash units; generally, less automation
Sports and action	***Pro:** Long lenses and high-speed film advance **Con:** N/A	**Pro:** N/A **Con:** No long lenses or high-speed film advance
Hiking, trekking, climbing	**Pro:** One zoom lens may be all that is required **Con:** Greater weight	***Pro:** Generally small, light-weight camera and lenses **Con:** No zoom lenses
Quick shooting situations	***Pro:** Extensive automation and fast film advance; zoom lenses **Con:** N/A	**Pro:** Lightweight; some automation available **Con:** Frequent lens changes; slower film advance
Low light	**Pro:** Lenses with image stabilizer becoming available **Con:** Dimmer viewing screen	***Pro:** Brighter view for ease of focusing and framing; lenses with wider apertures reduce need for flash or tripod **Con:** N/A
Extreme close-ups	***Pro:** Many close-focusing lenses; accurate framing; depth-of-field preview available with some cameras and lenses **Con:** N/A	**Pro:** N/A **Con:** No extremely close-focusing lenses; less accurate framing; no depth-of-field preview
Landscape	***Pro:** No need to manually adjust exposure for filters; can see effect of polarizer in the viewfinder; depth-of-field preview and extremely short lenses available **Con:** N/A	**Pro:** 20mm and 21mm lenses are common and adequate for most scenes **Con:** No depth-of-field preview; cannot see effect of polarizer; filter factor must be calculated for correct exposure

Note: The *symbol indicates which camera type is generally more useful in the particular situation described.

The most common medium-format cameras are rangefinders and single-lens reflex models. Their level of automation varies from minimal to extensive; even autofocus is available with some newer 645-format models. Some systems allow additional capabilities to be added with modular components. Some cameras also feature removable backs, so film can be changed quickly in mid-roll. Because of the larger image size, photographers who shoot primarily weddings, portraits, or industrial and architectural subjects often use these medium-format cameras.

View Camera

The large-format or "view" cameras that use sheets of film (4x5 inches is most common) are quite specialized, so we will not discuss them in detail here. They are cumbersome, very large, time-consuming to set up and operate, and require extensive training and experience to master. They are fully manual cameras without any automation whatsoever—not even a built-in light meter; film has to be loaded one sheet at a time.

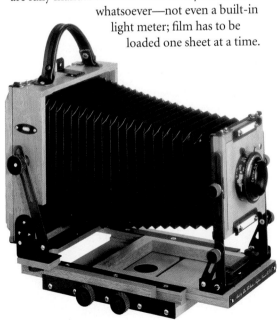

In addition to the APS and 35mm formats, there are many medium-format and large-format models. Appropriate film is available up to 11x14 inches. The 645 (above) and similar models are most like 35mm cameras—reasonably compact and automated. The 4x5-inch and larger models are preferred by those who need a very large image size and extensive perspective-control capabilities.

Courtesy Mamiya America Corporation (top); courtesy Calumet Photographic (lower)

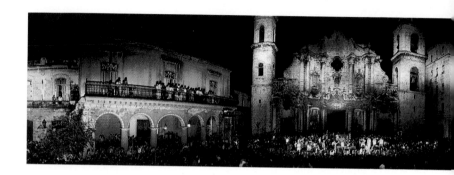

The photographer views and focuses the image—upside down and reversed from left to right—on a ground glass screen with a dark cloth over his head to keep bright light out.

However, the primary advantage of these cameras is obvious: The huge film size requires far less magnification when enlargements are made. (A 4x5-inch negative is 15 times larger than a 35mm negative.) The result is a print with extreme sharpness and superb definition of the most intricate detail. Even more important are the almost unlimited "movements" of the camera back and the front lens standard—up-down and left-right. This flexibility can be used to correct perspective distortion (see the chapter on lenses) and to

These panoramic cameras represent two of the various types of models currently available. The Fuji Gx617 (left) uses a fixed ultrawide lens that produces a 6x17cm image on medium-format roll film. The Noblex 135U exposes 35mm film using a rotating lens to create a 24mm x 66mm image.

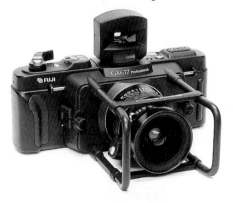
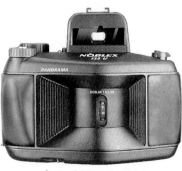

Courtesy Fuji Photo Film U.S.A., Inc. (left);
courtesy R.T.S. (right)

James L. Stanfield

To record the historic cathedral square of Havana, Cuba, the photographer used a camera that rotated a full 360 degrees during the exposure time. The strip reproduced here—half of the entire image—includes 180 degrees of the scene.

expand depth of field; with some skill, you can keep both foreground rocks and a mountain sharp in a photograph. All of these capabilities can substantially increase versatility—invaluable for professional applications such as product, landscape, and architectural photography.

Panoramic Cameras

Although they are not one of the primary types, cameras that produce a true panoramic image are available in 35mm and in medium format (plus a few in large format). Generally, they use a very long strip of film to produce a wide image that records 140 degrees (or more, or less) of a scene. Some models use ultrawide-angle lenses and record an image only on the central area of the film. Others include mechanisms for rotating the lens—or the entire camera—during the exposure. In medium format, the 6x12cm frame is common, whereas some cameras produce a 6x17cm negative or transparency. A few rotational cameras provide a full 360-degree image on a long strip of film— 24x224mm in size (35mm format) with one specific model.

Used by industrial as well as landscape and cityscape photographers, panoramic cameras produce unique images now in high demand among some publishers. But true panoramic cameras are specialty products intended for professional photographers. They are quite expensive and have limited use for general photography. Note, too,

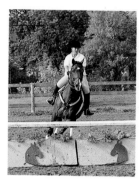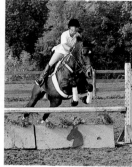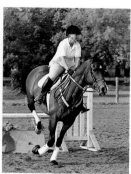

Peter K. Burian (all)

Using an autofocus SLR camera, the photographer was able to capture a series of sharply rendered images of this moving subject. Although some photographers have developed the ability to track a moving subject with manual focus, this automatic follow-focus technology is gaining in popularity.

that few labs can print the long negatives, and there are few projectors available for the long slides or transparencies. If you are interested in panoramic photography, check our list of recommended reading for a suitable book on this topic.

Manual Focus Versus Autofocus

Most 35mm SLR cameras sold today—in both professional and consumer models—incorporate autofocus or AF (even a few medium-format cameras now offer autofocus). Although autofocus systems are not foolproof or ideal for every situation, tests of recent 35mm SLR models confirm that these systems are extremely reliable. They work well in low-light conditions and have little difficulty focusing on varying subject and lighting patterns.

Although the technology is very complex, the basic "phase detection" system of such cameras operates as follows: Some of the light entering through the lens is split and directed to a pair of sensors. A computer compares the two images and, if they differ, it activates the lens to turn until they are "in phase" or identical, indicating that sharp

focus has been achieved. (Most point-and-shoot cameras employ an entirely different technology in which a near-infrared beam is projected onto the subject.)

Unlike a compact camera, an SLR allows you to switch to manual focus for critical work such as portrait or extreme close-up nature photography, while still taking advantage of the focus confirmation signal in the viewfinder that lights up when focus has been achieved. And even with AF you can precisely control the point of sharpest focus, say a rock over to the side in a panoramic scene. Simply place the central point of the viewfinder over the intended subject and activate the focus lock (standard with most current cameras) while you recompose. This simple and quick technique soon becomes second nature.

Virtually every current AF model also includes continuous follow focus with "predictive" capability: tracking focus that will produce a series of sharp frames of a moving subject. Such systems actually anticipate the exact point the subject will reach at the instant of exposure, rendering a sharp image in most cases.

Some SLRs incorporate wide-area or multi-point autofocus sensors that will home in on a subject to the left or right of center to avoid a static composition. This feature is also useful in action photography for continuing to track a moving subject that drifts off center. Fortunately, all but the most basic cameras with wide-area focus detection will allow you to switch to a single autofocus sensor. This feature is essential when you want to set the exact point of focus yourself rather than allow the system to select the most logical.

Selecting a Camera

It is difficult to choose a specific 35mm SLR from among the numerous models on the market. Some people prefer a computerized 35mm SLR camera with all of the latest high-tech capabilities such as

Tip

To narrow the field, look for buyers' guides—published by most photo magazines at least once a year—with charts listing all available models and the capabilities of each. You'll find these—or at least a specific issue listing all models within a certain category— at a well-stocked newsstand or bookstore.

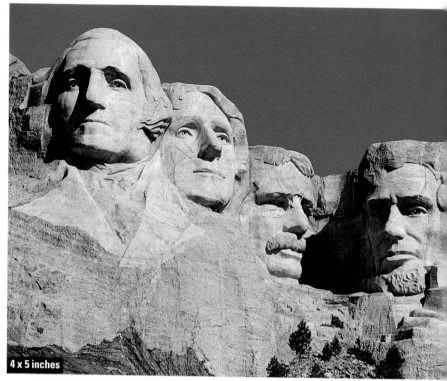

4 x 5 inches

Peter K. Burian (all)

Six pictures, all made from the same 35mm slide, illustrate the relative sizes of images produced by cameras in the most common formats. The advantages of a larger negative or transparency—finer relative grain and detail—are most important when huge enlargements are required.

autofocus, intelligent multizone exposure metering, custom functions for modifying camera operation, and a wealth of additional features, plus overrides. Others shun such special features, and insist on a traditional all-manual and often fully mechanical model that will operate even without batteries.

Between these extremes are many cameras with varying amounts of automation. Most have at least a few auto-assist features. Lack of space precludes surveying the 50 or more SLR cameras in the 35mm format or the dozens of features now available. This section on cameras and the upcoming

section on exposure outline the basic capabilities you'll want in any camera that offers user control.

For a versatile, all-round camera, 35mm is not the only choice. Especially today, with a broad variety of medium-format models available that use the larger roll films, you definitely have other options. Some brands start with a bare-bones body but offer accessories that can add automated

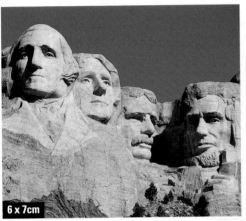

6 x 7cm

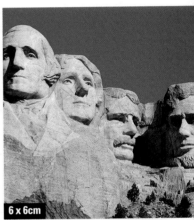

6 x 6cm

capabilities. As these systems continue to expand, many photographers have moved up to larger formats, keeping their 35mm SLR systems for occasional use, especially with supertelephoto lenses that tend to be unavailable or prohibitively expensive in larger formats.

6 x 4.5cm

The key to buying the right model is research. Narrow your scope to three or four that include the features you want at a price you can afford. Then evaluate them for handling qualities, the logic of the control layout, and simplicity of operation. A "test drive" is essential, so be sure to ask for a demonstration of your selected models at a well-stocked photo retailer. This may well be the single most valuable step to a wise investment and will ensure long-term satisfaction with your purchase.

35mm

APS

LENSES

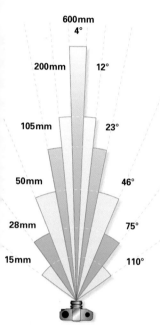

600mm
4°

200mm
12°

105mm
23°

50mm
46°

28mm
75°

15mm
110°

The primary difference between short and long lenses is the **angle of view**—the amount of a scene covered, designated in degrees. This ranges from wide (wide-angle lenses) to narrow (telephoto lenses) as depicted above and can be varied with zoom lenses.

Slim Films

NO MATTER HOW EXPENSIVE or technically advanced a camera may be, it is still basically a lighttight box designed to hold the film. It is really the lens—along with the creative vision of the photographer—that makes the image. Although a few photographers have produced a body of exceptional work with a single lens, most, by far, agree they need at least several lenses. The venerable 50mm lens, for example, is very useful, but it simply cannot do all things for all photographers.

One of the advantages of the SLR (single lens reflex) camera is its ability to accept a broad array of optics such as fish-eye lenses, wide-angle lenses, supertelephoto lenses, close-focusing macro lenses, and zooms. This ability applies both to 35mm and to medium-format cameras, although for the sake of simplicity, we'll discuss the concepts in terms of the 35mm systems. (Some rangefinder cameras will also accept interchangeable lenses but offer fewer choices, generally from ultrawide-angle to moderate telephoto.)

Lens Functions

A lens is composed of multiple elements of optical glass—both concave and convex—designed to focus light rays on a common point: the film. In order to produce an image that a viewer will perceive as "sharp," a lens must have high resolving power (an ability to clearly define intricate detail) and good contrast (well-defined distinction between light and dark areas). The lens controls the amount of light that will strike the film. The

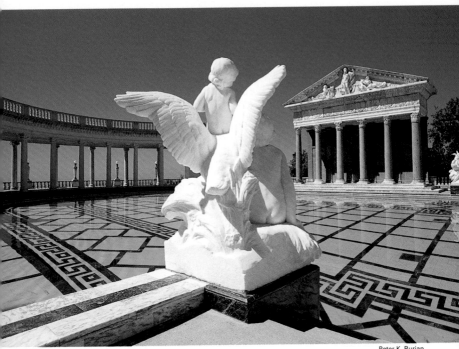

Peter K. Burian

amount of light depends on the size of the aperture in the diaphragm mechanism within the barrel.

The range of apparent sharpness within a scene (depth of field) depends on the aperture (f-stop) selected, as well as the focal length and other factors discussed previously.

The exact point of maximum sharpness—such as the eye in a portrait—is controlled by the photographer, who uses the focusing ring on the lens to set focus. An autofocus camera's system can be set to focus automatically.

The size of the subject in the frame is controlled by the lens, at least to some extent. Naturally, you can make the subject larger in the frame simply by getting closer to it. But some lenses (telephoto) are intended to magnify very distant subjects so they will appear much larger on the negative or slide. Others (macro) are designed to permit extremely close focusing for very high magnification.

If you set up the camera in one spot, the amount of the scene that will be included in the frame will

It is possible to create images with depth and a three-dimensional feeling by employing a wide-angle lens (in this case a 20mm on a 35mm camera) and extensive depth of field by selecting a subject that includes a strong foreground and clear, identifiable background.

Tip

The longer the lens, the more care you must take to avoid blur from camera shake. With a 50mm lens, you can get sharp pictures at a 1/60 shutter speed. With a 500mm telephoto, you'll need at least 1/500 if shooting handheld. For higher shutter speeds, switch to a faster film such as ISO 400. For the ultimate in sharpness, use a firm support, preferably a very rigid tripod.

depend on the focal length of the lens. A 15mm ultrawide-angle lens, for example, will cover a vast segment of a landscape, while a 600mm super telephoto will cover only a single element, say a bald eagle perched on a distant tree limb.

The Normal Lens

In the 35mm format, the 50mm to 55mm lens is considered normal. It offers an angle of view of about 45 degrees—about the same as that of your eye. Except in extreme close-ups, it produces images with a look or perspective that is very natural and without distortion. The scene in a photograph looks very much the way you remember it. Before zoom lenses became popular, most SLR cameras were sold with a 50mm lens. Some photographers still use one, since it is lightweight, affordable, useful in low-light situations, and produces excellent image quality.

Perspective

Perspective is a difficult concept to explain and to fully appreciate. In its most basic photographic definition, perspective is simply the effect that makes a distant object appear to be farther away than a nearby subject. A supertelephoto lens seems to make near and distant subjects appear very close to each other, while an ultrawide-angle lens has the opposite effect.

In truth, perspective depends on the distance from the camera to the subject. Take a picture with a 300mm lens and a 20mm lens from exactly the same distance. Enlarge the central area of the wide-angle photograph and you will notice that the perspective is identical in both images. We generally use long lenses for distant subjects, however, leading to "compressed" perspective; they tend to make the distance between the subject and the background appear to be very short. With a wide-angle lens, we may move in extremely

James L. Stanfield

close to fill the frame. This causes "exaggerated" perspective: A foreground subject appears much larger than it does to the naked eye, while more distant subjects appear to recede into the distance.

When we tilt a camera upward to include an entire building, the bottom of the structure is much closer to the lens than the top. This produces apparent distortion of perspective, with part of the structure appearing extremely close and the other part quite distant. Maintain an awareness of apparent perspective and how you can change it or take advantage of it for specific effects you want.

To make this image, designed to draw the viewer's attention to the building's construction and detailed facade, the photographer intentionally exaggerated the perspective by moving in close to the subject and tilting the lens upward at a steep angle.

Wide-Angle Lenses

Any lens with a focal length of less than 50mm can be called wide-angle. Within this broad definition we find everything from 35mm down to 6mm, including fish-eye lenses that cover a full 180-degree angle of view. Lenses of 20mm or shorter are called ultrawide. The primary advantage of a shorter focal length lens is that it will record more of a given scene in the frame.

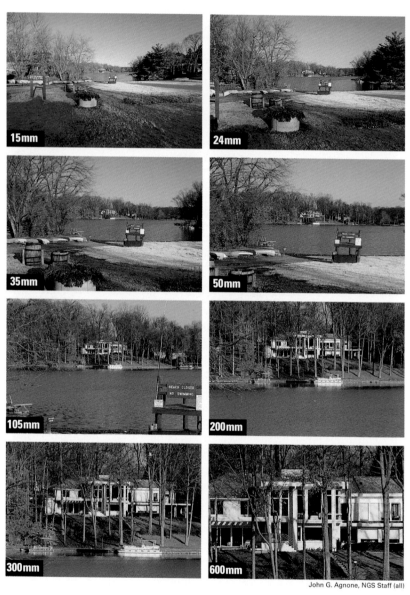

15mm
24mm
35mm
50mm
105mm
200mm
300mm
600mm

John G. Agnone, NGS Staff (all)

This series demonstrates the difference in magnification, angle of view, and depth of field with various lenses. The photographer recorded the same subject from a fixed position with eight different focal lengths. The primary subject is in the same relative position in each successive exposure.

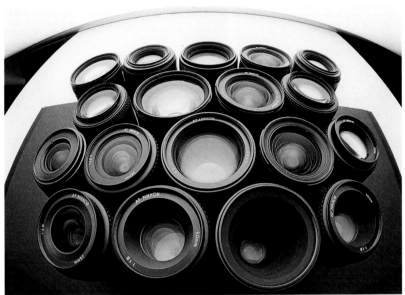

Courtesy Nikon, Inc.

A wide-angle lens can be useful if you cannot back up to include the entire subject you want to photograph using a longer lens. But the wide-angle lens has creative advantages too. A hillside of wildflowers, for example, with an expansive sweep of blossoms receding toward the horizon, makes an appealing picture. In magazines, you'll often see wide-angle images that include people in the fore-ground, the middle ground, and the background. Such complex images—containing several layers of activity and information in a single frame—are made possible by wide-angle lenses.

The leading camera manufacturers and several independent brand makers offer a wide variety of lens types and focal lengths intended to meet every need. The selection above may seem large, but it includes fewer than half of the lenses in the Nikkor series.

Wide-Angle Characteristics

Let's consider some factors common to wide-angle lenses. Keep in mind that the shorter the focal length, the more pronounced each of the following characteristics will be.

A Wide Coverage of the Subject
A 28mm lens offers an angle of view (75 degrees) roughly comparable to that of your own two eyes.

Stephen G. St. John, NGS Staff (both)

Accurate focus is generally a prerequisite for a technically good picture (left). However, for creative purposes, a photographer may decide to focus in front of or behind the usual point of sharp focus, thereby producing a different image: in this case, an abstract rendition of color and shape.

Move down to a shorter lens such as 15mm and the difference is very substantial. Now you have an ultrawide angle of view (110 degrees) that includes considerably more elements than your eyes can see without scanning.

Expanded or Exaggerated Perspective

This creates an optical illusion that distorts the relative size of objects and makes objects within a scene appear quite far apart. Those very close to the lens appear unusually large or exaggerated, overpowering the scene. Anything at a greater distance is "pushed back," or rendered much smaller than the eye perceives.

Occasional Distortion of Lines

When the lens is tilted upward or downward, lines in the scene converge. Point the lens upward to photograph a building, for example, and the structure will appear to be falling backward, an effect called "keystoning." This distortion of perspective, as discussed earlier, can be used for creative purposes.

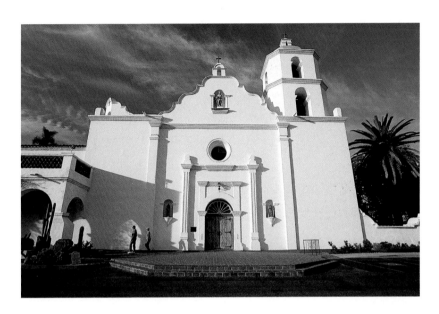

To record the entire church from near distance (above), the photographer used a 28mm wide-angle lens tilted upward. Deciding to eliminate the "keystoning" effect, he then moved farther back to a position where, with a 70mm lens, he could shoot with the camera back parallel to the subject, thereby producing an image with straight sides and "normal" perspective.

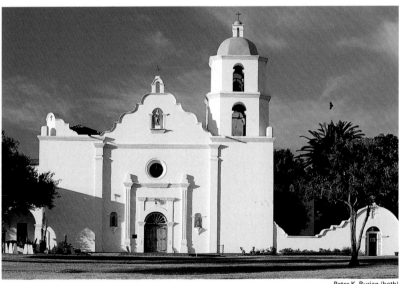

Peter K. Burian (both)

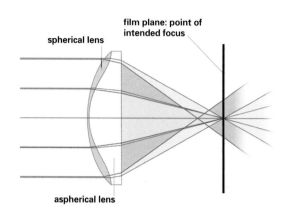

spherical lens

film plane: point of intended focus

aspherical lens

Courtesy Sigma Corporation of America (above); Slim Films (right)

Most lens manufacturers now offer wide-angle lenses and zooms with high-tech optical elements. These **aspherical optics** force all wavelengths of light to focus more accurately on the film for higher sharpness at the edges of the frame. Such lenses are worth considering—especially in the 20mm and shorter focal length—if you frequently order prints of 11x14 or larger.

Tip

To maximize depth of field, set focus at a point one-third of the way up from the bottom of the frame. Set a small aperture such as f/16. If your camera has depth-of-field preview, you can check the effect at various apertures. The viewing screen will darken, so shift to smaller apertures slowly, giving your eye time to accommodate to the dimmer view.

Extensive Depth of Field

An entire scene can be rendered in reasonably sharp focus from foreground to background. With a 24mm lens, for example, you can render an entire cruise ship—from bow to stern—suitably sharp, although it will appear much longer than the original. (Naturally, the smaller the aperture the greater the depth of field.)

Subjects at the Edges of the Frame Appear Elongated

This is an optical property—particularly with extremely short focal lengths when the lens is tilted—and not a sign of inferior design.

Telephoto Lenses

Lenses with a focal length longer than about 60mm, generally called telephotos, can be as long as 2000mm. Long lenses are problem solvers. They are useful when you want frame-filling images of distant subjects. In general, telephoto lenses have the following characteristics, and the longer the focal length, the more apparent each of these characteristics will become.

Greater Effective "Reach"

When you simply cannot get closer to the action, switch to a longer focal length to fill the frame.

A Narrow Angle of View

Since only a small part of what your eyes see falls within the frame, a telephoto lens makes it easy to exclude distracting elements around the center of interest. A long lens also makes it easy to place your subject against a small, uncluttered area of the background, thereby drawing attention to it.

Compressed Perspective

Telephoto lenses make objects at various distances appear closer together than the naked eye perceives. In an urban landscape, cars, signs, telephone poles, and pedestrians appear "stacked." In more scenic settings, telephotos can be used to create graphic patterns by compressing natural lines, shapes, and colors until patterns emerge that are not visible to the naked eye.

Shallow Depth of Field

This allows a narrow range of acceptably sharp focus so only the focused point is really sharp. Especially at wide apertures such as f/4, you can blur away a busy, distracting background into a soft wash of color with longer lenses. This does not work if the subject is too close to the background since both will appear in reasonably sharp focus.

Tip

Lens manufacturers now offer a line of professional telephoto and telephoto-zoom lenses. Their high-tech glass (low dispersion) causes all wavelengths of light to focus more accurately on the film. The result is greater sharpness and better color rendition.

In some situations it is impossible to move closer to the subject. Shooting from shore, the photographer used a 400mm telephoto lens to get closer to the subject. Compression of elements within a scene and shallow depth of field increase with focal length.

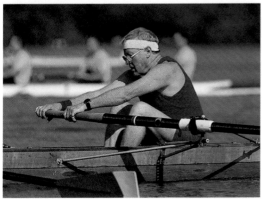

Peter K. Burian (above); Courtesy Canon U.S.A., Inc. (right)

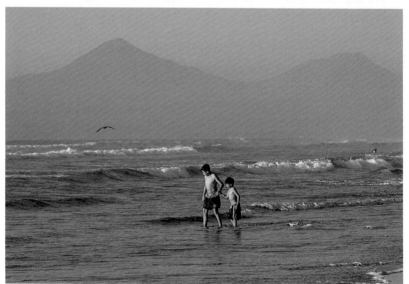

Melissa Farlow (both)

The photographer recorded this scene from approximately the same position with two different lenses, a 28mm wide-angle (top) and a 135mm telephoto. Note the difference in apparent perspective from "expanded" to "compressed" depending on the focal length of the lens.

Zoom Lenses

Zoom lenses allow photographers to shift the focal length instantly, without changing lenses. You can take a shot of a huge pack of cyclists in a race and on the next frame you can get a picture of a single competitor struggling to keep up. Even so, there are some trade-offs in return for the convenience. Although zooms are not ideal in every respect, they have become standard in 35mm SLR systems. Let's consider the characteristics and the pros and cons of zoom lenses.

Greater Weight and Size

Zoom lenses tend to be heavier and larger than their single-focal-length counterparts. On the other hand, a single zoom lens such as a 28-200mm can replace several others.

Smaller Maximum Apertures

Many zooms (especially the compact models) tend to be "slow": their maximum apertures are often only f/4.5 or f/5.6. By comparison, single-focal-length lenses are often "fast," with wide f/2 apertures, for example, resulting in faster shutter speeds—useful when hand-holding the camera. Today's excellent ISO 400 films or electronic flash can minimize the need for fast lenses by freezing the movement of subject or photographer.

Variable Aperture With Many Zooms

A 70-200mm f/4-5.6 zoom lens—set to f/4—starts at f/4 but, as you zoom toward the long end, the aperture gradually becomes smaller: f/5.6 by about 190mm. In an automatic mode, this is not a problem because your in-camera light meter reads the amount of light actually reaching the film and sets the shutter speed to maintain correct exposure.

Lower Optical Quality, Sometimes

Very affordable zoom lenses—especially those that range from wide-angle to telephoto—may not be up to professional standards. Still, the optical quality of today's computer-designed zoom lenses can

Tip

Long lenses tend to compress atmospheric haze, producing a soft image without much contrast. In hazy conditions, try to move closer to the subject and switch to a shorter lens.

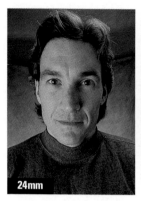
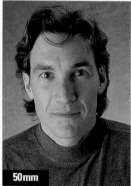
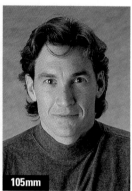

24mm

50mm

105mm

John G. Agnone, NGS Staff (all)

For portraits of people, professionals often use short telephoto lenses (85mm to 135mm.) These lenses allow photographers to shoot from a comfortable distance, without crowding the subject. In a head-and-shoulders photo, such lenses offer a very natural look without distortion of facial features.

be high. The premium-grade optics used in the pro zoom lenses produce superlative image quality.

The Verdict on Zooms

Zoom lenses developed a bad reputation because early models failed to live up to high expectations. But today, developments in technology have improved their optical performance. Some zooms match the best of their single-focal-length counterparts. In fact, the single most commonly used lenses by professional photographers (shooting outside a studio) are zooms: generally the pro 20-35mm, 35-70 mm and 80-200mm f/2.8 models. Zoom lenses provide great compositional freedom plus the ability for accurate framing when you cannot easily change your shooting position. Instead of missing opportunities while others switch lenses, you can capture a fleeting moment, vary the apparent perspective, or concentrate on composition while the light is rapidly changing.

Should you insist on a "fast," constant-aperture zoom, look for one of the f/2.8 models. The price, size, and weight of this type are higher, but many

photographers accept these drawbacks as a small penalty in return for the benefits. Although no zoom lens is perfect, zooms outsell single-focal-length lenses by a vast margin, and their growing popularity is understandable.

Specialty Optics

In addition to the primary lens types discussed, there are several others, including accessories, that should be considered.

Mirror Lenses

Also called "reflex" and "catadioptric" lenses, these affordable long-focal-length lenses are lightweight

Tip

Regardless of the type of lens, optical performance and maximum sharpness are usually best at f/8 or f/11, the midsize apertures.

A zoom lens is ideal for shooting from a fixed position. The photographer, using a 70mm to 210mm zoom lens, stood on the shore of a lake surrounded by mountains. In the image at left, the lens was set at 70mm. At right, he has zoomed to 210mm.

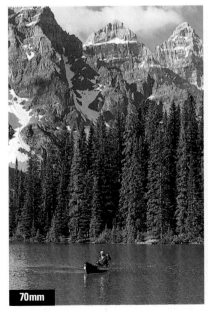

70mm

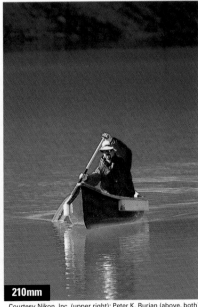

210mm

Courtesy Nikon, Inc. (upper right); Peter K. Burian (above, both)

Stephen G. St. John, NGS Staff (above, both); Slim Films (below)

A Christmas tree makes a pleasant picture when photographed in a conventional manner (left). By zooming—shifting focal lengths—during a one-second exposure, the photographer created an abstract image with color and motion.

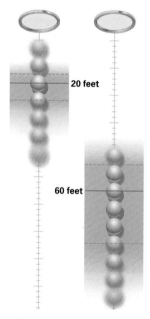

20 feet

60 feet

At a fixed aperture, **focusing at a greater distance** brings more of the foreground and background into the zone of sharpness.

and incredibly compact even in the 500mm focal-length range. They employ mirrors to fold the light path, allowing for a physically short barrel. Instead of a dozen heavy optical elements, they require only a few, thus helping to keep weight to a minimum. Image quality is not as high as with conventional telephoto lenses, however, and there are some other trade-offs in return for great reaching power.

The most important trade-off is the small aperture—typically f/8—which is fixed so you cannot change f-stops. Because f/8 is a fairly small aperture, a correct exposure will call for slow shutter speeds. Use a tripod to avoid camera shake and a fast (ISO 400 to 1000) film to prevent blur from camera or subject movement. Another disadvantage is that mirror lenses render out-of-focus highlights as doughnut-like shapes instead of the more pleasing solid round blobs. We recommend discussing the pros and cons with a knowledgeable photo retailer who can provide advice on the suitability of a mirror lens for your own photography.

Teleconverters

Many wildlife and sports photographers yearn for the fast 500mm or 600mm pro telephoto lenses,

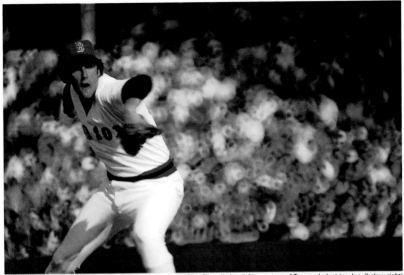

Todd Gipstein, NGS Staff (above); Slim Films (below left); courtesy of Tamron Industries, Inc. (below right)

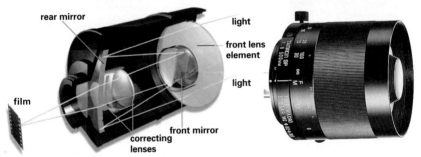

A mirror lens "folds" the light moving through it, thus requiring a shorter barrel than a true telephoto lens of similar focal length. Because of the circular mirror and the light path, out-of-focus highlights in the background look doughnut-shaped—a telltale characteristic of all mirror, or catadioptric, lenses.

but few can justify the high cost. A reasonable alternative that's a lot smaller and more affordable is the teleconverter, or extender. Available in 1.4x and 2x models, these devices extend the effective focal length of a shorter lens. If you already own a 200mm f/4 telephoto, a 1.4x converter will turn it into a 280mm f/5.6 lens, while a 2x converter will make a 400mm f/8 lens.

In this situation, a 300mm lens was adequate for a frame-filling image (left), but the photographer added a 1.4x teleconverter for increased magnification. The most common types of teleconverters are the 2x (below left) and the more compact 1.4x. Both are available from most lens manufacturers.

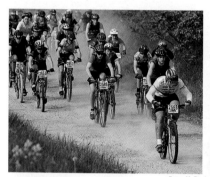 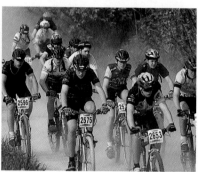

Peter K. Burian (above, both); Courtesy Sigma Corporation of America (below)

Note the loss of one stop of light with the 1.4x device and two stops with the 2x model. Your in-camera metering system will compensate for this, but you'll get longer shutter speeds. Use a tripod, a monopod, or a fast film (for higher shutter speeds) to get sharp results without blur.

Very few zoom lenses will produce acceptable image quality with a teleconverter (check your owner's manual) so they should generally be used with single-focal-length lenses, preferably 180mm and longer. Even the best extender will reduce image contrast and sharpness to some extent. The reduction varies dramatically from severe with a "no-name" $29 model to negligible with the finest and most expensive devices. The best choice is a teleconverter—the same brand as your lens—with five or seven optical elements.

Macro Lenses

The term "macro" simply refers to close-focusing ability in a lens. Many zoom lenses bear the macro designation: moderate close-focusing ability, with adequate magnification to render a subject at one-fourth to one-third life size on the slide or negative. A true macro lens must focus close

Tip

Even the best teleconverter will produce mediocre results with a cheap lens. And an inexpensive converter on an excellent lens will reduce image sharpness, clarity, and contrast. Buy the best combination you can afford, preferably with a 1.4x converter.

enough to reproduce the subject at least one-half life size on the film or 0.5x magnification. By a stricter definition, a macro lens must be capable of a life-size rendition or 1x magnification. (At life size, a nickel will be exactly nickel size on the slide or negative.) Macro lenses are designed to produce superlative image quality in extreme close focusing but are equally useful as high-quality lenses for subjects at any distance.

Perspective-Control Lenses

Specialized perspective-control or shift lenses are available to solve the problem of perspective distortion. Distortion can occur when you tilt a camera to photograph a tall subject—in its entirety—from a low vantage point. Converging vertical lines make the subject appear to be falling backward. Perspective-control lenses are designed with a mechanism that shifts only the optics— and not the camera—thus preventing converging lines. They are very expensive, however, and

Tip

You can make any lens focus closer with an accessory such as an extension tube or a supplementary close-up lens; the latter resembles a filter with magnifying glass.

A true macro lens—capable of focusing close enough for a 1:1 reproduction ratio—allowed the photographer to make a life-size image of the inside of a flower. Macro lenses are available in several focal lengths. Shown here are examples of common 105mm (top) and 50mm macro lenses.

Peter K. Burian (left); courtesy Sigma Corporation of America (above)

Peter K. Burian (both)

To illustrate the advantage of using longer focal lengths in a macro lens, the photographer used a true macro zoom—70mm-180mm—to make these pictures from the same position. The 180mm focal length (right) provided higher magnification than the 70mm focal length, eliminating the need to get closer.

are primarily intended for professional architectural photography.

Fish-Eye Lenses

These ultrawide-angle lenses with a 180-degree angle of view (or even greater with some models) are either gimmicks or creative tools, depending on your own judgment. They are available in focal lengths from 6mm to 16mm and longer zooms; you can also find adapters that simulate a fish-eye effect on any wide-angle lens. Fish-eye lenses have noticeable distortion—lines in the image curve or bend outward.

There are two very distinct types of fish-eye lenses. The circular fish-eye produces a distinctive round picture in the center of the film frame with full 180-degree coverage and extreme curving of

A full-frame fish-eye lens produces an image with curved lines (left, above), whereas a circular fish-eye lens produces a round image. A third wide-angle, the fully corrected rectilinear lens, produces an image (below) with straight lines and a natural look, unless the camera is tilted up or down. The 14mm lens at left is rectilinear, yet wider than some full-frame fish-eye lenses.

Peter K. Burian (top left); James L. Amos (top right); Courtesy Canon U.S.A., Inc. (middle); NGS Photographer Chris Johns (bottom)

lines. The diagonal, or full-frame, type produces a more familiar rectangular image, though lines near the edge of the frame are curved.

Circular fish-eye lenses, designed for scientific purposes, are expensive, but fish-eye accessories are available that are more affordable. They produce unique effects that are of limited use for most photography. A full-frame fish-eye is useful for shooting in very tight quarters such as the interior of a small helicopter. The distortion of lines and perspective produces an unusual effect: A small garden mound becomes a huge hill; columns on a mansion are bent outward, framing the central doorway which remains relatively straight. Such distortion effects can be irritating if used excessively or indiscriminately, however.

Conclusion

Almost any subject can be photographed with just about any lens from 14mm to 600mm if you can find a suitable shooting position. The key to creating the most striking image—and the most appropriate for the subject—is deciding which focal length to use. Serious photographers will often work the subject—changing focal length, shooting distance, and angle to explore a variety of possibilities. Owning several lenses makes this process possible. Each focal length will create a different effect, and several may be suitable for your purposes.

We do not recommend you buy every lens on the market, however. Expand your basic collection after you develop a specialty, or to solve frequently encountered problems—not merely because you can afford it. Rent an expensive 600mm f/4 super telephoto or a perspective-control lens for occasional use. On the other hand, a new type of lens can certainly give an entirely new look to your photographs; experiment until you learn how it can be used to best effect and begin to reshape your style accordingly. Become proficient, and the results can be extraordinary.

Recommended Lenses

Situation or Subject	Most Appropriate Lens	Other Lens Choices	Other Lens Choices
A small coin, butterfly, or a single blossom	True macro lens for high magnification	Macro zoom lens for lower magnification	Extension tube or supplementary close-up lens (see glossary)
Distant sports or racing action	Telephoto lens of 400mm or longer	Zoom lens including 300mm or longer focal length	2x or 1.4x teleconverter on a shorter telephoto lens; tripod or monopod
Tall buildings or trees	24mm to 35mm perspective-control lenses	Conventional wide-angle lens, or short telephoto from a greater distance	N/A
Distant bird or small animal	500mm telephoto	500mm f/8 mirror lens or zoom including 400mm focal length	Teleconverter on a 200mm or 300mm lens; tripod in all cases
General wildlife	300mm lens or zoom with 300mm	400mm lens or zoom with 400mm	Teleconverter on 300mm lens; tripod
Cramped interiors	Ultrawide-angle lens, e.g. , 20mm. Full-frame fish-eye lens if distortion is acceptable	Wide-angle lens, e.g., 28mm	May need tripod or fast film
Indoors, where flash and tripod are not allowed	"Fast" 50mm f/1.4 or f/1.8 lens	Any f/2.8 lens	Table-top tripod; "fast" ISO 400 or 800 film
Sports subjects at various distances	100-300mm (or similar zoom)	Longer zoom	Teleconverter with a 200mm or longer lens; ISO 400 film to stop action
Landscape or cityscape from a fixed position	20-35mm focal length	28-80mm zoom or 80-200mm for compressed perspective	N/A
Head and shoulders portraits of people	85mm to 135mm	70-210mm (or similar) zoom lens	1.4x teleconverter on a shorter lens
Large groups or family gathering	28mm lens or wide-angle zoom	24mm or shorter focal length in cramped quarters	N/A

LIGHT

It is important to develop an awareness of the various colors of light. The warm backlight around sunset produced a pleasing glow in this image. It illustrates the value of using light that complements the subject.

R. Ian Lloyd Productions

A PHOTOGRAPH CONSISTS of light reflected from the subject and recorded in the grains of a film. Obviously we cannot make photographs in the absence of light. We make images using natural light, artificial light, or a combination of both. Appropriate light—suitable for the subject, for the purpose of the photo, or for the photographer's creative intentions—is the key to an effective photograph. Generally, we want light that conveys a three-dimensional effect, reproduces the subject in a flattering manner, and creates an atmosphere or mood.

In a subsequent chapter we'll discuss the intensity of light and measuring the amount of light—both basic to making a technically good image. It's the other variable aspects of light—its quality, direction, source, and color—that are important for creative photography. In this chapter, we'll review light in all its forms and discuss how you can control, modify, and supplement it to make images instead of merely snap pictures.

The "Right" Lighting

Some people believe that when shooting outdoors, away from the controlled environment of a studio, we're at the mercy of nature. After all, we cannot push away the clouds or move the sun to a more advantageous spot. In truth, one of the skills that distinguishes the photographer from the snapshooter is an ability to solve lighting problems. This requires an awareness of the current lighting conditions. Sometimes the conditions may be unacceptable because the contrast, quality, direction, or color of the light is totally unsuitable for

Direct front-lighting in mid-morning or afternoon can be useful to emphasize bold colors and the graphic nature of certain subjects. The photographer used a polarizing filter to reduce glare from the surfaces of these hot air balloons.

the situation. Before considering solutions, let's take a look at these factors more specifically.

The Quality of Light

Light can be said to be "soft," "flat," "diffuse," "hard," "harsh," "contrasty," and so on. In outdoor photography, the quality of light is controlled primarily by the sun, as well as by clouds, atmospheric conditions, and any objects obscuring the sun. Light from the sky on a rainy afternoon, for example, will be quite different in quality from the light from direct sun in early morning. If necessary, wait for the conditions to improve or try a light modifier.

Hard Light

When the light is primarily from a small light source—a flash unit, a bare lightbulb, or the direct sun, especially at midday—it tends to be hard and directional. The effects can be dramatic, with deep shadows and bright highlights that create high contrast. Subjects cast dark, hard-edged shadows unless the light is coming from directly above

Peter K. Burian (both)

them. Much detail may be lost in a photo, in both shaded and highlighted areas of a scene, because the film simply cannot hold detail in both areas. Colors, however, can be accurate and intense, unless the light is so harsh that it "washes out" parts of the image with glare.

Soft Light

Soft light comes from a large, diffused light source; it is non directional and wraps around the subject from many directions, as it does on a cloudy day. Soft light is not contrasty—there are neither extremely bright highlights nor very dark shadow areas; the subject casts a faint shadow, if any. Photographs made in very soft light do not tend to be dramatic, but the film has no difficulty holding detail all across the frame, often essential for a documentary picture, or perhaps a portrait. Because glare is not a problem, both subtle tones and rich hues are well reproduced, and primary colors are bold—except on a day with dark gray clouds.

Haze, Mist, or Fog

Particles in the air act as a filter, reducing contrast

The direction of sunlight in relation to the subject—from above and behind, in this case—varies throughout the day. The photographer waited to make this image until the sun reached the desired position.

and muting colors to pastel. In such conditions the overall look is soft, especially in views of distant subjects. This can produce pictures with an interesting sense of atmosphere, but the low contrast will reduce sharpness, and there will be little bold color except perhaps in the near foreground.

Light Modifiers

When the light is harsh and extremely contrasty, you may be able to ask the subject to move into a shaded area or wait until some clouds diffuse the light from the sun. In some cases, fill-in flash (discussed later) can soften hard shadows, and improve photos of people, flowers, and other nearby subjects. However, there are other accessories that can be used with ambient light alone.

Reflector Panels

When shooting portraits or nature close-ups such as flowers or insects, you may find that hard shadows obliterate important details. A collapsible reflector panel—white, silver, or gold—can be useful for bouncing light into important subject areas. The quality and color of the light will depend on the size and color of the accessory you use, as well as your skill in determining the best position for the reflector.

Diffuser Panels

In harsh lighting, hold some diffusion material between the sun and the subject, or use a diffusion screen that is mounted on a rigid frame for ease of handling. This will soften the light to result in more vibrant colors while taming excessive contrast to a level the film can record.

Homemade Accessories

You can make a reflector by painting a sheet of cardboard white, or by covering it with tinfoil that has been crumpled first. For diffusion, you can use a thick, clear plastic sheet—even several layers of plastic if the sun is particularly intense.

Tip

Take the exposure meter reading only after adding a light modifier. Otherwise, incorrect exposure may result.

The Direction of Light

Light may strike a subject from any direction, but generally speaking there are four common lighting situations.

Top Lighting

When the light strikes the subject from above—such as at noon on a sunny day—it produces a "flat" image without any three-dimensional effect, apparent depth, or visual appeal. Shadows are very short and extremely dark. They can appear striking, especially when the subject is a graphic pattern on the ground, but seem unnatural for most other subject types. In pictures of people, top lighting

For a picture with good subject detail, frontlighting (left) can be useful. By waiting until the skier's position changed in relation to the sun, the photographer was able to make a different image, one that highlighted the water but rendered the remaining subject in near-silhouette.

Peter K. Burian (both)

Robert W. Madden, NGS Staff

A sunset or sunrise alone can make a very appealing picture. But such images become more visually satisfying when the photographer includes another center of interest. Try to find and add a foreground subject in such situations, particularly one that will work well as a silhouette.

causes eye sockets to darken, and the shadow cast by the chin can be unflattering.

Frontlighting

When the sun is behind the photographer's back, the light strikes the subject from the front. This situation may be easy to photograph but the result is often unsatisfactory. Shadows are cast behind the subject, creating a flat look. If people are included, the sun is often in their eyes so they tend to squint. When the sun is low in the sky, the warm light can add some appeal, but it may be difficult to exclude the photographer's shadow. Frontlighting can be effective for rich color rendition unless glare reflects from the subject and produces a washed-out appearance.

Sidelighting

When the light strikes the subject from the side, pockets of contrast are created that emphasize texture and contours. This can be ideal for, say, the rough, weathered planks of the old hotel in a ghost town, but sidelighting rarely makes for a flattering portrait. In landscapes, it can increase the sense of

depth, thanks to long shadows. Contrast may be high, causing some detail to be lost in the high-lighted and shadow areas, but overall, the effect is usually very pleasing.

Backlighting

Light from behind the subject, especially in extremely bright conditions, may render the subject as a silhouette on film. The light source may be the sun, reflections from a snow-covered hill or a sand dune, an extremely bright sky, and so on. In some cases, a subject may be surrounded by a halo of light. Contrast is generally extreme, so the photographs will have little detail in either the bright background or the darker subject unless flash is used to fill in the shadow areas. For translucent subjects such as colorful fall foliage, backlighting can produce a beautiful shimmer that is both graphically interesting and aesthetically pleasing.

Light may also strike a subject from another angle, e.g., partly from the side or partly from the front. When the angle of the light is not desirable, you can shoot from a different position, ask the subject to move, or wait until the direction of light changes.

Tip

Watch out for lens flare in backlighting. If the sun is included in the frame—or is just outside the picture area—lens flare may produce ghost images of the lens aperture, a bright haze over the entire image, or rainbow-like colors. Since these effects are visible in the viewfinder you can change your shooting position if you do not want them.

Slim Films

As illustrated here, the light from the sun must pass through more of the atmosphere at sunrise and sunset than at midday. Because it is filtered more by the atmosphere, **the color of the light** early and late in the day is "warm" when compared with the "cool" color of the light when the sun is higher in the sky.

James L. Stanfield (left); Peter K. Burian (right)

Mixed light sources at left are interesting because of the various colors they produce on film. Warm tungsten lighting, similar to the lightbulbs in most homes, can be corrected with blue filters or special films to neutralize the color, but the uncorrected image is usually more visually pleasing.

The Color of Light

Tip

Most film is balanced for a good rendition in daylight or with flash. Some films are balanced for use with artificial tungsten lights, but they are for specialized use with powerful photo flood lamps and will not remove all of the warm color-cast produced by low-wattage household lighting.

The color of light changes throughout the day; even though our eyes tend not to notice the difference, the results will be quite different when shooting color film. Direct sunlight mixed with light from the sky is close to white or colorless, especially around midday. When the sun is low in the sky, the light tends to be yellow or orange, at the warm end of the color spectrum. (Light from household lamps, a candle, or a fire is even warmer.) In shade, or when the subject is lit primarily by blue sky or on an overcast day, the light is cool or bluish. If the color bias and changed colors are not appropriate, wait until the light changes or use a filter over the lens to modify it.

The Kelvin scale measures color temperature. Daylight around noon on a clear day is around 5500K on this scale, as is light from electronic flash and some special fluorescent light tubes. Sunrise and sunset light are often in the 1000K to 3000K

Peter K. Burian (both)

range, while the cool light of an overcast sky can be 6000K to 8000K.

Warm Light

Make a portrait at sunset and the subject will take on a yellow or orange glow, perhaps giving too warm an effect. However, most people agree that warm tones are ideal for landscapes, and often for architecture. There is no hard rule here. If warm light works for you, use it.

Cool Light

At certain times of day, the light tends to reproduce as quite blue on color film: before sunrise, on a heavily overcast day, or when the subject is in the shade of a building, for example. At high elevations, the light is cool even on sunny days, because of a high ultraviolet component. Such light can be effective if you want to emphasize the cold on a snowy, overcast day, for example, but in most situations a warm glow would be preferable.

Optimal Light

As implied earlier, the "right" light—in terms of color, quality, and direction—depends on the subject matter. There are no absolutes in this regard, and even the guidelines in our chart on page 87 are merely starting points for making images that most people would consider good. The key is an awareness of the light and a conscious decision as to when—and from which camera angle—it might be best to photograph a certain type of subject.

At 7 a.m. on a summer morning, warm sunlight enhanced this subject (left). By 9 a.m., the color of the light was cooler, producing a rendition of the swan that was more neutral, although not as visually engaging.

Tip

When the sun is low in the sky, the color of light tends to be warm. That occurs because the oblique light must pass through more dust and water in the atmosphere where the short, blue wavelengths are scattered, leaving primarily reddish light.

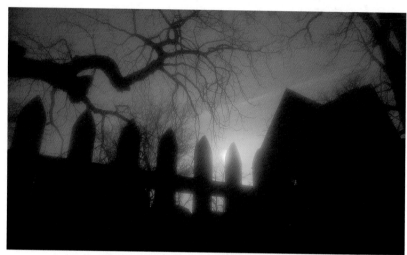

Todd Gipstein, NGS Staff (top), Peter K. Burian (middle, lower)

Instead of using a filter to slightly modify or neutralize the color of light, the photographer took some creative license. With a dark blue filter and some underexposure, he made an interpretive image that evokes a moonlit night.

The foliage was colorful unfiltered, but an enhancing filter produced richer tones. It's a matter of preference.

Controlling the Light

The lighting is rarely ideal at the instant you notice a photo opportunity. Fortunately, we have a lot of tools at our disposal. The most obvious is to change your shooting position in relation to the light; you may also be able to move the subject or simply wait for more appealing light. In many situations, you can exert some control over the quality and color of the light by using an accessory.

Filters to Modify Light

Colored filters can be used to modify the color temperature; a pale amber filter used an hour after sunrise, for example, can restore some of the warm glow that occurred naturally not much earlier. If you're taking a portrait around sunset and prefer not to have an excessively warm rendition, a pale blue filter can produce a more neutral look. The

Recommended Filters for Color Photography

Condition	Desired Result	Filter
Open shade, cool light	More neutral, less blue	Medium amber (81B) counters blue color cast
Heavily overcast or rainy day	More neutral, less blue	Darker amber (81C) to counter strong blue cast
Mid-morning or mid-afternoon, sunny day	Slightly warmer effect	Pale amber filter (81A)
At high elevations, high UV content, light is quite blue	Warmer effect; reduced haze and glare	Ultraviolet (UV) plus amber (81A) filter; polarizer to reduce haze and glare; "warming polarizer" combines both
Hazy conditions	Sharper pictures	2A haze filter; polarizer is more effective in cutting haze
Fluorescent lighting (green)	More natural look	Magenta filter (FLD) counter-acts green cast
Fall foliage or red rock country, with weak colors	More vivid, more deeply saturated colors	Polarizer enriches colors by removing glare; enhancing filter (didymium glass) enhances earth tones, but most brands produce a magenta cast as well as enhancing earth tones
Very warm sunset light or household lighting	More neutral (less yellow) effect	Blue (pale 82A or deeper 82C) counteracts excessively warm tone
Pale blue sky	Darker tone	Polarizer (PL) deepens blue tone and makes clouds stand out if used at correct angle to the sun
Landscape, excessively bright sky	Less bright sky	Graduated neutral-density (ND Grad) (gray) balances exposure for land and sky so film can hold detail in both
Reflections and glare on glass or painted surface obliterate subject detail	Reduced glare, enriched colors	Polarizer (PL) achieves both

Note: Certain filters reduce light transmission. In-camera exposure meters compensate for this, but manual compensation must be made if using handheld meters or a rangefinder camera that uses an external light sensor. (Manufacturers generally provide specifics.) Reduced light transmission requires longer shutter speeds or wider apertures.

above chart gives additional information on some recommended filters you can use to produce a more accurate effect in typical situations.

Try shooting with and without the filter. For the most natural results outdoors, use a filter only to enhance the color of light, not change it

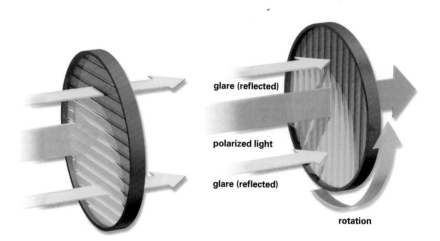

glare (reflected)

polarized light

glare (reflected)

rotation

When rotated to an appropriate angle, a **polarizing filter** blocks randomly polarized light only, allowing light polarized at the angle of the filter to be transmitted. As a result, glare is partially or completely removed from reflective objects, moisture, or particulate matter in the air.

Slim Films

completely. In mixed lighting, shoot without a filter unless standard fluorescent light makes up much of the overall illumination.

Many special-effects filters are available. Some create multiple images; others render bright highlights as star-shaped or produce motion streaks. Although you may wish to try some of these, remember that such effects can quickly become gimmicky and boring if overused.

The Polarizing Filter

The polarizer, best known as an accessory for darkening a pale blue sky, is not a colored filter and is equally useful with black-and-white and color films. By blocking randomly polarized light that bounces off water droplets and particles in the air, this filter produces richer skies. The effect is greatest when the camera is pointed at an area 90 degrees away from the sun. This filter also reduces or eliminates glare on reflective surfaces—especially glass, water, wet foliage, and painted surfaces and even on less reflective surfaces such as

Glare on glass and other reflective surfaces can obliterate detail and desaturate colors. By using a polarizing filter—rotated to provide maximum effect (left, below)—the photographer solved both problems.

John G. Agnone, NGS Staff (both)

rocks and soil. As a result, colors are richer and more subject detail is revealed.

Circular Versus Linear Polarizer

Many current cameras require a polarizer designated as "circular" instead of the older "linear" type. The term circular refers to the fact that it contains a second element that causes the light to vibrate in all axes again. The circular polarizer ensures that exposure and autofocus operation will be reliable—a problem with the older linear models.

Graduated Neutral-Density (ND Grad) Filter

Frequently used for landscape photography with both color and black-and-white film, the ND Grad filter is clear on one half and gray on the other. The line between the two halves is feathered, so there is no abrupt change. In situations where the sky (or water) is much brighter than the land,

Tip

For correct overall exposure, take the exposure meter reading from the foreground *before* mounting the "ND Grad" filter. Make your settings and hold them in the camera's manual operating mode. Add the filter, recompose, and shoot. A rectangular filter in an adjustable holder is most useful because it allows you to adjust the position.

place the dark half over the brightest area. Place the central line along the horizon or other subject line. By balancing the relative brightness of the two areas, contrast is reduced, allowing the film to hold more detail in both areas. The 4x filters (2 stops darker on the gray half) are most useful for a variety of situations.

Filters for Black-and-White Film

Contrast filters are extremely useful in monochrome (black-and-white) for changing the film's response to color. This is important because, unless a filter is used, all colors of the same intensity are recorded as a similar tone of gray on black-and-white film. A scene with a blue sky, green foliage, and an orange pumpkin will result in a print in which everything may appear to be the same tone of gray. A colored filter will lighten certain tones and darken others, thereby increasing the distinction between similar tones. The chart on the opposite page describes the effect of the most common filter types.

The Physics of Light

Photographers need not become experts in the physics of light, but it is important to understand the characteristics of light in order to appreciate the practical aspects of polarizer use. Light rays travel as electromagnetic radiation, best described as waves. Direct rays from the sun travel in straight lines but vibrate in all directions perpendicular to their path. When they strike an object such as a window, a rock, wet foliage, or the surface of a lake, some of the reflected light vibrates in a single plane, which is vertical or "polar."

A polarizing filter absorbs all the light vibrating at angles other than the angle to which the filter is set. This selective blocking—of randomly polarized light only—partially or completely removes glare. A turn of the outer ring of the

Tip

A polarizer is useful in black-and-white photography to reduce haze (although not as effectively as a red filter) and to reduce glare and increase contrast.

Recommended Filters for Black-and-White Photography

Subject/Situation	Desired Result	Filter
Blue sky or water	Natural and darker with clearly defined clouds	#8 Light Yellow and #15 Deep Yellow for darker effect—clouds really stand out; #25 Red for very dark sky
Distant landscapes	Penetrate haze	#15 Deep Yellow; #25 Red for greater effect
Flowers and foliage	Natural tone	#11 Yellow-green or #8 yellow; #58 Green for very light rendition of foliage
Red, orange, and similar colors	Lighter	#25 Red
Stone architecture, wood, fabrics	More noticeable texture	#15 Deep Yellow
Interiors in household lighting	More natural effect	#11 Yellow/Green
Outdoor portraits	More pleasing tonal rendition of light skin and more natural reproduction of foliage	#11 Yellow/Green
Snow scenes	Increased texture in snow in skylight conditions	#15 Deep Yellow or #16 Orange to enhance texture of snow
Portraits of ruddy complexions	More pleasing rendition	#47 Blue

Note: Filters transmit light of their own color and subtract those of other colors, e.g., a red filter makes red roses appear very light and makes blue sky appear very dark in a black-and-white photo. The identification numbers above are used by most filter manufacturers. #25 Red is very dark, and reduces light transmission by three stops.

filter controls the amount of polarized light that is transmitted.

Shooting from a location 30 to 35 degrees to a reflective subject, you can eliminate much of the glare by using a polarizing filter. You can see the effect in the viewfinder of your SLR camera.

For maximum darkening of the sky on a clear day, shoot at a 90-degree angle to the sun. A polarizer will increase the color saturation of the sky by blocking randomly polarized light bouncing off water droplets in the air. And since haze is caused by reflections from particles in the atmosphere, the polarizer will also reduce its effects. The filter has little effect on unpainted metal surfaces such as chrome or a mirror because these reflective surfaces do not alter the polarization of light.

ELECTRONIC FLASH AND ACCESSORIES

On-camera flash is a convenient technique that photographers frequently use.
But, when possible, off-camera flash is preferable because it gives better shape to the subject and reveals detail.

ALTHOUGH SOME photographers prefer to shoot everything by available light, an electronic flash unit can help make good pictures when lighting conditions are poor. For shooting indoors, the value of a powerful light source is obvious: It helps produce brightly lit, colorful pictures without the visible grain of a fast film or the need for a tripod. But this portable light source is being used increasingly both indoors and outdoors as fill-in lighting to create more interesting images.

Flash Basics

Before considering techniques for making photographs with electronic flash, let's review the basic operation of this equipment. First, install batteries and attach the flash unit to the camera. The attachment is usually made to the "hot shoe": a metal slide on top of the camera body. It contains electronic contact points that ensure that the flash will fire when the camera's shutter opens.

Although the exact operation of flash and light measurement varies, depending on the type of flash control in use, the basic premise remains the same for most modern equipment.

1. When the flash unit is turned on, a charge is built in a few seconds in a capacitor. A light on the unit is illuminated when it is ready.

2. The photographer sets the correct aperture (f-stop) on the lens, using guidance from a calculator on the back of the flash unit. The distance to the subject will determine which f-stop to use on

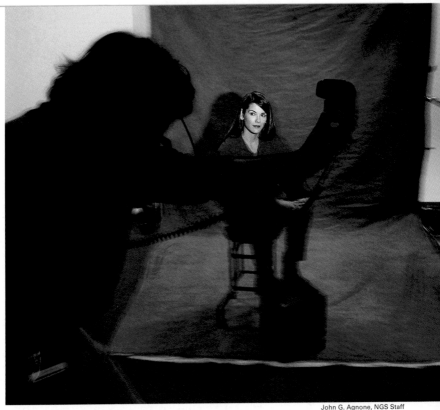

John G. Agnone, NGS Staff

the lens for a flash picture. (More recent flash systems may not require any calculation.)

3. When the photographer takes the picture, the flash fires for a very brief duration: from 1/1000 to 1/40,000 second at the instant when the camera's shutter opens to expose the frame.

4. After the exposure is made, any unused energy is returned to the capacitator by the "thyristor," or internal circuitry, to save battery life and speed up recycle time.

5. The flash begins to build up the full energy required for the next shot and the ready light comes on again. Waiting another second or two before taking the next picture ensures a full charge. The less energy expended, the faster the recycle process; close-ups require the least energy.

The "Sync" Speed

A "correct" shutter speed must be set on the camera in order for the burst of flash to synchronize with the shutter that opens to expose the film to light. (Most recent cameras automatically set a correct shutter speed.) Otherwise, a portion of the picture will be black. To understand the reason, let's review the operation of the shutter in most 35mm SLR cameras.

In order to expose the entire frame of film, the shutter moves a slit across it, using two separate "curtains," one following the other at a very high speed. At certain shutter speeds—1/60 or longer on many cameras—the flash will synchronize with the shutter so that the entire frame of film is exposed. Set a faster shutter speed—say 1/125—and the curtain will cover half the frame when the flash fires. Consequently, half the picture will be black (not exposed).

The exact timing of the burst of flash is critical. Every SLR camera has a "sync" speed: the fastest shutter speed that will ensure a proper photograph. Older models may have an "X" marked on the shutter speed dial; set this, and you will get the correct sync speed, usually 1/60. You can also use longer shutter speeds: 1/30, 1/15, 1/8, etc. Many of the latest high-tech cameras have a faster maximum sync speed: 1/125, 1/200, or 1/500. A few allow flash at any shutter speed—often up to 1/4000. These use flash units that produce a series of bursts during the entire exposure time, rather than a single burst.

Some medium-format cameras have a shutter mechanism that is built into the lens, as do the compact point-and-shoot cameras (also called lens/shutter cameras). In both these types of cameras the entire frame of film is effectively uncovered at any shutter speed, so the explanation of sync speed is not relevant for them. Many recent 35mm SLR cameras do not allow you to set an incorrect shutter speed with flash. If you have done

direct

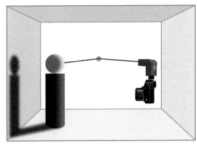

wall bounce

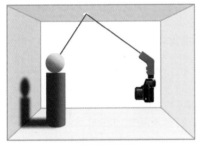

ceiling bounce

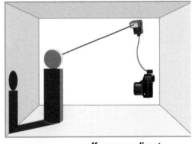

off-camera direct

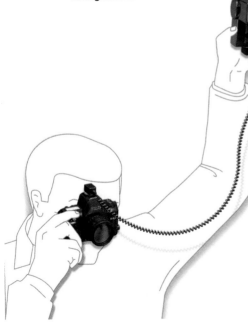

Illustrated here are the lighting effects produced by **direct, wall bounce, ceiling bounce,** and **off-camera direct flash.** The location and quality of the subject's shadow change, depending on the flash technique used. Direct flash, although sometimes necessary, produces a harsh image. Bounce flash produces softer light and softer shadows. Wall bounce flash is similar to ceiling bounce flash with the added benefit of better revealing the subject's shape.

Slim Films

so, the camera automatically switches the shutter speed to the sync speed as soon as the flash has recycled and you touch the shutter-release button.

Guide Numbers (GN)

GN is a measure of flash-illuminating power that is stated by the manufacturer for every flash unit, generally for ISO 100 film. Unless you primarily shoot with ISO 400 film, or photograph mostly close-ups, consider a model with a GN of at least 25 in meters or 80 in feet. If you plan to do a lot of bounce-flash photography (discussed later) a more powerful flash may be required: Look for one with a GN of about 40 in meters or 130 in feet. The GN is not meant to be a fixed indicator of the effective flash distance but is rather a guide to the relative power of a given unit.

Primary Flash Types

Three distinct technologies are in use for controlling flash exposure. We'll consider how all of the major types operate but emphasize through-the-lens (TTL) flash since it is the most common type.

Fully Manual Flash

This is the simplest type, with power output not usually controllable. (Some models do have power settings, such as 1/4 power.) It is not particularly difficult to use, but does require the photographer to make all settings. First, set the film speed on the unit and then set focus for the subject. Check the distance (from camera to subject) on the lens. Use the exposure calculator on the back of the flash unit to determine what f-stop you should set on the lens for a correct flash exposure for that distance. The farther the subject, the wider the aperture that must be set. The closer the subject, the smaller the aperture required.

There is another way to determine which f-stop should be used—with ISO 100 film only. You must know the flash unit's guide number (GN). Divide

Flash units designed to be mounted on the hot shoe on top of a camera are an easily portable light source that can also be used off-camera. Choices vary in features, size, and power output.

Courtesy Canon U.S.A., Inc.

the distance to the subject into the guide number. If the guide number is 60 and the subject is 10 feet from the camera, set f/5.6 on the lens (60 divided by 10 = 6, rounded to the closest f/number, f/5.6). To use a wider or smaller aperture, you must change the distance to the subject or switch to a film of a different ISO.

Studio flash systems (often incorrectly called strobes) generally require that contact with the camera be made by a cord, referred to as a PC cord. (Some shoe-mount flash units can be attached in this manner as well.) This technique is not possible if your camera doesn't have a terminal for plugging in the PC cord, although you may be able to find an aftermarket accessory (rare) that has a PC cord terminal and plugs into the camera's hot shoe.

Autoflash

This more modern system relies on an external sensor on the flash unit to read reflected light for automatic operation. Enter the ISO of the film first. On the flash unit calculator, dial in the distance to the subject, and set the recommended f-stop for the mode of flash you are using. When the flash fires, it automatically "reads" when adequate light has been delivered. (The sensor detects light reflected back from the subject to determine the correct duration of the flash burst for that distance.) A scale on the back of the flash unit indicates the minimum and maximum flash distance range at any aperture. Most flash units offer a choice of several appropriate apertures and will show a flash range at any of these f-stops.

TTL Flash

Good results with flash are easier to achieve than ever before, thanks to TTL—through-the-lens—flash metering. Most 35mm SLR cameras made in recent years include this technology. An in-camera cell reads the light reaching the film and a computer controls flash duration for a correct exposure

Built-in, pop-up flash units are now common on all types of cameras. Because their flash-illuminating power is rarely high, these units are most useful for close-ups, or fast film, or to add a hint of extra light outdoors.

Courtesy Minolta Corporation

Tip

A camera with TTL flash control may not produce correct exposure with particularly bright or very dark subjects or with an overly bright or dark background. In such situations, you will need to increase or decrease exposure, just as you would without flash.

Tip

There is rarely one single f-stop that will provide a correct flash exposure. At each f-stop, the exposure will be correct over a range of distances. That may be 20-30 feet at f/8, 25-35 feet at f/5.6, and so on. Just be sure that the subject is within the distance range for the f-stop you have selected.

within the effective range of the flash unit.

With a manual-focus camera, you may need to check the flash-to-subject distance and set an f-stop on the lens that is right for the distance. Refer to the guide on the back of the flash unit. With more recent cameras, the system will simply set a longer shutter speed, when necessary, that is suitable for the f-stop you have set. The newer autofocus cameras with "smart flash" automate all this as they determine the flash-to-subject distance. In program mode, they set a correct aperture automatically, but they allow you to select other f-stops in semiautomatic and manual camera operating modes. (Read your owner's manual since there is a great variation from one system to another and even from one camera to another in the same manufacturer's line.)

TTL Flash Advantages

Cameras using TTL flash-control technology have several advantages over those with the less sophisticated autoflash technology. Most significant is that exposure will remain accurate even if you use a filter on the lens (reducing light transmission), bounce the light from a ceiling (increasing the distance to the subject), use a colored filter over the flash, and so on. With the non-TTL systems, calculations must be made for the loss of light, as mentioned in the earlier section on filters.

The latest high-tech autofocus 35mm SLR cameras have various other flash advantages depending on the system. (Read the manufacturer's instruction booklet for the best explanation of these.) The artificial intelligence may control flash output so that a foreground object is not overexposed; automatically compensate for backlighting or a very bright or dark subject; balance flash with the ambient light; offer a red-eye reduction mode; provide a good exposure when two or more flash units are used; and so on. We'll discuss some of these briefly in subsequent sections.

The Right Equipment

Check your owner's manual to see whether your camera supports TTL flash. If so, make sure you are using a TTL flash unit. The SLR camera manufacturers all offer models dedicated to their line that are compatible with all of their cameras' features. Among independent brand TTL flash units, look for one that is specifically dedicated to the camera brand and model that you own, or ask a photo retailer to check for compatibility.

Some cameras have a very fast maximum flash sync speed—usually up to 1/250 versus the more common 1/60 or 1/125. This can be useful in bright conditions for nearby subjects at a wide aperture such as f/2.8, for example. A fast sync speed can also help eliminate "ghosting"—a second blurred image created by the ambient light exposure at longer sync speeds—with a moving subject. Check the manufacturers' brochures when shopping for a camera if you consider this feature important. A few cameras allow even higher sync speeds, but the effective range of flash is significantly reduced.

Some of today's flash units—especially those designed for use with high-tech SLR cameras—are very sophisticated, offering many features that can be accessed with the touch of a button. They minimize or eliminate the need for calculations, making advanced flash techniques relatively easy.

NGS Photographer Mark Thiessen

Outdoor Flash Photography

Before discussing flash indoors or at night, let's consider flash for outdoor use. Some photographers refuse to use flash outdoors because past experience—with older, less sophisticated equipment—has led them to believe that the effects are artificial looking. The illumination can indeed appear harsh with older systems (used without a lot of user override), since flash becomes the primary light source. Also, the backgrounds may be rendered darker, particularly if you are working in the shade. More natural results are possible with some user control or automatically.

Why use flash outdoors when there is already plenty of light? There are three primary reasons.

 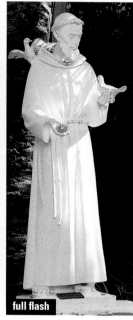 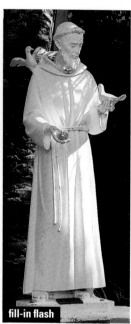

no flash full flash fill-in flash

Peter K. Burian (all)

In very contrasty lighting, dark shadows may fall over important subject areas (left). Full flash can produce an accurate rendition, but it may not be the most aesthetically pleasing. If flash output is reduced to fill-in only, sunlight remains the primary light source (right) and the effect is subtle.

Flash can be useful for softening hard shadows—such as shadows cast on a face by the brim of a hat—that obliterate important detail. It can also fill in dark eye sockets caused by top lighting during the hours around noon on a sunny day.

In extreme backlighting, a nonflash exposure will have excessive contrast: The film will not be able to hold detail in both the bright background and the much darker subject. If you expose for the highlight areas, the subject in shadow will be very dark, with little detail. Expose for the subject, and the background will be burned out. Add flash, however, and you can balance the lighting for an appropriate exposure in both areas.

On windy days, flowers or grasses will be mov-

ing and may be blurred on the film. The same holds true for a moving person. A short burst of flash can freeze the subject if that is what you want. The faster the sync speed, e.g., 1/250 versus 1/60, the more effective this technique will be. (If you do want blur, do not use flash, or set a long shutter speed such as 1/30 as described later.)

At fast shutter speeds with flash, the background may be quite dark in the picture. When the background is in shade, or very distant, it will not be illuminated by flash. If you want brighter backgrounds in such situations, you will need to use a longer exposure time: a shutter speed of 1/15, perhaps. (You may need to use a tripod to avoid the effects of camera shake.) TTL flash control should ensure that the closer subject is well exposed by flash. The background will be brighter because the longer ambient light exposure allows it to register on the film. With most cameras, you can use this technique in the manual or a semiautomatic operating mode.

Gentle Fill Lighting

The main problem with flash outdoors is that the artificial illumination may overpower the ambient light, producing a stark look. This may occur if you use the flash techniques described earlier with manual and auto flash, because those were intended for photography in low-light conditions. In sunny situations, you'll want to reduce flash output so the minimal light produced is just adequate for filling in shadows. In order to avoid a flat lighting effect, you want to retain some soft shadows and avoid an overly bright subject. The method for gentler flash depends on the type of equipment you are using.

Autoflash

With a non-TTL Autoflash system, you'll need to fool the system into believing that you are using fast film so it will stop the flash before a full burst is produced. This means setting a high ISO number

In extreme backlighting, electronic flash can be very useful for filling in important subject areas to avoid a silhouette. With some camera and flash combinations, such results are possible automatically.

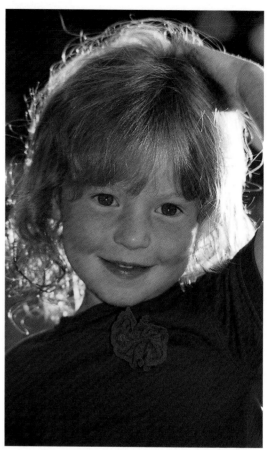

Peter K. Burian

on the flash unit's calculator dial: four times higher than the actual ISO of the film loaded in the camera. Let's say you are shooting with ISO 100 film. Set the ISO on the flash unit to 400 (100x4=400). Now, the flash will be extinguished before "enough" light has been output, but it should be adequate for fill-in lighting. For even more subtle flash effects outdoors, set the ISO on the flash unit to six times the true film speed (to ISO 600 in this example).

Manual Flash

With user-controlled manual systems, fill-in flash is not as convenient. Take an exposure meter

reading of the ambient light to determine the exposure at the camera's top sync speed—say f/8 at 1/60—and set the lens at that aperture. Determine the flash-to-subject distance (using the guide number or calculator on the unit) that would require two stops more exposure: f/4 in this example. Move your shooting position to that distance and take the picture from that location; this may call for a longer lens. If the unit has a variable power control, you will not need to physically move. Set a power level that calls for the wider aperture and take the picture. (Covering the flash head with tracing paper also reduces the amount of flash striking the subject, but it is difficult to predict the exact amount of reduction.)

TTL Flash

With some older TTL flash units, you may be able to trick the system into putting out less light by changing the film speed if your camera permits. If you are using ISO 100 film, set the ISO on the back of the flash unit to 400. With ISO 200 film, set 800; with ISO 400 film, set 1600. The system will believe that you are using a more light-sensitive film than you have loaded and will output less light.

High-Tech TTL Flash

Most of the latest autofocus SLR cameras (and a few high-tech manual-focus cameras) provide "daylight-balanced" fill-in flash automatically in bright lighting conditions. When TTL flash metering is combined with an "intelligent" system of this type, the technology can deliver good results without any override of camera or flash unit. The computer automatically reduces flash output (intensity) by about 1.5 stops—at least in some automatic modes such as program mode. Sunlight remains the primary illumination, with the extra burst of light providing fill-in lighting only. Check your manual for specifics.

Reducing Flash Output

Some photographers find that daylight-balanced fill-in flash is excessive because it is apparent to the

Tip

Unless you are familiar with your camera's flash-metering strategies, you cannot decide how to handle any of the situations described. Read your owner's manual to determine exactly what flash control your equipment has and what effects will occur in each automatic or manual operating mode.

viewer that flash was used for the picture. But overall brightness can be reduced when prints are made. You may need to request reprints; explain your specific needs in terms of overall print exposure. And if you make your own prints or use digital imaging to modify pictures scanned into a computer, you can tone down brightness.

Otherwise—especially with slide film—you will want to further reduce flash output before making the picture. Some of today's high-tech flash units—and some SLR cameras—include a "flash exposure compensation" control. If you find daylight-balanced fill-flash too intense, set a -1 or a -0.5 flash exposure compensation factor for more subtle fill-in lighting. Experiment first to check which setting produces the most natural effects; with most systems, little compensation may be needed on heavily overcast days. If your camera does not provide daylight-balanced fill-in flash automatically, then a -2 or -2.5 flash exposure compensation setting may produce the best results.

Avoid Underexposure

In the case of extreme backlighting or a very bright background, underexposure will occur with most camera/TTL flash combinations set for daylight-balanced fill, resulting in too dark a rendition of the subject. To avoid this result, increase exposure. If you have a flash exposure-compensation control, try setting a +1 factor to increase flash output. If you don't, set the exposure compensation dial (for ambient light exposure) of the camera to +1 in an automatic mode. Now the subject will be brighter, but the background will be extremely bright, not neccessarily an ideal effect.

Other Techniques

Only the more expensive cameras and/or flash units provide a flash exposure compensation control. If you find output excessive with automatic

Slim Films

| 10 feet | 20 feet | 30 feet |

Flash is of little value with distant subjects because of the **inverse square law**: As you double the distance from a light source, the light reaching a subject has only one-quarter the intensity. If you triple the distance, it has only one-ninth the intensity.

daylight-balanced fill-in flash, you have few options. Very few recent flash units allow you to change the ISO on the flash unit itself. And covering the flash head with tissue or tracing paper may not work, since the system will compensate by increasing flash output to produce what it considers correct flash exposure.

There is one practical tactic worth trying. If your flash unit has a zoom head (adjustable to match the focal length of the lens in use), set it to the widest setting possible. If you are shooting with a lens of 100mm, set the flash head to the 28mm setting—or 35mm if that is the widest it allows. Now the light will be spread over a much wider area. The result should be less light striking the subject and a less noticeable flash effect. If the flash unit does not have a zoom head, adding a diffuser accessory can also spread the light. This may or may not help. Experiment with your own equipment to find the best method for reducing the amount of flash that strikes the subject.

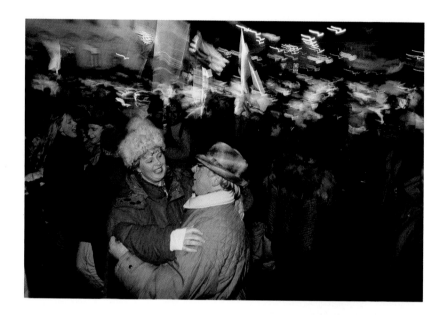

Advanced flash techniques allow photographers to create interesting effects—such as the flash/blur above—by moving the camera during a long exposure. They also allow for the interesting light in the photograph below, for which the photographer used two light sources, one for shape, and one for detail.

James L. Stanfield (top); NGS Photographer Chris Johns (bottom)

Modifying Flash Light

When flash is used only for fill, it provides only a small percentage of the total light. Hence, on-camera flash generally produces acceptable results outdoors, especially when the subject is at least ten feet from the camera. In close-up work, however, you'll get better results by getting the flash off-camera—positioning it 45 degrees to the side and 45 degrees above the subject, as a starting point. As well, one of the modifier accessories may be useful for close-ups. Both techniques are discussed later.

The single most useful accessory for outdoor photography is a warming filter over the flash head. When you take flash pictures around sunrise or sunset, the light from flash is very cool (about 5500 on the Kelvin scale) in comparison to the yellow/orange light from the sun (perhaps 2000K). If you use flash for filling in shadows on the primary subject, the results may appear very unnatural, because the sunlight on the rest of the scene will have a different color temperature. A pale amber filter over the flash head will help in such cases. Suitable products are made by filter manufacturers; check with a well-stocked photo retailer.

Conventional Flash Photography

In low-light situations, especially indoors, flash will become the primary light source. The explanations of conventional manual, auto, and TTL flash now apply fully, because you will rarely want to reduce flash output. (If your camera/flash combination routinely produces flash pictures that are too bright, you may need to reduce output, but to a much lesser extent than you would outdoors on bright days.) For the most pleasing effects with flash, there are a few techniques and accessories to consider.

Several manufacturers offer accessories for electronic flash units. Most are intended to soften and diffuse the light. Some also allow for filters to be placed in the light path to create special effects or to balance flash-unit light with the color temperature of the existing light.

Courtesy LumiQuest

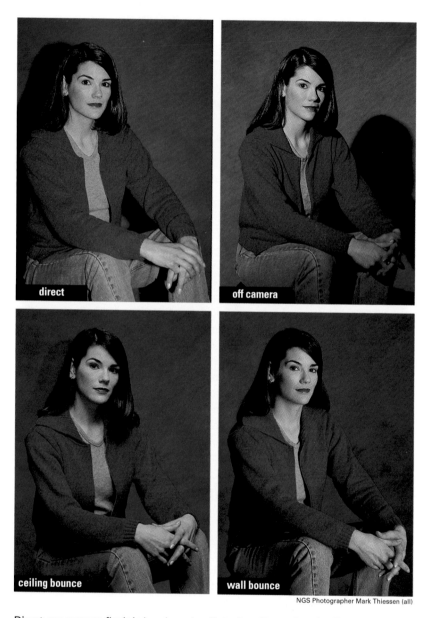

direct

off camera

ceiling bounce

wall bounce

NGS Photographer Mark Thiessen (all)

Direct, on-camera flash is harsh and unflattering. Removing the flash from the camera, or bouncing the flash light from a nearby surface produces different effects. Light bounced from a ceiling, although commonly used, causes dark shadows in the eye sockets and under the nose and chin. The most successful technique indoors is to bounce light from a nearby light-colored wall.

Bounce Flash

Direct on-camera flash does not flatter people because flat light striking the subject from the front eliminates all shadows. It also creates hard shadows on a wall behind the subject. Both problems can be minimized by bouncing flash light off a side wall or the ceiling. This requires a flash unit that has a tilt head (for bouncing light from the ceiling) or a swivel head (for using walls as a bounce surface). You can also use the flash off-camera and simply point it at the wall or ceiling. The bounce surface should be white, if possible, to avoid an unwanted color cast.

Remote Flash Placement

To get the flash off-camera, you will need a cable to maintain a connection between the camera and the remote unit. Some traditional SLR cameras have a terminal that accepts a PC sync cord, for non-TTL flash. In that case, remember to calculate the distance from the flash unit to the bounce surface and then to the subject. If you have a recent SLR camera, the manufacturer probably offers a TTL cable to extend the dedicated features. One end slides onto the camera's hot shoe and the other end (holding an accessory hot shoe) accommodates a flash unit—or several, depending on the accessories used. You can now hold the light source exactly where you want it, letting the system handle exposure calculations for you.

Flash recycle times can be very long in bounce-flash photography. Because of the greater flash-to-subject distance, all or most of the flash energy is used up for each exposure. A remote battery pack can help assure faster flash recycling and is useful for shooting a series of pictures quickly.

Flash Brackets

Holding the flash unit some 18 to 24 inches off camera—say at 45 degrees to the side and 45 degrees above the subject—produces the most pleasing effect, indoors or out. It also ensures that

Tip

If the ceiling is too high or the wall is too far away, bounce flash won't work because of the inverse square law.

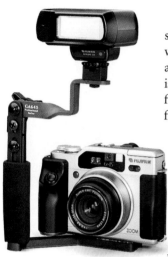

Many types of flash brackets are available from camera, flash, and accessory manufacturers. Designs vary, but the primary goal is similar: to conveniently hold the portable light source off-camera for better lighting and less risk of red-eye.

Courtesy Fuji Photo Film
U.S.A., Inc.

shadows fall below the subject, rather than on the wall directly behind it, so they will not be noticeable in the pictures. (A long TTL cable or PC cord is required for this technique.) You may be able to find a very long flash-bracket accessory to hold the flash, which is far more convenient than trying to hand-hold it. However, shorter flash brackets—commonly used by wedding and news photographers—are more readily available and also produce good results.

Red-Eye Control

Red-eye occurs when flash illuminates the blood vessels at the back of the eye. To minimize the risk of this syndrome, try one (or several) of the following techniques. Get the flash far away from the lens, or bounce the light from a wall or ceiling; shoot with a shorter focal length lens, and move closer to the subject; brighten the room by turning on more lamps; ask the subject not to look toward the camera; use the camera's built-in red-eye reduction feature (a bright light that causes the pupil to close down before the exposure is made).

Avoid Unwanted Reflections

Try to position the subject so that there is no object in the frame that would reflect unwanted light from electronic flash: a window, mirror, or framed picture, for example.

Light Modifiers

A flash diffuser or a bounce/reflector accessory on the flash unit can produce softer illumination, for a more subtle effect indoors, and for softer shadows outdoors. Such accessories modify the light by softening or spreading it, useful especially with on-camera flash. They are most effective when the subject is nearby—six feet or less from the camera—because they become a larger light source in

relation to subject size. However, they do reduce light transmission, making them less useful for distant subjects unless you have an extremely powerful flash unit.

Multiple Flash

Professional portrait photographers often use several strobes in their studios: a primary or main light for the subject, another to add highlights to the hair, a third to light the backdrop, a fourth for fill-in, and so on. Although such techniques are beyond the scope of this book, you can use multiple flash too. Many recent 35mm SLR systems offer TTL connecting cables designed for two or more flash units. You can also buy accessory "slave units," without any connecting cords, that trigger remote flash units when the main flash fires. A handy alternative is one of the new cordless systems available with certain brands of flash units and autofocus SLR cameras. They require no connecting cords and may maintain TTL flash control.

Not all "wireless" systems retain full TTL flash metering. If yours doesn't, you'll need an accessory flash meter to determine the correct exposure. If your camera system does not allow for wireless TTL flash, stick with the TTL extension cords (to connect two or more flash units) because they maintain full-system automation.

Conclusion

Naturally, your own needs and techniques will be governed by personal preference, choice of subject matter, and the type of equipment you own or can afford. Review some of the manufacturers' brochures, and get professional advice in buying the right equipment and accessories for your own types of flash photography. Experiment, try new techniques, and you'll become proficient with flash; soon, you'll wonder how you ever managed without it, especially in your outdoor photography.

Red-eye commonly occurs in low-light conditions with on-camera flash. The photographer eliminated the problem by moving the flash unit from the lens axis (arm's length or less, using a connecting cord between flash and camera). Contrary to popular myth, the color of the subject's eyes doesn't matter. Red-eye is caused by focused light bouncing off blood vessels at the back of the eye.

NGS Photographer
Mark Thiessen (both)

FILM: THE PHOTOGRAPHER'S PALETTE

FILM is an important factor in creating effective photographs. Often we load film without attention to the speed and the specific advantages of each type. Since the numerous subjects and scenes that we photograph will vary, a film that's perfect for one situation may be totally inappropriate for another. Let's consider the right choice of film to maximize image quality, to get the most from your equipment, and to achieve your photographic intentions most effectively.

Film Speed

Film is a polyester or acetate base covered with light-sensitive crystals and dyes in layers called emulsion. To measure each film's sensitivity to light, a system of numbers called ISO (International Standards Organization) was devised. Formerly called ASA, these numbers denote film speed, most commonly from the very "slow" low ISO films to the "ultrafast" high ISO films. Although the ISO series runs from 6 to 6400, the most common film speeds are ISO 25, 50, 100, 200, 400, 800, 1600, and 3200. There are also some films of intermediate ISO, especially ISO 64, 160, and 1000. (ISO 50, 64, 100, and 200 are common in slide films.)

It is important to remember that as the ISO number doubles, the film is twice as sensitive to light. Thus an ISO 200 film would require only half as much light as an ISO 100 film for the same exposure. Conversely, an ISO 100 film would require twice as much light as an ISO 200 film.

Todd Gipstein, NGS Staff

"Slow" Versus "Fast" Film

A film that is not very sensitive to light will call for long—or slow—shutter speeds to produce a nicely exposed photo. On a gray, overcast day, that may mean a shutter speed of 1/30 second, using an aperture of f/5.6 with an ISO 25 film. Slow films—in the ISO 25 to 50 range—are the least sensitive to light. Medium-speed ISO 200 films are more sensitive, and fast films of higher ISO are even more sensitive. As we get into the ISO 800 and faster films, shutter speeds become much faster.

Pros and Cons

Fast shutter speeds are ideal for sharp pictures because they enable the photographer to "freeze" subject motion and reduce the risk of blur from camera shake when not using a tripod. In that case, why not load an ISO 800 film for all of our photography? In addition to the points in the

Color film does not reproduce hues and tones exactly as our eyes perceive them, and each film emulsion offers a different rendition of the same subject. This is an advantage for photographers because they can select the color palette that best suits their preferences or that most closely conforms to what they see.

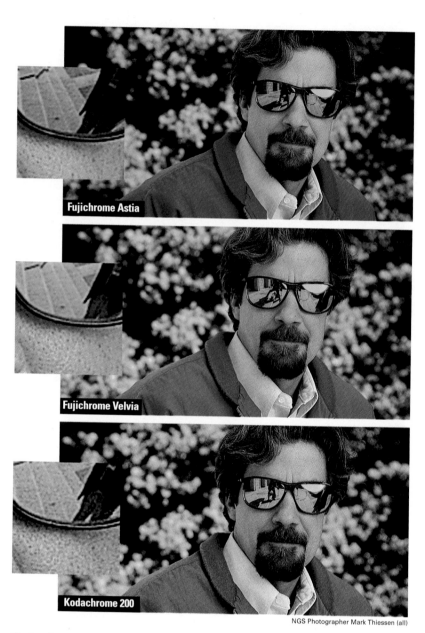

Fujichrome Astia

Fujichrome Velvia

Kodachrome 200

NGS Photographer Mark Thiessen (all)

Grain, sharpness, contrast, and the depiction of skin tones and foliage vary from film to film, even within the same brand. It's worth testing several to become familiar with their characteristics. This will allow you to select film appropriate for the subject, the lighting, or the intended effect in any given situation.

film speed selection tips chart on page 117, consider the following factors when selecting film.

- The faster the film, the lower the overall image quality in terms of resolution of intricate detail, sharpness, noticeable graininess, and vivid color rendition. An ISO 100 film (in 35mm format) may make a nice 16x20 print, but if you use an ISO 1000 film, the print will be grainy and less sharp, and colors will not be as bold.

- In some cases, you may want to render the subject as blurred—to record a waterfall in fluid motion, or if you want to blur a marathon runner for an impression of speed rather than freeze him in midstep. To achieve this, a slower film may be more appropriate in very bright sun.

- If you use a tripod to eliminate vibration, and stopping action is not an issue, a slow shutter speed will not be a problem. In this case, use a slower film of superb quality instead of a grainy fast film.

- For handheld photography, an ISO 200 film will usually provide shutter speeds fast enough to produce a sharp image except in low-light situations.

- When you want to use a small aperture for greater depth of field—f/22, for example—shutter speeds may become very slow. Unless you are using a tripod, a faster film is essential to avoid the effects of natural hand and body tremors.

- Although blur from subject motion can be used for creative effect, we often want a sharp rendering of the subject, be it a field of flowers on a windy day or our children during a soccer game. Faster films allow for faster shutter speeds, making ISO 400 more appropriate than ISO 50, for example.

- A faster film increases the effective range of flash. Because the film is more sensitive to light, you may be able to get a nicely exposed subject around 25 feet away at ISO 400, instead of a dark picture at ISO 50 at the same f-stop.

A very fast film such as ISO 800 is not always the best choice for low-light photography, especially when some motion blur is desirable (right). The film selection tips (opposite) are merely starting points. Your film choice should depend on your creative intentions.

James L. Stanfield

Tip

Today's name-brand ISO 400 color and black-and-white negative films are far superior to those of five years ago. In the 35mm format, you won't notice much difference between an ISO 100 and an ISO 400 film in 4x6 prints. And you can get excellent 8x10 prints as well as decent 11x14s.

■ In formats larger than 35mm, you can get large prints of high quality even with faster films. The larger the negative or slide, the less enlargement will be required to make a print of any size and therefore less need to use very slow film.

■ Today's ISO 400 color-negative films are excellent for prints of at least 8x10 in the 35mm format. However, for comparable image quality from slide films, ISO 200 is the upper limit.

The Verdict on Film Speed

In the 35mm format (and the smaller APS format), ISO 100 films have become standard for those who

Film Speed Selection Tips

Film Speed Selection Tips	Recommended Film Speed	Alternative
Indoors, with window light, with SLR camera and accessory flash unit; nearby subject	ISO 100	ISO 400 with small, built-in flash or with a compact camera
Indoors, with window light, more distant subject with equipment above	ISO 200 or ISO 400	ISO 800 with equipment above
Indoors at night with incandescent light and distant subject	ISO 400	ISO 800; move closer if possible
Outdoors, sunny day at the beach or in snow	ISO 50 or 100	ISO 200 with compact camera
Dark, overcast day, no flash	ISO 200; ISO 50 or 100 if using tripod	ISO 400 with compact camera
Buildings, monuments, or landscapes in moderate light, with small aperture (e.g., f/16); SLR camera	ISO 400 if handheld	ISO 50 or 100 if using tripod
Animals or sports, with 300mm to 400mm lens	ISO 400 to freeze motion and camera shake	ISO 100 or 200 with tripod; ISO 100 for motion blur (panning)
General travel or family photography, with SLR camera	ISO 200	ISO 400 with compact camera
For oversize prints	ISO 50 or 100 in 35mm format	ISO 100 is the slowest film in APS format

Note: These recommendations are only a starting point for photographers using print films. With slide film, image quality is substantially lowered when film speeds above ISO 200 are used.

use high-quality equipment (an SLR camera and "fast" lens) and want exceptional prints that have micro-fine grain, incredible sharpness, the richest, most brilliant colors, and superb resolution for excellent definition of the most intricate detail. At times, however, a tripod or high-powered flash may be required when the shutter speeds are too long for a sharp picture in handheld photography.

For the compact point-and-shoot cameras, however, ISO 400 print films are generally recommended. Since their lenses have small apertures, their shutter speeds tend to be slow with ISO 100 films. Also, because their flash units are low-powered, their "reach" is very short with ISO 100

film. Unless you have very bright light, the faster ISO 400 film should be your first choice. Switch to ISO 800 film in very low light. Films of higher ISO produce a grainy print with soft colors and should be used for special effects or when there is no other way to get the picture.

Larger and Smaller Film Formats

Although the 35mm format is the most common, there are larger and smaller formats as well. The smallest in current use is Advanced Photo System (APS), sometimes called 24mm. The image size is 16.7x30.2mm, roughly 40 percent smaller than that of the 35mm slide or negative, which measures 24x36mm. The largest readily available film size is 8x10—the sheet of film is 8 inches by 10 inches—allowing for mural-size enlargements of superb image quality. (The 4x5-inch format is more common, however.) Between these two extremes are the medium-format cameras that use rolls of film on a spool rather than in a cassette. Common formats today include 6x4.5cm, 6x6cm (or 2¼ inches square), 6x7cm, 6x9cm, 6x17cm panoramic, and so on.

For the purposes of this chapter, our comments relate to 35mm films, since they outsell all others by a huge margin. Occasional mention is made of APS (24mm) and larger formats. Some of the products in our upcoming charts are available in sheet film as well, although most manufacturers offer them only for medium-format and smaller cameras. For specifics on films for larger formats, contact a photo retailer or film manufacturer.

Slide Films (Transparencies)

Although color negative film is appropriate if you want only prints, why not consider slide film for some of your photography? Slides offer a brilliant, three-dimensional effect when projected, and affordable slide viewers can allow you to enjoy the

Tip
A larger negative or transparency offers superior image quality in oversize prints or reproductions on the printed page. For example, a 6x7cm negative from ISO 400 film will produce a beautiful 20x24-inch print, whereas the same film in the 35mm format may be noticeably grainy at 16x20 inches.

Slide Versus Print Film

Slides	Color Prints
Processing cost is usually cheaper	When prints are required, less costly to make from negatives
Projected slides can be beautiful because they are viewed using transmitted (versus reflected) light	Easier to make excellent prints from negatives; no need for a projector and screen
For publication, slides are preferred by photo buyers	Few photographers shoot for publication; those selling prints generally shoot negative films
Superb image quality at ISO 50 to 100	Superb quality to ISO 400, for greater choice
Can be easily "push processed," at extra cost	Greater latitude for exposure errors; good prints can be made even if overexposed or under- exposed by one or two stops
Note: Slide film requires correct exposure to avoid an image that is too dark or has excessively bright highlights. It calls for a camera with a sophisticated exposure meter and, in some cases, the use of overrides on the camera. Few of the affordable, compact point-and-shoot cameras are designed for excellent results with slide film, and they rarely have any exposure-control options.	

impact of a subtle backlit image. In formats larger than 35mm, transparencies are not called slides; and they are not routinely mounted by the lab in a plastic or cardboard mount because they are not intended for projection. (Medium-format projectors, though rare, are available, however.)

Unlike print films, transparency films produce a positive image when processed; there is no negative. The positive films are denoted by manufacturers with the suffix "chrome," as in Ektachrome or Fujichrome, regardless of the format. There is no logical technical reason for this, although the term has been commonly applied for years. Naturally, prints can be made directly from the positive image using positive printing paper—a process that requires some expertise on the part of the lab for image quality beyond the snapshot level.

Slide Versus Print Film

Serious photographers often debate the pros and cons of transparencies versus color prints. In the chart above, we feature their relative advantages.

Because neither flash nor tripod was permitted at this museum, the photographer was unable to use his favorite ISO 100 slide film at its rated speed. For the faster shutter speed needed for sharp pictures, he set the ISO control of the camera to 400 for the entire roll. Later, he asked the lab to process it with a two-stop "push"—extending developing time to compensate for the intentional underexposure.

Peter K. Burian

"Push" and "Pull" Processing

Both black-and-white and color slide film can be easily "pushed," meaning that it is exposed at a higher film speed than its indicated ISO. This tactic can be useful if you're using a slow film but find that you need higher shutter speeds as dark clouds roll in. You can push the film by setting the ISO dial on the camera to a higher number than the film calls for, thus increasing its effective speed. Special processing is required for this higher exposure index, as it is called.

"Pushing" Film

Here's how pushing works. Set ISO 200 on the camera when using an ISO 100 film, and shoot the entire roll in this manner. When you drop the film off at the lab, specify a "one-stop push." The lab will extend the processing time so that the final images are not underexposed as a result of your "error." An extra charge applies for this service, however. With slide film, contrast increases, so push film only in soft lighting or indoors, and only when absolutely necessary. Although you'll notice some increase in grain, this is a problem only in large prints.

Not all labs can process conventional black-and-white film. And only a few pro labs offer push processing of color negative film; in fact, only a handful of pro films are suitable for this process.

"Pulling" Film

Although it is more rarely done, slide and black-and-white films can also be "pull" processed. If you accidentally shoot an ISO 400 film at an ISO 200 setting, for example, notify the lab and request "one-stop pull processing." They will reduce development time to avoid overexposed images. For all practical purposes, there is little value in intentionally shooting a slide film at a speed lower than its true ISO. Experts in black-and-white photography do so occasionally for specific effects or to achieve a desired tonal range.

Black-and-White Films

Although we primarily discuss color photography in this book, some photographers really appreciate black-and-white prints. When you look at classic news photos, note the gritty reality of photojournalism—without the distraction of color. When looking at the stunning landscapes of Ansel Adams or the definitive portraits by Yousuf Karsh, stop to

Tip

You can "push" a film by more than a single stop: Expose an ISO 100 film at an ISO 400 setting, for example, and specify a "two-stop push." However, the results will be very contrasty (with murky shadows and unpleasant highlights) except in very flat light. Sharpness, grain, and color rendition will suffer too, though less so if you use the few films specifically intended for this process.

appreciate the rich blacks and the luminous whites of an artistically printed image. Although our eyes see the world in color, monochrome permits the photographer to convey an impressionistic glimpse of reality. This colorless representation of people, places, and events can have a profound impact on the viewer's experience.

To really do justice to a black-and-white image, you need a darkroom and skills gained through extensive experience. However, you can also order custom-made prints from a professional lab and rely on the printer's expertise to make a beautiful enlargement. Or take advantage of digital technology, discussed in a later chapter, to modify the photo until it satisfies your creative demands. Filters are also important for black-and-white photography and we offer some basic tips on them in the chapter on light.

Black-and-White Labs

Few minilabs can develop traditional black-and-white films since they require an entirely different process from color. But most minilabs have access to a wholesale lab that offers full black-and-white services. Several manufacturers now offer black-and-white films based on color film technology (called "chromogenic" and labeled "C-41 Process"). Any lab that can process color negative films can develop and print these. The prints may be "brown and white" although true black and white is possible if the equipment is correctly set up. Select the best 4x6 images and ask for enlargements on true black-and-white paper for the best results.

The Verdict on Black-and-White Films

Working in black and white requires an effective vision on the part of the photographer. This medium is entirely different from color and may appeal to photographers who want to try a new creative avenue or to evoke nostalgia in photographs of such subjects as ghost towns,

Maynard Owen Williams

Because we do not see the world in shades of gray, a black-and-white image tends to be interpretive. We can more readily appreciate the effective composition, striking play of light and shadow, and rich tonal contrast of an excellent monochrome print such as this without the distraction of color.

Commonly Used Black-and-White Films

Brand	Sizes	Qualities	Comments
Fuji Neopan Acros 100	35mm and 120	Excellent image quality; extremely sharp; ultra fine grained	New high-tech film
Fuji Neopan 400	35mm and 120	Very sharp, very fine grain; moderate contrast	Multipurpose; can be "pushed" for higher speeds
Ilford Delta 100 and 400	35mm and 120	Extremely sharp, ultrafine grained, good contrast	New high-tech film
Ilford XP-2 Super 400	35mm, 120, and sheets	Excellent image quality, esp. on b&w paper; very wide exposure latitude	C-41 process (color chemicals)
Kodak Advantix Black and White 400	APS format	Excellent image quality, esp. on b&w paper; very wide exposure latitude	C-41 process (color chemicals)
Kodak 100 and 400 TMAX	35mm, 120, and sheets	Extremely sharp; ultra fine grained; contrasty	Requires care in processing; best in T-Max chemicals
Kodak Black and White 400 and Pro T400 CN	35mm	Excellent image quality, esp. on b&w paper; very wide exposure latitude	C-41 process; T400 CN can be "pushed" for higher speed

pioneer villages, or interpreters wearing costumes of a bygone era. In color photography, deeply saturated hues can carry even a mediocre picture, but the impact of a monochrome image depends more significantly on other ingredients such as composition, dynamic perspective, or graphic designs, patterns, textures, and contrasts.

Contrast Filters

If you decide to try black-and-white film, make filters a part of your essential equipment. For example, imagine a wheat field with a vast azure sky and puffy cumulus clouds. Shoot the scene in black and white and you'll get a flat rendition, in which almost everything is reproduced in a similar shade of gray. Mount an orange filter, however, and the print will be far more powerful: You'll get

an ominous dark sky, clouds standing out in bold, near-white relief, and a much lighter foreground. Take the time to become familiar with the effects produced by several different filters so that you can visualize the look of the final print.

Private-Label Brands

In addition to the familiar films, there are numerous generic "no-name," or private-label, brands on the market. They generally bear the name of a supermarket, drugstore, or photo retailer chain, or a name trademarked by the company. The majority of such films are supplied by the manufacturers of major brands, although it may be impossible to determine which company made which film.

Tip

In black-and-white photography, colored filters do not produce color, but they do alter the rendition of various tones on the gray scale, for better overall contrast. A filter lightens its own color and darkens complementary colors.

Color infrared film is manufactured with an emulsion layer that is sensitive to the invisible light of heat. Conventional film is designed to depict a scene as we see it (left), whereas infrared film produces false colors of the same scene that can be useful for special effects or scientific purposes.

James E. Russell (both)

Tip

Avoid buying film from booths or kiosks while traveling. The stock may be "counterfeit" (an off-brand placed in a major brand container), old, or may have overheated. Film used after the expiration date may not render color accurately, and film that has not been kept cool may have an unattractive color shift.

Since private-label brands are often the last to be updated, they may not be of the recently improved type. Choice in generic brands is usually limited to a single type of color negative in ISO 100, 200, and 400, and perhaps in slide film. Some generic brands are sold with processing included—but only by that chain's stores—so you may not be able to patronize your usual film lab.

Pro Versus Amateur Films

Some films—especially in medium and larger formats—are designated as "professional" as opposed to the more common "consumer" products found in any local store. Pro films are generally sold by photo retailers and labs that cater to professional photographers. Although many photographers use pro films, we will not discuss them in detail. However, the following information is worth noting.

■ Some professional color negative films are intended for specialized applications, such as portraiture. They are optimized for skin tone reproduction and lower contrast to give a softer, more flaw-hiding look. (ISO 160 is common in this type.)

■ Most consumer slide films have a pro counterpart—useful if consistency from roll to roll and batch to batch is essential. Otherwise, there is no difference, although Fujichrome brand pro films are said to be optimized for reproduction on the printed page; they are also suitable for projection.

■ Some pro slide films do not have equivalent consumer films. Fujichrome Velvia (ISO 50), for example, is a pro film with extremely high color saturation, sharpness, and micro-fine grain that is used by many serious photographers.

■ Pro films are generally more expensive than consumer films, and some stores sell them only in packages of 20 rolls.

If a photo lab produces a print from your roll of color negative film with an off-color cast (above) or poor exposure, do not simply accept it and walk away. In most cases—because of negative film's greater latitude—better results are possible if a reprint is made with extra care.

Courtesy A.R. Williams (both)

Commonly Used Color Negative Films

Brand/Type	Sizes	Qualities	Comments
Agfacolor VISTA, 100, 200, 400, 800	35mm (also 110 size in ISO 200)	Very sharp, ultra fine grained films with high color saturation	High color accuracy in unusual lighting conditions and highly efficient crystals
Fujicolor Superia 100 to 1600	35mm	High color accuracy under all lighting conditions	High color saturation
Fujicolor Portrait 160, 400	35mm and 120	Sharp, ultra fine grained films optimized for skin tones	160 film has moderate contrast; 400 film offers very high color saturation
Kodak Gold 100, 200 and MAX 400 and 800	35mm	Sharp, ultra fine grained films	High color saturation
Kodak Portra 160, 400, 800 VC and NC	35mm and 120	Various portrait films	VC for high color saturation; NC for neutral colors
Konica Centuria 100 to 1600	35mm	Sharp, very fine grained film with fairly high color saturation	Optimized for good skin tones and color fidelity
Agfacolor Futura 200, 400	APS format	Similar to Agfacolor VISTA	N/A
Fujicolor Nexia 200, 400, 800	APS format	Similar to Fujicolor Superia	N/A
Kodak Advantix 200, 400	APS format	Similar to Kodak Gold and MAX	N/A
Konica Centuria APS 200, 400, 800	APS format	Similar to Centuria 35mm	APS 200 offers very high color saturation

Note: Color negative films above ISO 400 generally exhibit more prominent grain, higher contrast, and lower sharpness.

■ Some pro slide and color negative films are formulated for better push-processing results than are the consumer films.

The Verdict on Pro Films

Some photographers will shoot nothing but pro-designated films in the belief that products intended for amateurs and snapshooters are

inherently inferior. It is difficult to justify this assessment. Although some cheap "no-name" films may be inferior, the majority of major brand films are excellent. Shoot pro films if you have specific needs: for a film type or size not otherwise available, when color consistency from roll to roll is essential, or for that once-in-a-lifetime trip or event when you must be absolutely certain of optimum results.

High-Quality Prints and Slides

Thanks to advanced technology, today's color negative films will produce sharp, fine-grained prints with bright, vivid colors. Of course this presumes that the photofinisher has high standards of quality control. When your own pictures come back from the lab are you truly satisfied? You should be, unless your camera malfunctioned or your technique or some unusual lighting condition created problems that could not easily be corrected. To increase the odds of being satisfied with your pictures, consider the following suggestions:

■ Use fresh film (not too close to the expiration date) of high quality, that has been stored at temperatures below 74°F. Never keep film in a hot location like the inside of a car on a hot, sunny day.

■ If you are mailing film to a lab in summer, deliver the rolls to a post office; avoid mailboxes, which can become extremely hot.

■ Select a brand and type of film the lab is familiar with, preferably one that it stocks. (Labs rarely have their automated equipment set up for optimum results with unusual films.)

■ If you are not satisfied with the prints, discuss the problem with the manager. He may be willing to make reprints or can explain what you need to do to get better results next time. (For example, "Don't shoot flash pictures in a dark cathedral of subjects that are 100 feet from the camera.")

Tip

Pro films are not necessarily superior to consumer films. In many cases, they are the same emulsion but are released for sale only when they reach their optimum level of film speed, color, etc. Then they are refrigerated to slow the aging (deterioration) process.

Tip

In the charts that follow, we refer to roll film for medium-format cameras as "120," a common term; longer rolls called "220" are available in a few types of film as well. The number of exposures per roll varies depending on the size of the format. Sheet film is available in sizes 4x5 inches and larger.

■ Be ready to provide reasons for your lack of satisfaction, (e.g., "I prefer pink skin tones, not blue"; "this barn was red, not dark brown"; "the prints are too dark"). Even with automated printmaking equipment, operator overrides are possible; if the lab understands your expectations, the reprints should come closer to meeting your demands.

■ Deal with a lab that produces high quality, and does so consistently. As a starting point, try taking the same strip of negatives to several labs to determine which one produces the best results with the type of film (and subject matter) that you commonly shoot.

■ When you find a lab that is consistently reliable, stick with it; don't switch every time someone advertises a cut-rate price.

■ For prints larger than 8x10, consider a professional or custom lab for important pictures. Check the telephone directory or the ads in photo magazines, or ask for suggestions from a local camera club.

■ Slide film processing is standardized (in terms of time and temperature), but some labs produce much better results than others. A local camera club may be able to steer you to labs with a good track record of high-quality slide processing. (Only Kodak and a few other labs can process Kodachrome films.)

Films at National Geographic

Like most photographers who shoot for publication, those who work for the Geographic use slide film for the majority of their work. The brand varies from photographer to photographer— often based on personal preference and intimate familiarity with a favorite film. The type and ISO depend on the situation, the lighting, and the intended effect. In the past, Kodachrome 64 was a standard film for National Geographic

Commonly Used Color Transparency Films

Brand/Type	Sizes	Qualities	Comments
Agfachrome RSX II 100 (pro)	35mm, 120, and sheets	Very sharp, very fine grained film; high color saturation; realistic colors; neutral balance; moderate contrast	Excellent all-purpose film, especially for skin tones
Fujichrome Astia 100 (pro)	35mm, 120, and sheets	Very sharp, very fine grained film for natural color rendition; highly accurate skin tones and great color fidelity	Best Fujichrome film for skin tones
Fujichrome Provia 100F and 400F (pro) and Sensia 400	Pro films: all sizes except APS format; Sensia 400: 35mm only	Finest grain currently available in their speed class; exceptional definition and sharpness; very high color saturation; slightly "warm"; moderately high contrast	Excellent all-purpose films, especially for oversize reproduction; Provia films are optimized for push processing for higher speeds
Fujichrome Velvia 50 (pro)	35mm, 120, and sheets	Extraordinarily sharp, super fine grained; extremely high color saturation; "warm" balance; high contrast	Often used at ISO 40; primarily used for landscapes, nature, architecture; excellent especially for oversize reproduction
Fujichrome Sensia II 100	35mm	Extremely sharp, ultra fine grain; very high color saturation; realistic colors; moderately high contrast	Excellent all-purpose film
Kodak Ektachrome 100G and 100GX (pro) and Elite Chrome 100	Pro films: all formats except APS; Elite Chrome 100 in 35mm only	New films with very high sharpness and ultra fine grain; 100G and Elite Chrome 100 have neutral color balance; 100GX has warm balance	High color saturation, great color accuracy; the pro films produce very good skin tones
Kodak Ektachrome E100 VS (Vivid Saturation) pro and Elite Chrome 100EC (Extra Color)	E100VS in all formats; Elite Chrome 100EC in 35mm only	Very sharp, fine grained films with "hyper" color saturation. Extremely bold, vibrant colors	Excellent for travel and advertising photography, especially when enhanced color rendition is desirable
Kodak Ektachrome E200 (pro)	35mm and 120	Very sharp, fine grain; moderately high color saturation and contrast; neutral balance	Optimized for push processing up to 3 stops

Commonly Used Color Transparency Films (continued)

Brand/Type	Sizes	Qualities	Comments
Kodak Ektachrome E200 (pro)	35mm and 120	Very sharp, fine grained; moderately high color saturation and contrast; neutral balance	Optimized for push processing up to 3 stops
Kodak Kodachrome 64	35mm	Very sharp, fairly fine grained, moderate color saturation; accurate colors; moderately high contrast	Processing only by Kodak and special labs; will not fade in dark storage
Kodak Kodachrome 200	35mm	Very sharp, medium grained; medium saturation; warm balance; moderately high contrast	Processing only by Kodak and special labs; very warm balance especially when pushed

Note: Transparency films of ISO 400 and higher generally exhibit more prominent grain, higher contrast, and lower sharpness than "slower" films; their color rendition also tends to be less vivid. As noted above, however, Fujichrome Provia 400F and Sensia 400 are exceptions to that rule.

As the three pictures opposite illustrate, color saturation and the rendition of red and blue elements vary among slide films. Some produce very neutral colors, whereas others are designed for increased, or hyper-color, saturation.

photographers, whereas they often used Kodachrome 200 for low-light situations. Now, however, they are more likely to select the ISO 50 and 100 films and Ektachrome E200 (with a more neutral color balance). Kodachrome 64 is rarely used. Newer films incorporate the latest emulsion technology, offering finer grain and more vivid colors—characteristics maintained even in push processing.

Conclusion

At last count, there were some 150 films on the market, including color and black and white, color slide/transparency, "instant" film, specialty products such as infrared films, portrait films, various larger formats, and so on—far too many to cover in this book. Photo magazines, which provide test reports of new products as well as occasional surveys of all films currently available, are a good source of additional information.

Kodachrome 64

Fujichrome Velvia

Ektachrome E100 VS

Peter K. Burian (all)

EXPOSURE AND EXPOSURE METERING

IN ORDER to move beyond point-and-shoot photography, it is necessary to understand the concepts of exposure and the use of exposure meters. Although you can get some good prints using a high-tech camera's computer system to make all the settings, it is possible to increase the number of technically correct images. Even if you regularly shoot in the camera's fully automatic program modes, there are certain concepts you should understand. Since most models allow for some override with the touch of a button or the turn of a dial, you can easily produce a different effect. Because only a few of the point-and-shoot cameras allow for any user control, most of this chapter refers to SLR cameras that have a full set of controls and a fully manual operating mode.

Exposure Basics

To produce a photograph that is clear, with the full complement of tones, the exposure must be correct, meaning that the right amount of light must expose the film. This depends on the film speed plus two other factors. First is the camera's shutter speed, which controls the amount of time that light will be allowed to strike the film. Second is the size of the aperture (f-stop), which controls the volume of light that will pass through the lens.

You can allow the camera to set either or both in a semiautomatic or fully automatic mode. Or you can switch to the camera's manual mode and set both by turning the shutter speed control and the f-stop ring, or dial.

Slim Films

In-camera exposure meters measure the intensity of the light reflected by the subject to determine the shutter speed and aperture combinations that will produce "correct" exposure. This system is not infallible, however. For predominately dark or very bright subjects, the camera's exposure meter may tend to overexpose or underexpose unless you compensate.

Measuring Light

Nearly every camera sold today has a built-in exposure meter. Set the film speed (ISO), point the lens toward the subject, and the meter will take a reading of the brightness level. You can then accept the camera's recommendation and shoot. Or you can override the meter, as discussed later. The built-in systems are called "reflected-light" meters since they measure the amount of light that is reflected from the subject.

Peter K. Burian

Many scenes average out to a mid-tone, like the one above, making a good exposure easy to achieve. When the scene consists mostly of light or dark subjects, take an exposure-meter reading from a gray card. You may use the card inside the front and back covers. The gray card below is for illustration only.

NATIONAL GEOGRAPHIC
PHOTOGRAPHY
FIELD GUIDE

"Correct" Exposure

There is no simple definition of correct exposure. Some photographers like their images a bit darker than others. Some people consider any image well exposed as long as they can see the subject and make out its surroundings. In principle, a good exposure is true to what the eye saw: white snow with detail, medium-green grass, a black panther with detail, and so on. Some detail or texture should be visible in nearly all areas. If a picture shows gray snow, pale grass, and a gray panther, the exposure is unlikely to be considered correct.

Negative Films

Significant changes in exposure can be made by the lab when prints are made from negative films. As a general rule, a good print is possible even if a color negative is underexposed by one stop or overexposed by up to two stops. But the very best prints come from a well-exposed—or slightly over-exposed—color negative.

Slide Films

Exposure is critical for slide films. If the slide is overexposed (so everything is excessively bright) or underexposed (dark and murky), little can be done to correct it. You can order a corrected duplicate slide, or you can digitally manipulate the image in a computer. Only limited correction is possible, however. Also, overexposed slides often have excessively bright highlight areas that lack subject detail. We recommend learning to produce well-exposed slides.

The Mid-Tone

All exposure meters are preprogrammed to produce correct exposure of a mid-tone: a scene that is not excessively dark or light. A certain shade of gray happens to be a mid-tone but a mid-tone need not be gray in color. The gray of a rock, a darker shade of concrete, or some palm trees' bark, for example, is often a mid-tone, or close to it. A tanned face, a clear blue northern sky, or green grass and foliage can be fairly close to a mid-tone

Tip

Scientific studies now indicate that an average scene actually reflects 13 percent (not 18 percent) of the light that falls on it. For the sake of consistency, gray cards have continued to be 18 percent gray, as is the one in this book. When using any 18 percent gray card for substitute metering, increase exposure by a half stop (+0.5 compensation factor) for most subjects, as Kodak recomends. If the subject is very light—a snow-covered landscape, for example—decrease exposure instead, by a half stop (-0.5 compensation factor) from the gray card reading. This will help maintain detail and texture.

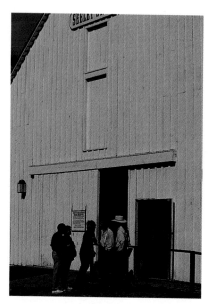 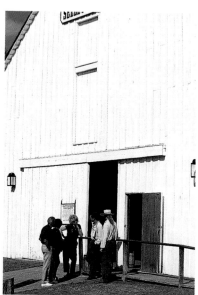

Peter K. Burian (both)

When a mid-tone subject is surrounded by a large expanse of a very light area, the picture will be underexposed (left) if taken at the in-camera metered reading. To achieve a correct exposure, the photographer increased exposure by +1.5 stops from the indicated meter reading.

Tip

For good results with color print film, expose for the shadows—take the meter reading from the gray card in a shaded part of a landscape. With slide film, meter for the highlights—take the meter reading from a mid-tone in a sunny area.

too, but it varies depending on the actual shade. The light greens of early spring, for example, are brighter than a mid-tone.

Bright and Dark Areas

In many situations, you will photograph a scene that includes both bright and dark areas. Such scenes often average out to a mid-tone. Here is a typical picture: green grass in the foreground, people wearing clothing of various shades, and a bit of bright sky. Such a scene will be properly exposed, or very close to it. However, there are many nonaverage scenes and subjects in which you cannot trust the meter to produce a good exposure.

White or Black Subjects

Whenever the scene consists primarily of white or black subjects—or includes large areas that are

extremely bright or very dark—most exposure meters will produce unsatisfactory results. If you take a quick shot of a black automobile, it will be rendered as gray in a color slide. Snap a picture of a snowman, and it will be gray too. A landscape with a large expanse of bright sky or water will be dark because the meter strives to render the scene as a mid-tone overall. In nonaverage situations, you cannot rely on the camera's exposure meter to make—or recommend—settings that will produce good exposure.

Substitute Metering

The first method for getting better exposures is probably the simplest. Point the lens at a mid-tone area, and take the exposure meter reading from the substitute subject. Use that reading's aperture and shutter speed to take the picture, after you reframe for the desired composition. So if the sky is excessively bright, take the meter reading from the rest of the scene only.

In the above example, you are estimating—assuming that the rest of the scene is indeed a mid-tone. Such guesswork can be eliminated if you carry something that has been proved to be a mid-tone. A photographic gray card (a sheet of gray cardboard with a matte finish that is guaranteed to reflect 18 percent of the light) is ideal. Set up the card near the primary subject, and move in close to take the light reading from the card alone in the camera's manual operating mode. Find the shutter speed and aperture combination that the meter indicates, and you will get a correct exposure if you follow the tip on page 137.

Holding Exposure Value

There are two ways to hold the settings while recomposing. In the camera's manual operating mode, the camera will not change the settings, so you need not take any steps. Ignore any warning

Tip

You can change either shutter speed or aperture in manual mode to increase or decrease exposure from the indicated meter reading—or both, to a lesser extent. For example, to increase exposure by one stop, open up the aperture by a half stop, and switch to a shutter speed that is a half stop slower. Your decision as to which control to use will depend on whether depth of field or the depiction of motion is the more important consideration.

of incorrect exposure after you recompose. In an automatic mode, the camera will change the settings as you recompose. You must press and hold the auto-exposure lock button as you take the meter reading from the mid-tone.

Check your owner's manual: There may be an AE lock button, or exposure may be locked as long as you maintain light pressure on the shutter-release button. If there is no AE lock, you will have to shoot in the manual operating mode to use substitute metering. Virtually every SLR camera on the market has a manual operating mode.

Override the Camera

In cases when you don't have a gray card, or when substitute metering is not practical—when you're in the middle of a snow-covered landscape, for example—you may need to start with a camera meter reading and override it if the subject is not a mid-tone. As a rule of thumb, increase exposure for white or bright subjects to keep them bright, and decrease exposure to accurately render dark subjects. The procedure will differ depending on whether you use the camera's manual or automatic operating mode.

Manual Camera Operation

Adjust either the aperture (f-stop) or the shutter speed or both, until the metering indicator in the viewfinder suggests correct exposure. Now switch to a wider aperture and/or a slower shutter speed to compensate for a bright subject, or to a smaller aperture and/or faster shutter speed to compensate for a dark subject. A switch from f/11 to f/8 doubles the size of the aperture, so the amount of light reaching the film is doubled (+1 in our chart, denoting an increase of one stop). Switching from 1/250 to 1/500 reduces the exposure time by half, thus reducing the amount of light that will strike the film (-1 in our chart, denoting a decrease of one stop), and so on.

Exposure Override Suggestions

Scene/Situation	Metering Problem	Solution
Snow-covered ski slope	Underexposure will occur (gray snow)	Increase exposure by +1.5 stops
Child on a beach, bright surf and sand	Underexposure will occur (child will be too dark)	Increase exposure by +1.5 stops
Very dark subject: 1) black car fills much of the frame or 2) a small person or object against a black building	Overexposure will occur (gray subject)	Decrease exposure by -1.5 or -1 stop
Landscape; 2/3 of the frame is hazy bright sky	Underexposure will occur (foreground will be too dark)	Increase exposure by +1 stop
Backlighting—a person or object against the sun	Underexposure will occur (subject may be a silhouette)	Increase exposure by +2 stops; as an alternative, use flash (if possible)
Spotlit performer surrounded by a large dark area	Overexposure may occur	Decrease exposure by -1 stop
Landscape with sun in the frame	Severe underexposure may occur	Increase exposure by +2.5 stops

Note: The recommendations for amount of override necessary—from a center-weighted meter reading—are estimates for use with print film. With slide film, consider these only as a starting point for experimentation or "bracketing."

Automatic Camera Operation

Changing aperture and/or shutter speed in automatic mode will not affect exposure. If you wish to change exposure, set some exposure compensation. Check your owner's manual if you don't see a clearly marked dial with a series of plus and minus numbers. A setting of +1 will mean that you are increasing the amount of light by one stop from the meter reading; -½ (or -0.5) will mean you are decreasing the amount of light by a half stop from the meter reading, and so on.

In-Camera Exposure Meters

There are three types of reflected-exposure meters in current cameras. They all read light reflected from the subject, but there are some differences.

Center-Weighted Meters

These meters read the light in most of the area you

Tip

Spot metering requires extensive experience in assessing tonal values. If the metered area is darker or lighter than a mid-tone, exposure error will occur unless you compensate.

see in the viewfinder, but favor subjects closer to the center, ignoring an extremely bright sky at the very top of the scene, for example. Since the meter averages the tones in a fairly large area, the exposure is likely to be close to correct in many—but not all—common outdoor scenes.

Spot Meters

These less common meters measure the reflected light over a much smaller area, so you can take a reading of a small, specific subject such as a child's face backlit by sun or a gray card. Generally, there will be a circle etched in the viewing screen that indicates the area the meter will read. Remember that you will need to override the meter reading if the subject is not a mid-tone.

Multi-Segment Meters

These meters are also called "evaluative," "multi-zone," "matrix," or "honeycomb" pattern by various manufacturers. They evaluate the lighting pattern in a scene and make settings guided by artificial intelligence. For example, they may ignore an extremely bright area in the frame (such as the sun) and expose only for the rest of the scene. Generally, they produce more accurate results in quick shooting than do center-weighted meters. Some of the latest, ultra high-tech models recognize extremely bright scenes and automatically compensate. With the better systems, you'll get printable (though not necessarily perfect) negatives in up to 95 percent of common situations.

Useful Exposure Guidelines

You can also ignore your camera's exposure meter completely, and set exposures using the suggested settings that are packed with some rolls of film. To do so, you must shoot in the camera's manual mode. For example, these instructions may suggest f/16 at 1/125 for a snow-covered scene in sunlight with ISO 100 film. Remember the concept of equivalent exposure: Many combinations of aper-

Tip

Multi-segment metering systems are not predictable —you really cannot be certain how the meter will handle a particular subject or condition. Switch to a center-weighted exposure meter if you plan to override the meter.

Suggested Exposures With ISO 100 Film

Situation	Camera Settings	Comments
Skier on snow-covered hill, sunny day	f/5.6 at 1/1000	Will freeze motion
Children running on white sand, sunny day	f/8 at 1/500	Will freeze motion
Landscape photo, in snow or on a bright beach	f/16 at 1/125	Provides extensive depth of field
Amateur sports, cloudy bright day	f/5.6 at 1/250	Will freeze most motion, unless quite close to the camera; in that case, try f/4 at 1/500
The moon, at night	f/8 at 1/250	Some suggest f/16 at 1/125 (or equivalent) but that may underexpose
People on cloudy bright day	f/8 at 1/125	N/A
People, when shooting toward the sun	f/5.6 at 1/125	Fill-in flash may be necessary for best results
People on dark overcast day	f/4 at 1/125	As above
People in shade	f/4 at 1/125	As above
City street at night, brightly lit	f/2 at 1/30	There are few f/2 lenses; f/4 at 1/8 is equivalent.
Neon signs	f/4 at 1/30	Or f/5.6 at 1/15
Skyline, 10 minutes after sunset	f/4 at 1/30	Or f/5.6 at 1/15

Note: The recommendations above are rules of thumb or estimates for use with print film. With slide film, consider these only as a starting point for experimentation or bracketing. Although many combinations of aperture (f-stop) will yield an equivalent exposure, our chart considers subject type and the probable effect you will want. We have already taken into consideration the factors relating to depth of field and the rendition of motion.

ture and shutter speed will produce the same exposure—a wide aperture plus a shorter exposure time, a smaller aperture plus a longer exposure time, and so on.

Equivalent Exposure

As you have learned, you can get exactly the equivalent exposure at many settings: f/16 at 1/125, f/11 at 1/250, f/8 at 1/500, f/5.6 at 1/1000, f/4 at 1/2000, and so on. If your subject is a skier, and you don't want him blurred, you might shoot at f/5.6 at 1/500 to freeze the motion. If it's a landscape, and

For a blurred effect, the photographer selected a long shutter speed and a small aperture. When he decided to stop the motion, he selected a fast shutter speed and the corresponding wide aperture. Since many combinations of aperture and shutter speed will produce the same exposure, the choice depends on the photographer's creative intentions.

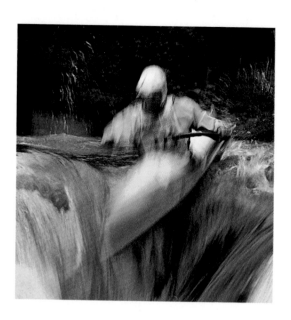

you want everything in the scene sharply rendered, you might select f/16 at 1/125.

The Sunny f/16 Rule

There is also a simplified guideline that says: "On a sunny day, use f/16 as the aperture and the film ISO number as the shutter speed for good results in the camera's manual mode." With ISO 100 film for example, your settings on a sunny day would be f/16 at 1/100. At ISO 400, you would use 1/400. Since cameras rarely offer such shutter speeds, you would select the closest—1/125 and 1/500 in the above examples.

The Verdict on the Sunny f/16 Rule

A note of caution is in order. The sunny f/16 rule is correct on very bright days in highly reflective situations such as snow or light sand, as the exposure tips packed with film confirm. However, with more typical surroundings such as grass, trees, people, and a bit of sky, the rule may result in some underexposure. This may not be noticeable

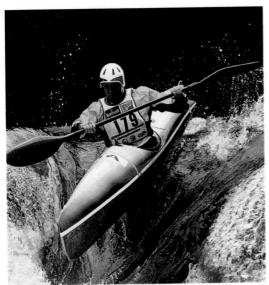

Bruce Dale (both)

with print film, but with slide film the images may be darker than you want.

Bracketing Exposures

Accurate exposure is crucial for slide film. The results may be unacceptable if your exposure is off by more than a half stop in most cases. Especially in difficult lighting conditions, it is prudent to "bracket" your exposures. In other words, shoot the same scene three times—varying the exposure slightly for each frame, above and below the starting point.

Bracketing in Manual

In the camera's manual operating mode, shoot the first frame at the meter-recommended settings or at one of the guidelines: perhaps f/16 at 1/125 for a landscape based on a reading from a gray card or from shrubbery. For the next frame, open up the aperture a half stop (a half click on the f-stop ring or dial). For the third frame, return to the original settings and stop down by a half stop.

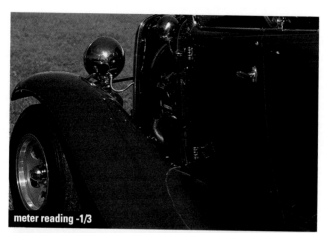

meter reading -1/3

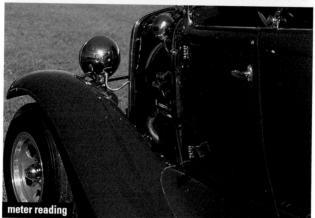

meter reading

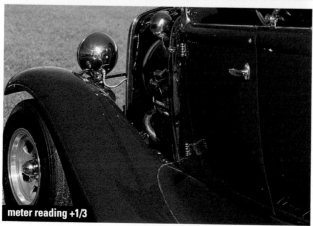

meter reading +1/3

Peter K. Burian (all)

Bracketing by adjusting the shutter speed is possible, too, but many cameras do not allow you to set shutter speeds in such small increments. Also, not all cameras or lenses allow you to set f-stops in small increments. In that case, bracket in an automatic mode using the exposure compensation dial.

Bracketing in Automatic Mode

Shoot the first frame at the metered value. For the next, set a +1/2 (or +0.5) exposure compensation for a slightly increased exposure. For the third, set at -1/2 (-0.5) for a slightly decreased exposure. (Some cameras have an automatic bracketing feature; when set, the exposure compensation is set automatically.)

Results of Bracketing

When you get all three slides back, you may find the original exposure settings were correct, or not. In any event, one of the three slides should be just about perfect—unless your original setting was way off. If you bracket with color-print film, do so in full stops and only toward overexposure (+1 and +2); color-print films do not respond well to underexposure.

Accessory Exposure Meters

Most 35mm and medium-format cameras include an exposure meter to measure scene brightness and to offer guidance on settings for correct exposure. Even so, you may sometimes see photographers using a handheld accessory exposure meter. Some professionals never trust their in-camera meters, whereas others use the accessory as a second opinion to provide more information. An accessory exposure meter measures light intensity and translates this information into exposure values and suggested combinations of shutter speed and f-stop. You must then make those settings on the camera, using the manual operating mode. Naturally, you may decide to deviate from the meter's recommendation for certain subjects.

Exposure accuracy is important for slide film, which makes bracketing a useful technique to ensure that at least one slide is perfectly exposed. For the series opposite, the photographer shot three frames, varying the exposure by a third of a stop for a subtle difference in each slide.

Common accessory light meters include those that measure incident light—light falling on a subject—and spot meters (bottom) that read the light reflected from a narrow subject area. Some meters are hybrids: They can measure either incident or reflected light.

Courtesy Minolta Corporation (top); courtesy Bogen Photo Corp. (lower)

Reflected-Light Exposure Meters

These meters—like those built into cameras—read reflected light. A spot meter is the most common: It reads the reflectance only in an extremely small area (often a one-degree angle) for pinpoint measurement. Some meters can take several measurements quickly: of a shadow area, a mid-tone, and a bright area, for example, thus allowing scene contrast to be accurately measured. Some spot meters will cumulatively average the readings.

Incident-Light Exposure Meters

These meters measure the light falling onto the subject rather than the reflected light. Used properly, incident meters provide the most accurate information about the quantity of light. Instead of pointing an incident meter at the subject, hold the diffuser dome (light collector) in front of the subject, pointing toward the camera. If the subject is across a busy highway, for example, hold the meter in the same light as the subject. In some situations, you may need to deviate from an incident meter's recommended settings. With a bright subject (like snow) decrease exposure slightly to retain texture. With a dark subject—such as a black cat in shadow—increase exposure slightly. This is contrary to the reflected exposure metering technique, but is correct with an incident meter.

Flash Exposure Meters

An incident-light flash meter can be invaluable for working in a studio with a strobe system. It will indicate the right settings to use after a test burst from the flash system.

The Verdict on Meters

While some photographers use handheld exposure

meters, most are well served by a camera that includes several metering patterns: spot, center-weighted and multi-segment. Using an accessory exposure meter—generally taught in advanced photography courses—is somewhat more difficult. If you want greater creative control, develop a full understanding of all factors governing exposure, and master the various accessory light meters. The extra effort will reward you with more consistent and predictable results.

When using an **incident exposure meter** to measure the intensity of light falling onto a subject, hold the meter near the subject with the dome pointed toward the camera. If you cannot get close to the subject (e.g., it is across a river), take a reading in similar light. Transfer the settings to the camera in its manual mode.

Slim Films

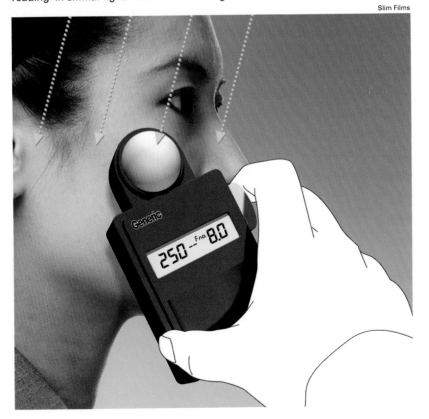

GEAR AND MAINTENANCE

Tripods

PHOTOGRAPHERS know that cameras and lenses are essential for photography, but they often overlook the tripod. Although working with three extra legs can be time-consuming and sometimes frustrating, indoors or out, the firm support provided by the tripod offers several benefits.

By holding the camera rock-steady, the tripod eliminates vibration, resulting in sharper pictures. It allows you to use whatever film, aperture, and shutter speed best suit the subject, without having to worry about blur from camera shake during long exposures.

A tripod permits careful study of the composition on the focusing screen. You can adjust the height or the camera angle and continue to make small adjustments until you get ideal framing.

In studio work, photographers can easily use the largest and heaviest tripod on the market for maximum support. Travel and outdoor photography, however, calls for smaller size and less weight. An ultralight model can be a pleasure to carry, but it may not provide a rigid support for cameras with long lenses. On the other hand, a tripod that is too heavy will spend much of its life in a closet.

Buying a Tripod

When shopping for a tripod, check several models for rigidity; any that sway too easily will not provide much support.

- Tripods with three-section legs tend to be more rigid than those with four.

Courtesy James L. Stanfield

- Models made of tubular metal offer greater stability than those with a U-shaped "channel design."

- For outdoor photography, spiked feet can be very useful on soft ground, but make sure they are retractable or removable for use indoors or on hard surfaces.

- Individual leg-angle adjustments offer maximum convenience for working on uneven ground; they allow you to vary the spread as well as the height of each leg independently.

- Leg locks prevent the legs from collapsing. Clamping locks are the quickest to operate, but some photographers prefer threaded twist locks for maximum security.

Although many tripods are sold with a head already attached, it may be flimsy. The familiar pan head (with two or three control knobs) is still the

Especially valuable for use with telephoto lenses, a rigid tripod is an important accessory for stabilizing camera equipment. Long focal lengths magnify the effect of vibration, making a firm support essential for sharp pictures.

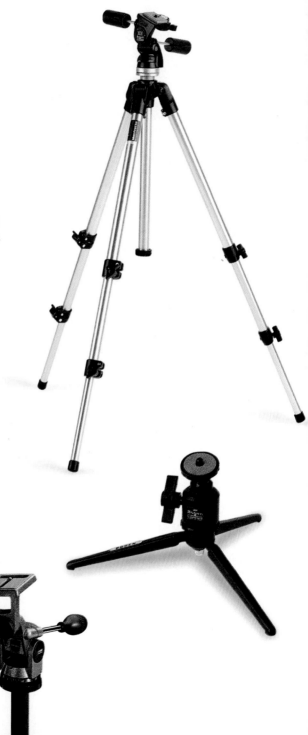

You'll find a broad variety of tripods and heads at a well-stocked photo retail store. Sizes and designs can differ significantly even within the same brand. Your choice will be governed by the weight and size you can handle and the type of camera equipment you will use.

Courtesy Hakuba USA, Inc. (top left); courtesy Bogen Photo Corporation (top right, middle, lower)

most common, but some people find operating these controls slow and inconvenient. The new ball heads are quicker to operate because a single knob allows infinite adjustment of camera position. Some models also include a tension control. Use this to increase the tension on the ball when you mount a heavy lens so it will not suddenly flop down, allowing a heavy lens to strike a leg of the tripod when you loosen the primary control.

Many models have a quick-release mechanism on the head that makes using a tripod a pleasure. These provide a plate that attaches to the camera—or to a telephoto lens—and a clamp on the tripod head. Switching camera or lens is much quicker than with traditional tripod heads that require screwing and unscrewing.

Courtesy Bogen Photo Corp.

Conclusion

When looking for a tripod, check out several brands and models. Select the one that seems most rigid and provides quick and secure operation. Use it frequently, and your dedication will be rewarded. Using a tripod is one of the most practical steps to bridge the gap between amateur and professional—at least in terms of the superior technical quality your images can attain.

Camera Bags

Active photographers find they need three different kinds of camera bags: a small one for short outings and family vacation trips, a large one for serious shooting, and a hip pack or backpack for mobility for adventure and action photography.

If you haven't shopped for a camera bag in a few years, you'll be pleasantly surprised by the innovative new designs that have increased convenience tremendously. Styling, durability, and craftsmanship have also improved. Let's consider each type.

Shoulder Bag

By far the most common type, the top-loading shoulder bag is ideal when you're on the run,

For sports and other action photography, mobility may be more important than a very stable platform for the camera and lens. A relatively lightweight monopod is a suitable, yet nimble, means of support. Monopods are most effective when braced against a solid object.

Tip

To ensure rigid support, avoid extending the tripod's legs—especially the center post—any more than necessary, particularly on windy days.

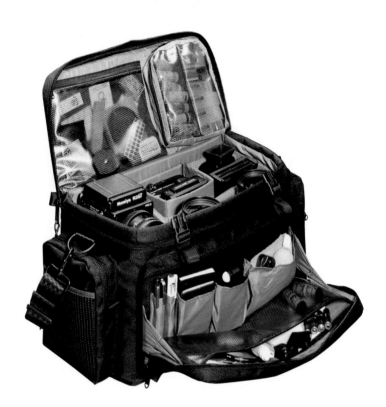

working in crowds, or need to access equipment quickly. Sizes vary substantially, from small bags to extra-large bags that are capable of holding an entire medium-format camera system. Inexpensive models usually include lightly padded foam inserts, which cannot be customized. The higher-end bags offer more padding and removable inserts so you can set up the bag for whatever equipment you decide to take on a particular trip.

Photo Backpack

The midsize photo day packs and larger backpacks are winning a lot of converts. For hiking, trekking, or cross-country skiing, nothing beats the convenience of a pack specially configured to hold camera equipment. Full mobility and freedom from fatigue are aided by a suspension system that distributes weight over a large area. The only drawback is that the pack must generally be removed to access all but the top compartment.

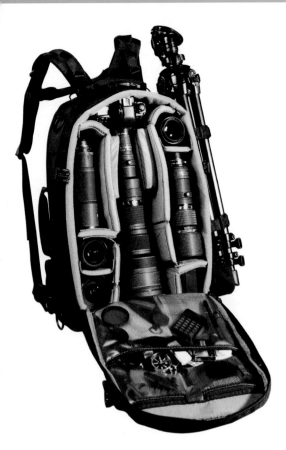

Just two of the many types of camera bags on the market, this shoulder bag (opposite) and photo backpack (left) will hold a great deal of gear. Some photographers prefer a much smaller bag or an entirely different style. You will find a broad selection at any well-stocked photo retail store.

Courtesy Lowepro USA (both)

Ultra-Rugged Cases

Photographers who travel by air with large amounts of gear that must be checked as cargo often use hard-sided cases made of ABS, polycarbonates, or aluminum for maximum protection. Some come with a large chunk of foam that you cut to suit your specific equipment; others allow you to pick out precut chunks. But lately, foam-padded dividers are becoming more common. On arrival at your destination, you can transfer your equipment to a bag for everyday use.

Waist Packs (Hip Packs)

Another choice is the top-loading holster pack that holds an SLR camera with zoom lens. The larger hip or "fanny" packs will hold a couple more lenses, or another zoom and a full-size flash unit. These packs are useful when you're cycling,

boating, or hiking because they offer quick access to equipment. When you're ready to shoot, simply shift the pack to the front. Some hip packs open toward the front and others toward the back; opinions vary as to which is more convenient.

Photo Vests

In the field, many photographers prefer a photo vest because it distributes the weight of equipment over the shoulders and back. Vests are also ideal when you need to change lenses quickly to keep up with the action. Vests range from sleek and very stylish (with limited capacity) to those with very large pockets for oversize gear. The many pockets of various size will hold cameras, lenses, film, and accessories. In summer, look for cotton fabric and mesh panels for ventilation. Padded shoulders offer extra comfort for carrying a tripod or heavy bag.

Pros and Cons

No single type of bag, case, or vest is ideal for all situations.

■ Hip or waist packs are very inconvenient when you are wearing an overcoat, ski jacket, or other bulky clothing. A shoulder bag or an oversize photo vest may be preferable.

■ Backpacks can be inconvenient when you need to access the contents frequently. Laying the pack down on a city sidewalk to switch lenses can create problems. A shoulder bag is preferable.

■ A photo vest is a pickpocket's dream. A strong Velcro closure on every pocket may help, since you can hear it being opened.

■ In urban areas, a classy shoulder bag may be more appropriate than a hip pack or a backpack. However, in locations where theft is a concern, a shabby, well-worn bag that does not suggest expensive contents is recommended.

The Ideal Camera Bag

Although the perfect bag may not exist, look for a

combination of the following characteristics to ensure maximum satisfaction with your purchase.

■ Tough materials such as canvas or nylon (1,000 denier or higher) with strong seams that are reinforced at stress points.

■ A rigid, foam-padded bottom in shoulder bags for shock protection.

■ High-density foam-padded internal dividers; if you need to customize the interior, adjustable and removable inserts are useful.

■ Plenty of outside pockets for quick access to film and other small items, and several interior compartments for organizing cameras and lenses.

■ Wide zippers, welded metal hardware, or tough, plastic, quick-release snap-hook buckles plus a flap to shed rain.

Some camera bags are water-resistant, but only a few, like this, are waterproof. The extra security of this type of bag should be considered whenever camera equipment faces the risk of splashes, salt spray, or dunking.

Courtesy LowePro USA

- A strong strap with a curved, foam-padded shoulder to reduce shoulder strain when carrying a heavy load.

- A well-designed harness system in a backpack — one that fits your frame comfortably.

- For travel by air, a size not exceeding the international standard for carry-on luggage. Regulations vary, so check with your airline before you fly.

Care of Camera Equipment

Clean the Camera
Sand, dust, lint, hair, or pieces of film can jam delicate mechanisms or scratch the film. Open the camera back and hold the body upside down. Use a puff of air from a large blower bulb to dislodge any unwanted matter. Take care never to touch the fragile shutter mechanism.

Keep the Lens Spotless
Remove fingerprints, pollutants, or water-spray marks from the front and rear elements. Use warm breath or just a drop of quality lens cleaner and one of the new microfiber cloths instead of tissue. To avoid dirt, use a lens cap when not shooting.

Avoid Lens Damage
An almost clear Skylight, UV, or 1A filter on every lens will prevent scratching or other damage to the expensive front element. A metal lens hood can also offer some protection against impact.

Reduce Static Electricity
In low-humidity conditions, lenses and filters become dust magnets. Shop for one of the anti-static brushes available from a well-stocked photo retailer. A couple of gentle strokes will dissipate dust-attracting static electricity.

Keep Current Flowing
Most cameras today are useless without power, so carry spare batteries—especially if you need one of

the new types not available at every corner store. To solve problems with poor electrical contact, rub the battery terminals—and those in the camera—with a pencil eraser to remove oxidation. Blow away any small particles with the blower bulb. Remove batteries if the equipment will not be used for a month or more to avoid damage and the risk of corrosion.

Avoid Moisture

Water is potentially very harmful to electronic and mechanical cameras and lenses. Keep your rolls of film in their plastic containers; pack each item of equipment into its own sealed plastic bag; consider a hard-sided (sealed) camera case. Humidity can create problems too. In damp conditions, packets of moisture-absorbing silica gel crystals are of little value since they will become saturated in minutes and lose their ability to absorb moisture. Pro camera stores and some mail-order retailers sell larger metal canisters of silica gel that can be reactivated in an oven or over a campfire or stove.

Beware of Saltwater

Ocean spray will corrode any metal parts of the camera and lens barrel. In saltwater spray conditions, wrap the entire camera and lens in a clear plastic bag, and manipulate the controls through the plastic. Cut a hole for the front lens element.

Avoid Condensation

When you leave an air-conditioned car or room in a humid location, condensation will immediately form on your camera and lenses. (The same problem can occur in winter, if you take ice-cold equipment into a house with a high humidity level.) In a pinch, use a hair dryer to clear condensation. To prevent the problem, place each item in its own sealed plastic bag, or pop the entire pack into a garbage bag. Condensation will form on the exterior of the bag only. Wait until the equipment has warmed to the ambient temperature before using it.

Tip

Today's electronic cameras and flash units are rarely repairable if submerged in water even for an instant. Ask your insurance agent to add an all-risk rider to your homeowner's policy—specifically for itemized photo equipment—to cover various perils.

BLACK-AND-WHITE PHOTOGRAPHY: FROM FILM TO PRINT

Ansel Adams Publishing Rights/Corbis

"Photography is more than a medium for factual communication of ideas. It is a creative art."
—Ansel Adams

ONE OF THE BEST-KNOWN proponents of black-and-white photography, Ansel Adams was also a master in the darkroom. Convinced that processing and printing are essential components of the photographer's art and craft, he spent countless hours making prints that embodied his vision of the American landscape. "The negative is comparable to the composer's score," wrote Adams, "and the print to its performance. Each performance differs in subtle ways."

As explained in the Film chapter, black-and-white photography differs from color photography in two key aspects: aesthetics and craftsmanship. We see the world in color, so the shades of gray that make up a monochrome image offer a more abstract, interpretive view of reality. The black-and-white medium also offers greater latitude in creative printmaking, allowing the photographer to control such critical facets of the final print as contrast, tonal range, image tone, paper surface, crispness of the image, and much more.

Photo hobbyists who practice all aspects of black-and-white photography find it to be an enjoyable pastime. They look on the investment as one that pays dividends, transforming the darkroom into a creative outlet. The black-and-white medium allows dedicated photographers to put their own subjective spin on a print rather than ceding creative control to a commercial lab.

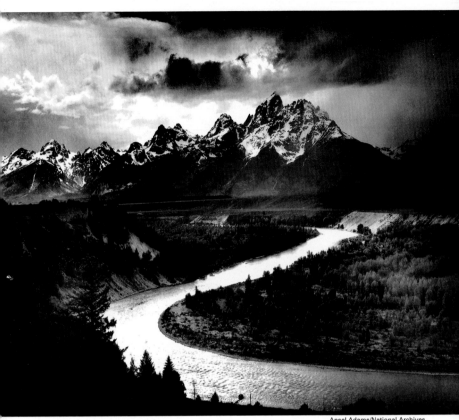

Ansel Adams/National Archives

Ansel Adams, opposite in his darkroom, considered one of the greatest photographers, worked almost exclusively in black-and-white. A master technician in the field and darkroom, Adams conveyed a majestic sense of the American West. His creative, interpretive vision went far beyond a recording of the land.

The Basic Process

A single chapter cannot hope to cover every aspect of black-and-white photography and darkroom techniques (entire books have been written about single facets of this art and science). This chapter does consider, however, the basics that are required for making well-exposed black-and-white images, then processing the negatives and making prints.

An excellent monochrome image starts with a well-exposed frame of film; avoid underexposure if

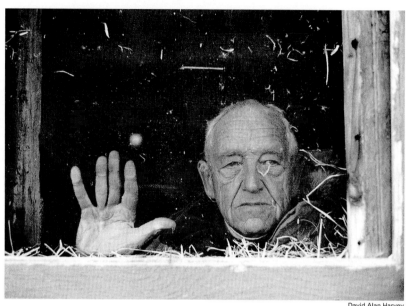

David Alan Harvey

When David Alan Harvey photographed the Wyeth family for NATIONAL GEOGRAPHIC magazine he worked in black-and-white. By doing so the images he made of the family did not have to compete with the subtle palette of colors the Wyeths used in their paintings.

you want to maintain detail in important shadow areas. If you are a serious photographer willing to devote time and effort to the study of exposure techniques, consider buying an instructional book about the Zone System. This is a highly effective approach to using light metering and modified film developing to match the tonal range of the negative to that of a specific photographic paper. Used for serious black-and-white photography, the Zone System can provide maximum control.

Processing Film

Some black-and-white films are called "chromogenic," meaning they employ color film technology. Any color lab can process chromogenic films.

Conventional black-and-white films are easier to process yourself. By doing so, you gain control over every important factor. You can use the film developer that is most suitable for the film type, rather than some generic solution. With some expertise you can also increase or decrease the effective film speed, and control contrast, sharp-

ness, and grain; you can also produce negatives that will be easier to print.

You must remove the roll of film from the 35mm film cassette and spool it onto a reel that comes with a film tank in total darkness. To guarantee you'll be able to wind your film onto the reel properly, it's an excellent idea to practice on an old roll of film. Once the film is loaded and the tank's lightproof lid is in place, you can turn the lights back on. Follow the manufacturer's instructions as to agitation and development time, which will depend on the exact temperature of the solution, which must be gauged using a highly accurate thermometer designed for darkroom use. The developer converts the exposed silver-halide crystals in the film emulsion to metallic silver; the silver blocks light, producing the negative image you see when viewing the processed film.

After development, remove the tank's lightproof cap and pour out the developer solution.

The next step is to stop the chemical activity of the developer remaining on the film using an acid "stop bath," which neutralizes the alkaline developer. After this step, a fixing bath (sometimes called a "hypo") is used to remove the undeveloped silver from the film.

With the fixing bath concluded, the chemicals must be removed from the film. This can be speeded up by using a solution called "hypo-clearing agent." Following this step, the film is washed using water that is approximately the same temperature as the chemicals; this prevents damage to the film. Finally, allow the film to soak for 30 seconds in a wetting agent such as Kodak Photoflo; the point of this last step is to allow the film to dry without water spots.

The Next Steps

Once the film is completely dry, choose a negative and put it in the holder of an enlarger that projects an image onto light-sensitive paper. Expose the

Tip

Few home darkrooms are completely light tight, even with the safelights turned off. Because film can be fogged by any stray light, many photographers use a changing bag to load film into a tank. Available from photo retailers, this accessory is a sealed bag with armholes that excludes all light.

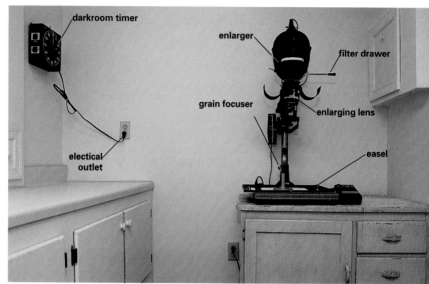

darkroom timer

enlarger

filter drawer

grain focuser

enlarging lens

electical outlet

easel

Charles Kogod, NGS Staff

A home darkroom can be set up in a bathroom or laundry room in your house. The main criteria are to have an area that you can make lightproof and to have running water nearby. Electrical outlets as well as storage for paper, chemicals, and supplies are also very helpful.

paper for an appropriate time, develop it, rinse it in a stop bath, and fix it in chemicals in trays; then wash and dry the print. This process is similar to the one used for film, except the prints are processed in trays.

Darkroom Equipment

Because exposed film and printing papers are sensitive to ambient light, you will need at least a temporary darkroom, that is, a room that can be blacked out. To confirm that your darkroom is utterly lighttight, try this technique: Place a coin on a piece of photographic paper and leave it exposed on your darkroom counter for five minutes, then process the paper. If you can see the outline of the coin, too much light is still leaking into your darkroom.

A bathroom or especially a laundry room with taps and a large sink is the preferred location for a darkroom, because running water is essential for washing prints. At least two electrical outlets—grounded and equipped with ground-fault interrupters for maximum safety—will be necessary.

Because you will be working with chemicals, it's

essential to guarantee a well-ventilated work space. An extractor fan system removes fumes but is completely lighttight.

Divide the darkroom into two sections: a dry side for using the enlarger, and a wet side with a sink for developing and washing.

The Enlarger

The heart of the darkroom, the enlarger is used to direct light through the negative, projecting the enlarged image onto light-sensitive paper to form a positive image. A modern enlarger includes the following components in a head: a lamp; a slot that accepts negatives placed in a "negative carrier"; a lens assembly with a focusing mechanism; and a filter drawer or built-in filters in a module with an adjustable control.

The enlarger lens includes a choice of f/stops that can be selected to control the amount of light being projected. The head is mounted on a tall column that allows it to be moved up or down, increasing or decreasing the size of the projected image. The head is anchored to a solid baseboard so that the printing paper lies perfectly flat and parallel to the negative.

Two types of enlargers are used for monochrome printing.

The most common is the condenser enlarger. It projects undiffused light, producing a print with high contrast and definition of fine detail. The one liability of a condenser enlarger is that it tends to emphasize any scratches on a negative.

Less widespread in use is the diffusion enlarger, which diffuses (that is, scatters) the projected light, with the result that fine details and scratches do not appear as sharp.

Filters for the Enlarger

Print contrast is no longer determined by the type of paper used. To be sure, single-grade papers (ranging from soft to hard contrast) are still available, but most photographers prefer to use a variable-contrast paper; this may be called

Tip

The chemicals discussed in this chapter are readily available from darkroom-accessory retailers and must be diluted before use. The developer you select will depend on the type of film (or any special developing process) you are using. Books on darkroom technique as well as the instructions that come with the film recommend developers that produce finer grain and lower contrast.

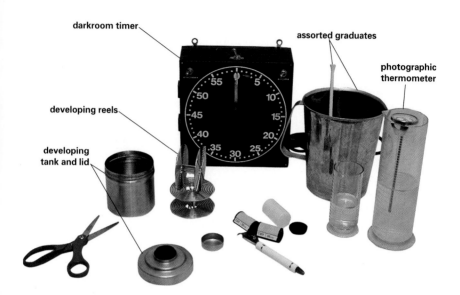

The materials needed to develop black-and-white film include: reels to load the film onto, a developing tank with a lightproof lid to pour the chemicals in and out of, graduates of different sizes to mix and hold the chemicals, an accurate thermometer designed for darkroom work, and a good timer. Charles Kogod, NGS Staff (all)

Loading the film onto a stainless steel reel can be very difficult for beginners and is best practiced with a spare roll of film, first with the lights on, then in total darkness. Only after you have done this several times with practice rolls should you attempt it with your finest pictures.

Polycontrast or Multigrade. Variable-grade paper allows contrast to be modified by filtering out different levels of yellow or magenta light.

Enlargers with a built-in filter module for black-and-white printing allow you to dial in the level of filtration required to achieve the desired grade of contrast. With other enlargers, buy acetate filters made for use with variable-contrast papers.

Printing Paper
Most photographers today use RC paper. The initials stand for "resin coated" and indicate that the paper is coated with a polyethylene finish. Uncoated, fiber-based paper is still available, but RC paper offers several clear advantages: a more scratch-resistant finish, shorter washing time, faster drying time, and a resistance to curling. Because RC paper provides excellent

quality and greater convenience, only this type is discussed below.

Several manufacturers make RC paper. Available finishes include glossy, luster, pearl, and semi-matte. Given this wealth of choices, you should eventually be able to settle on the finish or texture that satisfies your preferences.

Other Darkroom Accessories

Essential: At the very least, you'll need the following items for printmaking:

■ Safelights with a low-powered 15-watt bulb and an amber dome that blocks the spectrum of light that would expose black-and-white paper.

■ An easel or masking frame that holds a sheet of paper securely on the enlarger's baseboard. This accessory can be adjusted to provide a border of the desired size on a print. An 11x14-inch easel is useful for any print size up to 11x14.

■ Three 11x14-inch print trays for the chemicals used after photographic paper is exposed. A large tray offers convenience and better circulation of liquids around the print.

■ A print washer. This can be a deep, 16x20-inch tray with holes in one end and a hose from your tap at the other end for washing prints. Special print washers are available; they offer reliable washing that is faster and uses less water.

■ Three print tongs with soft rubber tips for handling prints.

■ A timer for accurate timing of print exposures. Large models with a luminescent dial are easy to read under the low illumination of a safelight.

■ An accurate thermometer designed for darkroom work.

■ A set of small, medium, and large graduates for measuring and mixing chemicals.

Open film in the dark.

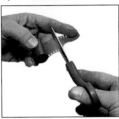

Cut the leader off the film.

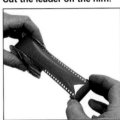

Carefully load film onto reel.

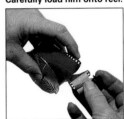

Tear the spool from film.

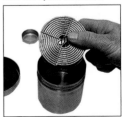

Place the loaded reel into the developing tank, put on the lid, then turn on lights.

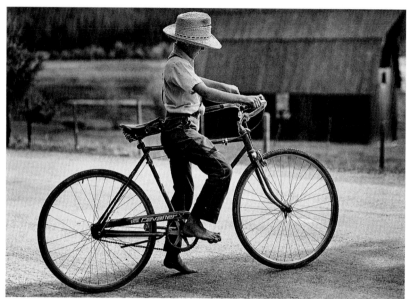

Raymond Gehman (both)

Color or Black and White?
Photographer Raymond Gehman photographed this Amish boy and his bicycle in both color and black and white. The increased contrast possible in black and white helped separate the boy from the background and helped turn a color snapshot into an evocative photograph.

■ Accessories for drying processed negatives or prints. You can make your own print-drying racks using nonmetallic screens purchased from a hardware store. Hang strips of negatives to dry on a diagonal, providing some tension to keep them from streaking or curling. Using special film clips, attach the strip to something solid at both ends. Electrically operated film and print dryers are available but costly.

■ Optional: The following accessories, though not mandatory, are certainly worth considering.

A contact-sheet frame. This is convenient for making a single 8x10-inch print of all the negatives on a roll of processed film.

A grain-focusing magnifier. This lets you determine when critical focus has been set.

Compressed air. This is used to blow dust from negatives before and after they are placed in the carrier in your enlarger.

An enlarging exposure meter. This inexpensive device can help you estimate the amount

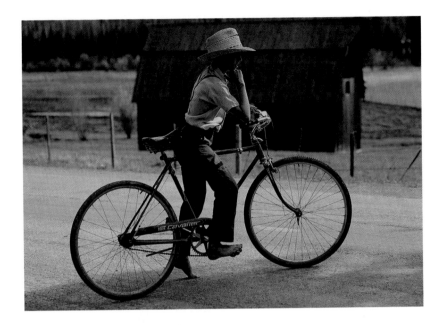

of exposure any image will need.

A dodging and burning kit. This should include tools designed for adjusting the exposure in certain areas of a print.

A lighttight container for storing printing paper.

A squeegee. This is designed for removing excess water from prints after they have been washed.

Polyethylene sleeves for storing strips of negatives. Use only those sleeves designated "archival"; other types can damage film.

A paper cutter for trimming prints.

Basic Printing Techniques

Once you have established and equipped a dark-room, be it temporary or permanent, you can begin making prints. The following discussion assumes that you plan to start with 35mm negatives and variable-contrast RC-type paper, the most common combination. Though not comprehensive, this review

of the process should provide a good starting point for making 8x10-inch prints suitable for framing.

Making the First Print

To make your first print select a negative and place it in the enlarger's negative carrier with its dull side down. Turn out the lights (except for the safelight) and turn the enlarger on, projecting an image on the easel. For this first print, set the enlarger's filtration dial at 2, or use a number 2 acetate filter.

Crank the enlarger up or down until the important parts of the image fill an 8x10-inch area on the easel. Set the lens to the widest aperture (or smallest f/number) available to provide the brightest projected image. Adjust the focusing knob until the image looks sharp. If you have a grain-focusing magnifier, use it to set critical focus. (Always focus on a sheet of paper that's the same thickness as the paper you will use to make the print.) Now change the lens aperture to f/8.

If you have an enlarging exposure meter, place it in the light path and follow the manufacturer's instructions. If you're simply experimenting, try a 30-second exposure (a customary time for an 8x10-inch print from a well-exposed negative). Turn the enlarger lamp off and place a sheet of fresh paper on the easel, shiny side up. Set the timer for the required duration, turn the enlarger back on, and expose the print for the proper time.

It is difficult at first to evaluate a print when it is wet as it will "dry down" some 10 to 20 percent and look darker when dry. With experience you will be able to judge this even when the print is wet. If you are not satisfied with the exposure or contrast of your first print, use a different exposure and/or filtration setting to make another.

Processing the Print

This discussion assumes you have readied three trays of developer, stop-bath, and fixer solution, as

well as a special washer tray.

Remove the paper from the easel, holding it by the extreme edges, and place it in the first tray—that is, the one filled with diluted print-developer solution. Gently rock the tray back and forth to distribute the developer evenly.

The print should develop in two or three minutes. Just when it starts to show tone in highlight areas (recalling that prints look darker under a safelight than they do in normal room light), grasp the print at one corner with the tongs, lift it from the developer, and drop it into the diluted stop-bath solution. Rock the tray gently for 30 seconds. Then do the same in the fixer solution for either 60 seconds or whatever length of time the manufacturer recommends.

Finally, transfer the print to the special washer tray and let water circulate over it for a full two minutes. Next, gently squeegee the print to remove excess water, then let it air-dry for a few hours. This may take place in a rack, or you can hang the print from a line in a dust-free area. Any dust spots on the print can be corrected later, using special spotting pens available in various shades, or spotting dye applied with a fine brush.

Advanced Printmaking

Though it may take you several tries to get just the right exposure, contrast, and cropping, the basic steps described above should soon have you turning out perfectly acceptable prints. Once you've reached a certain level of confidence and expertise, try your hand at some more advanced techniques, outlined below.

In some images, you may want to lighten a certain very dark segment of an image or darken an excessively bright area. Either step is done while the enlarger is projecting the negative onto the printing paper. To darken an area such as an unusually bright sky, allow more light to strike that area of the paper. This technique, called burning in,

Tip

For best results, both the chemical solutions and the water with which you process the print should be approximately room temperature—68°F (20°C). Use your darkroom thermometer to guarantee that the temperatures do not stray far from this norm. In hotter conditions, use cool water when diluting the chemicals; in colder conditions, use warm water.

Slide exposed paper in the developer solution.

The image begins to appear in about 30 seconds.

Use tongs to move the paper between trays.

requires you to increase the exposure time for the patch of the image in question.

After making the normal print exposure, turn the enlarger back on for an additional 50 to 100 percent of the original exposure time. Hold a sheet of black cardboard over most of the paper, allowing only the sky area to receive extra light. To burn in smaller areas, cut a hole in another cardboard sheet, then position the hole over the area you want to darken during the second exposure so that only this section of the paper receives more light. In either case, you must move the cardboard during the extra exposure time to prevent an obvious edge between dark and light areas.

If you want to lighten a certain element, such as a person's face obscured by dark shadow, allow less light to strike that section of the paper during a single exposure. Called dodging, this tactic requires you to withhold light from the desired area. You can buy dodging tools of various shapes and sizes, or fashion your own by attaching a roughly cut piece of cardboard to a thin wire. Select the tool best suited for the area you plan to lighten. Then, for about one-third of the exposure time, cover that small section of the paper, moving the tool slightly throughout the process to avoid creating a clearly defined edge.

Both of these techniques can be applied to a single print. You might wish to lighten a person's face during the main exposure, for example, then darken the sky during the second exposure.

As with standard printmaking, several dry runs will probably be necessary before you master burning in and dodging; with each new experience, however, you will gain skill at correctly estimating exposure times and properly using the various tools involved. You may also wish to experiment with increasing or decreasing the

Develolping prints is very similar to developing film except that the paper is processed in trays instead of a developing tank and the chemicals are slightly different. Watching a print appear in the developer, under the warm glow of a safelight, is one of the most magical moments in black-and-white photography.

contrast of areas of a print by combining burning-in and dodging techniques with a different filter than the one used for the overall exposure.

Other advanced darkroom techniques include toning a print, be it in sepia or another color; adding texture; achieving soft-focus effects; creating a speckled frame; and combining portions of two negatives in a single print. You can aspire toward these levels of printmaking once the standard techniques have become second nature.

Plan to frame some of your best work. That is the best way to display a photograph. Matting the print and covering it with glass also reduces the risk of having it fade from exposure to sunlight or contaminants. Framing services are available in most cities, but are expensive. You can buy precut frames and glass, reducing the cost of finishing and framing your own black-and-white prints.

Drain the chemicals into the current tray before transferring the print to the next.

Wash the print to remove all chemicals before placing it to dry in a dust-free environment. Charles Kogod, NGS Staff (all)

A WORLD OF SUBJECTS

by Robert Caputo

Timing is everything. Pressing the shutter button just as this toddler reached the bottom of the slide captured him at the moment of highest speed and joy, thereby successfully communicating the thrills of the playground. A fast shutter speed froze his windblown hair and the exuberant expression on his face.

Robert Caputo

WHETHER WE ARE making photographs on assignment for a magazine, shooting stock for our files, or recording a vacation trip, we want to be ready for any situation that presents itself—from photographing a football game to making a portrait of grandpa on his 90th birthday; from shooting the great Pyramids at Giza to recording baby's first step. In this chapter, we will discuss how to apply the technical knowledge and aesthetic tips from Chapter Two to real situations. If you know you will be encountering a particular situation, look at the pertinent section—if you are taking a trip to the Grand Canyon, for example, study the tips on landscapes. Also look at photographs in books and magazines to see how other photographers treated the same or a similar subject. Think about—and keep in mind—how they achieved their effects. Just as painters study the works of the masters, we can all learn from the efforts of others.

WEATHER

Rain did not stop this woman from trying to sell her produce to passengers on a train at a station in Ethiopia. A fast shutter speed would have frozen the rain drops and made them practically invisible. A speed of 1/60 of a second allowed the drops to blur nicely against the dark side of the train but was still fast enough for the human subjects.

Robert Caputo

PHOTOGRAPHERS love dramatic weather. Rain, snow, fog, stormy skies—using the weather can enhance a photograph and help you convey a mood or feeling. A rain-slicked street reflecting neon lights looks quite different from one basking in sunlight, and an abandoned house is more evocative in fog than on a clear day. Try photographing something near your home in all different sorts of weather and compare the moods each image communicates.

Rain

When shooting in the rain, find a location that is sheltered (such as a porch). Use an umbrella, or loosely wrap your camera in a clear plastic bag, leaving an opening for the lens, since water can damage your equipment. Watch out for raindrops on your lens or filter, and wipe it clean frequently.

Freeze It or Streak It?

To freeze raindrops in midair, use a shutter speed of 1/125 or higher. At 1/60 the rain will appear as streaks that get longer as your shutter speed decreases. The raindrops stand out best if shot against a dark background, but if this is not possible, try to include another element that makes clear it is raining—people holding umbrellas or raindrops hitting a puddle, for example.

Effects of Rain

Look for ways the rain is affecting your scene. Leaves will glisten and the windward sides of trees may darken from the water, making a picture of a

Tip

If it is raining or has just rained and you are photographing a town or city, get out there—the glistening streets will enhance your pictures.

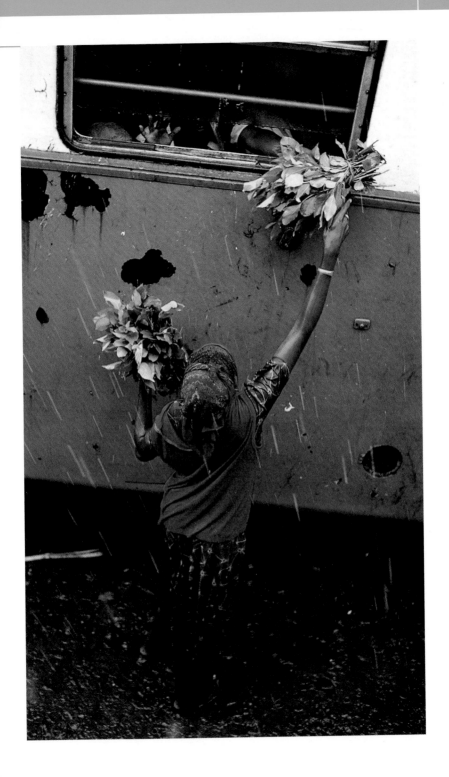

1/60

1/15

Phil Schermeister (both)

Same shot, same exposure, different effect: A shutter speed of 1/60 of a second nearly freezes the snowflakes at left, while one of 1/15 allows them to streak. Think about which effect you want before adjusting your camera's f-stop and shutter speed for the correct exposure.

forest more dramatic. A farmer may stand in his field smiling at the needed rain, but a businessman commuting to work might look disgruntled.

Snow

Snow and ice, like sandy beaches, are meter-foolers: The bright white makes the meter under-expose, because—don't forget—the meter takes a reading for 18 percent gray. The easiest way to compensate is to take a reading off a gray card or something in the scene you know is a neutral tone. Make sure it is in the same light as your subject,

George F. Mobley

The right combination of fast shutter speed and proper aperture freezes the action of these sledders and records the snow as bright-white. Camera meters will generally want to underexpose scenes with lots of snow, so take a reading from a gray card or set your camera's exposure meter to compensate for the brightness of the snow.

and that the meter is not reading a bright background. Bracket, if it's an important shot.

If you are going to shoot a lot of one scene and you have determined by how much your meter is underexposing, you can set the exposure compensation dial to compensate automatically. If your camera does not have such a dial, you can change the ISO rating to "fool" the meter. For example, let's say your meter is reading f/16 at 1/250 for 200 ISO film. From a gray card you get a reading of f/11 at 1/250. Simply change the ISO rating to 100 to compensate for the one-stop difference. (Remember that halving the ISO rating doubles the amount of light needed to hit the film.) Don't forget to change back to the film's real ISO afterward.

If it's sunny, get out early in the morning and late in the afternoon. The low sun raking across the snow will show more detail and texture than the midday sun. Try to avoid shooting with the sun directly behind you. The light reflected straight back into the lens from the snow will most likely give you a blindingly white mass with no detail.

If you're shooting action—skiers or sledders—see the section on motion for details on how to freeze the action or pan with it.

In really cold conditions, try to keep your camera reasonably warm so the batteries will work efficiently. I normally keep mine inside my jacket, unzip to make pictures, and then put it back again

Tip

Be wary of shooting falling snow with a flash. The light will bounce off the nearest flakes and not illuminate anything else.

Robert Caputo

Fog envelops a river in China with an air of mystery, yet is thin enough for the film to capture some detail in the boats. The same scene in bright daylight would have conveyed a very different mood.

while I move to the next location. Also remember that skin sticks to metal when it's extremely cold, so cover any surfaces you may touch with tape. (Don't forget the spot where your nose touches the camera.) Watch out for condensation when you go inside on really cold days. Seal the camera in a plastic bag while you are still in the cold air, and when you move into the heat let the camera warm up before opening the bag.

Look for details that really say "cold": a bird hunkered down in its feathers, children with only their eyes peering out of brightly colored parkas, frosty breath hanging in the air between two people talking, ice on a mustache.

Fog and Mist

A ship suspended in a bank of fog, mist lying gently over a lily pond—water vapor can make for very evocative pictures. Like snow, though, fog and mist can fool your meter and your flash. Some fog may be a perfect neutral gray or so thin that it doesn't matter, whereas some can be nearly white. To be certain of a good exposure, take a reading off

your subject or, if you can't get close enough, from a gray card. In thick fog, your flash will bounce off the water particles and usually not reach your subject, just the way headlights from a car will sometimes light up the fog but not the road.

If the fog is really thick, protect your camera with a loosely wrapped clear plastic bag. Watch out for moisture collecting on the lens.

Don't be put off by what seems like dull light when it's misty outside—the diffuse light is perfect for some types of moody shots.

Stormy Skies

When I see a dramatic, stormy sky, I run around trying to find something interesting to put in front of it. Dramatic skies create a feeling you just can't get with anything else, as classical painters have shown. If you are photographing shafts of sunlight bursting through clouds, be careful not to take a reading of the shaft, since you want it to be bright. The same goes for spumes of white surf crashing against a rocky shore. Remember, if the sky is really dark, the meter will want to overexpose it.

Gathering storm clouds lend this landscape an air of foreboding and depth that would be missing with a sunny blue sky. If you see stormy skies, go out with your camera. If it begins to rain, remember to protect your camera by shooting from under a roof overhang or an umbrella.

O. Louis Mazzatenta

SAM ABELL
Art and Photojournalism

Bill Luster

SAM ABELL is not interested in assignments that require complex equipment. He does not carry a flash unit. "It goes against my sense of what photography is about," he explains. Nor does he use reflector panels to bounce light onto a subject in shade.

Abell insists that his photographs be true to what his eyes saw at the moment of exposure, "without the least imposition of anything." And although he is not a documentary photographer, he wants his work to be "all straight."

Abell recognizes that photography is a tool-based endeavor with a broad array of practitioners, and he does not pass judgment on photographers who own all the latest equipment. Still, for the sake of efficiency and economy, his own walk-around pack contains only a 28mm lens and a 90mm lens, two camera bodies, and one film type. "I'm interested in a certain kind of picture, and I don't need sophisticated gear to take it," he says.

A poetic man, an artist with a camera who wanted to make "quiet pictures," Sam Abell nearly failed in his goal to become a magazine photographer. One of his first NATIONAL GEOGRAPHIC magazine stories in the early 1970s, a profile of Newfoundland (January 1974), came close to being his last.

Iconic image of a nearly extinct lifestyle, an early photograph by Abell (left) exemplifies his approach to editorial photography. "It is so reduced, and expressive of the North

Atlantic, I think. Not loud in any way—in color, content, or action—it is a subtle picture," he says, "but the quietude and stillness are among its best attributes."

The editors' reaction to most of those images was not positive, he says, and this feeling lingered over several subsequent assignments. "Too quiet—that was the hallmark of my photography, and it left a powerful question about my suitability. I was put on notice to consider changing my style," he says. The solution, he decided, was not to reinvent himself. "Instead, I resolved to make the quiet in my photographs more compelling."

Since his teens, Abell has been interested in the "expressive power of photography as an art form,"

Abell made this picture with an artistic sensibility and a journalistic purpose—to evoke the spirit of Tolstoy and tsarist Russia for a magazine story. He included the pears, veiling curtain, and frame to give the Kremlin something it lacked, a human scale.

partly due to the influence of his father, a geography teacher who ran a camera club. In high school, Abell was the photographer and co-editor for the newspaper and yearbook, an experience that expanded his views. "That is when I came under the spell of photojournalism and editorial photography," he recalls. "I also came to consider that the relationship between photography and publishing was intimate. That was photography to me—to be published. When your name appears under the pictures, that tells you to take photographs you will be proud of."

"I believed in editorial photography but I aspired to be an artist, and I thought that the twain could meet," he says. He began to think about the possibility of fusing the two types of expression. In college, he worked on a yearbook volume that was dedicated to "progressive photography" with an artistic approach.

Abell is often asked what goes into a NATIONAL GEOGRAPHIC photograph. "Everything; it has content, mood, light…there has to be a moment there. I think we've added levels or layers to the equation, and we demand of our photographs that they be complex in addition to everything else," he replies. In his quest to make such images, Abell has covered a wide range of subject matter. His assignments have ranged from hiking the Pacific Crest Trail, to ranching in Australia, to Yellowstone, to the expedition of Lewis and Clark. But what, over the years, has been his specialty? "Any assignment where the emphasis is on scene, an interpretive scene, where the poetics of the subject or an emotional quality will be called for—like my stories on Shakers, hedgerows, or canoeing," he says.

His coverage often includes powerful images of people, and Abell has no secret technique to offer, although he insists that time with the subject is essential. While on assignment in northern Queensland, Australia, he worked at a cattle station photographing the ten residents as well as the youngsters at a nearby school for youths who had experienced difficulties in an urban environment (June 1996). He devoted a full six days of a five-week assignment to this small group alone. Five of the resulting pictures were published in the magazine, including the cover, a double-page, and a triple-page spread. That was the reward for understanding the value of time—something that can only be developed through experience.

"It is a gift to work for the Geographic," he says. "It would be hard for me to identify a richer life, in totality, than the life of an editorial photographer. But no path is without its potholes, so to speak, though I would not trade it for any other job."

Aside from the difficulty in maintaining friendships because of extensive travel, he has been robbed and mugged, contracted malaria, been seriously injured, been nearly killed in small airplanes, and fallen in love. "If you aren't having any experiences, you're probably not taking

pictures. The demand on you is to have experiences, and they can exhaust you, but it is out of these that the photography comes."

Today, he views the photographer's life in broader terms. "It means more than putting film in the camera; it now means that, plus editing, plus writing, plus teaching, plus publishing—which is also a form of teaching."

There's a revealing passage from Abell's 1990 book, *Stay This Moment*: "The photographs…were not hard to make…. Something, though,was hard. It was hard being between photographs and not knowing when or how another image would reveal itself. Above all, it is hard learning to live with vivid mental images of scenes I cared for and failed to photograph. It is the edgy existence within me of these unmade images that is my only assurance that the best photographs are yet to be made."

Peter K. Burian

The face of an Australian cattle rancher reflects the stress of a marginal existence, while his granddaughter imagines her life as idyllic. "I spent six days on the ranch trying to get this complex, layered picture that suggests two states of awareness—realism and fantasy, age and youth," Abell recalls.

Abell's Photo Tips

Sam Abell frequently teaches workshops, but he rarely discusses camera equipment and places little emphasis on technique. "The Next Step," one of his sessions at the Santa Fe Workshops, is designed for photographers who want to "jump start" their creativity and move to the next level of their ability.

■ Achieve something of consequence, he advises. Consider taking on a life project.

■ Photographers with full-time jobs or heavy family responsibilities have taken Sam's advice. One woman photographed all of the businesses in Maine that were more than a hundred years old and still in the same family. Another student with a full-time job did figure studies. A newspaper photographer in Kentucky has a definitive project of our time. She photographed one family for 20 years, entirely on her own time, using her own money.

■ The subject may be landscapes, people, places, or abstracts, and the photographer may be a professional or an ardent amateur. Regardless of subject matter or status, Abell offers a significant piece of advice to photographers who are considering a life project: The most important thing is that it be heartfelt and that you be the author of it; no one else can do that for you.

LANDSCAPES

Foreground and depth: In the image at right, the photographer successfully conveys both the vastness of the plains and the detail of what is growing there. In the foreground, the large wheat heads framing the barn add a sense of depth and scale. A small aperture permitted great depth of field.

THE SWEEPING GRANDEUR of the Grand Canyon or Monument Valley, the majesty of the Rockies, the eeriness of the Badlands—landscapes are, next to people, our favorite subjects. But they're also one of the trickiest: When the beauty of a scene arrests us, our eyes travel over it, taking in the whole while at the same time focusing in on the gorgeous details. It's a total experience; not only the visual elements are playing on our senses. We are enthralled too by the sound of rustling leaves or a gurgling stream, the smell of the air, the wind in our faces. Being there is part of what makes a scene grand. The challenge is how to capture this feeling, how to convey grandeur in two dimensions on a tiny piece of film. It calls for thought, patience, and often hard physical effort.

Too often, when we return from a trip, our photographs of landscapes seem flat and confusing. All the elements that enthralled us are there, but the picture doesn't grab us the way the scene did. Usually this is due to the absence of a central element or subject. When we look at a photograph, our eyes want something to focus on, some center of interest. In landscape photography, the trick is to compose the image in such a way that whatever attracted you—the mountain, the lake, the splash of color in the forest—becomes that center.

What Should I Shoot?

Making great pictures is primarily a mental process. To begin with, think about the essence of the place. This is what has already struck you and

James P. Blair

made you feel the place was worth photographing, and this is what you want to capture. Think of adjectives you would use to describe the place to a friend: a wide-open prairie, an arid desert, a lush forest, a majestic mountain, and so on.

Study the scene to find elements that you can emphasize to get the feeling across. Then think of ways—choice of lens, time of day or season, compositional elements—to accentuate it. On a prairie, for example, you would want to find a view of an uninterrupted, flat horizon, with maybe a single distant tree or farmhouse to suggest vastness and loneliness. You might want the sky to take up two-thirds of the frame. In a desert, you might want a wide shot that includes the sun in order to empha-size the heat, or you may find that a single small plant growing in a sand dune best represents the severity of the place.

Tip

If you are pho-tographing a well-known place, look at postcards and books to see how others have treated it—not because you want to copy these pictures, but because they will give you ideas for photographs of your own.

Two pictures made in the Mustang region of Nepal illustrate the rewards of waiting. The image above is perfectly acceptable, but not very dynamic. As I pondered how to improve the picture, this boy came along and threw a rock at his goats. Including him added energy as well as depth to the image.

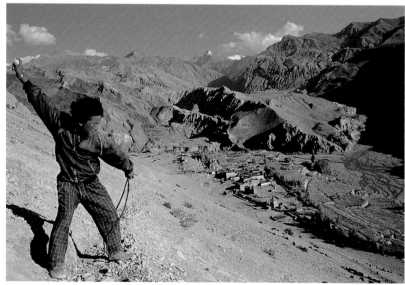

Robert Caputo (both)

Keep Coming Back

If you have the time, try coming back to the scene at different times of day (or even different seasons) to see how the changing light affects it—perhaps the early morning sun strikes a mountaintop in just the right way, while the afternoon sun casts an unwanted shadow on it. Early morning or late afternoon light is usually best for landscapes because the low sun is warmer in tone and casts long shadows that lend depth and contouring to the scene. Remember too that the sun changes angles with the time of year. What may be in shade on a winter afternoon may be in full sunlight in the summer. Overcast days can be good for photographing scenes where color is important— autumn leaves or emerald-green meadows— because of the increased color saturation. And don't be put off by stormy skies. They can add drama, and, if you're patient, you may get gorgeous shafts of sunlight breaking through.

Graphic Elements

Look for graphic elements you can use: a winding river or road, a dramatic shadow, the angle of a cliff. Use them to carry the viewer's eye into the picture. Move around: You'll be surprised to see how a scene changes if you move to a different viewpoint. And don't just drive down the road a piece: Hike up that nearby hill, climb a cliff, get down on your belly. I always seem to get really dirty when I'm making landscape photographs, because the best angle seems to be from the middle of a stream or halfway up a cliff.

Gear

Large-Format Cameras

For landscape photography, large-format cameras are best because they can be manipulated to provide almost infinite depth of field and because the

Tip

Get out early; not only is the light usually good, but to shoot a slope of virgin snow or a deserted beach, you have to be there before the crowds arrive.

Isolate the element that is most interesting. The straightforward picture of Magado Crater in Kenya (bottom) is less interesting than the detail of the mud and water, to which the woman adds scale. Both were taken from the same spot, one with a 35mm lens, the other with a 400mm.

Robert Caputo (both)

size of the film renders extremely fine detail. But the evidence in NATIONAL GEOGRAPHIC magazine and elsewhere proves that good landscapes can be made with 35mm cameras if you are willing to explore and have the patience to wait for the light. It's also important to use slow film to get fine grain and good color rendition. I often make landscapes with Kodachrome 25 or Fuji 50.

Wide-Angle Lenses

For landscapes, wide-angle lenses are useful because they can include a lot of the scene and keep everything in focus even at middle f-stops. But beware of making a picture that's too flat. Carry the viewer into the frame with a graphic

element like a river or road, or have objects in the foreground and middleground to achieve the same end. After you've made a picture of a person standing at the edge of a canyon, try moving back and posing him off to one side looking into the gorge, so that he becomes an element in the frame. In this case, the person helps the eye travel into the picture and also provides scale, another important element in landscapes.

When shooting landscapes with wide lenses, be careful of the horizon—remember the rule of thirds. The sky should usually be in the upper third of the frame unless it is an important part of the picture, in which case it might occupy two-thirds. If the symmetry of a halfway horizon works, though, don't be afraid to use it—in a reflection of a mountain range in a lake, for example. Be careful not to meter the sky, which is usually bright and will therefore cause an underexposure of the rest of the scene. Look for a mid-tone part of the scene or use a gray card. Check the frame for any unwanted elements such as power lines or radio antennae.

Don't limit yourself to wide-angle lenses. Telephotos can also make good landscape pictures. If you are photographing a range of mountains, you can dramatically "stack" them with a long lens, or you can make it appear that a mountain is looming over a small cabin.

Look for Details and Patterns

A detail can be more telling than the whole; a single weather-sculpted rock, for example, might communicate the feeling of a place better than a picture of the entire valley. The pattern of bark on an old tree might say a lot about a forest. Such pictures can also convey more of your own personal interpretation than a standard wide shot could.

Waterfalls and Streams

If you want to show the leap of spray at the bottom

Tip

As you contemplate how to photograph a landscape, look at it through different lenses to see which works best. With a telephoto, pan around looking for details and patterns and to see how the narrow field of view isolates certain aspects of the scene. And watch the light. Even a half hour can make a dramatic difference early and late in the day.

 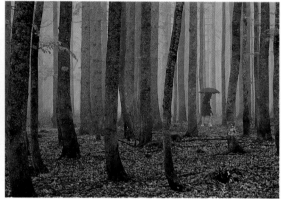

Robert Caputo (left); George F. Mobley (right)

Move around: A side view of the Blue Nile Falls in Ethiopia (left) was much more interesting than a straight-on shot. The figure carrying an umbrella adds both scale and mood to a forest scene. Be careful metering in forests like this one because the dark tree trunks will make your meter want to overexpose.

of a waterfall, use a high shutter speed to freeze it in midair. But if you want to show the flow of water in a fall or stream, use a slow shutter speed of 1/8 or so. Use a tripod or other support and a remote trigger or auto-timer to avoid shaking the camera; if there are people in the shot, ask them to hold very still.

Forests

Forests are usually rather dark, so you will probably need a fast film unless you are using a tripod and there is no motion in the frame. If you're shooting in the forest, look for shafts of light penetrating the canopy, and even the sun itself peeking through the branches. Be careful metering, since both the sun and the shafts of light will make the meter want to underexpose.

Look for a center of interest—a dramatically illuminated fern, patterns of tree trunks, a narrow, winding trail, or the splash of color from a flower—that will enhance the frame.

Beaches

Your beach photography should convey a feeling—
of warm serenity, stormy drama, solitary contem-
plation, or crowded vacationland. Every beach has
its own character and even that can change with
the weather. Think about the particular beach you
are photographing and look for ways to emphasize
its character. What do you find interesting? Is it a
palm-studded expanse of white sand rising up
from turquoise water or a dramatically rocky shore
pounded by waves? A wide shot from the top of a
dune might be appropriate for the former. A tele-
photo shot of backlit waves crashing against rocks
might best capture the latter.

Robert Caputo

Bright sand, like
snow, tends to fool
in-camera meters into
underexposing. Take
a meter reading off
something you know
to be neutral in tone.
Don't be surprised if
your camera meter
reads sand up to two
stops brighter.

PEOPLE

Be friendly: People react to your manner, and your photographs will show it. I joked around with this young girl on a street in Havana for a few minutes and was rewarded with this adorable and friendly pose (opposite). Always have your camera preset to grab moments quickly.

WE MAKE more photographs of people than of anything else—our families, friends, Little League teams, or local people when we travel. Just as with landscapes, we strive to get more than just a picture of someone. We want to make an image that captures the individual spirit of the person, just as a successful portrait painter conveys more than the physical appearance of his subject.

There are two kinds of people photography: portraits and candids. In portrait photography, there is a cooperation between you and the subject who is, after all, actively posing for you. In candids, you are more like a news or documentary photographer, hunting for moments that occur naturally and without your intervention. For both kinds, it is important to spend time beforehand thinking about your subject and the situation, so that you will have ideas about what you want to capture.

Portraits

Formal Portraits

When making formal portraits, think about your subjects. Who are they? What are the qualities of their personalities that you want to record; are they intellectual, sensual, happy-go-lucky, dour? Then think of ways—different poses, dress, surroundings—to communicate those qualities. The expression on a face is usually the most immediate and clear indication of personality, but all the elements of the photograph contribute to the feeling.

Scout First

Find the spot where you want the subject to pose,

Robert Caputo

and determine your camera position. Set up and test any lights or reflectors you will be using. The most important thing is that the person be relaxed and at ease. You don't want him to have to stand around waiting while you fiddle with equipment. When your subject comes into the location, you should be ready and able to devote all your attention to him.

Lenses

Short telephoto lenses—85, 105, or 135mm—are best for close-up portraits of faces or head-and-shoulder shots. They are more flattering than shorter lenses and allow you to stand back a bit and avoid crowding the subject. Long lenses have little depth of field, though, so be very careful of focus. Focus on the person's eye nearest the camera

Tip

An autowinder is very useful when making both individual and group portraits. Often, a person will become a bit stiff just as you are about to press the shutter button, but will relax just afterward. With an autowinder you can immediately make another frame, capturing the more relaxed pose. If you've set up your camera on a tripod, you might want to try using a remote trigger so you can continue to engage the subject without disappearing behind the camera.

and use the depth-of-field preview button to see how much of the face is in focus. If it is very little, you may want to use a slower shutter speed and smaller f-stop or faster film. For full-length or environmental portraits, you may want to use a normal or wide-angle lens so as to include the whole body or the whole room. Be careful of distortion, though, when using a wide-angle.

Angles

Look through the viewfinder and have your subject strike different poses—profile, three-quarters, full face; head tilted up or down. Look at how each pose portrays the person's individual face. A prominent nose might be elongated by a three-quarter pose, especially with a normal or wide lens. A round face might be too round in a head-on view. Your subject won't mind cooperating—both of you want to find the most flattering angle.

Lighting

Lighting is the most important element of portraiture. Soft, diffuse light is generally the best and most flattering, but there may be times when dramatic sidelighting is more appropriate for your subject. Experiment with different kinds of lighting so that you are comfortable with them, and when a particular situation arises, you will be able to light it in a way appropriate to the subject.

Window Light

Windows often provide a soft, diffuse, natural light. Place the person next to the window, either standing or in a chair, so that three-quarters of the face is lit by the window. If direct sunlight is coming in through the window, diffuse it with thin curtains, a white sheet, or tracing paper. Remember that the side of the face away from the light will be in shadow. This may work for your subject, or you may want to bounce some light onto the dark side of the face to soften the shadows. Use any white surface to reflect the light, such as a piece of

NGS Photographer William Albert Allard

Cooperatively candid: The photographer spotted this Italian actress as she was preparing to go on stage and unobtrusively made frames of her without breaking the spell of her meditation. The soft late light enhances the mood of the image.

white construction paper. Move the reflector back and forth to change the amount of fill.

Fixed Strobes and Photo Lights

Standard lighting for portraits is to have the main source of light (either a strobe or photo light) at 45 degrees to and sightly higher than the subject, with a reflector on the opposite side to provide fill. Diffuse the light by bouncing it into a photographic umbrella or by placing some sort of diffusion material in front of it; tracing paper or a white sheet will do. (Keep the diffusion material some distance from the light to prevent it from burning.) By moving the light toward 90 degrees to the subject (and adjusting the reflector), you can vary the amount of contour shadow on the face.

Tip

Pay attention to the background. You don't want it to compete with the subject or be distracting. Watch out for unwanted elements such as a lamp that seems to grow out of your subject's head.

Using More Than One Light

A second light can be used to backlight a person's hair or throw light onto the background. For backlighting hair, you should place the second light high and to one side behind the subject, and use a snoot—an attachment that narrows the beam of light. Or you can place the light low and directly behind the subject so that it is hidden from the camera. To illuminate the background, aim the second light at it, making sure to balance the intensity with the light on your subject.

Mobile Strobes

Besides using strobes in fixed positions and softened by reflectors or diffusion material, you can often bounce a strobe off the ceiling or a nearby wall to achieve a soft, diffuse light. Especially in white or light-colored rooms, the light from the strobe will bounce all around the room, giving an even distribution. Simply aim the strobe straight up at the ceiling or, better yet, bend it to point at a wall. You can also fit a white plastic diffusion head to your strobe to achieve a similar effect.

Outdoor Light

Just as with indoor portraits, lighting is the most important element when you are shooting outside. Find your location well in advance, paying attention to what might make an appropriate background for the picture, and to how the light falls at different times of day. Then schedule the shoot for that time. The warm light of early morning or late afternoon is best. Overcast days, with their soft, diffuse light are good for outdoor portraits. If you must photograph in the middle of a sunny day, find a shaded spot to place your subject, and be careful of backgrounds that are too bright.

Meter off the subject's face or off a gray card, being certain that it is in the same light as your subject. You can also use reflectors outdoors to add a little more light to the face or soften the shadows on sunny days. Be sure to set up the reflector before you meter.

George F. Mobley

Environmental Portraits

An environmental portrait places the subject in his customary work environment. The idea is to portray not just the individual person but also something of what he does with his life, either as a profession or hobby. You want to capture the interests of the person and reinforce them compositionally. Environmental portraits are usually not head or head-and-shoulder shots, but ones in which the person is but one element in the frame.

Scout first, preferably by visiting the subject while he is working. Ask your subject if you can just hang around for a while and watch what he does. Make mental notes about what might make a good photo. Find out if there is anything your subject is particularly proud of—a cattle breeder of a certain bull, a gardener of a favorite flower, etc. Notice what clothes he is wearing and politely suggest that he wear the same or similar ones for the shoot. People often want to get dressed up for a portrait, which is fine for formal ones, but

Spend time with your subject. The photographer of this portrait of Georgia O'Keefe was fortunate to spend two days with her to get this frame. The moment came when they were visiting a gallery that displayed her paintings, and she sat down to rest. Always have your camera ready for the serendipitous moment.

When making environmental portraits, wait for your subject to become engrossed in work, and include enough of the work space to clearly communicate what that work is about. The statue in the foreground reveals some of this art restorer's skills.

Robert Caputo

emphasize in this case that you are after a "natural" look. Often it's best to make the suggestion indirectly by saying something like, "I think that shirt will work really well in this setting."

If you will be outdoors, scout the location at different times of day to determine what light will work best. If you are working indoors, set up and test any lights and reflectors you will need beforehand. Remember that you and the subject may be moving around a lot within the space, so try to light it in a way that permits this without having to move lights all the time.

Fill-in flash works in much the same way as a reflector—it adds just a touch of light to a scene, and helps bring out a little more detail than might be exposed under the normal lighting.

You want fill-in flash to be diffuse and not to overpower or even equal your main lighting. The easiest way to soften the light is to place a diffusion head over your strobe. If the strobe angle is adjustable, click it up one-third toward vertical. If you don't have a diffusion head, point the strobe straight up and tape a piece of white construction paper or something similar to the back, bending the paper so it tilts over the strobe and reflects light into the scene. Then set the flash unit to emit about one f-stop less light than it would normally emit to expose the scene.

Tip

After you have made portraits in your preselected location, walk around with your subject—maybe back to where he's parked his car or to his house. Sometimes a serendipitous event will occur (he stops to talk with a friend, bends down to pet a dog) that will yield a good photo.

Be ready for the moment to change: The picture of the old woman (above) in northern Sudan was fine, and I was about to leave when a girl appeared in the doorway to see what was going on. Her presence made both the composition and the idea of "age" more interesting.

Robert Caputo (both)

JODI COBB
Beyond the Barriers

Courtesy Jodi Cobb

JODI COBB's latest assignment is a review of the cultural notions of beauty around the world. The content ranges from scientific research on the importance of symmetry in the survival of the species to the economic importance of cosmetics in the global economy. Aside from the obvious beauty pageants, Cobb photographed cultures that employ scarification, foot-binding, lip plates, body piercing, or tattooing as a sign of beauty, fertility, or resistance to disease. Her coverage required trips to ten countries, including remote parts of Africa and the highlands of Papua New Guinea.

Although she has photographed people in remote regions, Jodi Cobb has frequently worked in less forbidding locations from Hong Kong to Venezuela. When she's not covering specific events, she will do some street shooting to record the local life and culture. "Countries are very different, of course, as to whether people like to be photographed," she says. Where there is no cultural barrier, she will generally begin making candid pictures as she notices an interesting situation or interaction. "I find it easier to get forgiveness than permission," she says. Afterward, she will explain her intentions if necessary, using an interpreter or a smile and a friendly gesture.

Like all photographers, Jodi Cobb (left) sometimes faces risks in the field, as she did during a 1982 demonstration by Palestinians in East Jerusalem. In such cases, she is forced to work quickly and must

rely on her journalistic and photographic skills to make a picture that conveys her intended message: the anger and grief felt by this woman as the police were leading a relative away.

Cobb's primary strength in people photography is an ability to work in intimate situations, a process that takes a great deal more time than shooting in a marketplace. "You get the best pictures when you engage in a process of discovering each other," she says. Special effects play no part in such photography. "I want the viewer to have an emotional response to the subject, without some obvious technique getting in the way," she insists.

Her philosophy on photo equipment is equally straightforward. Not inclined to get involved with

Revealing an intimate moment to the photographer, these geishas read an astrology magazine between performances. "Access is important," Cobb says, "but then it's the time you spend with people, becoming trusted, that allows their lives to be played out in front of your camera."

complex technical gear, Cobb prefers to keep things simple. She often works with an older Nikkor 80-200mm f/4.5 zoom lens on a midsize Nikon N90s, with on-camera fill-in flash when appropriate. "I find the new autofocus f/2.8 zoom lenses and the professional cameras too heavy and too large," she says. "When I photograph people, I need to be unobtrusive, small, and compact. And when I'm in a small geisha room or backstage at a fashion show, I don't want strobes going off all over the place."

She uses flash frequently, adding a hint of light, using colored gel filters sometimes, or popping the strobe during long exposures. The strobe produces a dynamic sense of movement, with the brief burst of light rendering much of the subject fairly sharp. She admits that this technique is not new, but it works well for her. In fact, Cobb is not interested in the current fad, whether it's multiple strobes, intentional slanting of every frame, or processing film in the wrong chemicals for weird and wonderful colors. "I tell my students, be true to yourself. If you follow every trend, it's like trying to follow the stock market—you'll miss them all. Figure out your own style and vision and stick to it."

Among the first photojournalists to get into Saudi Arabia, Cobb photographed the women—frequently unveiled—revealing lives that are usually hidden (October 1987). "The women are so repressed in that culture," she explains. "I would ask to photograph them, but they had to get permission from their husbands or guardians or face divorce, loss of their passports, or banishment." Some 90 percent of them refused, but Cobb persevered and managed to photograph several with the help of the story's well-connected writer, who "unlocked all the doors." Her success with this story encouraged Cobb to try to uncover another hidden society some years later.

After photographing a geisha in Kyoto, Japan, Cobb decided that this topic had rich potential for an entire book. She took a leave of absence from the Society and began the project with a grant from

When Cobb was about to make this picture, the subject relaxed, giving non-verbal consent. Working hard to understand other cultures— being sensitive to their reactions and ideas of privacy—has allowed Cobb to enter worlds that are usually closed to photojournalists.

Eastman Kodak. At first, she had only a single contact who might help her enter a world that outsiders never see. "The geisha profession depends on a strict code of silence," she explains, "and they don't want to share their lives or secrets with the outside world." She succeeded in getting full coverage by taking it one day at a time, by persuading a single geisha to allow her to make just one picture, then another, and eventually a third, and so on.

Cobb's new friend helped persuade other reluctant subjects to be photographed, both on- and offstage, in their homes and on their dates. To supplement the pictures, Cobb recorded the life stories of the geisha, allowing them to speak for themselves so as to present them as individuals instead of stereotypes. The pictures and words were published in the highly acclaimed 1995 book *Geisha: The Life, the Voices, the Art* that won the Special Achievement Award from the American Society of Media Photographers. An intimate glimpse into the ceremonial and private lives of

these traditional icons of Japanese culture, the book was excerpted in a NATIONAL GEOGRAPHIC magazine article (October 1995). Cobb's success confirmed her as the ideal photographer for the major assignment about beauty, which she had proposed.

"I would like to do more projects that bring men and women closer to really understanding each other. In many parts of the world, women live in complete secrecy, and I want to record and celebrate their difficulties and their triumphs. Men think they're not interested, but then they see pictures of Saudi women or the geisha and they realize they're actually fascinated. I think that's important for people to realize."

Peter K. Burian

Cobb's Photo Tips

■ Photograph what really interests you, something you're passionate about. Ask yourself what you think and feel about this subject and why you are photographing it. If you photograph a flower only because it's pretty, or a mountain because it's a landmark, your pictures will reveal only the surface.

■ If you're not completely confident in the basics, take a course to get the technical aspects down cold and to get advice as to what equipment will meet your goals or expectations.

■ Even if you only want to take pictures of well-known monuments, commit to the situation. Come back when the light is better, experiment with a different technique, lens, vantage point, or light to go beyond the snapshot or the cliché.

■ Sunrise and sunset light can be beautiful, but you can shoot all day long. In high noon light, shoot downward from a high vantage point; in harsh light, shoot in the shade or indoors; if hard shadows fall over the subject, pop some strobe in there. Do something inter-esting, make any lighting situation work for you—it can, if you do it creatively.

■ Review your pictures closely and learn from the mistakes. The next time you go out, correct the problems, try something more experimental and dramatic.

■ Clip interesting photographs that you see in magazines. Ask yourself why you're drawn to certain pictures. Is it the lighting? Is it the exotic locations or people? What is it about these photographs that inspires you?

Tip

After you've made the "natural" photos, pose your subject with the thing he is particularly proud of—the breeder with his bull, for instance. Get him to tell you about it—why this bull is special, how he bred it, what it feeds it. Don't forget to include enough of the background to convey a sense of place. And always be ready. Sometimes you will get the best shots at unexpected moments—when the breeder is getting the bull out of his pen, for example.

The Shoot

Ask the subject to go about his normal activity and try not to pay any attention to you; when he gets engrossed in his work, you will get some of your best shots. Move around, looking for angles; shoot some wide, some closer, some straight on, some from the side. Every once in a while, ask the person to look up from his work. Always keep in mind what is special about this person and look for moments that communicate it: If it's a musician playing a piano, look for that moment of rapture on his face, if it's a weight lifter, that moment of strain. Be patient. You may have to wait for the person to forget about you and become relaxed, for the sweat to stain the workout suit, for the basket to be full of flowers.

Group Portraits

Group portraits can be of two people or dozens of people. You may want to make a portrait of a small family in a studio or of a crowd at a family reunion picnic. Whatever the case, remember that because you want to be able to see everyone's face, light and angle are very important.

If you are shooting a small group indoors, use the same setups that you would for an individual portrait. If it is a large group, arrange them in some sort of stacked position—on a stairway, on bleachers, or simply have the people in front kneel. Make sure that the light is falling on everyone equally, and that people don't cast shadows on those behind them.

Outdoors, use hills, benches, or anything you can to stack your subjects, and be aware of the angle of the sun and how shadows are falling. Arrange people in the same way as for indoors and look through the viewfinder to check for shadows. Overcast days, with their diffuse light, are good for group shots.

To include everyone in a large group, you may have to raise the camera position and shoot down

Robert Caputo

on the gathering: Climb the stairs or a tree with people assembled below you, or stand on a chair next to the dining table. You will probably be using a wide lens, so be careful of distortion, and check the depth-of-field preview to make sure everyone is in focus. Beware of blinking. You should make several frames to make sure that you have one in which all the subjects have their eyes open—if they blink just as you press the shutter button, you won't know it until you see the photograph.

It helps to have a center of interest, even in large group shots. Focus attention on the Little League team's trophy or most valuable player, on Grandma and Grandpa, or on the company president. These don't have to be in the middle of the picture, but should be plainly visible and should be the object of attention for the other people in the shot.

Joke around with your subjects while you are shooting. Get them to laugh. Have someone tell a

Don't wait for everyone to get into position before shooting group portraits. The moments just before and just after often yield more engaging frames, as this portrait of a wedding party demonstrates.

NGS Photographer Jodi Cobb

Pictures can present themselves anywhere, even on a subway escalator. Keep your camera handy.

Tip

Have your camera preset for exposure. If you are using an automatic mode, make sure the situation is one where the meter is reading accurately and not being fooled by the location—a beach or ski slope, or a very dark background, for example.

story and get a picture at the story's punch line.

Use your imagination: If you're shooting a basketball team, have some players perched on a backboard and the others gathered around below. Or climb onto the backboard yourself and shoot them through the basket.

Candids

Candid photographs can be of people we know or of strangers, in intimate situations or on crowded streets. Sometimes the subject is aware of you but absorbed in something else, or sometimes oblivious to your presence. You may be wandering around or, having chosen a background you really like, waiting patiently for something striking to pass in front of it. The most important thing is to be ready—think of yourself as a hunter in search of an elusive and telling moment.

Think about what sort of photograph you want to make—perhaps it's several different kinds. If you are photographing in a market, for example, you might want to make wide images that show

how big it is as well as portraits of some of the vendors. Look for activities that say "market": crates of vegetables being unloaded from trucks, people haggling over a price, a display of fish on ice.

If you are using a wide lens, preset the f-stop to give you great depth of field. If using a telephoto, prefocus on a spot where your subject is likely to be and give yourself as much depth of field as you can, mindful that you will need a fairly fast shutter speed if your lens is 135mm or longer and the subject is moving. An autowinder is very helpful for getting several frames off quickly. Use fill-in flash sparingly because it calls attention to the fact that you are making pictures.

If people notice you, smile and be friendly. Tell them what you are doing. If you are concentrating

When shooting candids on the street, look for angles that best tell the story. Moving around behind these Cuban musicians enabled the photographer to show how the crowd was enjoying the concert (top). Think about how wide and tight shots can complement each other. And engage your subjects: The smile on this Cairo street vendor's face (left) is the product of a few minutes spent talking with her and buying one of her buns.

Robert Caputo (all)

Robert Caputo

All dressed up. The dark background makes this toddler's white baptism suit really stand out, and Mom's stabilizing hand lends scale. Be careful metering in scenes like this where bright white fills so much of the frame.

on a person or group, ask permission. Usually people don't mind having their picture made if you are unobtrusive and act quickly. If you have the time and it's a group activity, join in. People will accept you more easily, and it's a way of learning what the important elements of the activity are, and what to make pictures of.

Being Sneaky

There are occasions when you need to be a bit surreptitious. In Somalia a few years ago, I wanted to get some photographs of young men selling food they had stolen from relief agencies, but I knew they wouldn't allow me if I asked. I used a 20mm lens so that I wouldn't have to worry about focus, and I preset the exposure before I entered the situation. I lengthened the camera strap so that the camera was hanging about waist high, figuring that the men wouldn't be looking that low while talking to me. With an interpreter, I approached the young men and struck up a conversation, keeping one hand resting on the camera. With my thumb, I squeezed off a few frames, and the noise of the market covered up the sound of the shutter and winder. It's hard to compose a picture this way, of course, and you have to take whatever you can get, but in some situations, especially dangerous ones, it may be the only way to get an image.

You don't have to be surreptitious to get good candid photos. The important thing is that you be natural and relaxed—people will soon get used to you and your camera and get back to what they were doing. Above all, be friendly and sensitive to people's feelings. If they object, or if you sense them getting nervous, move on. There are many other pictures out there.

Photographing the Family

Our families are our favorite and most frequently photographed subjects. We start making pictures of our children almost the moment they are born and continue on from crawling and first step to

Robert Caputo

graduation and their own parenthood. We photograph our spouses, parents, grandparents, and other relatives in all sorts of situations—from birthday parties and Thanksgiving dinner to amusement parks and camping trips in the woods. Family pictures are not only the ones we have the most of, they are also the ones we cherish the most.

Making pictures of your family is a great way to practice the portrait and candid techniques discussed above. You already know the characters and, more important, they know and trust you—and they will be more willing than most other people to be patient and indulge you while you experiment with lighting and lenses. You might make a project of making formal and informal portraits of everyone in the family, and try different setups for each. On the next family vacation, make candids of everyone. The experience you gain from this will stand you in good stead when you set out to make pictures of other people.

Photographing Children
Always have your camera loaded and at hand—

Yummy corn. Capture moments in your children's lives. A diffusion cap on the on-camera strobe softened the light to prevent harsh shadows and minimize red-eye.

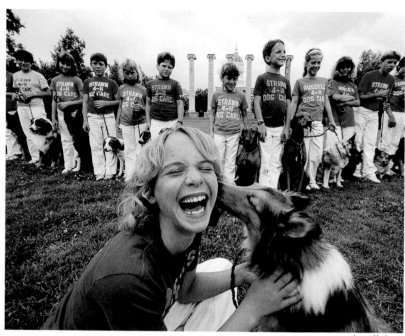

James Vanhoose

Whether it's a special event like a dog show or a normal day around the house, be ready for the telling moment. Step out in front to get the frame—such as the line of contestants here—that you want, then anticipate what the action will be. The photographer saw the dog going for the girl's ear, and snapped the joy on her face.

you never know when a child is going to do something you just have to photograph. Most of these moments are fleeting, and you don't want to miss them. Keep fast film like a 400 ISO in the camera so you'll be able to make available light shots quickly, without having to mount a flash and wait for it to charge. Make lots of pictures; your child is a baby only once—and for such a brief time.

Flash is very useful indoors, especially if you're shooting in a fairly small room. Bounce the flash off the ceiling for diffuse light, or use fill-in flash. Using a single flash will allow you to move around quickly and easily, and the diffused flash is not as disturbing as a direct one and doesn't create harsh shadows. If even the bounced flash is distracting your subject, try to go with available light.

Outdoors, be aware of the angle of the sun and how it is casting shadows. Just as in most situations, early morning and late afternoon are best on sunny days. Be careful metering—watch

NGS Photographer William Albert Allard (left); Robert Caputo (right)

At sporting events, don't concentrate only on the game—take a look at the crowd too. This Little Leaguer was so enraptured with the game that he ignored the photographer. Look for graphic elements—such as the lines of the spear and the doorway that frame this Kenyan boy—to enhance your photographs.

out for the bright reflection from the sandbox or sledding slope. And remember that you will want a fairly fast shutter speed of 1/250 or higher if the kids are running around.

Get involved in the children's activities—play ball with them, tell stories, do whatever they are doing so they get used to your being around and can relax in your presence. When you take out your camera, let them look through the viewfinder—but be mindful of sticky fingers on the lens. Soon the novelty will wear off and the children will go back to what they were doing. Use a telephoto or a telephoto zoom lens so you can stay out of the way but still get close-up shots. Try getting down to the children's level. I find that I spend a lot of time on my knees or even lying on my stomach when photographing children. It's the only way you can really see the expressions on their faces and also gives you some idea of the world from their point of view.

Tip

Ask a child to show you his favorite toy. Make frames while he is hunting for it in the toy box and of his proud expression when he shows it to you. If a toddler is about to appear teetering in a doorway or reach for her favorite doll, get set beforehand so you can capture the moment.

George F. Mobley (left); Annie Griffiths Belt (right)

Whether it's a literal birth day or one a few years on, try to capture the emotion of the event. In the delivery room, the photographer used high-speed film and fill-in flash to illuminate the moment when Dad shows Mom their new baby. At parties, always be ready for moments like this hug (left).

Tip

Make a lot of candids. At a child's party, the children will be passing around the new toys, eating the cake with their fingers, pulling at the strap of the party hat. It's a great time to get natural shots of them all. At Grandpa's party, relatives who haven't seen each other in years will be hugging and kissing. Try a group portrait, too.

Birthdays

The standard pictures are the ones we all want: blowing out the candles, opening presents, a little face smeared with chocolate icing. Be ready when the moment arrives, and shoot.

Blowing out the candles: Find a good position. If you're indoors, use available light, fill-in flash, or a flash bounced off the ceiling. To capture the flames of the candles, you will need a slow shutter speed (1/30 or slower, depending on the speed of the film). You may want to use a tripod or other camera support. Take one frame just before, when cheeks are puffed with air and the candles are burning, one in mid-blow, then quickly another right after, for the look of joy on the child's face. If it's Grandma's birthday and there are lots and lots of candles, they may give off enough light for a good picture of her and the cake without flash.

Try a slightly wide shot that includes other children gathered around the cake. Their expressions of eager anticipation really say "Happy Birthday."

Opening the gifts: Anticipate the moments

NGS Photographer Jodi Cobb

when the paper is ripped off and the new toy revealed, when the child's expression says it all. Look for the gift-givers, too, as they react to their presents being opened. After the party, make some pictures of the child with all her presents piled around her.

Graduation

Just as with birthday parties, you want to look for the standard pictures—in this case the graduate receiving his diploma, the class hurling their hats in the air, etc. These pictures are the most popular for good reason; they capture the essence of the occasion. But also look for other moments—your daughter hugging her best friend, the proud expression on Mom's face.

To get a good picture of your child receiving the diploma, you will probably want to use a telephoto lens. If you are seated far back, go to the front just before your child's turn. Kneel while you wait so you don't block other people's view, then quickly take the shots and return to your seat.

Record the joy of graduation by positioning yourself to face the new graduates as they cheer. A fast shutter speed captures their expressions and their raised hats.

Tip

Remember that a frame mostly filled with black graduation gowns will fool the meter. Take a reading from a face or a gray card.

George F. Mobley (both)

Get behind the scenes at weddings if you can. The wedding couple's best friends and close family will be with them, and you will find good possibilities for candids. Indoors, use a fast film and fill-in flash if necessary. Outdoors (above, right), use a slow film for better color and finer grain.

Weddings

Weddings are probably the most photogenic events in our lives, so be prepared to shoot a lot of film. Since weddings progress in a predictable way, it is best to approach them as a picture story; plan out what you are going to shoot and how to get in the right position beforehand.

You will be shooting both candids and portraits, and most of the locations will be indoors. Some of the situations will be tricky—the interiors of churches are often rather dark. High-speed print films are best for these situations, because they have a lot of exposure latitude. They will also help you take advantage of available light at the rehearsal dinner and reception, and, when you are using flash, will call for less output and faster recycling.

Start with the bachelor party, the bride having her hair done, the bridesmaids getting dressed. Make both candid shots and portraits—the groom pacing nervously, the bride staring out a window. Indoors, use fast film and a combination of available light and fill-in flash or bounced flash. Be careful when shooting the bride—her white dress can fool the meter, as can the groom's dark suit.

Ask permission before shooting inside the church and avoid using a flash if you can. Get a shot of the bride marching down the aisle and then move behind and to one side of the altar for the ceremony.

The best time for formal portraits is usually just after the ceremony, either at the church or when people first arrive at the reception. You will want several portraits: the bride and groom, the two of them with their parents, the bride with her brides-maids, the groom with his best man and ushers, and so on. When shooting outside, be mindful of the light: If it's late in the day the low sun may be flattering, but if it's early afternoon you will want to pose your subjects in the shade. Use a reflector or fill-in flash if the background is bright.

At the reception, make candids as the bride and

> **Tip**
>
> Scout the location for formal portraits beforehand so you can get them done quickly—everyone will be anxious to get to the party.

George F. Mobley

Old and young raise the flag at a Memorial Day celebration. At festivals, look for the moments that typify the occasion as well as relationships between the participants.

Richard T. Nowitz

Don't be afraid to make frames in low light. This picture of children lighting a menorah was made with only the light given off by the candles. The photographer mounted his camera on a tripod, used a cable release, and asked the children to hold very still. He used an incident exposure meter reading to ensure proper exposure.

groom cut the wedding cake. Go outside to get pictures of the ushers decorating the escape car. Keep an eye out for special moments—the bride dancing with her dad, the tears on Mom's face. Get pictures of all the main characters, including the ring bearer and the flower girl. For the last shot in the essay, don't forget the "Just Married" car pulling away.

Holidays

Holidays provide many opportunities for all sorts of pictures—candids, group portraits, games, sports, parades, and moments of family togetherness. Keep your camera loaded and ready so you don't miss anything. And don't be shy—everyone enjoys pictures of themselves and their loved ones.

Look for moments that symbolize the event. Think about the particular quality of the holiday and then make pictures that convey it.

Thanksgiving

Most of the pictures will be indoors, so you will want to use available light, flash, or, a combination. Use a fast film so you can take advantage of the available light. (Don't be afraid to turn on all the lights in a room. In late November it gets dark outside pretty early.) Then bounce a flash off the ceiling or light-colored wall. Use fill-in flash if needed.

Give yourself the assignment of shooting a photo essay about the Thanksgiving feast: Make candid shots as people arrive and greet each other, of the cooks and helpers in the kitchen, of mom carrying the turkey to the table. Pose everyone at one end of the table for a group portrait. Show Dad teaching little Jack how to carve. As the dishes are being passed around, stand on a chair at one side of the table and make a picture as people help themselves. During the meal, keep your camera in your lap and make pictures while people are talking and eating. After the meal, join the cleanup crew as they do the dishes and the gang collapsed in front of the television watching football. If there's a game of touch football outside, capture the action. Show people leaving—carrying sleepy children to the car, hugging good-bye. Make prints of the best pictures, arrange them as an essay, and send them to your relatives. They will treasure them for years to come.

Christmas

You want to be ready when the children first enter the room to see what Santa has brought them. Just as with Thanksgiving, use a combination of fast film and bounced or fill-in flash so you can move around and capture the action and expressions.

On Christmas Eve, make a portrait of the family in front of the tree: Turn on all the lights in the room and, of course, the lights on the tree. Set up the camera on a tripod or other camera support; you want to use a slow shutter speed (about 1/8 at f/2.8) so the tree lights "burn in." Bounce the flash off the ceiling to light up the rest of the scene.

Tip

If you use fast film, the strobe will not have to put out as much light and the recycling time will be faster, so you'll be able to shoot quickly. You'll also be able to use smaller f-stops and get greater depth of field, so that all the people at the table will be in focus.

Tip

Anticipate the expression on a child's face when she is opening a present you know she has been longing for, and the hug she gives Mom just afterward.

ANNIE GRIFFITHS BELT
Getting Close to People

Yossi Aloni, Maariv

As a GENERAL assignment photographer, Annie Griffiths Belt shoots a broad variety of subjects ranging from archaeological sites to landscapes and social geography. One of her particular strengths is her ability to photograph people involved in their day-to-day activities. "Whether working for the yellow border magazine or a book project, I try to include a human element. That makes readers care about the story more than if it were just a series of pretty pictures; it adds another dimension," she says. Belt develops a rapport with her subjects. "If something interesting is happening, I'll gradually edge as close as possible and start shooting. As soon as they see me, I wave and smile, letting them know I wish no harm," she explains. "At other times I'll stop and talk to people. If they speak English, I'll give them a compliment and ask them to continue with whatever they were doing. They may strike a pose, but usually just for a minute; then they go back to being natural."

Belt recognizes that many people are uncomfortable taking photographs of strangers, but believes they often rationalize their own fear of getting close by saying, "I don't want to intrude or upset that person." And she doesn't believe that subjects feel their privacy is being invaded. "The

Instead of shooting from shore with a telephoto lens, Annie Griffiths Belt (left, with husband and children) waded into the River Jordan and photographed

this baptism with a 20-35mm zoom. "When you're physically close to people and you can 'feel their heat,' that's when your pictures will feel close," she explains.

media doesn't hound the farmer, the hairdresser, or the truck driver. By paying attention to them, you can make them feel special; by taking pictures, you can pay a wonderful compliment if you make it a positive experience."

In her people-photography workshops, Belt emphasizes the advantages of using short lenses and shooting from close up. "I work at getting my students physically closer to the subject. I try to help them understand that intimacy comes only from being close to somebody, that pictures made

In daily newspapers, we often see the Israeli Army involved in frightening or tragic events. For her story on Jerusalem, Belt wanted to show a different perspective. To humanize the soldiers, who are often very young, she worked unobtrusively to make this revealing image.

with a telephoto lens will not have the same feel of intimacy."

In foreign countries, she rarely uses an interpreter, preferring to connect with people on a one-to-one basis. Learning enough of the language to be polite, she moves beyond words with gestures, sign language, or a rough diagram—all with a smile—to explain her photographic intentions. In an African village, for example, she may hug the children and speak in English, knowing that her subjects don't understand the words. "In any country, you can tell a woman, 'What a beautiful baby!' and she will hear you. It's that kind of communication, that kind of being there, that works so much better than formal translation," she has found.

As a woman usually working alone in the field, Belt finds that some people worry about her. In truth, she actually feels safer in many situations than she might as a male photographer. "As a woman you look harmless; I try not to look too interesting and try to disappear when the situation

gets rough," she says. "And there is a perception in some cultures that American women are loose and free, so you do have to be careful and know as much about the place as is possible," she says. In fact, a greater concern for a female photographer is restricted access in certain cultures such as Arab societies, where she cannot enter a mosque. "I'll turn this around to my advantage," she explains. "I'll stay with the women, and get pictures that the guys could never get."

Among the first women to shoot regularly for the Geographic, Belt began her career 20 years ago in an era when few publications would send women into risky situations. After 5 years of assignment work, Belt landed her first overseas job. Since then, she has worked around the world. She takes her two children with her on long trips, renting a cottage or a neighborhood home to maintain normalcy. With the assistance of a nanny, Lily and Charlie keep up with their schoolwork. Don Belt, an assistant editor and writer for NATIONAL GEOGRAPHIC magazine, joins them during his vacation so there's rarely a gap of more than a month in family time.

In addition to months of long days, many major stories demand vast amounts of research, which Belt considers an investment that will pay dividends in the coverage. "I rarely shoot the obvious, because NATIONAL GEOGRAPHIC almost never publishes the obvious," she says. "To be interpretive, you have to go well beyond the surface." During the workshops she teaches, Belt has noticed an interesting fact: Most students don't understand the meaning of the word "work," she explains. "Because anybody can shoot pictures, they rarely appreciate how hard you have to work to get a good picture. They're attracted to exotic locations or colorful costuming because it can almost take its own picture: It's important to go beyond the subject to create well-taken, interesting pictures that reveal the character of the place or the people."

Frequently asked what it takes to succeed as a

photographer for NATIONAL GEOGRAPHIC, Belt's response is to the point: "You must have the photographic skills and the ability to be creative with the technology. And it takes a sense of humor, curiosity about the world, a strong point of view, and tremendous self-motivation—the ability to push yourself beyond what you thought you could do."

She agrees that developing a photographic vision is difficult—that it's an evolution, enhanced by experience. "I do see things now that I didn't see 20 years ago; you do become attuned to a whole different set of elements that combine to make something happen. It's almost like choreography, because you feel things start to happen—the light, for example. It's a sensitivity that comes from having that as your focus for so many years."

Peter K. Burian

A firm believer in the value of manually controlling the camera, Belt makes photographs such as this without relying on automation. Here, she used an incident light meter to determine exposure, then carefully selected the point of focus and the aperture (f/8) for adequate depth of field, and a shutter speed (1/60 second) fast enough to avoid blur.

Belt's Photo Tips

■ A lot of people either love the toys (camera equipment) or they love making pictures. I think you have to combine skill and craft: Take the technology and be creative with it. If you're hung up on the gear, you may never get past it.

■ Don't shoot a lot just to stay busy. Learn to be a better editor in the camera, compositionally. But when things are happening, don't skimp on film.

■ Learn to meter light instead of relying on the camera to set a correct aperture and shutter speed. Create photographs using a combination of light and camera settings that will achieve your intentions. Make all those choices for yourself.

■ The direction, quality, and color of light—and how it's touching the subject—are far more important than the quantity of light in most photography. With landscapes or very simple graphic things, I think the single biggest element missing in many pictures is a sense of light. Just as you get a better ear for music as time goes on, you get more attuned to light in photography with experience.

■ Remain aware of what f-stop you're using; select f/4 or f/16 for a specific reason, because of the particular effect you want for that picture.

■ If you're interested in photojournalism, learn the concept of storytelling with a camera. Sometimes you can do that in a single frame, but it's more rewarding to tell it in a body of work.

ARCHITECTURE

Look for patterns when photographing buildings and monuments. Although centering the main subject is usually not advisable, in some cases it enhances the picture. The symmetry created by the arches and radiating paths at the Ahmad ibn Tulun mosque in Cairo, and the lone figure in the foreground, make the "bull's-eye" approach work for this image.

NOTHING captures the character of a town or city like its buildings—the skyscrapers of Manhattan, the old homes of Charleston, or the weathered facades of a western ghost town. Perhaps you are doing a travel story or visiting a far-off city on vacation—the important thing is to get photographs that evoke the spirit of the place.

Approach making pictures of buildings—be it your house or a famous monument—in the same way you would landscapes: What interests you? What makes you want to photograph it? Each building has its own character. For some it might be a snug, warm, homey feeling. For others it might be foursquare solidity or a glittering glass facade. Figure out what qualities you want to emphasize, and then look for the angles and light that will help you.

Make use of all the elements the situation has to offer. Pedestrians help give scale to city buildings as well as add bustle and a sense of place. If a curving driveway leads to an old Victorian house, use it as an element in the foreground to carry the eye to the house. If a statue is surrounded by beautiful flowers, use them in the foreground to add contrast and color. Don't be afraid to experiment with different perspectives. Long lenses can be quite useful to isolate a building or just part of it or to "stack" a series of colorful storefronts.

Look for details: A close-up of intricately wrought ironwork or reflections in a wall of glass can say a lot about a building.

In cities, it's hard to get unblocked views of entire buildings except when very close to them, so

Robert Caputo

you will often be working with wide-angle lenses. Since you will be aiming the camera up to include all of the building, you will get a distortion of perspective where all the lines converge at the top of the frame—the buildings will seem to be leaning. This effect can be used to your advantage to accentuate the soaring quality of skyscrapers. If you find the distortion unacceptable, though, or if you need to get an accurate image of the building, you can use a view camera or, for smaller formats like 35mm, a perspective control (PC) lens, also called a shift lens. These allow you to tilt just the lens, so you can keep the film plane parallel to your subject and eliminate the distortion. Another solution is to get into a high position opposite the building where you will not have to tilt the camera. You may have to ask permission to enter someone's office or apartment, but often there are windows in stairwells, and there's always the roof.

You'll need a tripod for long telephotos and for

Tip

Use a polarizing filter, especially if you are shooting modern buildings with lots of glass. The polarizer will cut down unwanted reflections and glare, as well as add more contrast to the colors of the buildings and sky.

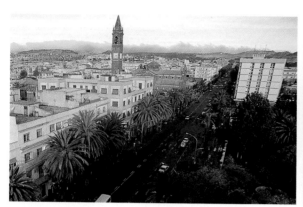

Three identical views of Asmara, Eritrea, feel very different due to the quality of the light at late afternoon, sunset, and nearly twilight. Find the view you want, and then wait for the light that is most pleasing—in this case the last shot where the buildings seem to glow and the cars create streams of light in the street.

long exposures at dawn and dusk. Try making a picture of a busy city street at rush hour with a slow shutter speed of 1/15. The pedestrians and cars will be slight blurs moving through a canyon of buildings. This can be even more effective at dusk with an even slower shutter speed; the lights of the cars will look like streams of white and red.

Skylines

Skyline shots are one of the best ways to convey the feeling of a town or city. Scout first: Find a location with an uninterrupted view—you can often find these on postcards or in tourist brochures. Then determine what time of day will provide the best light. Don't limit yourself to frontal lighting. Look for angles where the rising or setting sun shines through a gap in the buildings. View the skyline through different lenses and choose the one that isolates just those elements of the skyline that you want.

Some of the best skyline shots are just before dawn or just after sunset, when the lighted

Robert Caputo (all)

buildings are silhouetted against a colorful sky. You will need a tripod for a long exposure and it helps to use a cable release or the camera's self-timer to avoid shaking. Metering can be quite tricky, especially as the sky darkens. You will want to override the camera's meter to underexpose a bit, and bracket to be sure. All films lose effective speed at long exposures, so if you are shooting at a few seconds or more, consult the reciprocity table in the night photography section to determine the compensation you will need for the film you are using.

Monuments and Famous Places

When visiting famous places, you will naturally want to get photographs of the sites—the Colosseum in Rome, the Washington Monument, etc. This can be a bit intimidating, as these buildings have been photographed so often and so well. You may wonder why you should bother. Have a look at postcards and pictures in the guidebooks. You will notice that most of them are pretty much the same; the standard view. There's nothing wrong with this, of course, and you will probably want to get one yourself. After you have, though, go looking for something different—a unique angle, something unusual in the foreground, a view from an entirely different spot. Look for serendipitous elements—a cleanup crew sweeping the

Tip

Pay close attention to the colors of the buildings you are photographing—if there are a lot of very light or very dark buildings, the meter might be fooled.

Robert Caputo (both)

Always think about the mood you want your image to convey. The tomb of Hatshepsut at Luxor in Egypt, for example, feels much more tomblike in the evening when it glows beneath a red sky than it does in full sunlight.

Colosseum, a child climbing on a statue. Include your companions—they will add scale to the scene.

When photographing a monument, think about what it represents and what its architectural elements are, then look for ways to reflect these in the image. The Lincoln Memorial, for example, is a very solid cube. The Jefferson Memorial is softer—it's round and has a domed roof. You might want to photograph the Lincoln Memorial straight on, showing it perched at the top of its wide flight of stairs, to emphasize its foursquare solidity. The Jefferson Memorial might best be photographed from the side, framed by pink cherry blossoms in the foreground. Photographing a battlefield statue on a misty morning will emphasize the solemnity of the site. The soaring Washington Monument might look best on a clear blue-sky day with the flags fluttering around its base.

Try to visit monuments at different times of day to see how the changing angle of the sun affects them. Many monuments are lit at night, and you can use these lights to get dramatic pictures at dusk. Just as with skylines, you will need a tripod for a long exposure, and be careful of metering. Bracket to be sure of getting a well-exposed frame.

Look for unusual ways to photograph popular subjects. Both of these pictures show tourists visiting the Pyramids at Giza. The one with the camels is like many that appear in brochures and travel books. The bottom one is more unusual, and more striking because of the unexpected pool and luxury hotel.

Robert Caputo (both)

Nathan Benn (left); NGS Photographer Jodi Cobb (right)

Frame your image to reflect your subject. The stately quality of this room in a historic Savannah mansion is enhanced by straightforward treatment, while the combination of window and lamp light complements the mood. Attention to the sweeping curves in the building at right emphasizes its size and modernity.

Tip

If you are photographing a detail like a mantle or a piece of furniture, light it the way you would an individual portrait, but watch out for reflections from glass, mirrors, or glossy paint. You can use a flashlight from the position of your light or flash to check for these, and to see how the shadows will fall.

Interiors

Figure out what it is that you find appealing about a room and ways that your photograph will accentuate that quality: Is it the way the sunlight streams through a window? Is it the arrangement of furniture? Is it the great mantle above the fireplace? Whatever it is, find an angle that communicates those things that made you decide you wanted to photograph it.

Lighting is the most important element of interior photography. You may want to show the room's natural light, whether from windows or lamps, or you may want to highlight a certain section of the room with photo lights or strobes. Think about the architectural quality of the room. If it's a bright, modern office with a wall of windows, you want the picture to be bright. If it's an old Victorian living room stuffed with upholstered furniture, you might want it to look dark and moody. Look at the room at different times of day. The sunlight coming in through the window of the office might be just right or may be too much—you might want to wait until it is not direct. The

living room might be so dark that you have no choice but to light it.

If you want to include a room's lamps in your picture, you may want to use tungsten film or replace the bulbs with photo bulbs to give yourself the right color and more light. Or you may decide that the warm glow of normal bulbs looks just right for this room. You may want to bounce a little light off the ceiling or a reflector to give yourself more detail. But be careful not to overpower the lamps. Set the strobe to underexpose by a stop or more, as you would for fill-in flash.

If you are shooting interiors while on a tour—of Monticello, say, or some other historic building—you may have to get whatever pictures you can while the group is moving through. Tripods and flash are usually not allowed in these places, so use fast film and brace the camera as best you can.

As you wander around looking for candid pictures, make notes about subjects that strike your fancy. I noticed the detail above a Havana doorway (below, left) on an overcast, rather dull, day then returned to photograph it in better light.

Robert Caputo (both)

JAMES L. STANFIELD
Making History Come Alive

Sisse Brimberg

JIM STANFIELD admits that he overworks the subject. He exposes thousands of frames, always looking for that "banger picture." He'll photograph a tribe or a single individual for a long time, to get that single definitive image: when the gesture, activity, or the moment of interaction is just right. Shooting a great deal is essential to his technique. "That's the way I scrape off that surplus, or that preconceived idea and get down to mirroring the personality of the subject."

For landscapes and architecture, "It's not just the significance of the place; it's the interpretation—the photographer's eye—that's important," he says. "The more I look at it, the more I wonder how I can make it better." To do so, he'll try different lenses and return to photograph at various times of day, changing vantage points with the light and shadows. He finds that his most interpretive pictures, with the right mood, are made in inclement weather. "Rain and fog, for example, add a mystical veil that the artist is always looking for," he says.

Because mobility is required for much of his work with people, he carries only two cameras:

Difficult subjects and unpredictable conditions—such as this rare guillotine displayed in a very small, daylit room—often require special equipment. That's one reason why Jim Stanfield (left) travels with a large quantity of gear: everything he might conceivably need. To make this eerie image that evokes the French Revolution, he used ten mini-spotlights to create highlights and shadows. Then he selected tungsten-balanced film, which has a built-in blue cast, to produce an icy cold effect.

When photographing people, Jim Stanfield often spends hours following a subject, waiting for just the right moment and never allowing himself to become distracted. Here, he was rewarded for his concentration by a spontaneous few seconds of bliss—a rare display of affection among the Bedouin.

Nikon N90s bodies and his workhorse 20-35mm zoom, plus 80-200mm and 28-70mm zooms. His vest is stuffed with dozens of rolls of Kodachrome 200, Fujichrome Provia 100, and Velvia 50, plus an extra lens: an 18mm ultrawide, useful in case he finds a great architectural subject. He usually operates his cameras and flash in manual mode, taking advantage of automation only to solve problems: autofocus for some high-speed action subjects and matrix metering on automatic in the rapidly changing light at a street market.

Stanfield's career is the subject of a 1998 National Geographic book, *Eye of the Beholder*. "The book is a celebration of my life at National Geographic and reflects the world I've been fortunate to explore," he says.

Among Jim Stanfield's most finely tuned skills is an ability to evoke the past—using the people of today to personify those who lived centuries ago. "Even if the story is about an empire, or mostly architecture, I try and bring it alive, to breathe life

into it; the human element will do that," he explains. The key to success here is finding the right locations, where people have not yet succumbed to modern culture. Traditional clothing, agricultural methods, and modes of transportation are important.

When walking in the footsteps of Alexander the Great, for example, his research suggested a visit to Gwadar, Pakistan. "The camel caravan still runs through the area, using the same mode of transportation," he explains. "So I caught up with them and started scouring the faces of the camel men. They have these incredible leather faces, lived-in faces, and you can very seldom go wrong. It could be today, or it could be a thousand years ago."

When street shooting, Stanfield manages to make numerous pictures although it's often difficult for him to blend in with the crowds. "I am innocent looking; people can read an awful lot into your eyes, your movements, and your facial expressions," he explains. Sometimes he'll make photographs without asking. After getting the shots, he'll approach the subjects, let them know what he is doing, and develop a rapport.

For greater depth of coverage, Stanfield must go beyond candid images and weave himself into the fabric of people's lives. That may mean living with a Bedouin community for weeks in order to go beyond the surface of their culture.

"I don't speak a lot of languages," he admits, "but it all depends on your character, your personality. They see how comfortable you are with their children, in their tents, having dinner, sleeping under their quilts." He takes a few pictures to break the ice, works his way in slowly when photographing the ladies, and shows copies of the magazine. In societies with strong religious beliefs or tribal taboos, he's sensitive and honors the local customs. "Eventually they realize you're not such a bad guy, you're not a threat, and you're not going to be there forever. Then they just let down their guard and they go about their business; it's rewarding getting

those photographs."

Stanfield believes he finally reached his full potential in 1990 when working on the Ibn Battuta story (December 1991) about a Muslim scholar who roamed Asia and Africa. "This was the best set of pictures I had ever handed the editor, and I really enjoyed that assignment," he recalls. "It was a point in time when I thought, 'This is why I came to the NATIONAL GEOGRAPHIC.'" That coverage also cemented Stanfield's reputation as a capable interpreter of history and historical figures, and many other assignments of that type followed—most recently a three-part story on ancient Greece, published in late 1999 and early 2000.

Peter K. Burian

Stanfield captured this sensuous gesture after several days attending rehearsals and performances of dancers in Tel Aviv. Striving to make a single, extraordinary picture while retaining the atmosphere of the location, he chose to not use flash, selecting instead a fast film (ISO 800).

Stanfield's Photo Tips

■ As a starting point in your research in a new city, check the better postcards and tour books that include a lot of photographs. Scout locations when the light is not right, and make a note to return at dawn or dusk. Find a new vantage point, not the same one that other photographers always use. Revisit key locations for different light or activity.

■ Light is the photographer's most powerful tool; take full advantage of sunrise, sunset, and inclement weather. If you're traveling with a tour group, go back to the best locations on your own, in a taxi; miss breakfast; arrive late for dinner. Beautiful things happen in early morning: warm light or climatic conditions such as fog, snow, rain, or frost.

■ To find local color for people photography, visit a market in any country. If you hope to find people in traditional clothing, it will be at the market, very early in the morning.

■ If you use flash indoors, try to make it seem natural; bounce it off something instead of using a direct, harsh burst. Add to the ambient light but don't destroy it; use an amber gel over the flash head to balance its color temperature with that of the lamps. When there's window light, use fill-in flash to augment it—to stop the action or to moderate contrast.

■ Committed photographers push themselves a bit. Do research; ask questions; get up early; stay out late. And, with a quick eye and a curious mind, look for spontaneous moments.

FESTIVALS, PARADES, AND SPORTS

Tip

Use both wide and long lenses: The wide shots will give a sense of the whole event and the location. Telephoto shots will isolate particular floats, drummers, or costumes to convey the flavor.

FESTIVALS, parades, and sports make for some of the most colorful and active photographs, but whether you're shooting the Rose Bowl parade, the high school marching band, or the local soccer league, location is of primary importance. You've got to be able to see it if you want to photograph it.

Scout first. Walk or drive the parade route the day before to find good vantage points, and plan to get there early so you can be at the front of the crowd. Street corners are good places to shoot from because each band or group turns off, giving you a clear shot of the next one. If you have time, plan to shoot from two locations—one at street level and one high up, such as a balcony, window, or set of bleachers. At the street-level position, try kneeling or even lying down to shoot up at the approaching line of majorettes. The high position will give you an overall view of the parade and the

Hands reach toward a float at Mardis Gras, in New Orleans. At parades and festivals, look for ways to connect the attractions and the crowd.

Priit J. Vesilind

James P. Blair

street. If you can get a program, figure out ahead of time which group you will want a street-level close-up of and which might be appropriate for the high, wide-angle shot.

You can't do much about the light at a parade or festival—it happens when it happens. If it's sunny, estimate where the sun will be at the time you're shooting as you scout the locations. Remember that tall buildings will cast shadows on city streets fairly early in the day. Use a film that's fast enough to capture such actions as batons being hurled in the air.

If you are shooting a festival or a demonstration, be sure to get pictures that tell the story of what the event is about. Climb up high for a wide shot that shows how big the crowd is. Walk around in the crowd for candids. If it's a county fair, make pictures of the booths displaying their goods, the

Capture the spirit of the parade as well as the setting. Don't be afraid to step out of the crowd for a wide-angle shot. The frame above includes not only smiling faces and raised flags but also the band, the crowd, and the city street.

George F. Mobley

At children's sporting events, position yourself near where most of the action will happen. Use a 300mm lens to capture the action in the middle of the field and a fast shutter speed to freeze it.

livestock judging, and the baker of the best pie. If it's a rally, get photos of the speakers and people carrying placards.

Always look for isolated details that tell the story of the event—the child's hand holding the tiny flag at the parade, the spurs hanging on a peg at the rodeo, and so on.

Sports

Location is also of primary importance for baseball games and other sporting activities—you need to get a good view of the action. If it's a Little League or minor league game, or the local soccer league, you should be able to move around quite a bit. At major league games, unless you have a press pass, you'll pretty much be limited to your seat—but you can sneak down to the front once in a while.

Telephoto lenses are a must for sports—300mm is probably the most useful, though at times you will need longer ones. Use a tripod or monopod. At baseball games, find a location with a side-on view of the batter at the plate. Focus on him and

NGS Photographer Jodi Cobb

anticipate when the pitch will arrive to catch him in mid-swing. You'll need to make several frames because sometimes the pitcher throws balls. If it's a batter you think will likely get a hit, focus on first base and be ready for the action when he arrives. Use a fast shutter speed to freeze the action, but make sure you have enough depth of field so that both the runner and fielder are in focus.

Look for views into the dugout and go up into the bleachers for a shot of the whole stadium. And again, be on the lookout for the telling detail.

If you are shooting a soccer or hockey game, set up on the sidelines nearest to where your favorite player's position is. Make sure the tripod head is level so you can pan with the action. Small spirit levels that can be attached to tripod heads are very useful for quick setups. Have the camera set up high enough so you can pan and follow-focus easily and comfortably. Telephotos have very limited depths of field, and to freeze the action you will want fast shutter speeds of 1/500 or higher, and therefore large f-stops. Use a film that's fast enough to allow you a reasonable depth of field.

To capture baseball action at home plate or at one of the bases, a long lens is required. Frame the image beforehand, then anticipate the swing or slide.

Tip

Many night games are lit for television, so there will be plenty of light if you use a fairly fast film.

MICHAEL YAMASHITA
Capturing the Essence

Susan Welchman, NGS Staff

MIKE YAMASHITA does a great deal of homework before he starts shooting. "I'm paid to be lucky and that means making your own luck—getting yourself in the right position, in front of the right subject at the right time, and in the right light," he says.

"It's a matter of being there when something is happening. You scope out the possibilities in advance and you go back when there is some activity to photograph. You can't count on it every day—that's part of the luck aspect. But when the conditions are right, you work the subject as long as it takes to get that one great picture that begs to be published," he explains.

When teaching photography workshops, he finds that students are more inclined to trip the shutter once or twice and then move on to another subject. "Sometimes you do get the best picture in the first few minutes," he admits, "but I try to teach them a process of visual thinking." To illustrate that concept, he'll shoot 36 frames on a single subject— say a farmer doing his morning chores. As the group watches, Yamashita varies his position and keeps shooting as the situation develops. The next day, he'll show all of the slides in sequence.

"In the first few shots, I'm finding where to position myself in terms of the light, the right

A 16mm full-frame fish-eye lens produces some linear distortion, but Mike Yamashita (left) selected that lens in order to emphasize the roundness of this baseball stadium in

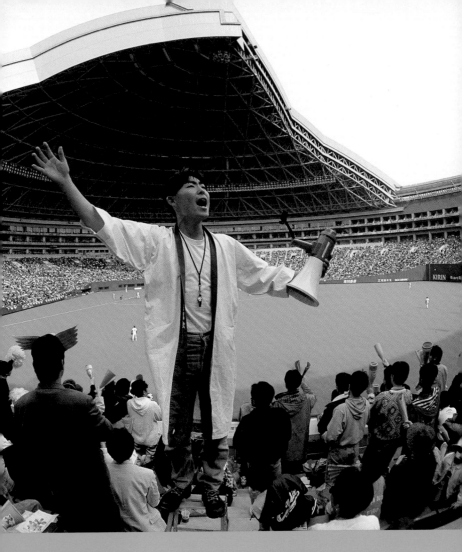

Japan. Although he photographed the cheerleader for some time, only this frame captured the peak moment he considered essential for telling the story.

background, the subject, and his motion. In this process, you're working toward something that's in your mind's eye. You have an idea of what you want from the elements you see; you're working to get all of them in the right place at the right moment," he explains. When reviewing his students' images after the first day of a workshop, Yamashita often finds nice beginnings, but encourages them to go deeper.

Yamashita was an amateur photographer during his early years, entirely self-taught. "I bought a

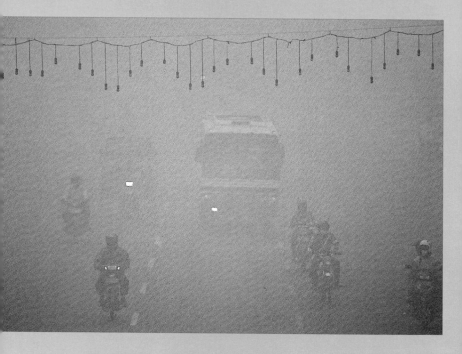

Toxic haze from fires obscures the sun at midday on the island of Sumatra—a scenario requiring some experimentation. "A wide-angle lens did not reproduce the 'feel' of this situation," Yamashita recalls, "while a very long telephoto compressed the haze to totally impenetrable." He made the image above using a telephoto zoom set somewhere between 135mm and 180mm.

camera to record the places I visited, without any plans for a career," he recalls, "but then I got more and more serious about photography." After two years of taking pictures, he began to get a steady stream of work from a small Tokyo magazine, *Far East Traveler,* which sent him to the Philippines, Singapore, and Thailand. Asia was the land of opportunity in the mid-seventies, he says, and he was lucky to be in the right place at the right time.

The formal gardens of Japan were the subject of one of Yamashita's most highly acclaimed NATIONAL GEOGRAPHIC stories (November 1989). His pictures were later exhibited at the National Gallery of Art and, with additional coverage, they formed the basis of a book, *In the Japanese Garden.* As a result of this success, Yamashita was asked to teach landscape photography workshops. "Once that story and book were published, I was perceived as this Zen landscape photographer, although people were an element in many of the pictures."

Yamashita appreciated the favorable response, but he prefers not to be pigeonholed. "Fortunately, after the Japanese gardens story was published, my next shoot was on the Mekong River, the lifeline of Indochina (February 1993)," he recalls. "It was kind of an adventure travel story, starting at the source and coming down to the mouth, and including everything from landmine victims to opium smokers to some very striking landscapes." Determined to remain versatile, he still works on a broad variety of projects from journalistic—such as fires in Indonesia (August 1998)—to economic stories such as the booming capitalism on China's Gold Coast (March 1997). "It's the variety that keeps me interested. And I try to reinvent myself every time there's a new story," he says with a smile.

His NATIONAL GEOGRAPHIC story of seasons in Vermont (September 1998) is impressionistic: a leaf in a pond, distorted by water; light playing on frost patterns; the reflection of trees in a brook; the rushing, lime-green motion of a boiling spring; and the flowing color of red sumac leaves whipped by the wind. It was a favorite assignment for Yamashita because he was given great freedom to be creative. "The story is about a sense of seasons; therefore it's basically about evoking a feeling. It really lent itself to abstracts, because it's not necessarily about a particular thing or place," he says.

Although he rarely misses a sunrise or sunset, Yamashita says he's not a stickler for a certain type of light. "Nor am I a blue sky photographer. In fact, I like working in the rain," he says. "In the soft, flat light the wet look makes colors pop and the overall feeling in the pictures is different. And in the subdued light, you don't have the problem of trying to hold detail in extreme highlights and shadows."

When shooting for magazines, Yamashita strives to make images that will be "page stoppers"—the arresting photographs that stop readers from page flipping and entice them to delve more deeply into the story. "It's all about high visual impact," he maintains. "In the end

you want great pictures to illustrate the story." Because magazines can print only a few images per story, he endeavors to include a great deal of information in each frame.

Since he shoots an average of 100 rolls a week— often without seeing the processed slides along the way—how does he know when he's producing excellent work? "If I shoot a hundred rolls, I have to assume my eye has seen good things and it's on the film, so I must be doing well. I get worried if I'm not sending in much film." When he returns, Yamashita finds that he's satisfied with many of the frames. "But the editing process is not only about the best photography," he explains. "It's about the pictures that will best illustrate the story."

Peter K. Burian

In Hokkaido, Japan, Yamashita made this image with a telephoto lens to define the subject on several levels: The woman's body language speaks to both age and optimism, the background depicts the traditional architecture of the region, and the snowflakes and her clothing confirm the harshness of the area's winters.

Yamashita's Photo Tips

■ Often, it's easiest to photograph people when they're not focused on you. I prefer not to control the situation. I'll hang around, get myself in position to take advantage of the best light, and then react to whatever happens, covering the event from a variety of angles.

■ The best landscape photographs include rich color, pattern, pleasing composition, line, texture, and perhaps movement. Ask yourself "What is it about this scene that gives it visual appeal?" and get

those elements on film.

■ When you find a great location with ideal light, wait for people to walk into the scene to add a human element. If you plan to shoot around sunrise or sunset, set up in advance to be prepared for something to happen.

■ If you're shooting toward the sun, try to include a strong visual element—something instantly recognizable to the viewer—in the foreground that will work well as a silhouette against the bright backlighting.

■ Take only those lenses you tend to use most often. I use two zooms for 90 percent of my work: a 17-35mm and a 70-200mm; I do have lenses as short as 14mm and as long as 800mm, but I leave them in the hotel or the car until needed.

■ Make photography a part of your lifestyle. Carry a camera with you and practice on friends or family. Develop your visual skills in familiar surroundings. Even at home, I'm constantly shooting—experimenting with lighting or new equipment.

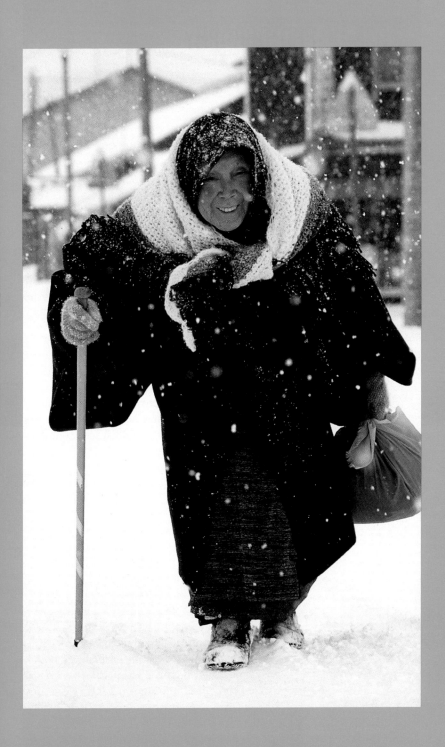

CLOSE-UP PHOTOGRAPHY

Close-up photography requires skill, patience, and the right equipment. This praying mantis was photographed using a macro lens, a tripod and cable release to eliminate camera shake, and a reflector to fill in and soften the shadows.

Peter K. Burian

A WHOLE new world awaits the photographer who is willing to ponder the tiny things in the world—flowers, the veins in a leaf, multicolored insects, the patterns of small objects arranged on a table. These photographs reveal a part of our environment that few people ever stop to really look at, and usually marvel at when shown.

Close-up photography calls for time and care. Don't expect to be able to do it quickly. Since many of the subjects are immobile, you'll have plenty of time to set things up just right and wait for or create the best light. For insects and other things that move, you have to be quick.

There are three different choices when it comes to making close-ups: macro lenses, extension tubes or bellows, and close-up lenses that screw onto the front of a lens like a filter.

Macro Lenses

Macros are the easiest and quickest to use of the close-up choices, but cost the most. They are essentially normal lenses that allow you to rack out the front element quite far from the film, and, since they are designed for close-ups, they offer the best image quality and transmit more light than the other options. You can simply use your meter as you normally would. The most popular focal lengths are 55 and 105mm, though some modern zooms can also focus close-up. I actually do not own a "normal" (50mm) lens, but carry a 55mm macro that I use as both a normal and a close-up lens—there is less to carry around, and the quality

Robert Caputo (both)

Depth of field is shallow in close-up photography. Both of these images were made with a 55mm macro lens—the one at left at f/5.6, the other at f/22 to maximize depth of field. Small apertures mean slow shutter speeds, so use a tripod and cable release, and watch out for breezes that could cause movement.

Tip

If you can't shoot your subject in the early or late sunlight, shoot it in open shade or make your own shade. A white sheet suspended on poles over your subject will cast an even, diffuse light. Experiment with fill-in flash and reflectors to lighten up shadows.

is high. If you plan to do a lot of close-up work, a macro lens is well worth the investment.

Bellows and Extension Tubes

Both of these pieces of equipment work in the same way by moving the lens away from the film and increasing magnification. They are a bit fiddly to work with but are inexpensive and will give you very good close-ups. The added distance between lens and film causes light loss, however, so metering can be a bit tricky. Once you have set up and focused, take a reading with your meter. If it is not registering because there is too little light, remove the extension and take a reading through the lens as you would normally. Then reattach the extension and open up the diaphragm

according to the instructions that came with your close-up equipment.

Supplementary Close-Up Lenses

These are the cheapest option and can provide quite good close-ups. They are simply magnifying elements that screw onto the front of the lens like a filter, and come in different powers. They can be used in combination to increase magnification, but remember that the more glass the light has to pass through, the less sharp the image. Try to shoot at f/8 or smaller when using screw-on magnifiers to keep the image as sharp as possible. A split-field filter, which is half magnifier and half normal, is useful if you want to shoot something extremely close-up in the foreground along with a normal background.

There are several things to keep in mind, whatever close-up system you are using: The closer the camera gets to the subject, the less depth of field you will have. Use as small an aperture as you can to give yourself maximum depth of field. If you can, arrange the subject so that all or most of it is parallel to the plane of the film and will therefore be in focus. If you are photographing a butterfly, for example, tilt the camera so that its wings are parallel to the film.

Any movement, either of the camera or the subject, is greatly magnified at extreme close-up, and can throw your subject out of focus. Use a tripod and cable release or the camera's self-timer if working at slow shutter speeds. Watch out for the wind. You may have to shelter your subject (and maybe the camera) by protecting it from even a very gentle breeze. In the field, you can often do this with a jacket or tarp. Early mornings not only offer great light for sidelighting flowers and other macro subjects but also tend to be windless.

Look for patterns to shoot at extreme close-up. The bark of a tree, moss on a rock, dew on a leaf— all these can make for beautiful abstract pictures.

Robert Caputo

Soft, diffuse light is often the best for close-up photography, especially of subjects with muted colors. When photographing plants, get out early to take advantage of frost or dew.

Tip

The image size changes as you focus, so be careful to keep the composition you want. Focus by moving the camera back and forth rather than by adjusting the lens.

MOTION—STOPPING IT, USING IT

A slow shutter speed enabled the photographer to add motion by blurring these rose petals dropping into a bag. Since the worker's hands were steady, they appear still. A slower shutter speed (longer exposure) must be compensated for by a higher f-stop (aperture). Experiment with different combinations of shutter speeds and f-stops to communicate motion, either by blurring or freezing the subject.

Robb Kendrick

A BASEBALL player frozen in midair as he dives for the ball, a streaking race car speeding past a blurry grandstand—action photographs are some of the most exciting and dynamic ones we make. But shooting action can be very demanding and calls for both thought and skill.

The first thing to determine is how you want to represent the action. In some cases you may want to freeze it so that every detail is sharp, and movement is implied by other elements of the picture: The ballplayer in midair is obviously in motion because he and the ball could not just be hanging there. But for other action pictures, you may want the blur of the background to convey the sense of speed: If you froze the race car with a fast shutter speed, the picture would look no different from one made when it was parked on the race track. Think about what kind of effect you want, then use one of the methods described below to achieve it.

Freezing the Action

The most important requirement for freezing action is a fast shutter speed, although just how fast depends on the subject as well as your angle to it: A person running does not require as fast a speed as a race car at full throttle, and the same car does not need as fast a shutter speed if it is moving toward (or away from) you as it does if you are shooting at right angles to its course. Lens choice also matters: The subject will move less within the frame of a wide-angle than it will in a telephoto, so you can use a slower shutter speed.

In many cases, you will want to use your fastest shutter speed. But you also have to think about

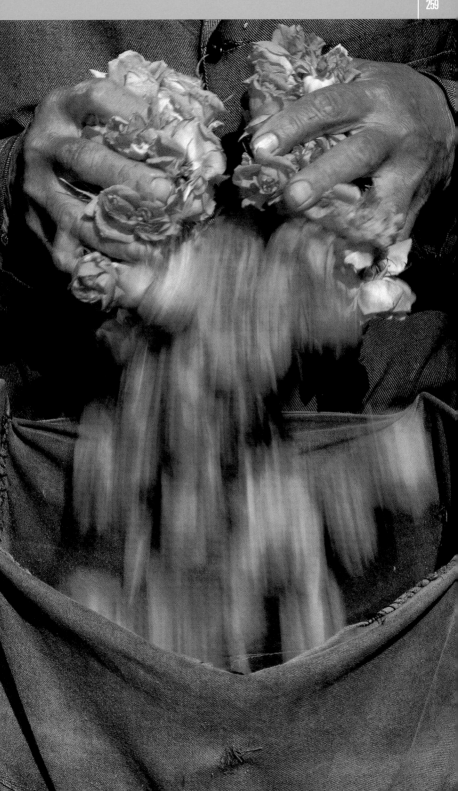

The light was fading by the time these monks began their dance at a festival in the Mustang region of Nepal. The image below is properly exposed, but dull. By using a slow shutter speed and adding fill-in flash, above, I was able to blur slightly to convey motion and bring out the bright colors of the monk's dress.

Robert Caputo (both)

depth of field. Since focusing on speeding subjects can be very tricky, you might want to find a combination of shutter speed and f-stop that both freezes the action and also allows some leeway in focusing. If you can't get the combination you need because there's not enough light, switch to a faster film. Or move around so that the subject is approaching you from an angle and can be frozen with a slightly slower shutter speed.

You may, however, want a very shallow depth of field so that the subject stands out from a very soft background. In that case, you want a wide f-stop. The best way to be reasonably sure of focus in this situation is to find a spot you know your subject will pass, and set up beforehand. Prefocus on that spot and wait for the subject to enter the frame.

Some autofocus cameras cannot react quickly to fast-moving subjects so you may have to switch off the autofocus feature. But some have "focus traps" that fire as soon as anything appears in a preset focal plane—very useful for action pictures.

Also, preset the exposure so that you don't have to wait for the meter to respond to the new element that has entered its view. You can do this either manually or, in auto modes, by slightly depressing the shutter button to activate the meter and keep it activated until you fire.

Freezing action with a flash works well in dim or dark situations, but remember that your camera has a maximum sync shutter speed—usually between 1/60 and 1/250 of a second.

Using Motion

You can use motion to create dynamic pictures either by panning with your subject or by blurring. For the former you try to keep the subject (or most of it) sharp while the background blurs. For the latter you let the movement of the subject create the blur within a still frame.

Panning

The purpose of panning is to have the camera and the subject move at the same speed relative to each other, so that the resulting image captures a sharp subject against a blur of background. It is more easily done in low-light situations. Your shutter speed and the speed of the panning motion both depend on the speed of the subject and your distance from it, but generally between 1/4 and 1/30 of a second is good panning shutter-speed range.

First find your location—a good view of a spot you know the subject will pass and the background you want. Set your shutter speed and aperture for the correct exposure. Raise the camera and frame the picture as you want it, focusing on something you know is close to where the subject will be. Then swivel from your hips back along the course the subject will take, either to your right or left.

Tip

If something is moving really fast, I find it helpful to keep one eye looking through the viewfinder and the other watching for the approaching subject. If you wait until you see the subject in the frame, you might end up with no more than the tail end—or nothing at all.

Tip

If you are freezing a subject such as a car that would look the same whether it was going 2 or 100 miles an hour, try to find other elements that get across the notion of speed—a big spray of water splashing up as the car crashes through a puddle, for example. Something in the frame should say "fast."

Tip

You can jerk the camera on purpose to increase the blurring. Since you never know exactly what you will get, though, make several frames.

Don't move your feet. Pick up the subject in the lens and follow it back toward your spot, pressing the shutter button as it enters the location. You should be able to feel this, too, because your body will be back to a comfortable position. Don't stop the motion when you have released the shutter—follow through.

Panning takes practice. If you are using an SLR camera, the viewfinder goes black when the film is being exposed. This is noticeable at slow shutter speeds, and can be disconcerting—it is hard to keep panning when you can't see the subject. The easiest way to practice is to stand by a city street and make panning shots of cars as they pass. Try different shutter speeds and compare the results.

Blurring

Motion itself is the subject in blurred photographs. The object you're shooting becomes an impressionistic blur that is sometimes barely recognizable.

Blurred photographs are achieved with slow shutter speeds—just how slow depends on how fast your subject is moving, but generally 1/8 or less. Just as with panning, you may need to use a slow film or neutral-density filter to get the desired shutter speed if you are shooting in bright light.

Stopping motion

This table gives some examples of the minimum shutter speeds necessary to freeze motion for different subjects at different angles to the camera. They are for a normal (50mm) lens at about 25 feet from the subject. If you halve the distance, you need to double the speed; if you double the distance, you can halve the speed. If you double the focal length of the lens (to 100mm), you should double the speed, and if you halve the focal length (to 28mm) you can halve the speed.

MPH	Motion	Direction of motion relative to camera		
		←→	✕	↕
5	Walking	1/250	1/125	1/60
10	Jogging, children playing, slow cars	1/500	1/250	1/125
20-30	Dancing, sports, city traffic, horses trotting	1/1000	1/500	1/250
40-60	Highway traffic, racehorses, speedboats	1/2000	1/1000	1/500

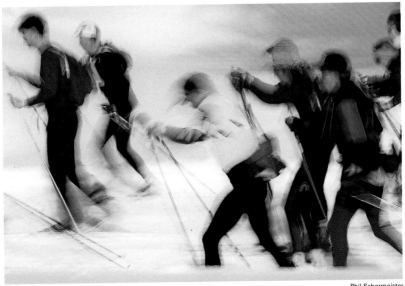

Phil Schermeister

Blurring with Flash

You can also create very dynamic pictures by combining panning or blurring with a flash. In this case, you are either following the subject or holding the camera still, using a slow shutter speed to create movement, and freezing the subject with a flash. Generally, this works best in dimly lit situations with shutter speeds of 1/15 or slower, depending on how much blur you want.

Take a meter reading of the scene as you normally would. Set the shutter speed at 1/15 (or slower if you want more blur) and select the appropriate f-stop. You may want to underexpose a little bit so that the subject stands out even more. If you are using an automatic camera, you may have to switch out of program mode if it will not sync with the flash at under 1/60. Choose manual or shutter priority mode instead.

You can practice blurring with flash around your home—children in-line skating, someone raking leaves at dusk, anything with movement in it. Experiment with shutter speeds of one second or even longer.

A pan-blur combination says "movement" in this impressionistic photograph of cross-country skiers.

DAVID ALAN HARVEY
Finding the Symbol

Kenneth Garrett

NATIONAL GEOGRAPHIC staffer David Alan Harvey has developed an ability to capture the heart and soul of a country on film. Combining honest reporting with a visually interpretive style, he depicts not only the characteristic places but also the timeless human moments and the passions of the people—a challenging task because of limitations in time and in the number of pictures that can be published.

His coverage of Barcelona (December 1998), the capital of Spain's Catalonia region, was completed in a mere four weeks. In 13 images, Harvey managed to represent the spirit of the Catalan people—both their professional, businesslike nature and their more flamboyant, or hedonistic, side. How does he approach such an assignment? "The trick, for any photographer, is to distill the information down to the symbols of what the story is about," he replies. "You can't catalog everything in an area so the icons become important."

This was especially true when Harvey was covering all of Spain for NATIONAL GEOGRAPHIC magazine (March 1978). While conducting research, he listed some key words: passion, Mediterranean, Catholicism, individualism, traditions, isolationism—concepts he would attempt to illustrate. He read in a Madrid newspaper about

Symbols of passion and independence, these fighting stallions were participants in a one-day roundup that David Alan Harvey (left) could not have predicted while doing his advance research for a story on Spain. Although he recommends homework and the value of being prepared, Harvey especially believes in the importance of putting oneself into situations where something unplanned but meaningful may occur.

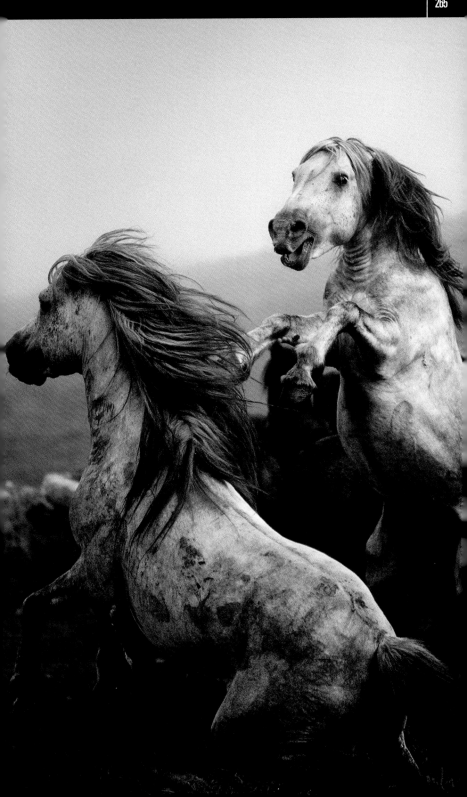

Deceptively simple, this picture made by Harvey in Old Havana, Cuba, employs direct contact with the subject and includes the visual texture of the location. "You can get so caught up with your style that you destroy the subject," he says. "I prefer journalistic integrity where style does not overwhelm content."

a roundup of wild horses that sounded interesting. A 13-hour drive later, he arrived in Galicia.

"The wranglers were throwing horses to the ground to trim their manes. This symbol of Spanish machismo was better than bullfighting, because it was not a cliché," he says. Another symbol— of Spain's military tradition in that era—shows a veteran's hand pointing at medals on his chest. The image did not include the usual weapons or troops.

Neither of these pictures was specifically planned, Harvey emphasizes. "You just do your homework and then try to put yourself in a situation where something may happen; you're not sure what will come out of it." Some luck is required, of course, plus a high comfort level with people. " If you're the kind of person who can slide into a situation and relate to what they're all about, they see that you're not nervous; they relax, and you get the pictures," he says.

Because Harvey often shoots in intimate or crowded locations, he favors compact photo equipment. He generally carries two Leica M6 rangefinders—sophisticated cameras, but lacking automation or a multitude of operating modes or controls. "I have no problem with technical advances," he maintains, "but only if they work for me." He finds he can shoot more quickly and effectively without high-tech SLR cameras loaded with artificial intelligence. "The brain is a pretty good computer," he says with a smile. "I don't have to worry about being in the right mode or which buttons to push and I know exactly what my flash [a basic Vivitar 2800] will do."

Harvey rarely finds a need for more than three lenses: 28mm f/2.8, 50mm f/1.4, and his primary workhorse, a 35mm f/1.4. "I've chosen a style that involves simplicity, direct contact with people, and the texture of the location; this doesn't call for long lenses." Even his stock car racing coverage (June 1998) was photographed with these focal lengths. "Everyone else had super telephotos, so I was a real freak, but I enjoy limiting myself to see what I can do, shooting an entire assignment with just the basic equipment."

To the uninitiated, his small beat-up cameras and lenses look like point-and-shoot equipment, a fact he considers advantageous. "I don't look like a professional and that gives me greater access. When sitting with a group on a porch, I can shoot with one hand while drinking coffee and they barely realize I'm working. I also like loose street photography. I try to be unobtrusive, scrunching down to reduce my physical size, getting in close to people. The Leica equipment is part of that technique."

Harvey was 12 when he first purchased a used Leica IIIF with money earned from a newspaper route. Even then, he was attracted by the life of a magazine photographer: the potential for travel, discovery, a personal education, and the possibility for artistic expression and communication. Over the following years, his style evolved. Naturally, he

experimented with different techniques, cameras, and lenses, but eventually he returned to his preferred shooting style—a style reminiscent of Henri Cartier-Bresson, who advocated a minimalist approach to equipment and believed in developing your eye to capture the decisive moment.

"I don't attack the subject, but my mind is always racing; I'm looking at the background, the subject, the light, and waiting for the situation to evolve." He agrees that his philosophy on serendipity and photo equipment differs from that of many of his contemporaries. "We have all kinds of photographers at the Geographic. It's like having different types of players on a football team; they—or we—all contribute to winning the game."

Peter K. Burian

Through the use of color, light, balance, and unity of design, Harvey was able to weave together several important symbols representative of Spain: tradition, family, and Catholicism. He believes that studying fine art is one way to develop a photographic vision.

Harvey's Photo Tips

■ Before visiting a foreign country, read up on the social protocols so you won't offend people. An appreciation for the history and the culture will help you respect traditions, blend in, and get up close.

■ Include people around architecture or in a landscape photo. A cathedral may be awe-inspiring, but the picture will gain interest, personality, depth, and a sense of scale if you include a human element.

■ Most photographers would benefit from personalizing their work: finding the element of a picture situation that they can relate to. It's easy to get caught up in the festivals and other exotic situations. But look for universal moments too—the relationships among people. Isolate a microcosm, a slice of life. Try to meet a family while traveling; get to know the people, and the pictures will come.

■ Look for symbols that are representative of the country's culture: the food, clothing, textiles, pottery, and other handicrafts. A market can be a very rich source.

■ Study the work of classical painters. Develop a sense of composition and an awareness for texture, light, color, balance, and design.

■ When the perfect picture situation happens, you may not have time to worry about perfect exposure and f-stop. Just take the picture. Don't be afraid to experiment—especially in dark locations where you cannot use a tripod or flash. Brace your elbows on a table, lean against a telephone pole, or rest the camera on a fence post or a Coke bottle.

EVENING AND NIGHT

Silhouettes are tricky. The combination of bright spots, like those in the sky and water in this photograph, and deep shadows (along the edges) can fool your meter, so bracket to be sure. Make sure your main subject is backed by a bright enough background to make it stand out, like this fisherman on the Orinoco River in Venezuela.

PHOTOGRAPHY literally means "light drawing." Twilight and nighttime offer some of the most wonderful light, both natural and man-made, with which to make your drawings: the glorious and varied clouds just after sunset, the pale glow of a winter's evening sky, the rides at the fairground, neon signs reflecting in a wet street. The best time of the day, photographically speaking, is the last hour of sunlight and the first hour of dusk. So don't pack up and go in when it starts to get dark.

Many of the frames you make at this time of day will be long exposures, so use a tripod and a cable release to avoid shaking the camera when it is set on bulb (B). You can use the camera's self-timer for anything above B. Be careful metering, because there are often sources of light in the frame that can fool the meter. It's best to bracket when doing night photography, just to be sure.

Sunsets and Silhouettes

Long lenses are usually best for sunsets because they give you a big solar disk. If possible, try to scout the location ahead of time—look for elements to silhouette against the sky and sun. Haze or clouds enhances sunsets by diffusing the light and making the sun itself soft enough to photograph, as well as giving dramatic color. If it's a clear day, the best shots may be of the sky just after the sun has set. Be careful metering the scene—look for mid-tones in the scene to meter, usually in the sky about 45 degrees away from the

Robert Caputo

sun. Sunsets can be very tricky for getting the correct exposure, so bracket up and down to be certain.

After sunset, you can meter the sky itself to get details of the colors and patterns in the clouds. Anything you have in the foreground will be silhouetted unless you open up to get some detail in it or use a flash to illuminate it. If you use a flash, you might want to set it to underexpose to soften the contrast a bit. The rich royal blue of a sky after sunset on a cloudless day, and the orange and pink sky after sunset on a cloudy one, make gorgeous backdrops for silhouettes of all sorts of things.

Cities and Towns

If you want to make a view of a city just after sunset, when there is still plenty of light to record detail at a slow shutter speed, find your location in the afternoon and wait for the light. Then watch how the light changes as the sky grows darker and the lights in the buildings become more and more visible. Keep shooting. There's a moment when the

Tip

Get out on the streets at dusk after it has rained. The streetlights, neon signs, store windows, and car lights reflected in the glistening street make beautiful pictures. Try long exposures with a tripod if the frame includes cars on the streets.

sky and the city lights are evenly balanced, and you can get detail in both. Try long exposures that allow the cars in the streets to pass all the way through the frame and you'll get rivers of white and red lights weaving through the city.

Be careful metering if there are light sources in the frame, since these will tend to make the meter underexpose. Bracket to be sure.

Monuments and Statues

Many monuments, statues, and buildings are lit at night, and you can use these lights to get effective photographs. The floodlights are often warmer than daylight, but this usually doesn't matter—the photograph will still be very pleasing. If accurate color is important, use tungsten film or a Blue 80A filter for daylight film. If the lights are sodium or mercury vapor, they will cast a yellow or green tint on daylight film. While you can use a magenta filter (for daylight film) or an orange filter (for tungsten) to correct most fluorescent lights, the casts of these two are almost impossible to get rid

Try sunset pictures with and without the sun. A dusty sky softened the setting sun enough to include it behind the ostriches in Namibia (below, right). On a clear day, I waited for the too-bright sun to drop below the horizon before making a silhouette of children in a Kenyan village. Both were made with a 600mm lens.

Robert Caputo (all)

Try shooting monuments at dusk, when their lights are on but there is still color in the sky. Use a tripod and cable release to prevent camera shake at slow shutter speeds. Both pictures were taken from the same spot using an 80-200mm zoom lens. Daylight film lends an interesting reddish cast to Lincoln's statue.

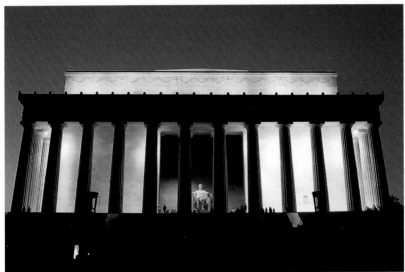

of. The best thing to do is find a way to use the color as part of the picture.

As you would with city shots, look for that time in the evening when the light in the sky is in balance with the light on the building.

Fairs and Fireworks

Fairs are often brightly lit, and you can make hand-held shots with a fast film. Use fill-in flash for candids and make some stop-motion pictures using your flash, as described in the motion section: If your child is riding the merry-go-round, try to get a motion-frozen-with-flash picture of her reaching for the brass ring. But take your tripod too. Make long exposures of the rides going around and let their lights paint patterns onto the film.

Fireworks require a tripod because the

Tip

When metering a building or monument, consider its color. If it is white, as many buildings are, your meter can be fooled and will underexpose.

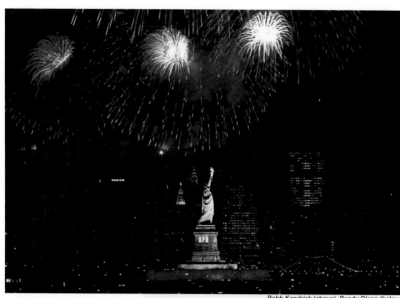

Robb Kendrick (above) Randy Olson (below)

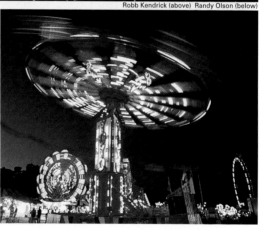

Use a tripod and cable release when photographing moving lights like the fireworks (above) or rides at a fairground. A long shutter speed will allow the lights to blur, while the steady camera will keep objects such as the Statue of Liberty or the pillar beneath the whirling ride sharp.

exposures are usually long. Get to the location early to get a good vantage point and set up. If the fireworks are in a public park with a floodlit statue or monument, you may want to make some frames that include it to give your photos a sense of place.

Use the first few rounds of fireworks to look through the viewfinder and get the frame you want, then lock down the tripod head. Single bursts can be recorded at 1/30 of a second using

fast film, but if you want several bursts in the same frame, you will want to leave the shutter open from 10 to 30 seconds or so—you don't want to leave it open too long since succeeding bursts may obscure each other. As a rule of thumb, expose slow film at f/8, 125-200 ISO film at f/11, and 400 ISO film at f/16. Block the front of the lens with your hand or a hat between bursts, but be sure not to touch the camera. If the fireworks are spread out over a lot of the sky, try a wide shot.

Dean Conger

Shooting campfires at dusk with a fast film allows the fire to really pop out and picks up detail in subjects sitting reasonably close. Use daylight film for a pleasing yellow-orange tint, and bracket.

Campfires

Fires give off light that is even warmer than tungsten, but this is not a problem since we are used to perceiving them as orange or yellow. You can safely use daylight film when photographing them. The main problem is the low level of the light. If you are photographing a group of campers around a campfire, try to make the pictures at dusk when there is still a bit of ambient light or get them as near to the frame as possible. Be sure to meter off their faces—don't include the fire, or the meter will want to underexpose by quite a lot. It doesn't matter if the flames themselves are overexposed.

Recommended Exposures For Low Light

Subject	Film Speed					
	ISO 50-100		ISO 125-200		ISO 250-400	
City streets	1/30	f/2	1/30	f/2.8	1/30	f/4
Subjects lit by firelight	1/8	f/2	1/15	f/2	1/15	f/2.8
Floodlit buildings, statues, etc.	1/2	f/2.8	1/2	f/4	1/2	f/5.6
Fairs, amusement parks	1/8	f/2.8	1/15	f/2.8	1/30	f/2.8
City skylines—at dusk	1/60	f/2.8	1/60	f/4	1/60	f/5.6
City skylines—at night	2 sec.	f/2	2 sec.	f2.8	1 sec.	f/2.8
Full moonlit landscapes	4 min.	f/4	2 min.	f/4	30 sec.	f/2.8
	(If scene is of sand or snow, cut exposure time in half)					

Lightning streaks paint the film while the shutter remains open on bulb. Use a tripod and cable release, and try several different apertures.

Bruce Dale

Lightning

To photograph lightning at night, set the camera up on a tripod and point it at an area of the sky where lightning has been flashing. Focus on infinity and set the camera to bulb (B), with an f-stop of 5.6 for slow film and 8 or 11 for ISO 100 or 200 film. Leave the shutter open for several lightning flashes and then close it. If there is a lot of ambient light in the sky because it is still twilight or because you are near a city, you will need to limit the exposure to between 5 and 20 seconds, depending on how much other light there is in the sky. Experiment.

Star Trails

Recording the paths of stars across the sky requires very long exposures—anywhere from 15 minutes to several hours, depending on how much of their arcs you want to include in the image. Photographs of star trails are best made on clear, moonless nights away from city or other lights, Use fast film and have your lens wide open. For circular paths, point the camera at the North Star. Try including a dimly lit building to give the night sky an Earth-related context.

The Moon

The best time to make shots that include the moon is the first couple of nights of a full moon, just as it rises and is big but not too bright. You will need to use a telephoto lens if you want the moon to be more than a tiny white spot in the sky. If you want to take shots of the moon's surface, you'll need a very long telephoto lens, or you can try using a telescope, most of which have camera adapters. If you are shooting the moon itself or silhouetting something against it, remember to open up a stop or two to avoid underexposure and ensure that the moon will be white.

Tip

If you are making landscape pictures in moonlight, you will need exposures of several minutes. Don't include the moon itself because it will burn out and move, giving you a white streak in the sky.

The serene mood of this hill town is enhanced by the soft cool light of evening and the glowing white buildings. A long exposure is required for shots like this, but not too long—the moon moves more quickly than we perceive and would blur at shutter speeds longer than 1/4 of a second.

James L. Stanfield

WILLIAM ALBERT ALLARD
The Cultural Essay

Ani Allard

WORKING NUMEROUS 16-hour days, often 7 days a week, Bill Allard shoots close to a thousand rolls of film on a three-month assignment. Aside from the sheer number of hours he's shooting, there's another reason for the high volume of film: the lack of control over many situations that include people. "I'm at the mercy of whatever clothing the person happened to put on and whatever light is available at that moment," he says. And the frequently marginal light calls for very long shutter speeds with moving people, an added difficulty when using the camera handheld. When "working on the edge" he produces some unusable frames and a few exceptional images. Even in less difficult conditions, he does not skimp on film. He'll use the camera as a sketch pad to explore and fragment a situation. He also believes in serendipity rather than a highly methodical, preplanned approach.

"I don't expect every frame to be brilliant," he says. "And I don't feel guilty about the amount of film when the failures are promising or interesting—when the picture almost made it." Amateurs sometimes say, "If I shot 900 rolls, I could get some great things too." Allard agrees that a competent shooter would produce many usable frames, but his goal is to make some "really special pictures."

A wide-angle image from Bill Allard's cultural essays of the West, this is a "clean" picture— it includes only the subject and its supporting elements. Although Allard (left) often

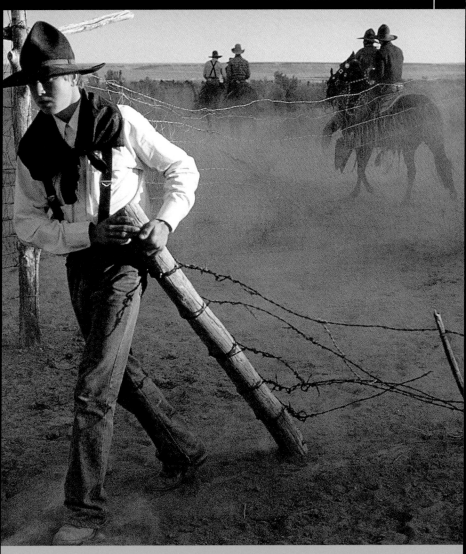

does not have time to consciously plan the composition when a subject is in motion, his well-designed photographs are the result of a skill that has become intuitive.

How does he define such images? "They are the pictures that ask questions and maybe there isn't an answer; or the pictures where you can go back later and see something you hadn't noticed before."

Allard was once categorized as a specialist in the American West. Although born and raised in Minnesota and now living in Virginia, many of his early NATIONAL GEOGRAPHIC magazine assignments, such as stories on cowboys and Chief Joseph of the Nez Perce, branded him as a Western photographer. Reinforced by his successful 1982

Using fill-in flash in a subtle, almost imperceptible way, Allard retained the atmosphere of this candlelit Easter parade in Peru. He did it by mixing just a hint of flash—bounced off a reflector attached to his flash unit—with the ambient candlelight.

book on cowboys, *Vanishing Breed*, the Western photographer reputation still follows him.

Allard admits he's had a love affair with the West since 1966—with its physical geography and its way of life: the independence, the openness, the value system, and the simple pleasures of work. The lure of the West and its people enticed him to return again and again to ride with the cowboys. "I might have made better pictures as an observer, but that's not the way I work; I need to participate," he says. He actively sought stories out West, and many major assignments continued to fuel that passion. In 1979, however, he realized it was time for a change. "By that time I didn't want to be thought of as a cowboy photographer."

Allard is a master of the photographic essay on people and their culture. He began to develop this skill while doing picture stories in college— experience that would serve him well on his first GEOGRAPHIC magazine assignment. While a summer intern fresh out of the journalism program at the University of Minnesota in 1964, he was sent

to photograph a Pennsylvania Dutch festival. He was asked to take a few pictures of the Amish as well, if possible. "These are people who live in a closed society," he explains. "They don't want to be photographed, and they're not interested in the curiosity of the outside world."

Instead of going though formal channels, Allard asked around town and finally met a young man whose father owned a stone quarry that dealt with the Amish. Through this contact, he met an Amish man who agreed to be photographed, and this led to the cooperation of several other families. His strategy did not involve high-powered salesmanship. He explained what he wanted to do: to show a way of life that others do not understand. "It was a very simple, direct approach; I also promised to do the most honest work I could," he says.

Acknowledging that most photographers find it difficult to photograph people, Allard offers some advice: "There's a high rejection rate, especially in street photography, and you need to be prepared for that. Try to be aware of your subject; you don't need a Ph.D. to see whether someone resents your taking pictures. If they do, then you back off."

Allard's finest images exhibit a very striking design with strong composition: color contrasts, a sensitivity for dramatic light, deep shadows with symbolic importance, and an intensity of emotion or a subtle nuance of gesture. But he's not willing to rest on his laurels. "I want to get better in the way I see and the pictures I produce," he says. "When I reach a plateau, I'll bump the bar up a notch or two; it may take a year or more to get there, but I'm always trying to grow."

"I love this work—making pictures and exploring with a camera—probably more today than ever. I try very hard to get assignments that I really care about; otherwise it would be just a job." Allard agrees that his life has not been "normal," but that's offset by the people he's met while in the field. Is it painful to leave them after three or four months? "Well, I have maintained some friendships for 30

years, but yes, eventually you have to get on a plane knowing you'll never see most of them again. There is a sadness to that, but there's a beauty too: How fortunate I was to have experienced those people, to have had them as part of my life, even for a bit of time."

Allard does not use a great deal of equipment for his people photography: a 28mm and 35mm moderate wide-angle, plus a 50mm and 90mm lens—often on Leica M6 rangefinder cameras. "Every single frame of my recent story on black

This photograph for a story on William Faulkner's Mississippi required precise framing and camera positioning to take advantage of the light of a single lightbulb hanging from the

blues music was made with a rangefinder, without any automation," he says. He does use fill-in flash frequently, to add just a hint of extra light without changing the atmosphere. He'll do so in a fully manual mode with the Leicas, but with his newer Canon EOS system he takes advantage of TTL flash metering to reduce flash output so it's almost imperceptible to the viewer.

Peter K. Burian

Allard's Photo Tips

■ There's no secret to people photography except intimacy. You can't establish rapport if you're hiding behind a tree and shooting with a long lens. Robert Capa talked about making stronger pictures by getting closer in a physical way, but it's very valid psychologically too. You have to project that you're trustworthy—in words, mannerisms, and voice.

■ The rules of composition are important, but the idea is to learn them and then break them. You can't divide a picture in the middle? You can do anything if it works. Composition should become intuitive; I now see mostly in terms of color, form, light, and shadow.

■ When you photograph, you're putting together a puzzle and there are an infinite number of ways to do that. Ultra-wide-angle lenses can be difficult to use well because they add more pieces. You think you're getting everything in the frame, but is it all tied together? Does the primary subject relate to all the pieces around it? Is there a sense of balance and grace?

■ Explore with the camera from various angles. The difference between a nice picture and a really fine one is often a matter of inches—of bending your knees a bit or shifting to the right or left. Move your vision six inches and you can make a tremendous change.

ceiling. Moving inches at a time, Allard was able to pre-visualize, and then make, this powerful image symbolizing hunting and violence—both significant themes in Faulkner's work.

MAKING PHOTOGRAPHS

by Robert Caputo

Adventure photo-
graphs should
communicate both
the thrill and a sense
of the environment.
In this photograph of
a mountaineer, the
inclusion of the rock
wall shows just how
hard it is to scale, and
the lower left part of
the frame gives an
idea of how high the
climber is (and the
photographer, too).

Gordon Wiltsie

UP IN THE SKY, under the oceans, atop
snow-covered mountains, in the heart of
searing deserts—we carry cameras into
any environment the world has to offer.
Each one presents its own challenges and
rewards. Some are dangerous and require
a lot of thought and preparation to ensure
that you get into and out of them safely.
Many are physically grueling, others
require great patience. If you are going
into an unusual environment, take care
of the logistic and survival elements first.
You want to be able to concentrate on
the photographs once you're there, not
worry about staying alive.

Whatever environment you are
photographing, apply the same technical
and aesthetic principles you would to
making photographs near home—think
about light, composition, and just what
it is you want to say about this particular
place. Remember that you always want
to do more than just get a picture of
something—you want to communicate
something about it.

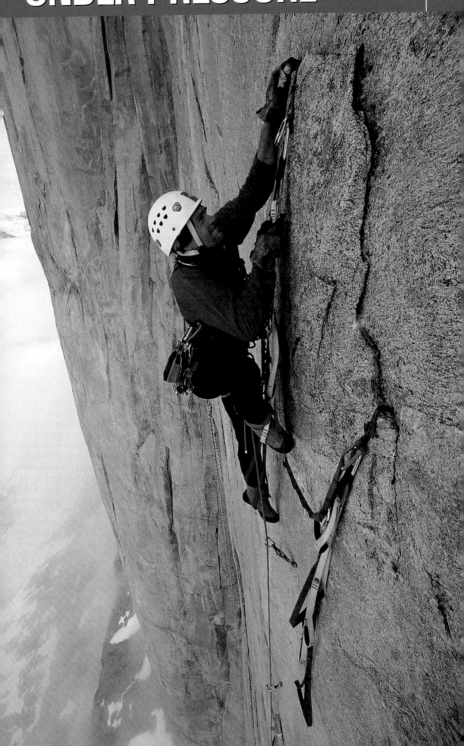

UNDERWATER

Half in, half out: When the water is shallow, as it is in this lagoon off the Polynesian island of Tubuai, enough sunlight penetrates the water to allow a proper exposure both above and below. If your subject is in deeper water, try using a filter that is one-half neutral density to equalize the exposure above and below.

Tip

Water and cameras don't mix, and salt is extremely corrosive. After each dive, soak your amphibious camera or underwater housing in fresh water and then hose it off with more. Let it air dry.

UNDERWATER PHOTOGRAPHY is logistically challenging. Special equipment is needed, and you can work only for a limited amount of time each day. But the rewards are great. Underwater photographers reveal a part of the world most of us never get to see, and they do it with the same application of composition and light as photographers on solid ground. If you think you would like to make pictures underwater, here are the basics.

There are inexpensive underwater cameras that you can use in depths of 15 feet or so. Many of these are single-use cameras intended for use by vacationers in the surf and on shallow reefs.

The Nikonos, with a range of interchangeable lenses and off-camera strobes, is a true underwater camera system good to about 300 feet. Another camera, made by Sea & Sea, has supplementary wide and close-up lenses. It's good to about 150 feet. Most professional underwater photographers, however, use regular SLR cameras with image-enlarging sports finders in underwater housings.

When photographing underwater, try to work at midday when the sunlight is strongest. You'll lose about one f-stop for every ten feet of depth, so you may need to use a fast film of ISO 200 or so. To minimize light loss, try to shoot from within ten feet of your subject.

Not only does the intensity of the light change as you descend—the color does too. As light is filtered by water, the red end of the spectrum goes first and the scene becomes increasingly blue.

In dark, blue-filtered water, capturing the colors of deep-sea animals requires the use of strobes. Underwater, on-camera strobes produce images

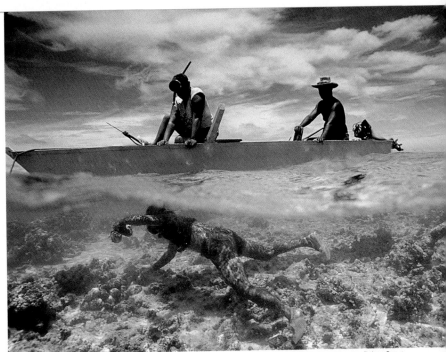

Robert Caputo

that are flat and harsh, just as they do on land. It helps to use strobes on flexible arms off to the side. The best way to master the art of bringing light into the sea is to practice in the relative safety of a swimming pool.

Refraction of light underwater makes things seem closer than they really are. If you are focusing through the viewfinder of an SLR camera, this poses no problem, but if you are not looking through the viewfinder, focus for the apparent distance, which is 25 percent closer than the real one. This will also affect how you should set your strobes. Refraction also limits the angle of view of lenses underwater, making a 35mm lens about the same as a 50mm lens on land.

Finally, because people tend to float in the ocean, most underwater photographs look like aerials. Dive down and get close to the creatures. You will be rewarded for the effort with close-up views of animals and colors that few people will ever have the privilege of seeing.

Tip

Water absorbs a lot of light, and many of the creatures in the sea are the size of your hand or smaller. You always want to be as close to your subject as possible—that's why underwater photographers often work with macro or telemacro lenses. As David Doubilet says, "Get as close as you can, and then get closer."

DAVID DOUBILET
Visual Impact Underwater

Courtesy David Doubilet

"THE GREAT WHITE kept getting closer, sensed my nervousness, and came after me. I pushed it back with the camera, but it kept coming very aggressively. Then I realized I couldn't swim to the cage, because I had no fins. I began to retreat in a nightmare-like slow motion." David Doubilet made it just in time, and slammed the door just as the shark crashed into the cage.

This was one of his several shark encounters, and there have been other close calls. But it is the logistics of working with camera equipment underwater that consumes much of his energy. "The time and effort are compounded by water and the burden of the diving gear. A mountain of equipment has to be moved daily from the hotel to the boat and back again at night unless you're working from a boat," he explains. And in the evening, at least two hours of maintenance and testing are required. "All the equipment wants to break; water wants to come in, air wants to come out, seals leak, and strobes malfunction."

On some assignments, he'll take as many as ten cameras, with lenses from ultrawide to telemacro, in Aquatica or Nexus housings. "You cannot change lenses or film underwater and everything has to be lit; that's why I need at least six cameras and twelve strobes, plus an assistant."

Close calls are a fact of life for David Doubilet (left and above), who rarely stays inside a shark cage except for certain types of high-risk photographs. Because of the

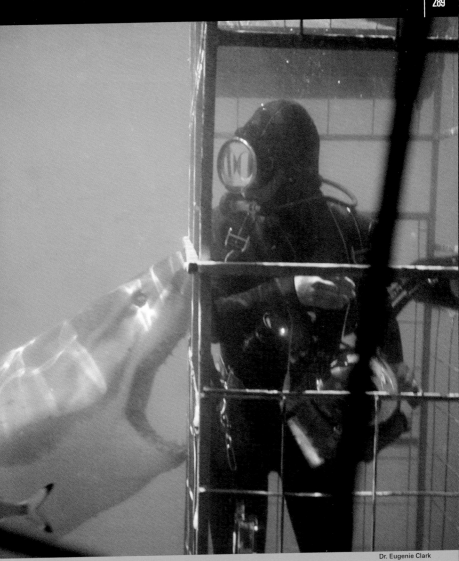

Dr. Eugenie Clark

possibility of malfunction or leaks from the increased pressure underwater, his more constant concern is taking huge amounts of camera equipment below the surface.

As a boy growing up in New York, Doubilet discovered the sea along the New Jersey shore and snorkeling became his great escape. "Whenever I put my head below the surface, civilization vanished: the crowds, my parents, most of the noise, my difficulties at school, and even my childhood asthma," he recalls. After being captivated by the movie *The Silent World* at age 11, Doubilet met Jacques Cousteau and blurted out: "I want to take pictures underwater." The great captain loomed over him and, with a shrug, replied, "Why not?"

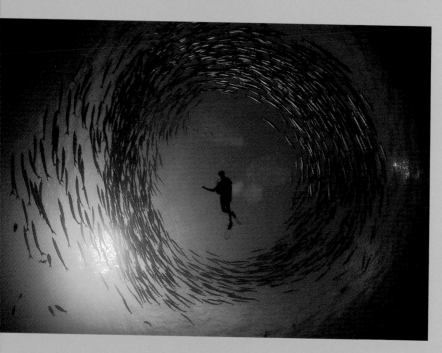

Working in the South Pacific, Doubilet made this image of barracuda slowly rotating around a diver. Shooting from below and into the sun, he used a 16mm full-frame fish-eye lens and two off-camera flash units. Seeing and photographing this rare behavior was memorable for David. "It was one of my most wonderful moments in the ocean."

Doubilet has completed 50 assignments for NATIONAL GEOGRAPHIC, in addition to those for other clients. His images stand out because of their powerful aesthetic qualities: effective composition, an appealing interplay of light and shadow, vibrant color, and meaningful subject behavior.

Consistently making photographs with high visual impact can be difficult on land, but the challenges are multiplied when working at depths up to 200 feet. But David Doubilet decided long ago that an underwater photograph deserves the same treatment as one made on land. "There's no difference in philosophy," he maintains. "You have to apply the same imagination and skill to the underwater subject as you do to the surface subject."

The underwater environment is often dark, cold, and full of potential peril. Both photographer and subject are moving or drifting, precluding the use of a tripod or light stands. Compounding these problems, fish simply do not want to be photographed. "You need to be a hunter—first finding

the subject and then stalking it, trying to get in front of the fish for a picture with eye contact," Doubilet says. In spite of these difficulties, he is determined to produce images that work and will leave a lasting impression on the viewer.

How does he define such photographs? "A good underwater picture has wonderful intense behavior, the quality of serious light, and the mood of the place, as well as a vibrational field of color with color film, or the effective use of light and shadow in black and white."

The single greatest obstacle in underwater photography is a lack of time. "A land-based photographer potentially has 24 hours a day to shoot, but if I get 2 hours a day, I'm lucky. At 150 feet, you can work approximately 20 minutes a day and it's so dark you can't see well." Still, Doubilet works every subject relentlessly. "I may shoot 50 rolls in a week, and get one extraordinary roll."

Doubilet emphasizes the importance of developing an understanding of electronic flash. Even today, he uses strictly manual flash units without any automation. The manual alternative is not really complicated when the technique is developed through experience. "When shooting a diver four feet away with ISO 100 film, you should know that your exposure with strobe is at f/11; for a fish three feet away, it's f/16 with the shutter speed set to meet the natural light on the background. And there are 36 frames, so you can bracket too. Practice in a swimming pool," he recommends.

Doubilet's career at NATIONAL GEOGRAPHIC was helped by two developments during the 1970s. "The magazine increased its coverage of the oceans as the technical ability to make pictures underwater increased," he recalls. And editors began to appreciate the value of photographers who specialized in marine subjects. From the beginning, he has found the magazine to be "a very mature place to work because photographers can propose stories and shoot them with a great deal of freedom; then they have a voice in the selection of images

and in the layout, all very rare at other publications."

He believes that photography will always have a lot to say. "We remember still pictures, no matter how many television documentaries we watch. This is not only true for our generation, it's as old as time, because that's the way our brains work."

In spite of the challenges, the ocean draws Doubilet back again and again. "Even after decades of exploration, this is a completely new world, and it contains creatures that are beyond our dreams. As we bring light into it, the ocean holds the potential for extraordinary images. And that's what I want to continue doing as long as I can: to look, see, and produce the pictures that will come out of this world."

Peter K. Burian

Doubilet strives to make dramatic photographs with vibrant color and beautiful illumination, usually enhanced with electronic flash. For the Tasmanian saw shark (opposite) he used manual non-TTL flash, setting the right aperture based on subject distance and experience.

Doubilet's Photo Tips

■ First, become an accomplished diver—not just competent, but relaxed enough to start shooting. Don't take a camera in your first year. Then, begin with black and white, to learn the concepts of composition and light; study the work of the masters of art and photography.

■ Learn some marine biology; crack a few books so you'll know the sea, what you are seeing, what you want to shoot, and how to find a fish.

■ Develop an ability to see light, to make light, to make light

work for you; shoot with different ratios, different shapes of light in close-up photography. Don't shoot like the paparazzi with a harsh, direct burst of on-camera light; use long flash arms and adjust them to the right position for the most pleasing effects.

■ Work with a buddy who can help find a great subject. After taking a few pictures, wait for the situation to change in order to get a better picture.

■ Think about the film you'll be using. For example, Kodachrome 200 is marvelous for greeny blue water

with lower visibility. For a medium-speed situation such as dolphins, you may want to use Fujichrome Provia 100. And for reef creatures with astounding color, Fujichrome Velvia may be ideal for intense colors and rich, black shadows.

■ With black-and-white film, everything needs to be filtered. Light yellow is the base, but for shooting toward the light, you'll need a red filter. Because that reduces light transmission, you may need to use faster film such as Kodak T-Max 400 or T400CN.

ANIMALS

Look for pictures that capture a wild animal's environment, like this photograph of a lion cub in tall grass (opposite). In East African parks, where the animals are used to vehicles, a 300mm lens is long enough for most wildlife.

Because a flash would have overpowered the warm glow of Christmas lights, the photographer used a fast film instead to capture his pet's endearing pose.

Stephen G. St. John, NGS Staff

PHOTOGRAPHING animals, be it your pet dog or a lion in the wild, calls for time, patience, and sensitivity. You should treat making images of animals the same way you would those of people: Think about their character and then try to get it on film. But of course you can't ask animals to smile, hold still, or walk over into the good light. You have to wait for, and learn to anticipate, their behavior. The first thing to determine is what you want to convey about the animal you are photographing—is it the spunkiness of your new puppy, the nobility of a full-maned male lion, or the tenderness of a monkey with her baby? Whatever that quality is, look for compositions, lighting, and angles that emphasize it, and be willing to invest the time to wait for those elements to come together.

Pets

Some of your best shots of pets will be from their level, which often means lying on the floor or the ground. It's the only way to get their expressions, and it conveys something of what the world is like at their level. And get close. A puppy eating out of its dish won't be distracted by you lying right next to him with a wide-angle lens.

If it's a pet of your own, you probably know its personality pretty well and can anticipate how it will act in different situations. Does your cat usually curl up in a particular place? Does your dog get the leash when it's time for a walk, or sleep at the foot of your daughter's bed? Once you have decided where and when you want to photograph

Robert Caputo

your pet, think about the lighting and where you should be when the anticipated behavior happens: Maybe the cat sleeps on a cushion next to the fire-place—you can use a high-speed film, fairly low shutter speed, and fill-in flash to capture the sleeping feline and the flames of the fire. For the dog at the foot of the bed, you might want to bounce a strobe off the ceiling.

Look for moments when the pet has the expression or posture you think is typical of it—Rover scratching at the door, your cat staring out the window. This is the way you will remember your pet, and your photographs should reflect it.

Outdoors you might want to capture your pet's behavior—the cat stalking a squirrel, your dog catching a Frisbee. Use the tips from the motion chapter if you want to freeze the cat in mid-pounce or the dog in mid-leap.

Make portraits as well as behavioral pictures, and don't forget to make some that reflect the pet's relationship with different members of the family—pictures that will bring back fond memories.

Tip

If your dog or cat is black, and is filling most of the frame, your meter will want to overexpose; if your pet is white, it will underexpose. Take a reading off something in the scene that is the same as neutral gray.

Joseph H. Bailey

The patience of a mom: Pets have moods and feelings, too, so look for ways to capture them on film. The blue cloth adds a needed touch of color and interest to the scene of brown dogs and a brown wall.

Backyards

You don't have to travel to the ends of the Earth to get interesting natural history shots—a whole world awaits you right in your own backyard.

Flowers, and the insects that visit them, make great subjects for macro photography, as do ferns, berry-producing bushes, and almost anything else that grows in your garden. To capture insects on film, you will need fast shutter speeds, so try to shoot them in strong sunlight early or late in the day when it is at a low angle and warmest. Many insects, such as praying mantises, are quite approachable, and you should have no difficulty getting near them with a macro lens.

Wildlife, in the form of squirrels, raccoons, rabbits, or birds can also be photographed in many backyards. With observation, the behavior of many animals is somewhat predictable—certain flowers will attract hummingbirds, squirrels may like to bury acorns in a particular part of your yard, rabbits may be very fond of the lettuce you've planted.

Set up with a telephoto lens in a good position and wait for the subject to arrive. In the case of shy animals, you may have to build a small blind—a poncho suspended from a couple of poles will do. Use the poncho's head hole for the lens. Try to set up your camera as low as possible; shots at an animal's eye level are more engaging than those looking down on it. Since most of the animals are rather skittish, you will want to use a fast shutter speed, and may need to use a high ISO film if you are not shooting in full sunlight. Use a motor drive if you have one—you'll probably have to shoot a lot of frames, especially of action, to get one that is just right. Try to get as close to the subjects as you can without spooking them. Getting tight shots of wild animals is one of the most challenging and fun parts of natural history photography.

You might also want to put up a nesting box in a location where you can photograph it from a window or blind. Be sure it is close enough to the house for you to get good shots of the nestlings in the spring.

Tip

To photograph birds, put a feeder near a window, preferably close to a tree or bush that offers a natural perch and background for your pictures. Open the window enough for the front of your lens and pull the shade down so the birds don't see you moving around inside the house.

Both of these images were made from a tent blind the photographer erected and then left vacant for two weeks so the animals would get used to it. By crawling in early in the morning, and remaining very still, he was able to observe and photograph the animals at close range.

NGS Photographer Chris Johns (both)

Be patient. Making pictures of wild animals takes a lot of time. You may get set up in a perfect situation and find that no animals show up. Or they do, and the light goes bad. Or your dog runs up and scares them away. It's not so bad to spend a nice day out in your yard, however, and when you do get the shots, you will be amply rewarded.

Zoos

There are two ways to approach making photographs of animals in zoos: portraits or other fairly tight shots of the animals, and environmental portraits that show the pens within which the animals are confined. If you are after the first, try to get as tight a shot as you can—omit the background, since it is not a native habitat for the animal. If what you want to say is "zoo," though, find a composition that shows one or more of the boundaries of the animal's area, and how the animal relates to it. There are all sorts of zoos, of course, from those with small barred cages to those with large mock habitats. Figure out what you want to communicate about the zoo you are working in—if you think the area allotted to a certain animal is too restrictive, show that; if you think it is fine, then let the photograph convey that feeling.

Scout first: Visit the zoo beforehand to observe the animals you want to photograph. Find out when they are likely to be active or in a certain part of their pen. Return at that time with your camera.

If you are shooting portraits, use a long telephoto like a 300mm or a shorter one with a teleconverter. Most zoos don't have restrictions on photography, so you will probably be able to use a tripod. You lose quite a bit of light with a teleconverter, so you may need faster film.

Exposures can be tricky—polar bears and black bears will fool your meter in opposite directions. Think about the tonal quality of your subject, and, to be certain, take a reading from a neutral object in the scene or off a gray card.

Tip

Just as with any other wildlife photography, patience is key. Set up and wait. Animals in zoos tend to lie around a lot, and you want to be ready for those brief moments when they are active. Behavioral shots will be hard to come by, so look for animals with babies and photograph them playing with each other or with mom.

Take a long lens to the zoo, select your subject, get set up, and then wait for the action. You will be rewarded with beautiful portraits like this one, taken when the keeper sprayed the parrot with water (left). Zoos are also about the crowds of people who visit them, so don't limit yourself to just portraits of the animals. Turn around and show the people too.

Parks

Parks, wildlife refuges, and wilderness areas offer great opportunities for wildlife pictures. If you are willing to invest the time and effort to get to know and get close to the animals, you will be rewarded with wonderful images. Most serious wildlife photographers are also naturalists who study their subjects and habitats and are willing to spend untold

Nathan Benn (top); Robert Caputo (lower)

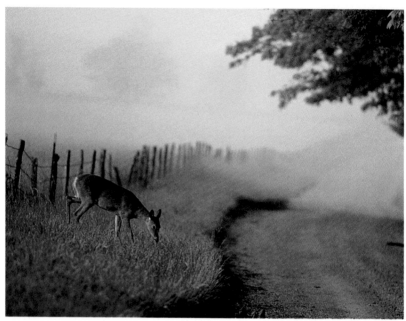

George F. Mobley

Cars make great blinds. In most parks, animals are quite used to cars, and if you move slowly you will be able to get fairly close without disturbing them. This peaceful scene is enhanced by the lines of the road and fence that curve off into the mist, and by the greenery at top right that brings the eye back into the frame.

hours in what can often be arduous circumstances.

Many parks have displays and brochures about their wildlife that will give you good tips, and postcards and books will give you ideas of what to look for. The park rangers usually know different animals' hangouts and habits. Talk to the rangers. Ask them where you are likely to find the animals and how approachable they are. In more remote areas, the animals will probably be extremely shy. Be careful about approaching bear cubs whose protective mother may be nearby. Early mornings and late afternoons are usually best for wildlife photography because the animals are moving in search of water or grazing.

There are two basic ways to do wildlife photography—from blinds and by stalking. The idea is to be as unobtrusive as you can. The animals should be unaware or at least undisturbed by your presence so that you can record their natural behavior.

Wear clothes that make you as inconspicuous as possible. Animals are very alert to any intrusion

into their territories, and usually flee if they see or sense anything approaching too near. Military surplus camouflage clothes are best (in parts of Africa where camouflage is standard army uniform, it may be illegal for civilians to wear it), but anything that is close to the color and tone of the environment you will be working in is fine. If you are fair skinned, be sure to cover your arms and legs. If you are doing serious stalking, you might want to smear your face and the backs of your hands with dirt. The glint of metal is a dead giveaway, so cover any bright surfaces on your equipment with black tape. Make sure there are no coins, keys, or anything else in your pockets that jingles. And don't wear cologne, aftershave, or scented antiperspirant—animals have very keen noses.

Blinds

If you are working from a blind, be sure to erect it a reasonable distance from the water hole, den, or whatever spot you will be photographing. You want to be as close as possible, but not so close that you disturb your subjects.

Enter the blind at a time when the animals are not present so they don't see you going in. This is fairly easy at water holes or forest glades, which tend to be unoccupied for several hours each day. If you are working near a den, try to sneak into the blind when the adults are away or when everyone

Tip

Have your camera loaded. A lot of wildlife photography is serendipitous, and you want to be ready. Using your car as a blind, move slowly closer to the animal. Use a folded-up jacket to support a long lens in the car window. Be patient. An animal in this situation is probably used to cars, and you may get some very interesting shots.

NGS Photographer William Albert Allard

The harshness of a Wyoming winter is conveyed in this photograph of bison struggling through deep snow. By surrounding them with white, the photographer implies the vastness of the bison's habitat.

Push and pull: Both these photographs were made with a 600mm lens. For the image of flamingos on a Kenyan lake, I wanted to convey the huge number of birds, so I climbed a cliff to get an angle that was graphically interesting. For the ibises in Venezuela (bottom) I crept close, then waited for them to take off.

Robert Caputo (both)

is asleep. Bring a book—there will be a lot of waiting time. Be patient and be quiet. The animals may sense something, but if you are quiet, they will soon calm down and go on about their business.

For tight portraits, use a tripod and a long lens such as a 400mm or 600mm, or use a teleconverter on a shorter telephoto.

Stalking

Carry as little as possible so you can move about quickly and quietly. A photographer's vest or jacket with big pockets is useful for carrying extra film, lenses, and even an extra camera body. A small backpack can also hold quite a bit.

If you meet an animal on the trail, stop immediately. If it has not seen you, you may be able to sneak into a better position. If it has, hold very still

until it has relaxed—if it didn't run the moment it saw you, the likelihood is that it won't unless you scare it. Don't stare at it; eye contact is a threat. Wait until it has looked away, then raise your camera slowly and make your picture. If it's still there, try crouching down slowly (no sudden movements) to get some more frames—you are less threatening if you are not so big. If it is tolerating your presence, hang out with it for a while looking for behavioral shots. Move on only when you are satisfied that you've gotten everything you want out of the situation.

As you near an area where you think your subject might be, stop frequently to listen and look around. Animals often betray their presence with vocalizations or the noises they make when moving. Walk as quietly and slowly as you can—remember that they are watching and listening too.

You are a hunter with a camera, and the object is to get within range of your subject without its knowing. There are several things to consider: Is there enough cover in the form of trees, bushes, or rocks for you to creep behind? What about the background? Will you blend in, or will you be exposed by having to climb a ridge and risk the animal seeing you silhouetted against the sky? Are you up or downwind? Are there other animals nearby that might alert your intended subject? Where is the sun, and how is the light falling? Take all of these factors into consideration and then determine your best route. It will often involve a longer hike than a straight line at your subject but will give you a better chance of getting close.

Any time your subject looks up, freeze. Wait for it to go back to grazing or drinking and then move on slowly. As soon as you have gotten within reasonable range, make some photographs—the next step could always be the one that alarms your subject. Look for shots that show the animal in its environment. Make pictures that are a combination of wildlife and landscape shots to give a sense of the world the animals live in.

Tip

Many photographers place a blind fairly far away and leave it there for a couple of days, then move it a bit closer for a couple of days, and so on until they have reached the spot they want. This gives the animals time to get used to the new element in their landscape. Even if you can erect the blind in your chosen location right away, it's a good idea to leave it unoccupied for a day.

Robert Caputo (both)

Wildlife photography is mostly about patience. I followed this cheetah female and her cub for over a week, which often meant just sitting in the car while they napped. On the third day, I got the picture I wanted when the cub climbed onto a stump and his mother posed behind. But I decided to stick with them for a while longer and was rewarded with an even better frame (opposite).

On Safari

Going on safari to East Africa is one of the greatest adventure vacations imaginable, and close to paradise for the serious nature photographer. The staggering variety and numbers of wild animals and the breathtaking expanse of the great plains are truly intoxicating. You want to come home with intimate portraits and wide panoramas that capture the feeling you had when you were there, that communicate your sense of awe and wonder.

Before you go on safari, read about the animals. This will help you understand where to look for specific animals as well as what kinds of behavior to look for and photograph.

What to Take

If you are traveling to Africa or some other place renowned for its wildlife, take plenty of film—you'll probably shoot more than you plan to, and there's nothing worse than being in a great situation and running out of film. The film you like may not be available and will probably be very expensive if it is. Take different speeds: Medium ISO will be fine for most situations, but take some high-speed film for shots at dusk and dawn or for work in forests and with birds. If you have an extra camera body, take it as a backup—if your camera breaks, there's usually nowhere to get it fixed.

Take a range of lenses—the animals in most

Tip

Carry a beanbag. Much of your photography will be done from a car, and a beanbag makes a great support for long lenses. If you forget to take one, borrow a pillow from the lodge. I've also used my camera bag or simply a folded-up jacket when shooting from cars. A tripod is useful for shooting the birds and monkeys that visit most of the lodges.

parks are quite well habituated to cars, and you'll be surprised at how close you can approach without disturbing them. In most cases, you can get very tight portraits with a 300mm. If you are working with shy animals, though, or with birds, you will need something longer. A 600mm lens is great for these situations, but is big, heavy, and may be more than you want to lug around. If you think you might need the extra length but don't want to invest in a longer lens, you might try a teleconverter: A 2x teleconverter on a 300mm will give you a 600mm lens. Take a wide-angle for scenics, pictures of your family on safari, and the lodges.

When You're There

Get up before the sun. Early mornings and late afternoons provide the best light and are also the times when the animals are most active. Dawn is especially good—all the animals are frisky, and the lions, hyenas, and other night-hunters may still be on their kills. There tends to be little activity in the middle of the day; the herbivores mostly stand around chomping on grass and the predators sleep. In the late afternoon, things pick up again and you'll want to be out until after sunset.

If you are on a walking safari, see the parks section above for tips on getting close without disturbing the animals—with the added proviso that there are more likely to be dangerous animals lurking in the bush in Africa than in Yosemite. Never approach your subjects head-on—you might frighten them. Instead, take a zigzag course toward the subject, and when you get close, approach at an oblique angle so the animal doesn't think you're going to run it over. Most animals have flight distances that vary from species to species and often from one individual to another. If you have a tour guide, he will probably know these. If you are on your own, it won't take you long to learn what they are. Be careful: Some wild animals think of human beings as meat.

Be prepared to wait. It may be more productive to spend time with one group of animals and wait

Robert Caputo

for them to do something than to drive all over the plains looking for action. Sitting next to a pride of sleeping lions for several hours can be tedious, but the rewards are immense: You're there and ready when a cub wakes up from a nap and bites mom's tail, or when all the adults take off on a hunt.

Capturing action requires great patience, knowledge of the animals, and luck. You need to try to predict what course the hunt will take and position yourself so that you can photograph it, yet not be in the way or alert the potential prey. Please be sensitive to the animals' needs: The cheetahs in Amboseli National Park in Kenya have been greatly disturbed by tourists trying to get shots of them hunting. So many cars were following them around and racing ahead to get a good view that the cheetahs couldn't get anywhere near their prey. Always keep in mind that any animal is more important than a picture of it. The great joy of wildlife photography is in getting the shot without disturbing the animals. Shoot a lot of film. For most of us, a safari is a once-in-a-lifetime experience.

Look for patterns. The tight shot of these zebras drinking, and their reflections in the water, was more interesting than a wide shot of the whole water hole. Animals are very skittish when they have their heads down, so avoid sudden movements and loud noises.

CHRIS JOHNS
Working on Wild Turf

Kent J. Kobersteen, NGS Staff

"Making pictures with impact usually means staying low and being physically close to the subject," says National Geographic staff photographer Chris Johns. "Sometimes you begin thinking that the camera is more of a shield than it is; I have taken calculated risks that I would never recommend to other photographers." Given weeks of experience with a particular group of elephants, for example, he can generally predict their zone of comfort. Even so, he's had some close encounters. "The one that always scares you is the one you don't see coming," he says. Fortunately, long lenses, expert guides, and safe vehicles minimize the risks.

Although he developed manual follow-focus techniques when shooting sports years ago, the latest autofocus technology has made Johns a convert. "I've had cheetahs running toward me at 50mph; using tracking focus with the new Nikon F5 and the 600mm f/4 AF-S lens (with ultrasonic focus motor), I got virtually every frame razor sharp at eight frames per second," he says. "In dust, fog, and rain, I can make pictures now with autofocus that I couldn't make before. But it's important to learn its limitations and how to use it in difficult conditions."

He rarely relies on the "intelligent" exposure metering system, preferring to use the more

While working with a herpetologist in Florida, Chris Johns (left) found this rattlesnake in shade, while part of its environment was still brightly lit.

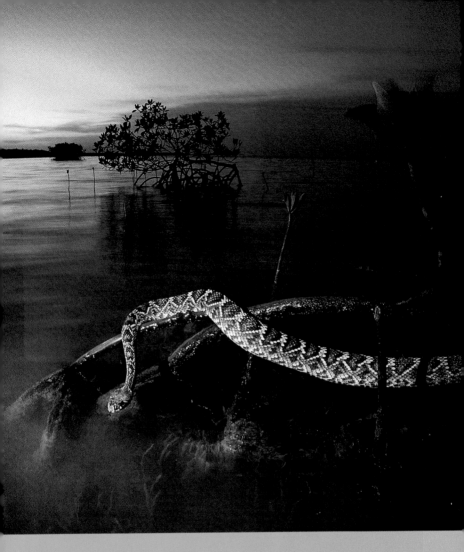

Because slide film cannot handle such a wide range of contrast, he used off-camera TTL flash—with reduced output—to fill in the foreground shadows.

familiar center-weighted or spot metering. Still, he praises the TTL (through-the-lens) flash metering for fill-in lighting. "Again, there is a learning curve, but then it becomes easy and fast; when you have to work quickly, it's fantastic. You won't miss pictures worrying about distance from the flash unit, and you get that bit of light in the eyes." For a natural effect, he gets the flash off-camera by using a connecting cord and—so that the flash will not overpower the ambient light—he reduces output with flash exposure compensation.

During a ceremony at dawn, these boys in Zambia were drumming near a large fire. To boost the level of illumination, while matching the quality of the existing light, Johns used flash with an amber filter mounted in a soft box for diffusion. "I don't want the viewer to be aware of the flash," he says. "The light should just seem interesting."

Many of Johns's wildlife photographs are made in low light. "It's my favorite time. That marginal light in the dusk-to-dawn window can be beautiful, but it's tough—especially with long lenses." Because he generally works with the slow (ISO 100 or 200) slide films preferred by magazines, motion blur is common when he photographs animals. Once a perfectionist, now he's more inclined to take chances with pictures that convey movement, energy, intensity, or conflict between animals in imperfect light. "I'm really trying to capture the essence of a fleeting moment," he says. "When the film is processed, there's a lot of pretty good stuff, and just one or two frames that are the knockouts—exactly what I was trying to get."

When considering his early stories such as "The Okies" (September 1984) he wishes he could turn the clock back. "I approached it literally; if I could do it over I would be more lyrical, and a bit more dramatic and conceptual," he says. Pictures that illustrate journalistic points are important, he agrees, but they should be able to stand visually

on their own merit, with greater depth.

Johns first recognized the need for a new approach while working on a magazine story about Frederic Remington (August 1988). He found inspiration in Remington's struggle to advance from working as a magazine illustrator to becoming a recognized artist. "He went to France, studied the Impressionists, and made a quantum leap in his painting," Johns explains. "This led me to wonder if I could take photography to a higher level while remaining in the journalistic realm." Since then, he has achieved exactly that. As he explains, "I'm consistently trying to put more layers into a picture, to put more spins or a surrealness into it. I want to make it more interesting visually and contentwise, to go beyond the obvious. I want to show people something they have seen often, but in a different, more insightful way."

His first opportunity to do that on a major story came while working in the Great Rift Valley. "This was a seminal moment in my life," he recalls, and the change in his work was noticeable. "As a child, I had read and fantasized about Africa, so I was completely enthralled. I couldn't wait to get up in the morning to start making pictures. It was incredibly stimulating to me." Aside from the inspiration provided by Africa, there was a greater willingness to experiment. "I didn't get so hung up trying to make this perfect NATIONAL GEOGRAPHIC picture; I just started shooting—increasingly loose—and trying new things."

Although Johns is not conservative in terms of technique, he is concerned about a recent trend to a highly stylistic approach. "If photographers are so busy showing you how clever they are, the story tends to be lost; I think it really inhibits the photographer's growth as well. I want a strong visual thread that ties a story together, with substance as well as beauty, but I won't let style interfere with content. I'm trying to educate people so we'll collectively make the right decisions; I'm not there to show what a great photographer I am."

Married, and the father of three young children, Johns is away from his family for up to two months at a time. He agrees that this is difficult, although he does keep in touch and spends a lot of time with them when not in the field. "It also takes an extraordinary amount of patience, effort, and love on my wife's part," he says. Thankfully, she shares his conservationist views and believes in the importance of his work. "Next year I'll take them all to Africa again," he says.

Looking ahead ten years, Johns does not expect

When making images of frequently photographed animals, Johns strives to show the familiar in a different way. When photographing this lion in South Africa, "I wanted to go beyond the obvious

that his role will change substantially. "I believe there will still be incredibly important stories out there and we'll need somebody to tell them," he predicts, "and I think that photography will continue to be a very valid way to do that because there is tremendous power in the still image."

Peter K. Burian

for a special picture, perhaps something the reader had not seen before," he says. A stiff wind from a thunderstorm provided a surreal effect that increased the visual power of the photograph.

Johns's Photo Tips

- If you want really good pictures of a species—the black bear, for example— research the animal, and spend time with people who know bears. Learn to respect bears; more people are getting hurt and animals have to be destroyed because of human ignorance. Avoid taking risks with wildlife.

- Get out of bed early in the morning. In Africa, I generally get up around 4:30 a.m.; animals are most active in early morning and late evening. Adjust your schedule to theirs.

- Spend time with an animal, explore it with different lenses, from different angles; try to keep low so you're not shooting downward on it. Wait for the kill or other activity; sit in a vehicle or in a blind and let the animal come to you. You seldom, if ever, get good pictures pursuing them.

- A 600mm f/4 lens is essential in some situations, but the 300mm f/2.8 lenses— with a matched 2x or 1.4x teleconverter— are great too. And some of my best wildlife pictures were taken with wide-angle lenses. Don't think in terms of getting extremely close with a short lens; think about including more of the habitat and using light to isolate the animal.

- In low light, try longer shutter speeds for motion blur—use flash to add a catch light to the eyes. A leopard or lion hunts with cover, so shoot through the heavy grass if you see one. If every picture on your roll is perfect, then you've failed.

AERIALS

Autumn colors enhance the Gothic Revival spires of this estate in Westchester County, New York. Try to shoot aerials on clear days either early or late in the day. The light is warmer when the sun is low, and the longer shadows create contours.

AERIAL pictures establish a sense of place and frequently let us see something familiar in a way we never have before. You can make aerial shots from big commercial planes, though small planes are much better because you have more control over where and how high you are flying.

If you are shooting from a big plane, sit on the side away from the sun and choose a seat forward of the wing that has a clean window. The best shots will be on takeoff and landing, when you are fairly low, though there are also some spectacular views from cruising altitude of the Rocky Mountains and other huge features of the landscape.

Single-engine, overhead-wing planes are better for aerials because they can fly very slowly, and the wing is out of the way. If the pilot is willing to take the rear door off, you will have a wonderful camera platform and a wide view. Remember to strap yourself in securely and keep your camera bag and

Aerial photography is often about patterns. By looking straight down on this home in southern Sudan, I was able to convey information as well as create a graphically interesting frame.

Robert Caputo

NGS Photographer Jodi Cobb

equipment on the floor of the seat next to you. If you wear glasses, strap them in place. Keep the camera straps around your neck, and lean well into the plane when you change film. In small planes and helicopters, try to shoot at 1/500 or higher.

If you rent a small plane, explain to the pilot before takeoff what you are after and what you think the best angle might be. Ask the pilot to make several passes at different altitudes. If possible, use a motor drive to get off as many frames as you can on each pass.

Whether you are shooting from a small plane you have chartered just to make photographs or from a commercial airliner, look for details in the landscape below you that will give a focus to your photograph. It could be the twisting route of a river or road, a farmhouse on the prairie, a particular mountain peak, or a skyscraper that soars above its neighbors. If the sky is particularly beautiful or dramatic, use it as a part of your frame. Pay attention to patterns of color or shapes.

Tip

When shooting aerials, you are really making landscape pictures, so think of them just as you would if you were standing on a cliff—what is the center of interest, and how should I compose the frame to accentuate it?

ADVENTURE

SCALING glacial peaks, careening through whitewater rapids, squirming into dank caves, trekking into the tangled depths of virgin rain forests—one of the greatest benefits of the advent of 35mm photography was that sophisticated cameras could easily be carried into the world's most extreme environments. And they are. Small, light, and versatile, 35mm cameras document the triumphs and failures of our pursuit of physical adventure in compelling detail. They also give us all a real sense of the look and feel of the remote corners of our world: Because of them, we have all seen the top of Everest and the face of a Yanomamo tribesman in the Amazon.

The first rule is this: Be careful. No picture is as important as your life or the safety of those with you. When you're off on an extreme adventure, the conditions are usually tough enough. It's often tempting to push just a little more to get into position to get a great shot. Think first: Is the picture really that great? Can I get it safely? You want to be around to tell the story.

In and Around Water

If you are kayaking through white water, sailing around the world, surfing, or doing anything on the water, the most important thing is to protect your equipment. Waterproof cases and bags are ideal: I keep my cameras and lenses stashed in the cases, and carry a small waterproof bag to use while shooting. If there is a lot of spray, you might want to loosely wrap the camera in a clear plastic

NGS Photographer Chris Johns

A fast shutter speed (1/1000 second) captures the drama of white-water rafting on the Zambezi River. The photographer scouted the location beforehand, found a bit of solid ground with a good view of the rapids, then waited for the raft to crash through.

bag with a hole for the lens. Carry plenty of lens-cleaning tissue or a soft cotton cloth to wipe droplets from the lens. For surfing, white-water work, and other situations where the equipment is bound to get wet, use a Nikonos or other water-proof camera, and if you're working in saltwater, be sure to soak and rinse the equipment in fresh water frequently.

You will probably want to freeze the action, so use a high shutter speed. Remember that a lot of white spray, a white sail, or other bright objects in the frame will fool the meter into underexposing, so check your settings.

Be sure to get photographs that give a sense of the environment—the extent of the rapids, the size of the wave. If you're in the same kayak or boat

The path and the goal: By including both the footprints in the foreground and the mountain peak behind, the photographer succeeded in conveying the grueling nature of this Everest expedition, as well as the drama of the landscape. Bright colors—such as the orange pack and clothing worn for easy spotting in emergencies—help in photography too.

that you're shooting, take an extremely wide lens so as to get as much of it in the frame as possible. If you're with a group of kayaks, remember that it's extremely difficult to paddle and shoot at the same time. Go in a double kayak so you can concentrate on shooting as you hurtle along next to your subjects. Go ahead to find good vantage points from which to shoot the others running the rapids.

Mountains

High altitudes are much harder on people than on equipment, but you do want to protect your gear as much as possible. If you are backpacking, try to keep your equipment to a minimum to avoid excess weight—usually a wide-angle and a short telephoto (135mm or so) or medium zoom (80-200mm) are plenty. Take an extra camera body just in case. Put your camera and lenses in plastic bags, wrap them in clothes, and put them in the center of your pack to cushion them from falls and jarring. Keep the camera and lens combination you're using in an outside pocket for easy access if you aren't carrying it around your neck, and keep extra film handy in a jacket pocket. There are also specialty photo backpacks you can use if you don't have much else to carry.

Very cold weather is hard on your batteries, the oil that lubricates your cameras, and film, which can turn brittle. Try to keep all your film and gear warm. When carrying your camera, keep it inside your jacket, taking it out only to actually shoot, and keep extra film in an inside pocket so the leader doesn't turn brittle and snap off. If your camera allows it, advance film slowly to reduce the risk of static electricity exposing the film. Take plenty of extra batteries.

Look for pictures that give a sense of the environment—walk ahead of your group in order to photograph them hiking up a ridge, climb the cliff first (or last) so you can shoot them on its face. Don't forget to take wide shots—a tight shot of a

Barry C. Bishop

NGS Photographer Michael Nichols

One day, one photograph: Lighting the inky darkness of Lechuguilla Cave, New Mexico, took several hours and many tests. Leaving parts of the scene black helped the photographer communicate the idea of "cave."

line of people hiking through the snow could be taken in your backyard. And, as always, be on the lookout for telling details—an ice-encrusted beard, someone pounding pitons into a cliff face, or a climber rappelling down a sheer rock face.

Caves

Caves are dark, and the only light you will have is what you bring in. Think of a cave as a studio. If you want to light up extensive areas of it, you will need a lot of lights and probably several assistants. If, however, you want to photograph one particular feature—a stalactite or a wall—light it as you would a model in your studio at home: Set up a strobe to one side of your camera position and a reflector on the other to provide a little fill. Work close-up, so that the unlit background is not too much a part of the frame. Try to avoid using direct, on-camera flash because the modeling provided by sidelighting is much more pleasing.

If you are working in a small cave, you will probably need a very wide lens. If it's a cavern, standard wide-angles or a normal lens will do. If it's wet in the cave, be sure to protect your gear with waterproof or freezer bags.

If your photograph includes people, use the lights they carry to illuminate the scene. Some of these, such as pressure kerosene lights, are quite strong, and if you include the light source in the frame, the harsh shadows they cast will not be objectionable. Use fill-in flash to soften the shadows a bit. For very large areas, you can use a strobe to "paint"—moving about and firing the strobe at parts of the scene while the shutter is open. Again, practice and make several exposures to give yourself the best chance of getting one just right.

In caves you can also "paint" the scene with a powerful flashlight: Set up your camera on a tripod, frame the picture you want, and set the shutter to bulb (B), which will keep the shutter open as long as there is pressure on the trigger. Use a cable release to lock the shutter open. Trip the shutter, then shine the flashlight on the objects you want to illuminate, being sure to keep the beam moving so that one spot does not overexpose. Turn off the flashlight, move around to the other side of your camera, and paint the objects again. You want to hit the objects from different angles to avoid harsh shadows. Then close the shutter.

Tropical Forests

Snakes, leeches, and various other nasty critters are a concern in tropical forests, but they don't really have anything to do with equipment. Heat and humidity do, however. Since you are usually in the shade, the heat is not a great problem. But humidity breeds all sorts of fungi that like to grow on camera equipment, and can leave little trails on the glass of lenses.

You will probably be sweating quite a bit, so make sure you have enough water, and drink before you are thirsty. It's easy to get dehydrated without realizing it. Take plenty of bandannas and keep them where they will stay dry. Wear one around your head so you don't drip sweat into the back of the camera. Wipe your hands before

Tip

The best defense against humidity is silica gel. Put the crystals in small cotton bags and keep them inside the waterproof cases with your equipment. If you aren't carrying cases, use plastic freezer bags. The silica gel crystals will absorb the moisture in the air, and turn pink when they are saturated. Dry them out in an oven or in a frying pan over a fire— shake them as you would popcorn until they are blue. Keep your equipment in the cases or freezer bags whenever you aren't using it.

NGS Photographer Chris Johns

A slow shutter speed and small aperture allowed the photographer to capture this Hawaiian forest with plenty of depth of field despite the low light. A tripod and cable release ensured steadiness on a windless early morning. Be careful metering in forests; your camera will usually want to overexpose the scene.

changing film. Be careful if you are using insect repellent—the stronger ones may melt plastic.

Look for rays of sunshine bursting through the canopy, and for details. Find elevated positions from which you can get a wide view of the forest. It's very hard to show the extent of a forest while you're in it—you can't see the forest for the trees.

Photographing People in Remote Places

Quite often, when we have trekked, climbed, paddled, or otherwise expended extreme effort to get to some faraway place, we find groups of people living there very comfortably and happily. It may be the back of beyond to us, but to them it is home. The people may be friendly or hostile, welcoming or afraid. Spending time with people who

live in traditional ways far from our hectic Western world is one of the great joys of adventure travel.

When photographing people in remote places, take some time to learn a bit about their customs and beliefs before you start shooting. Always remember that you are a guest in their land, and you should behave in a way that is respectful—you wouldn't go into your neighbor's house and put your muddy shoes up on his table. Many people in remote areas have little contact with other parts of the world, and they may not really understand just what you are doing. Pointing a camera at someone can seem quite aggressive, and you may offend your hosts without realizing it. You are, in fact, taking something (their images) from them. It's only considerate to do it in a way that does not offend. Taking time to learn about local attitudes will help your pictures, too: Photographs of people who are willing and at ease are much better than those of people who are nervous and afraid.

Be a good guest. Most people have traditions regarding travelers that involve feeding them and giving them a place to sleep. It's simply common courtesy. They would expect to be treated in the same way when they are on the trail.

Because most people in these situations live so close to subsistence, feeding you is a real sacrifice. In return, you should offer them some of whatever food you are carrying. They will be fascinated, especially by modern freeze-dried camping food. Eat whatever they offer you, even if you don't like the look, smell, or taste of it. It is an insult to refuse, and you do not want to offend your hosts. Any food that is well cooked cannot harm you. But be careful of water; never drink it unless it has been boiled or filtered. Carry a small water filter; besides cleaning up the water, it helps break the ice. People find it amusing to see visitors pumping water through a filter—especially since it looks and tastes just the same afterward.

After a day or two of being in a village, take out your camera. If people want to, let them look

Robert Caputo

Approach people gently, and try not to interfere. These men were simply watching the sunset from some rocks above an Eritrean village. I greeted them as I approached, then sat down nearby. Soon, they returned to their contemplation, and ignored me as I snapped away, using a wide-angle lens.

through the viewfinder—zoom lenses are particularly amusing. (Be careful not to let anyone press his eye right into the viewfinder, though, as there are often communicable eye diseases in tropical villages.) Start making pictures of the people you have gotten to know best, and of children. When other people in the village see that no harm comes to them, they will relax and allow you to make their pictures too. Before long, the novelty of what you are doing will wear off, and people will get back to the routines of their daily lives.

There are, of course, many different levels of "remote." If you are in an area previously visited by other travelers, the people may be quite comfortable around cameras—it depends on how they were treated. This is another reason to behave properly and respectfully; you want to leave a good trail.

In some places, people may want to be paid for allowing you to make pictures—they see it as a trade; you get something, they get something. If you are in a village, you will probably want to bar-

gain over the amount, but respect their wishes. After all, it is usually not much money to you but is probably a lot to them, and it is nothing compared with the other expenses of your trip. One fee for the whole village will often do, and you may be able to offer other things (T-shirts, etc.) instead.

In other areas, the concerns may be spiritual rather than monetary. Some people believe that when you take their picture, you are capturing their soul or in some other way interfering with their spirit. Respect this. If you are traveling with friends, make pictures of each other so the local people can see that it is harmless. Take magazines so you can show them what a photograph is. If you have an instant camera, give them pictures of themselves. Quite frequently, once a few people have agreed to be photographed, the others will too.

Make each visit to a village a photo essay: Get portraits, both tight and environmental. Follow people when they set off on their daily activities—working in their fields, hunting in the forest, fishing in the river, or collecting firewood. Climb a hill or a tree to get a wide shot of the village. Think about what you would tell a friend about this village when you get home, and then set out to get pictures that would illustrate that story.

If you are friendly, courteous, and respectful of local customs, people in remote areas will generally be hospitable and cooperative. Your visit is a chance for both you and them to learn something of another world. It should also be fun for them—an entertaining break from their ordinary routine.

Always remember that people are more important than photographs. Don't make pictures of unwilling subjects—you risk not only angering them but also causing quarrels in the village between those who mind and those who don't. Work with the people who have agreed. Besides being respectful and courteous, this is also quite practical: photographs of people are in many ways a record of your relationship to them at that moment. If they are not happy, it will show.

Tip

If you know beforehand that you will be visiting a particular group of people, try to find out what gifts they would like and what the etiquette for approaching them is. This will make it much more likely that they will accept you. I once visited the Rendille, a group of camel nomads in northern Kenya. Luckily, I'd picked up a young Rendille man on the way and he directed me to a large tree outside the village, where we waited for the elders to come and greet us. I distributed the salt, sugar, and tobacco I had heard they were fond of, and, because I had followed the proper etiquette and paid my respects, I had a wonderful and fruitful time with them.

MICHAEL "NICK" NICHOLS
Environmental Photojournalism

Courtesy Michael Nichols

NICK NICHOLS is particularly proud of his "Last Place on Earth" story (July 1995) about the Ndoki forest of central Africa. "This piece gave the forest such a high profile that the exploitation could not continue without international public-relations problems for the loggers and the government of the Republic of the Congo. It gave substantive strength to the conservationists working there, and seriously helped their fund raising," he explains. Nichols's "Apes and Humans" coverage (March 1992) had some meaningful results as well. "We covered apes in research, in animal studies, and performing in Las Vegas, and showed their habitat being destroyed."

His first stories as a staffer—"Making Room for Wild Tigers" and "Sita, Life of a Wild Tigress" (both December 1997)—received even more publicity than work he had done with Jane Goodall and Diane Fossey. The same topic became the subject of a National Geographic book, *The Year of the Tiger* (1998), and an exhibit at the Smithsonian. While first planning the two-year project, Nichols was determined to produce an intimate view of the tigers in India's national parks. That would be a challenge because the only approved method of photographing—from the backs of elephants—

A graceful animal at an awkward moment, this tigress takes her own picture as she breaks the infrared beam of a Trailmaster trigger attached to a waterproofed Nikon N90 camera

and three SB-25 flash units. The publicity generated by Nick Nichols's photographs has aided conservation fund-raising efforts that Nick (left) hopes will assure the wild tigers' future.

would not produce the necessary pictures.

He sought permission for greater leeway from the Forest Department for the central Indian state of Madhya Pradesh. Because the minister believed in the educational value that a NATIONAL GEOGRAPHIC magazine article would provide, Nichols was allowed to work more closely with the tigers. He was authorized to use the elephants for more than two hours per day, to walk in the parks, and to set up blinds and cameras at water holes.

"It's nearly impossible to get close to tigers, and

that's why most photographers work with captive animals," Nichols explains. He did get a few of the desired images while photographing from blinds, but found that he'd need another technique to capture certain other behaviors on film. In conjunction with the National Geographic Society's technical staff, he developed an ingenious solution consisting of cameras and multiple strobes (all wired together) with invisible triggers that the animals would inadvertently trip. The combination of these two strategies helped create the pictures that readers appreciated the most, "because there's an edge to them, a clean trustful view, because people can sense that the animals are truly wild," he says.

A NATIONAL GEOGRAPHIC staff photographer since 1996, Nichols was dubbed "The Indiana Jones of Photography" by France's *Photo* magazine while he worked as a freelancer in the 1980s. He has flown into the eye of a hurricane, walked across Death Valley in the summer, been charged by an elephant, been tossed like a bowling ball down a hill by a 400-pound gorilla, fallen off a raft into the unforgiving Indus River of Pakistan, survived typhoid and lung fungus, run the rapids below Victoria Falls, and rappelled into the deepest caves in North America.

Although Nichols is not addicted to adventure for the sake of adventure, he has the ability to make exciting photographs under difficult conditions. "Adventures are great but when you have climbed a certain mountain, you've achieved that goal and you look around for something more important. Once I focused on my real goal—to make people aware that the planet and its creatures are fragile—I found my reason to be."

Equipment breakdowns hundreds of miles from the nearest city can be serious. Every trip poses new challenges, and precautionary measures are essential. Nichols packs everything into hard-sided, waterproof Pelican cases with large cotton bags of moisture-absorbing silica gel; each item

The chief of a group of pygmies in the Ndoki forest expresses fear for the safety of Nichols's assistant, who was climbing a tree using ropes. It was their camera equipment, in fact, that faced greater risk in this tropical environment. Protected only by hard-shelled cases, it had to be occasionally dried out in a case full of silica gel that had been refreshed over a campfire.

is placed inside its own Ziploc bag. As soon as he stops shooting, everything goes back into the case to reduce exposure to dirt and moisture.

Rain and high humidity can create havoc with equipment, as Nichols discovered when he was still using standard backpacks. Even today, he assigns one case the role of "dry box" in wet environments. He places damp equipment inside each night, with silica gel that he refreshes regularly in a pot over a stove or fire. To make the silica last longer, he opens the dry case only to remove equipment.

Nichols carries doubles of all essential lenses and uses professional cameras: Canon EOS-1N models that are well sealed against moisture. As an extra measure of protection, he has added a seal over the control buttons for maximum water resistance. And in rain, he'll use an umbrella— sometimes attached to a tripod or to a blind without a roof—to prevent water damage. Film is less of a concern. Contrary to common wisdom, he does not find it overly sensitive to heat, and

color shifts are rare even in the tropics. "There's a misconception that a jungle is sweltering, but it's not, unless the trees are cut down," he explains. "Under a good canopy it is not that hot, though it can be unbearable in direct sun."

As a NATIONAL GEOGRAPHIC photographer, Nichols gets a lot of attention, but fame and praise are not what keep him going in horrendous conditions and months away from his family. "I want to make things happen through photojournalism," he says, "and I know that I can play a role in environmental change. I've seen species saved and the destruction of the Amazon rain forest slowed because the stories I and others have done have focused attention on these subjects. We can make a difference. People think this is the greatest job in the world, and they're right."

Peter K. Burian

Nichols's Photo Tips

■ Instead of attending photo school, get a liberal arts education. You can learn photography afterward. And study the masters of photography: Ernst Haas, Henri Cartier-Bresson, and others you admire.

■ If you find a photographer who is doing the kind of work that interests you, take a workshop with him or her, or become an assistant if that's possible.

■ Shoot something in your own area, a subject that you think you can do better than anyone else, instead of traveling to the Masai Mara and photographing something that others have already done exceptionally well.

■ Read photographic magazines that offer information on technique.

■ When photographing animals, pick a subject and spend a great deal of time with it. Stay focused, remain patient, and persevere.

■ When working with people, get closer. Use a shorter lens and get involved with the subject, learning self-expression along the way.

■ Find the subject matter that really motivates you and go in that direction.

■ Be critical of your own pictures. If you want to work with NATIONAL GEOGRAPHIC, you'll be competing with established photographers and we are obsessed. If you want to do photography of this type because you enjoy travel, forget it.

COMPUTERS

by Peter K. Burian

An example of the creative possibilities available today with imaging software, the image opposite was made by combining the three original pictures below—all shot with the end idea in mind. The key to success lay in matching the quality of the light for all of the elements. A little lightening around the edge of the fairy added a glowing effect.

"FROM THIS DAY, painting is dead," announced painter Paul Delaroche in 1840 when he first saw a daguerreotype portrait. Although some traditionalists wonder if digital imaging may lead to the demise of conventional photography, it is quite likely that traditional photography—in all its forms, including the darkroom—will be with us for generations to come. The digital aspects simply make up another branch of this art and craft, albeit one that is growing in popularity.

At last count, there were nearly 100 cameras on the market that use an electronic memory card instead of film. There are "photo-realistic" printers for personal computers, hardware for uploading photographs, a dozen types of imaging software, and a growing number of film and print scanners.

Many people have found that their interest in image making has been piqued or renewed by the new technology. Some may embrace digital imaging and find that, for them, it's the future of photography.

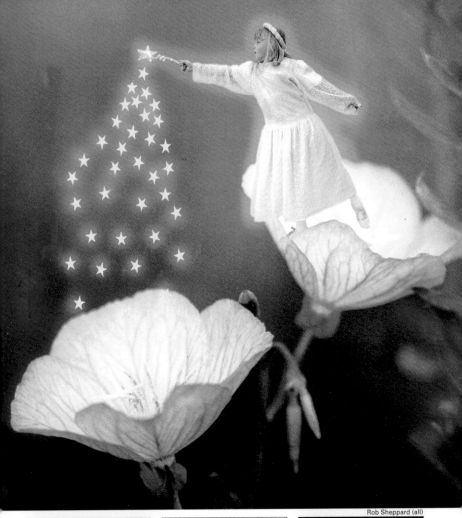

Rob Sheppard (all)

Tip

Many imaging software programs allow you to change image size. This is especially effective at decreasing size, but any very large increase will reduce the image quality. Applying sophisticated interpolation technology, software such as Photoshop and Genuine Fractals can increase the size of a high-quality image file by about 25 percent with only negligible loss of quality.

Film Versus Memory Cards

We hear a great deal about digital cameras that use memory cards, but many amateur and professional photographers still prefer film. That's because film remains the most effective means of recording razor-sharp pictures with vibrant color saturation. Start with a high-resolution slide, negative, or print, and scan it into your computer, where it becomes a digital file. Then you can view it on the monitor, manipulate it, send it to friends or photo buyers by e-mail, post it to a Web site, or produce a new print.

Rob Sheppard, editor of *PC Photo* magazine, puts all of this in perspective: "Combining new technologies with traditional photography has opened up a realm of possibilities that are very exciting and promise to revitalize everyone's photography." Although we will review the basics of various types of technology in this chapter, most of it is relevant whether you use digital or film-based cameras.

The Basic Concepts

All digital images consist of a series of ones and zeros that are transferred into pixels—an acronym for PICture (Pix) ELements. You can think of pixels as the equivalents of the light-sensitive grains that make up a photograph. They're picture points, minuscule squares that contain information; when combined, they form an image. The more pixels, the higher the resolution: well-defined intricate detail, high clarity, and an impression of great sharpness.

There are two definitions of resolution. A slide or negative is capable of a certain resolution and contrast that we perceive as sharpness. Resolution in a digital file refers to the amount of information in the image. It is the latter—whether in a digital camera or in your computer's memory—that is determined by the number of pixels.

Using the correct resolution for an image is critical. The above image is shown at a resolution of 72 dots per inch (dpi)—too low for this use, but adequate for Web use. The correct size, 300 dpi, was used for the printed image below. Three hundred dpi is also suitable for most ink-jet printers.

Rob Sheppard (both)

Flatbed scanners may be ideal for digitizing photographic prints, but a dedicated film scanner is best for making digital images from slides or negatives. Models of this type produce images with substantially higher resolution—a key factor to keep in mind if you are planning to make prints larger than 4x6 inches.

Courtesy Minolta Corporation

From Photo to Digital File

If you start with a photograph—be it a slide, a print, or a negative—the image must first be converted into a computer-usable format. This is done with a scanner—a piece of hardware that converts the picture into a digital file. You can buy a scanner for home use, or you can have your photograph scanned at a film lab or a computer service bureau. The lab will return the image file on a CD. At home, transfer the file to your computer's hard drive. There are several common format types

When scanning images to a Kodak Photo CD, the lab provides each image in five different levels of resolution from extremely low (128x192 pixels) to very high (3,072x2,048), in a proprietary format unique to the Photo CD. This CD can hold up to 100 pictures. The Pro Photo CD, a higher-end version of the Photo CD, adds an ultra-high resolution file (4,096x6,144 pixels) for each image; because of the extra files, capacity reduces to a maximum of 25 pictures per disc. Some labs offer the more affordable Kodak Picture CD or some generic CD system; these systems generally provide one scan of each image in medium resolution (1,600x1,200 pixels) in a JPEG format.

Scanner Basics
Scanners range in size and price from modest to substantial. The following types—all relatively

affordable, manageable, and reliable—are best suited for home use:

- Featuring a lid and a glass plate on which you place a photographic print, a flatbed scanner resembles a photocopier. It generally accepts prints up to 10x14 inches. Resolution, color depth, and density range—that is, the ability to retain detail in both highlight and shadow areas—all vary with price. High-end models typically offer an optical resolution of 2,400 dots per inch (dpi), a color depth of 36 bits, and a density range of 3.4 or higher. Most scanners of this type produce large files with excellent sharpness, color rendition, and image detail.

- A flatbed scanner that includes a transparency adapter can be used to scan negatives or slides into digital files. If you want to make a high-quality digital file from a scan of a small image (a 35mm slide or a negative), use a scanner whose optical resolution is 2,400dpi or higher

- Film scanners are tailored to scanning negatives and slides; most common are models for 35mm format. Models with an optical resolution of 2,400dpi to 2,800dpi yield scans suitable for making photographic-quality 8.5x11-inch prints and good 11x14s. Film scanners capable of 4,000dpi can produce extremely large image files, which in turn can generate photographic prints up to 16x24 inches. When comparing high-resolution models, check the scanning speed of each; it can vary considerably

Digital Cameras

Some people want a shortcut for the process described so far; others seek an entirely new experience or the ability to view their pictures immediately. The solution: a digital camera. Most contemporary models rely on an image-sensor chip whose light-sensitive areas (pixels) capture the

Tip

The ability to get a good photo from a print that has been scanned into your computer depends on the setting on the scanner, in dots per square inch (dpi). The higher the dpi setting, the larger the print you can make. Scan a 4x6 photograph at 300 dpi, and you can print it at a 4x6 size with good quality. If you want a good 8x10 print, you'll need to scan the 4x6 original at a higher resolution.

In the ever changing digital world, cameras come in many styles and shapes with varying features and capabilties. Models with over three million pixels of resolution are intended for hobbyists and they can produce true photographic quality prints up to 8.5x11-inches as well as good 11X14s.

Courtesy Fuji Photo Film U.S.A., Inc. (above); courtesy Nikon, Inc. (below)

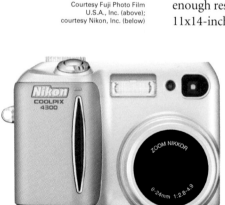

image. The images are stored in compressed format on a memory card. At a birthday party, for example, you can show recently shot pictures on the camera's color monitor right away; you can also make prints to hand out, or send pictures from the event to friends via e-mail.

Though a digital camera obviates such traditional expenses as film or photo finishing, you may want to buy extra memory cards to hold more images. (Think of the memory card as reusable film.) You can preview pictures on the spot, delete any rejects, and reshoot certain frames if you're unhappy with the results. Afterward, transfer the best few images to your computer and delete the rest.

Current Models

Digital cameras have plummeted in price since their introduction in the mid 1990s. Today you can buy high-resolution cameras with built-in zoom lenses for hundreds—rather than thousands— of dollars. Resolution varies, but most new models offer at least 3 megapixels of resolution. When images are made in the camera's "best" quality setting, the resolution is high enough to produce 8x10 prints of true photographic quality on a photorealistic inkjet printer. A growing number of models include sensors of 5 megapixels with enough resolution to turn out a very good 11x14-inch color print.

Several manufacturers now offer digital SLR cameras with 6-megapixel sensors, as well as the many capabilities found in conventional autofocus SLR cameras. Because they cost 50 percent less than professional models, a growing number of photo hobbyists have switched to digital for at least some of their photography. Digital SLR cameras use a larger image sensor with larger (and more numerous) pixels, so they produce a higher

image quality than do most compact digital cameras.

Most of today's digital cameras remain the compact point-and-shoot type. They have a built-in autofocus zoom lens, plus a built-in flash, a color LCD monitor, and an optical viewfinder. Although the monitor lets you view the scene and compose a picture, the viewfinder is preferable in bright sunlight; turning the LCD monitor off also extends battery life (digital cameras seem to devour batteries, so carry several spares). Most cost-effective are the rechargeable Ni-MH or Lith-Ion batteries, which last longer than the conventional alkaline types.

Most compact cameras are automatic, but many include manual overrides for white balance, color saturation, ISO equivalency, and for the exposure.

Entry-level compact cameras usually offer three image-quality settings, from low to high. More advanced models offer two distinct image-quality options: You can select the desired resolution (from low to high) as well as the desired image-file size (from small to large). Small image files are heavily compressed, so they lose a lot of image data; for most pictures, therefore, use the large-file option. If you plan to make 8x10-inch prints or larger, select the high-resolution, large-file combination. Keep in mind, though, that your memory card will not hold many images in the best quality settings.

Whatever its quality level, a digital camera usually comprises these components:

■ A USB cable to connect the camera to your computer (and transfer images to it). Naturally, your computer must have a USB port. A memory card reader plugged into your computer is another way of transferring images from your camera.

■ A software program to organize images, save them in the desired file format, and enhance their color, contrast, brightness, and sharpness.

High-resolution digital SLR cameras, intended for professional use and priced accordingly, are becoming more common among news photographers. Usually based on a familiar 35mm camera, these accept interchangeable lenses, TTL flash units, and other accessories.

Courtesy Eastman Kodak Company

Tip

For any camera with zoom capability, read the specifications carefully. Optical zoom is preferable to digital zoom. With the latter, image resolution drops substantially as you zoom in.

Incorporating micro-computers and advanced electronics, digital cameras are complex devices. At the same time, para-doxically, most models are designed for ease of operation: Electronic menus allow you to select either analog controls or newer digital controls.

■ A removable memory card—sometimes called "digital film"—for storing images. Digital cameras use several non interchangeable formats. Camera manufacturers are switching to smaller formats such as the SecureData and xD-Picture Card and moving away from SmartMedia and CompactFlash cards. Most Sony cameras accept only the MemoryStick card. None of these formats has a clear-cut edge over the others. Carry spare cards, so you don't run out of "film."

From Camera to Computer

Images taken by the digital camera can be trans-ferred to your computer by a cable that carries the digital signal. For several years, manufacturers packed serial cables with their cameras; subse-quently, most switched to USB cables because they accelerate the transfer process. A few cameras are now available with the newer IEEE 1394 connec-tivity system, also called FireWire and i.Link. This system allows for even faster transfer of image files to computers that have a FireWire port.

Storing Digital Files

Anyone with a computer knows that software and text files consume precious storage space on the hard drive; images (especially high-resolution files) occupy far more room. The following accessories can store images off of your hard drive:

▪ An additional hard drive can be added to your computer; some of these store 80-plus gigabytes.

▪ A drive with a removable cartridge such as the Iomega Zip can be useful for short-term storage. A single 250MB Zip disk holds a lot of information, but images saved to a hard drive or a Zip disk are stable for less than ten years.

▪ A drive for writing image data to readable compact discs (CD-Rs) is built into most new computers; it can also be added later. A single CD-R offers up to 700MB of image storage. Though you can neither erase nor overwrite the data on a CD-R, the medium is undeniably inexpensive (costlier CD-RW discs, by contrast, let you delete data and reuse the disc). A premium-grade CD-R (but not a CD-RW) offers stable, long-term storage of 50 to 100 years.

Modifying the Image

Whether the original picture was taken on film or on a digital memory card, it can be modified after it is transferred to your computer. Enhancing images to produce the best possible print or digital image file is an essential first step in the "digital darkroom." At the very least, contrast, brightness, sharpness, and color balance often need adjusting. Publishers and some photographers use expert software such as Corel PhotoPaint and Adobe Photoshop, but these are costly and complex.

Many imaging software programs today are affordable, simple to use, and easilymastered. These include Adobe Photoshop Elements, Microsoft Picture It!, and Roxio PhotoSuite. These vary in

Tip

Transferring images to your computer can be slow, and the images consume space on your hard drive. Hence, it's wise to preview the images on the camera's LCD monitor while you are shooting. and delete the less successful pictures, keeping only those you will want to use later. This will also preclude the need to carry several high-capacity memory cards.

their features and method of operation, but typical capabilities include:

■ Adjusting brightness and contrast for a more pleasing effect or for better digital prints. When necessary, you should also be able to lighten or darken specific areas, such as a face in shadow or an excessively bright sky.

■ Cropping pictures to eliminate distracting elements or to change the shape of the picture.

■ Eliminating a color cast or making colors richer or less deeply saturated. You should also be able to adjust colors in selected areas. Most software also allows you to convert color to black and white.

■ Sharpness control, sometimes called an "unsharp mask." Images that were scanned from a photograph or film will usually need some sharpening after they are uploaded to the computer. (Shots made with a digital camera may not need this.)

■ Cloning—a way of copying small parts of an image in order to fix defects such as scratches or dust and dirt specks. Copy part of the sky, for example, and use that to cover an adjacent area that has some defect.

■ Compositing to combine two or more images into one, with a richer blue sky, more people, unrelated elements, and so on.

Creative effects are possible with most software, at least to some extent. Filters of various types for distortions, patterns, high grain, or softening, for example, can be used. Experiment, and remember that special effects can be overused.

The Issue of Ethics

Image-editing software programs allow for relatively quick and easy manipulation of photographs, making it possible to create new images that are more fantasy than reality. Such manipulation has become standard practice in advertising

Rookie Prospect

45

Adam

Shortstop -- RB Mariners

Rob Sheppard

It is easy to make sports cards and pages featuring your favorite player with software that includes pre-designed templates, ready for a photo. You can change the text, color blocks, borders, decorative elements, and other features to create the end result you want.

and other commercial photography, and it is considered legitimate because ads do not pretend to depict the real world. However, the ease of making digital creations has led to debates on the ethics of using such work for documentary photography.

With pro-caliber software, an expert operator can create just about any effect. The operator can combine pictures of species that do not live on the same continent, composite photos of strangers into embarrassing situations, create situations that never actually happened, and so on. Professionally executed, these pictures can look highly convincing but may be used for unethical purposes.

Photo and computer hobbyists can manipulate photos to produce collages for artistic purposes. Few people see any ethical problem with doing so because the process is arguably similar to painting—an interpretive exercise that depicts the intentions of the artist, not necessarily reality. Frankly, photographers have been manipulating images for decades: making multiple exposures on a single frame of film; combining several negatives into one print; dodging, burning-in, and cropping in the darkroom; using special-effects filters; and retouching prints to satisfy their creative vision.

The expression, "the camera never lies," is (and was) a fantasy because tools and techniques for manipulation have always been available. Today, a computer and software merely make the process easier and different. Labeling the manipulated

Tip

Oversharpening can degrade an image. It will look unnatural—grainy with excessively sharp edges. This can be done intentionally for special effects, but not for everyday use. Nor can sharpening filters truly turn blurred areas sharp; they are no substitute for good photo technique, such as the use of a tripod.

images as "photo illustrations" can help photographers maintain their integrity. This is especially critical for journalistic, wildlife, and nature photography. To avoid misleading their readers, most publishers have strict rules about accepting—or at least labeling—manipulated images for editorial purposes.

There is no established code of ethics among publishers or even among professional photographers' associations. Discussions on this topic are continuing, however. Photo and computer hobbyists producing work for their own enjoyment or as digital art—with no intention of misleading the general public—should not get bogged down in the debates. Maintain a sense of fair play and integrity, label your manipulated images when appropriate, and continue to enjoy the creative possibilities that technology offers.

Internet Use of Photos

As mentioned earlier, images saved as digital files can be easily sent as an attachment to an e-mail message and can also be posted to a Web site. For a small fee, some photo finishers will post your pictures on a Web site for a period of time. Your friends can then view them if they have Internet access. Consider the following information as a starting point for Internet use of your pictures.

E-Mail Attachments

Many of the latest image-editing software programs allow you to send image files to an Internet address. If you attach the image file to an e-mail message, it must be significantly compressed first; otherwise, it will take a very long time for the recipient to open it. Most image-editing software discussed earlier allows you to do that easily.

Most e-mail software includes an "attach file" option. After selecting that option, you find the right file in your computer's memory, and attach it to the message. When your friends receive the message, they can download the file and open it.

The Right Format

Large files can take a long time to send and receive via the Internet, so plan to use a small file size. If you plan to post an image to an album on a photo-sharing web site, set the resolution of your image-editing software to 72dpi; if sending by e-mail, set it to 100dpi. Next, adjust the dimensions of the image until it is no larger than 500KB. Finally, to make the image file even smaller, save the image in a compressed format. The most common compressed-file format is JPEG, named after the Joint Photographic Experts' Group

Check the Glossary at the back of this book for more information on the following file formats: BMP, JPEG, TIFF, and GIF. The pros and cons—as well as typical applications—of each are important. TIFF files, for example, are too big (except in low resolution) to send electronically but they are ideal for digital imaging. JPEG is the most practical for sending photos, which can then be converted to TIFF by the recipient.

Web Site Creation

Courses are offered on the creation of Web pages and it is worth taking one if you plan to create your own. Thanks to today's simplified software programs, you no longer need to know HTML programming (the standard Web language). You can buy a Web-site creation package that will give you all the necessary tools and instructions to create your own. Contact a local Internet provider to lease a page or two on its site for a monthly fee, and you're on your way.

The latest versions of the imaging software discussed earlier have Web-design capabilities, as do print and design programs such as Microsoft Publisher and Adobe PageMill. You can also find programs for making photos Web ready and for doing some interesting design detail work. You'll find such software at any well-stocked computer store. It will include a facility for compressing files into small sizes so that they can be uploaded

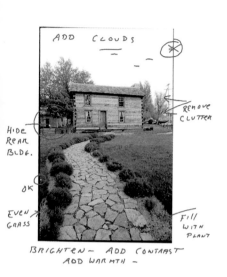

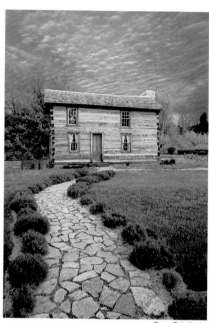

Bruce Dale (both)

Changes made with digital-imaging software can improve a photograph. Should the final image always be labeled a digital illustration, or should its intended use be a consideration? In advertising and artistic expression, we accept "license," but if you purport to be a journalist, you are usually held to a higher standard.

quickly. More important, people who want to view the images on your home page can do so quickly. Keep image files on Web pages as small as possible. Provide "thumbnail" images for viewers to consider. A viewer who is interested in one of these pictures can then link to a page with the full-size image that may take a minute or more to download. Image files in JPEG format are most common on the Web because of their very small size, high image quality, and the ability to reproduce a great deal of color information.

Creating a Web page does mean an expenditure of money, time, and effort. If you enjoy the process and consider it part of your photographic interests, then it is a creative endeavor you may want to try.

Whether you use it to show off your new baby, the places you are visiting on an extended trip, or merely as a showcase for family activities, a Web page can be a useful and fun communications tool.

Before creating your own Web site, check the sites of other photographers by searching the Web, using words such as "photographers" and "landscape photographs." This process is highly educational and will provide a lot of ideas that will be useful when you are considering your own design.

From Computer to Print

Making a print is the final step in the digital-darkroom process. Whereas any color printer can print pictures from your computer, those designed for printing photos yield the best results. Some film labs and commercial service bureaus offer to make prints from digital files, but this service can be expensive. Given the relatively modest cost of many photorealistic printers today, it makes sense to own such equipment if you regularly want prints. Surveyed below are the printers most commonly available for home use.

Color laser printers designed with a photo setting can produce decent (but not photo-quality) prints in seconds rather than minutes. This equipment is priced beyond the reach of hobbyists.

Dye-sublimation printers use stable and highly fade-resistant dyes. Prints are made by the application of heat to a ribbon, producing a colored gas that dries on the paper as dots. The photos exhibit vibrant colors and a true continuous tone effect closely resembling that of a conventional photograph. Dye-sub printers have two drawbacks: They are far costlier than their inkjet counterparts, and most cannot print larger than 8x10 inches.

Inkjet printers that make photorealistic prints are affordable and capable of producing exceptional quality—especially on premium-grade photo papers. Most common photo printers use inkjet technology, spraying numerous microfine

Tip

Although "ppi" (pixels per inch) is the correct term for image resolution, the term "dpi" (dots per inch) is often used as well. Inkjet printers are optimized for printing images at 300ppi, but most models produce excellent results even at coarser settings such as 240ppi. This lower image resolution allows you to make larger prints without significantly increasing the size of the image file, cutting your risk of lesser image quality. Note that image resolution and printer resolution are entirely different concepts.

droplets of ink onto the paper. Until recently, four ink colors were standard; many models now offer six or more. The extra colors often yield superior results in color nuances and with skin tones. Some printers allow you to replace only the color of ink that has run out—more economical in the long run than replacing the entire cartridge.

Many inkjet prints begin to fade after a year or two on display. Some newer printers therefore employ special inks for making lightfast (fade-resistant) prints. When combined with archival paper—and mounted and displayed according to the manufacturer's recommendations—the photos resist fading for 15 to 25 years, sometimes longer. Check the specifications for print longevity on the

Whether the original picture was an image from a digital camera or from a scanned photograph, there are many possibilities for using the picture after it has been transferred to a computer. It can be altered or adjusted, printed, uploaded to a Web site, or attached to an e-mail message.

digital camera

computer

film/print scanner

Slim Films

manufacturers' web sites before shopping for a photo printer.

Consider printer resolution, too, denoted by numbers such as 1,440x720 dpi (dots per square inch) or 2,400x1,200 dpi (the first number is more relevant for comparison purposes). Later models offer very high resolution: 4,880 x 1,200dpi, for example, or even 5,760 x 720dpi. Frankly, few people can discern any difference between prints made at 1,440dpi and those made at higher resolutions. For your finest images, however, you may want to use a setting of 2,400dpi instead of the more typical 1,440dpi. Bear in mind that a printer uses more ink at its higher-resolution settings, and that the printing time will be commensurately longer.

Make High-Quality Prints

Using today's sophisticated photo printers, anyone should be able to make good color prints at home. Even the best printer, however, cannot

printer

computer

Internet

your modem

someone else's modem

Tip

To determine which type and model of printer you prefer, visit a retailer that stocks several major brands and a broad variety of photorealistic models. Ask to see actual 8x10-inch photo prints made by the printers in your price range. Most manufacturers are happy to provide such samples; they show the very best results you can expect from any given model.

make beautiful prints automatically. If you want prints that rival true photographic enlargements, read on.

Whether you digitize your pictures with a digital camera or a scanner, the proper techniques and supplies can substantially improve the quality of your prints. You'll get the best results if you start with an excellent image that's just right for making a print suitable for framing. Begin with a high-resolution image file that is sharp, clear, and bright, with no excessive contrast. Using the image-size tool in your image-editing software, set the resolution to 240ppi (pixels per inch); the program will then automatically calculate the largest print you can make. With Adobe Photoshop or Genuine Fractals, you can increase the file size by about 50 percent without sacrificing image quality.

Once the image on your monitor looks right, make a 4x6-inch test print on the same type of paper that you plan for the final print. This will allow you to judge the print's color, brightness, and contrast while using less ink and paper. If the test print is not quite right, make the necessary corrections in your image-editing software and try again.

When you click the Print command in your image-editing program, you access various printer options. Select one labeled "Advanced," "Custom," or "Quality." Specify the correct paper type and size, then set the quality level to "Best" or set the resolution at 1,440dpi. (Dpi is the correct term in this case because it determines the number of ink droplets the printer will apply per square inch of paper.)

Plan to get your best photos matted and framed. Pleasing aesthetics aside, this step prolongs print life. Most data on the lightfast rating of an ink or a paper stock assume that the picture will be matted and covered with glass, filtering out some ultraviolet rays. Finally, to minimize fading, hang your photos on walls that do not receive direct sunlight. Follow these precautions and your work can be shown with pride for years on end.

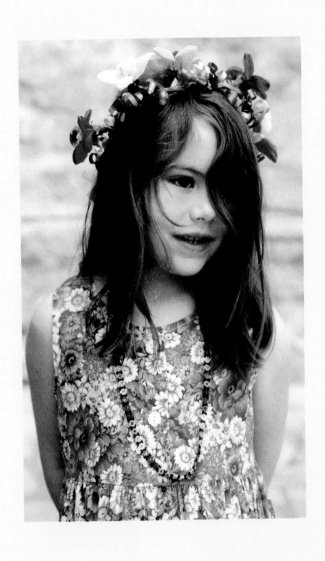

This image—originally a 35mm slide—was scanned by the photographer, who then made minor color and contrast adjustments with digital imaging software. He made this print using one of the top-rated but affordable "photo-realistic" ink-jet printers on photo-quality paper.

USEFUL INFORMATION

PREPARING FOR TRAVEL

Traveling, whether to a different region of our own country or to some faraway place, is always an eye-opener. Everything seems to grab our attention, and we notice things we just take for granted at home—the way people dress, the work they do, the look of the land, and the architecture of the cities. We assume a heightened awareness of everything in the environment and look at things with a childlike sense of wonder. Whether we are on assignment for a magazine or on a holiday, the pictures we come back with should reflect this feeling of marveling at the unfamiliar and should communicate it to those who haven't themselves had the chance to go.

Before You Go

Study. Read everything you can get your hands on about where you are going. Visit your local library to see what books they have about the place and to look it up in an encyclopedia. Go to a bookstore to look at travel guides, and don't forget the photography section, since many places are the subjects of some beautiful coffee table books. Surf the Internet, including sites for travel magazines that may have articles about your destination in their archives. Call up or visit the Web site of the country's tourism office and learn if there are any special events planned that coincide with your trip. Read up on the history of the place as well. The more you know about a place and its people, the better you will be able to determine what to seek out and photograph.

As you read, make notes about things you find interesting. Before you leave, convert the notes into a shooting list that is coordinated with your itinerary, being sure to include times and dates of any special events. Use a notebook that will fit easily into your pocket or camera bag.

Find out if you need a visa. If you do, apply for it well in advance. If you are going as a tourist, visas usually take a week or so. If you are going as a professional photographer, the embassy may need to get permission from a ministry at home, and this can take time. Tourists usually have no problem carrying a small amount of camera gear into foreign countries, but if you have a lot, find out if you need any special paperwork. If you are taking a lot of foreign-made camera equipment out of the U.S., you should register it with Customs before you leave—otherwise they may think you bought it overseas and are importing it, and may want you to pay duty when you return. You can register it at any international airport before you leave. Give yourself plenty of time, and take a typed list of all the equipment and the serial numbers. You can often use this same list when you arrive in a foreign country.

What to Take

Think about situations you are likely to encounter and figure out what is the minimum amount of gear you should take. You want to be able to cover the place thoroughly, but you don't want to be burdened with extraneous equipment—it's always a delicate balance. There's nothing worse than thinking, "I wish I'd brought that," unless it's missing a picture because you had too much stuff weighing you down. Don't buy new equipment just before you leave. Give yourself time to become familiar with it and make sure it all works properly.

If there are no special needs, everything should fit into your camera bag. I usually travel with two camera bodies, 20mm, 28mm, 85mm, and 80-200mm lenses, and a strobe and battery pack. Two bodies are useful because you can have two different lenses available without taking time to switch, or you can keep two different films loaded for different situations. It's also good insurance in case one of them breaks. The four lenses give me a wide range to cover just about anything, and the strobe is necessary for indoors, night, and fill-in flash.

Buy all the film you think you will need before you leave. The film you like may not be available at your destination, or it may

be very expensive. Buy all the film at once to take advantage of any bulk discounts, and get 36-exposure rolls—they are cheaper and save time in the field since you don't have to reload as often.

If you have only one camera body and want to change film before the end of the roll, make a note of the frame number, then rewind the film until it just comes loose from the take-up spool—you should be able to both feel and hear this. Write the last exposed frame number on the leader. When you load this roll into the camera again, set the shutter for the highest speed you have, close the aperture down as far as it will go, leave the lens cap on, and advance the film to the number on the leader plus one. Most auto-rewind cameras can be programmed to stop winding with the leader out.

Checklist for Travel

The following suggestions are for normal travel. If you are shooting wildlife, under-water, or any other special situation, you will need to adapt them.

Cameras:
35mm SLR. Take a second body for backup.

Lenses:
Wide-angle to medium telephoto
Examples:
28, 50, and 105mm
24, 50, and 80-200mm
35-70 and 80-200mm

Filters:
Skylight filters to protect lenses and cut haze
Polarizer to deepen sky color and cut down reflections

Flash:
Small, tilting-head unit. Take a connecting cord so you can hold it off-camera.

Accessories:
Tripod and cable release
Extra batteries for flash and camera
Charger for battery packs if you use them. Be sure to take a voltage converter and a set of plug adapters.
Camel-hair brush, air bulb, lens cleaning fluid and tissue

Set of jeweler's screwdrivers for on-the-road repairs
Notebook and pens

Packing

Take your gear in your camera bag as carry-on or pack it cushioned well in foam rubber in a camera case if you will be checking it. If you don't have a specially padded case, wrap the gear in clothes and put it in the middle of your suitcase where it will be protected from shocks. Take a camera case or suitcase that you can lock to prevent theft in airports and hotels—preferably an old beat-up one or one that looks ordinary. You don't want to carry a case that screams "expensive camera gear inside." If you are taking a metal case that is obviously for cameras, make a canvas cover for it so it doesn't stand out.

The X-Ray Dilemma

Carry-on: Extensive tests in the United States and Great Britain have shown that slow to medium-speed films are not appreciably affected by modern airport x-ray machines used to screen carry-on luggage even when subjected to multiple scans. If your film is ISO 400 or higher, try to limit exposure to five scans in countries with low-dose machines. You are unlikely to encounter more scans even on a long trip, and low ISO film tolerates multiple scans without visible damage. The results of these tests are probably good for about 90 percent of the world's airports. In North America you may be able to get security personnel to hand-inspect your carry-on—remove your film from the canisters and put it in clear plastic bags to make the job easier. If you are traveling in countries that use antiquated x-ray systems, the risk to your film is much higher. Don't count on manual inspection overseas. I have often been told, "Either everything goes through the machine or you don't get on the plane." If they won't hand-inspect it, use a lead-lined bag that will block the x-rays. The security people will usually just open up the bag on the other side of the machine, see that it contains film, and wave you through.

Checked baggage is a different story since it is now routinely screened by new, high-dose CT-scan systems. The high-power radiation of these machines will fog any unprocessed film, but high-speed films are the most vulnerable. The best solution is to carry unprocessed film as hand luggage.

Another way to get film back safely from overseas is to ship it home with a courier service. Check with them first to confirm that they do not use high-dose CT-scan systems on parcels. If no one is at your home, send it to a neighbor, your favorite lab, or to your office. I usually send film in two or more shipments, sending odd-numbered rolls in one and the even in another. That way I won't lose everything on a particular subject if anything should happen to one of the shipments.

When You Arrive

Look at local postcards for tips on what to photograph. Ask a taxi driver or the people at the hotel desk where there's a good view of the city skyline. Wander around—there's a lot to be said for getting lost. It helps you get a feel for the place, and you are more likely to run into things that are not on the normal tourist route. Get up early—in both cities and the countryside, early morning life is usually colorful and active and the light is good. Don't be shy. I have found that people are quite cooperative if you approach them in a friendly way and your interest in them is genuine. But be aware of local attitudes about photography. If people object to having their pictures made, respect their wishes and move on.

How to Behave

Westerners have in recent years taken the notion of casual dress to new levels. While this may be fine in many places in America and Europe or at beach resorts anywhere in the world, many cultures consider clothes such as shorts and tank tops to be unsettling, if not downright rude. Observe what the local people are wearing, and dress similarly: If you do not see any grown men in shorts, wear long pants. If local women cover their arms and legs, do the same.

You don't have to go native, but you should respect local mores. You are sending a signal of courtesy and respect as you do when you learn a few phrases of the local language.

In some countries, certain things are off-limits to photography: In many Moslem cultures, pictures of women are forbidden. In other places it may be anything deemed of military importance such as airports, bridges, dams, etc. Find out before you start shooting. I've spent many hours in some pretty dilapidated jails because of misunderstandings: Once I was making pictures of a river from a bridge and was arrested because the bridge was not to be photographed. It did me no good to explain that the bridge wasn't in the picture.

Always have your camera with you and ready—you never know what you will run into. Besides the items you have on your shooting list, look for scenes of daily life and for details. The smile on a street vendor's face can say as much about a place as a picture of a monument. If you come upon a particularly nice background, sit down on a bench or in a café with a good view of it and wait for something interesting to pass in front. Take your time. If you are patient, you will often find that the pictures will come to you. When wandering the streets, carry only what you really need. In a crowded area, keep your bag closed and swing it around to your front where you can keep an eye on it more easily. When working in such places, I use an old, rather tattered camera bag that looks as if it could not possibly hold anything very valuable.

People often ask how I decide what pictures to make. Usually, aside from the obvious things I discover from research, I don't know until I get there. A few days spent wandering rather aimlessly around gives me a pretty good idea of the character of the place—maybe it's the distinctive architecture, or the bustle of the market. Think about what makes the place different from any other and look for pictures that will show this quality. Trust your instincts. We all end up making pictures of those things that strike our fancy.

Robert Caputo

DISPLAYING AND ORGANIZING YOUR PHOTOGRAPHS

Archival Materials

Certain types of vinyl used as sleeves for negatives and as sheets for slides or larger transparencies release fumes that will damage photographic materials. As well, some paper products, such as the boards used for matting framed pictures, are acidic and will damage prints over time. A safer alternative to both is readily available in the form of archival materials that will not react chemically with their contents.

Look for plastic sheets marked "archival." They are made of polyethylene, polyester, or Tyvek and are available for negatives and transparencies from APS to medium-format and larger sheets. For 35mm slides, sheets holding 20 mounted slides are most common and are very convenient for quickly viewing your images. Just hold them up to the light, or place them on a slide sorter or light table that contains fluorescent tubes. You can also find archival binders and hanging files for filing cabinets to store pages of negatives or slides. Air circulation is important, and hanging files are probably the most useful in this regard.

Archival photo albums employ materials that will not stick to the prints. Color photographic materials fade quickly when stored or exhibited in bright light. Hang framed images out of direct sunlight. Store prints, slides, and negatives in a cool, dry, dark area such as a metal filing cabinet.

Archival paper goods are also available: envelopes, tape for securing prints to boards, matte board, boxes, and so on. They are usually marked "acid free" and "pH-balanced" (8.5 to 10) so they will not damage paper, dye, or emulsions. If you frame prints, be sure to use a mat so the photo does not come into contact with the glass; otherwise, it may stick and be damaged when you try to remove it later. Avoid storing photographic materials in furniture made of particleboard since fumes from the adhesives (often formaldehyde) can damage them. High humidity is also a problem, so do not store photographic materials in a basement or other damp area.

Exhibiting Your Work

The family photo album remains a popular way to record events and vacation trips. If the materials used are archival, an album can be an ideal way of storing and quickly showing pictures to your friends. (The biggest risk is damaging the prints as you lift the plastic sheet covering each page—a layer of the print may stick to the sheet.) Feel free to crop prints with scissors to eliminate distracting areas or to cut them into shapes such as hearts and stars. Label the pictures while dates, places, and names are still fresh in your mind.

Archival sheets that hold 20 slides are the most common way to mail slides. You may wish to insert each slide into its own 2x2-inch plastic cover first to minimize the risk of scratching when slides are removed for viewing. For a professional look in a portfolio, use black cardboard sheets with openings for each slide or larger transparency. Either type can be quickly viewed on a light table.

Framed prints—generally 11x14 or larger—can be used as wall decor. You can have photographs professionally matted and framed, or you can frame them yourself with materials available from frame retailers who often advertise in photo and art magazines. A mat adds a nice touch for a professional-looking presentation. Galleries generally use white mats, but you may prefer to coordinate the mat to colors in the print; for black-and-white photographs, white is still the preferred color, though some people use black. Some photo retailers and framing shops sell pre-cut mats in standard sizes or will make them for you on request.

Projecting Your Slides

There's no quicker way to clear a room than to drag out a projector and a screen. We have all sat through hours looking at slide after slide, bored but too polite to complain. To make your own presentations entertaining, remember the cardinal rule: Keep it short and keep it moving.

The optimum length of time for a slide show is 20 minutes; every moment beyond

invites monotony. Since people typically look at a picture intently for no more than 20 seconds, keep your slides moving at a lively pace; not every slide needs a lengthy commentary. You can always flip back for another look if someone insists.

Edit ruthlessly before preparing the trays of slides. Eliminate any slides that are less than excellent technically, or that are very similar. Present only the very best from any location or subject and in a logical sequence. Prepare several slide trays on specific themes—each organized logically and geographically if applicable. (Arrange prints on the wall with equal care.) Hold a dry run without an audience to confirm that all slides are in order, free of dust, and correctly inserted. As you organize and plan, remember to strive for audience impact. A well-packaged presentation will leave your friends asking for more.

Camera Clubs

Camera clubs range from small informal groups that meet in church basements to very large organizations in major cities, sometimes with their own premises. Typical activities include seminars on photo technique, field trips, mat-cutting, and audio-visual workshops. Regular group meetings can be useful for keeping you motivated in your photography, for refreshing essential concepts, and for encouraging you to try new, creative approaches.

Entering Photo Contests

There are numerous photo contests each year, from competitions offered by camera clubs, retailers, or equipment manufacturers to the major contests held by photographic and travel magazines. The majority of these are reputable, but some are not. Before entering a photo contest, review the fine print in the rules carefully to answer the following questions:

Will your photos be returned to you? If not, what will be done with them? Will the sponsors be allowed to use them for commercial purposes without any payment to you? Some contests clearly state that

entries will be destroyed to save the cost of returning them. In that case, do not submit valuable prints or original slides. Contests that do return entries generally require a self-addressed stamped envelope for this purpose. Some contests require you to give up your copyright to entries, or at least to any images declared as winners. In that case, the sponsor will effectively own some or all of the rights to the image. You may or may not want to enter such contests, depending on the value of the prizes.

Filing and Logging Images

If you shoot print film, it is essential to develop a system for quickly finding the negatives you may want at a later date. Ask your lab if it makes "contact prints": a single print that shows all of the pictures on the roll, in a small size. (Also called an index print, this is common with APS format but is available for 35mm and larger formats too.) If it does, store the negatives and contact print together, perhaps writing the same file number on each in case they become separated. Or write a file number on the back of your 4x6-inch prints so you can quickly identify the pack of negatives that each came from. Most labs print the frame number on the back of prints so you can easily locate the image on the strip of negatives.

File slides and larger transparencies by category: Animals, Action, Boats, Bombay, and so on. Assign a number to each, perhaps using a code indicating the year taken, location, and film type. Many affordable computer software programs are available for logging your images and for printing labels containing pertinent information.

Some photographers have hundreds of boxes of slides, making it difficult or impossible to find a particular image. Edit your work, keeping only the best images and perhaps those you intend to digitally improve, or at least separate the best ones from the ones that are not so good. File them in slide sheets, by category, to make retrieval easier.

Peter K. Burian

WEB SITES

There are many sites on the World Wide Web about photography, photographers, photo equipment, related associations, and travel destinations. The following sites have been recommended to the authors, and our review of them indicates they are appropriate and useful. Keep in mind, however, that site content can change. For additional Web sites on specific subjects, use the search engines associated with your Web browser.

AOL Photography Forums
(on AOL only; keyword: Photography)

American Society of Media Photographers
http://www.asmp.org/4

Apogee On-Line Photo mgazine
http://www.apogeephoto.com

Attractions Canada
http://www.attractionscanada.com

Camera & Darkroom News
http://www.camera-darkroom.com

Camera Arts magazine
http://www.cameraarts.com

Camera Shows/Photorama
http://www.photorama.com

CompuServe Photography Forums
(on Compuserve: "go photoforum")

E-Digital Photo magazine
http://www.edigitalphoto.com

Fodor's Focus on Travel Photography
http://www.fodors.com

GORP: Great Outdoor Recreational Pages and Links
(includes U.S. National Parks & Preserves by state)
http://www.gorp.com

Great Outdoor Recreation Pages, Canada
(links to numerous federal and provincial sites)
www.gorp.com/gorp/location/canada/canada.htm

Image Soup Magazine
http://home.dti.net/shadow/imagesoup/

National Park Service
http://www.nps.gov/planning

National Parks/by Name
http://www.nps.gov/parklists/byname.htm

National Wildlife Refuge System
http://bluegoose.arw.r9.fws.gov/

National Audubon Society
http://www.audubon.org

National Geographic Society
http://www.nationalgeographic.com

National Scenic Rivers
http://www.nps.gov/rivers

National Scenic Trails
http://www.nps.gov/trails

National Wildlife Federation
http://www.nwf.org/nwf

North American Nature Photography Association
http://www.nanpa.org

Outdoor and Travel Photographers Resources Center
http://members.aol.com/natureloco/index.html

Outdoor Photographer magazine
http://www.outdoorphotographer.com

Parks Canada
http://www.parkscanada.pch.gc.ca

PC Photo magazine
http://www.pcphotomag.com

Photo Books
http://www.amazon.com
http://www.barnesandnoble.com
http://www.buybooks.com

Photo District News magazine
http://www.pdn-pix.com

Photo Electronic Imaging magazine
http://www.peimag.com

Photo Travel Guides Online
http://phototravel.com/guides.htm

Photograph America newsletter
http://www.photographamerica.com

PHOTO LIFE magazine (Canada)
http://www.photolife.com

PhotoPoint magazine
http://www.photopoint.com/phototalk/magazine

PhotoSecret's Links to Photo and Travel Sites
(also called Travel Guides for Travel Photography)
http://www.photosecrets.com

Popular Photography magazine
on AOL only; keyword: POP PHOTO

Professional Photographers of America (PPA)
http://www.ppa-world.org

Recreational Photography Forums
(on AOL: rec.photo.technique.nature.com)

Shaw Guides to Photo Tours and Workshops
http://www.shawguides.com

Shutterbug magazine
http://www.shutterbug.net

Tourism Canada
http://www.tourism-canada.com

Trail maps from National Geographic
http://www.trailsillustrated.com/

Travel Canada
http://www.canadatourism.com

Travel Photography
http://www.travel-library.com/rtw/html/

U.S. Department of State
http://dosfan.lib.uic.edu/

USDA Forest Service National Headquarters
http://www.fs.fed.us/

U.S. Fish and Wildlife Service Home Page
http://www.fws.gov:80/~r9endspp/endspp.html

U.S. Photo Site Database/By State
http://www.viewcamera.com

Weather Channel
http://www.weather.com

PHOTOGRAPHY MAGAZINES AND BOOKS

Magazines

American Photo. Monthly publication with features on professional photographers, photography innovations, and equipment reviews.

Camera Arts. Bimonthly magazine including portfolios, interviews, and equipment reviews.

Digital Camera. Bimonthly publication emphasizing digital cameras, imaging software, and accessories.

Digital Photographer. Quarterly publication emphasizing digital cameras, accessories, and technique.

Nature Photographer. Quarterly magazine about nature photography.

Nature's Best Photography. Quarterly magazine showcasing nature photography and profiling top professional photographers.

Outdoor Photographer. Ten issues per year. Covers all aspects of photography outdoors, with articles about professional photographers, equipment, technique.

Outdoor & Nature Photography. Four issues a year. Heavily technique and equipment oriented with a strong "how to" approach.

PC Photo. Bimonthly publication covering all facets of computers and photography.

Petersen's PHOTOgraphic. Monthly publication covering all facets of photography.

Photo District News. Monthly business magazine for professional photographers.

Photo Life. Bimonthly publication with limited availability in the U.S. Covers all facets of photography.

Popular Photography. Monthly publication covering all facets of imaging from conventional photography to digital. Heavily equipment oriented, with comprehensive test reports.

Practical Photography. Monthly. Technique, equipment, and general interest for amateur photographers.

Shutterbug. Monthly publication covering all facets of photography from conventional to digital. Also includes numerous ads for used and collectible photo equipment.

View Camera. Bimonthly magazine covering all aspects of large-format photography.

Books

General Photography Books

Jenni Bidner, *Great Photos with the Advanced Photo System*, Kodak Books, Sterling.

Hubert Birnbaum et al., *Advanced Black-and-White Photography*, Kodak Workshop Series, Silver Pixel Press.

Hubert Birnbaum, *Black-and-White Darkroom Techniques*, Kodak Workshop Series, Kodak Books, Sterling.

Debbie Cohen, *Kodak Professional Photoguide*, Eastman Kodak Co.

Derek Doeffinger, *The Art of Seeing*, Kodak Workshop Series, Sterling.

Eastman Kodak Co., *Basic Developing and Printing in Black and White*, Kodak Books, Silver Pixel Press.

Eastman Kodak Co., *The Joy of Photographing People*, Kodak Books, Silver Pixel Press.

Eastman Kodak Co., *Kodak Guide to 35mm Photography*, Sterling.

Eastman Kodak Co., *Kodak Pocket Photoguide*, Sterling.

Lee Frost, *The Question-and-Answer Guide to Photo Techniques*, Sterling.

Tom Grimm and Michele Grimm, *The Basic Book of Photography*, 4th ed., Plume.

John Hedgecoe, *The Art of Colour Photography*, Focal Press.

John Hedgecoe, *John Hedgecoe's Complete Guide to Photography*, Sterling.

John Hedgecoe, *John Hedgecoe's Photography Basics*, Sterling.

John Hedgecoe, *The Photographer's Handbook*, Alfred A. Knopf.

Roger Hicks and Frances Schultz, *The Black and White Handbook*, David & Charles.

Kodak, *How to Take Good Pictures*, Ballantine Books.

Bob Krist, *Secrets of Lighting on Location: A Photographers Guide to Professional Techniques*, Amphoto.

Barbara London (Editor), and John Upton (Contributor), *Photography*, Addison-Wesley.

Joseph Meehan, *The Art of Close-up Photography*, Fountain Press.

Bryan Peterson, *Learning to See Creatively*, Amphoto.

Bryan Peterson, *Understanding Exposure*, Amphoto.

Bernhard J. Suess, *Creative Black & White Photography*, Allworth Press.

Roger Vail, *Kodak Book of Large Format Photography*, Saunders Photo.

William White, Jr., *Close-Up Photography*, Kodak Workshop Series, Eastman Kodak Co.

Equipment-Oriented Books

Peter K. Burian, Editor, *Camera Basics,* Eastman Kodak, Silver Pixel Press.

Eastman Kodak Co., *Using Filters,* Kodak Workshop Series, Kodak Books, Sterling.

Joseph Meehan, *The Complete Book of Photographic Lenses,* Amphoto.

Joseph Meehan, *Panoramic Photography,* Revised Edition, Amphoto.

Joseph Meehan, *The Photographer's Guide to Using Filters,* Amphoto.

Jack Neubart, *Electronic Flash,* Kodak Workshop Series, Silver Pixel Press.

Steve Simmons, *Using the View Camera,* Amphoto.

Outdoor and Nature Photography Books

Niall Benvie, *The Art of Nature Photography,* Amphoto.

John Fielder, *Photographing the Landscape,* Westcliffe.

Tim Fitzharris, *The Sierra Club Guide to Close-up Photography in Nature,* Sierra Club Books.

Tim Fitzharris, *The Sierra Club Guide to 35mm Landscape Photography,* Sierra Club Books.

Tim Fitzharris, *Wild Bird Photography: National Audubon Society Guide,* Firefly Books.

Jonathan Hilton, *Action Photography,* Amphoto.

Harvey Lloyd, *Aerial Photography,* Amphoto.

Joe McDonald, *Designing Wildlife Photographs,* Amphoto.

Joe McDonald, *The New Complete Guide to Wildlife Photography,* Amphoto.

Joe McDonald, *The Wildlife Photographer's Field Manual,* Amherst Media.

Arthur Morris, *The Art of Bird Photography,* Amphoto.

Clive Nichols, *Photographing Plants and Gardens,* Sterling.

Boyd Norton, *The Art of Outdoor Photography,* Voyageur Press.

B. Moose Peterson, *Wildlife Photography: Getting Started in the Field,* Silver Pixel Press.

Alan Rokach and Anne Millman, *Field Guide to Photographing Flowers,* Amphoto.

Alan Rokach and Anne Millman, *Field Guide to Photographing Gardens,* Watson-Guptill.

Nancy Rotenberg and Michael Lustbader, *How to Photograph Close-Ups in Nature,* Stackpole.

John Shaw, *John Shaw's Landscape Photography,* Amphoto.

John Shaw, *John Shaw's Nature Photography Field Guide,* Amphoto.

Mark Webster, *The Art & Technique of Underwater Photography,* Fountain Press.

Travel Photography Books

Eastman Kodak Co. *Kodak Pocket Guide to Travel Photography,* Sterling.

Lee Frost, *The Complete Guide to Night and Low Light Photography,* Amphoto.

Bob Krist, *Spirit of Place, The Art of the Traveling Photographer,* Amphoto.

Susan McCartney, *Travel Photography,* Second Edition, Allworth Press.

Cathy Newman, *Women Photographers at National Geographic,* National Geographic Society.

Jeff Wignall, *Kodak Guide to Shooting Great Travel Pictures,* Fodor's Travel Publications.

Computers and Photography Books

Jenni Bidner, *Digital Photography,* Kodak Workshop Series, Silver Pixel Press.

Joe Farace, *Digital Imaging: Tips, Tools and Techniques for Photographers,* Focal Press.

Tim Fitzharris, *Virtual Wilderness: The Nature Photographer's Guide to Computer Imaging,* Watson-Guptill.

Kodak Workshop Series, *Digital Photography,* Eastman Kodak, Silver Pixel Press.

John J. Larish, *Fun With Digital Photography,* Kodak Books, Silver Pixel Press.

Rob Sheppard, *Computer Photography Handbook,* Amherst Media.

Miscellaneous Books

Sam Abell, *Stay This Moment,* Lickle.

Leah Bendavid-Val, *National Geographic: The Photographs,* National Geographic Society.

Leah Bendavid-Val and Barbara Brownell, Editors, *National Geographic Photographs Then and Now,* National Geographic Society.

Jodi Cobb, *Geisha: The Life, the Voices, the Art,* Alfred A. Knopf.

Michael Nichols and Geoffrey C. Ward, *The Year of the Tiger,* National Geographic Society.

James L. Stanfield, *Eye of the Beholder,* National Geographic Society.

Priit Vesilind, *National Geographic On Assignment USA,* National Geographic Society.

GLOSSARY

Aberrations. Optical faults that cause a lens to produce an unsharp or distorted image. These can be corrected (and sometimes eliminated) by the optical design of a lens. Stopping down to smaller apertures also minimizes the effect of some aberrations.

AE (Autoexpose) Lock. A camera control that locks in the exposure value, allowing the photographer to recompose after taking the meter reading without changing the exposure value. Especially useful for substitute metering in automatic modes.

Angle of View. The amount of any scene that a lens "sees" measured in degrees; the shorter the focal length, the greater the coverage. (Also called field of view.)

Aperture. The opening inside the lens that allows light to pass; this is adjusted in size (except in mirror lenses and a few others) by the diaphragm and is expressed in f/numbers. (See F-stop and Diaphragm.)

Aperture Priority AE. A semiautomatic camera mode where the user sets the desired aperture and the camera sets the corresponding shutter speed for correct exposure. (Also called aperture preferred AE.)

Apochromatic. A term applied to telephoto lenses that cause all colors (wavelengths) of light to focus on a common plane, the film.

Aspheric Element. Optical element with a non-spherical surface used to correct certain optical flaws with fewer lens elements than in conventional designs.

BMP (Bit mapped). A digital file format that is very similar to TIFF but can be read only by Windows-based PCs.

Bounce Flash. Light from electronic flash bounced from a wall, ceiling, or other reflective material instead of being aimed directly at the subject. This produces a softer, more diffused lighting. Some flash units have a swivel and/or tilt head that allows for ease of bounce flash with the unit mounted on-camera.

Bracketing. Taking a series of identical photos, varying only the exposure for each frame so as to get at least one ideal exposure.

C-41. Common term for the (Eastman Kodak) chemistry used to process chromogenic films.

CCD (Charge-coupled device). The image-capture device in a digital camera, made up of millions of light sensors. The more sensors, the greater the number of pixels, and the higher the resolution, image clarity, and definition.

Cable Release. A mechanical or electronic cable used to trigger a tripod-mounted camera without touching it, to prevent shake or vibration.

Center-Weighted Metering. A light-metering pattern in which the photoelectric cell reads primarily the light reflected by objects in or near the center of the frame.

Chromatic Aberration. An optical flaw that occurs when a lens cannot bring all colors of light to focus at a common point, the film plane; producing color fringing (extraneous colors around subject edges) and lower apparent sharpness. Most common in telephoto lenses at wide apertures. It can be corrected with low-dispersion glass and other optical technology.

Chrome. Commonly used term to denote color slide or transparency films.

Chromogenic. Films in which the image is formed in dyes, as with most color negative films and a few new black-and-white films. These are processed in C-41 or comparable chemistry from other manufacturers.

Cloning. In digital imaging, copying parts of an image area and using those to cover other areas to correct flaws such as scratches or dust specks. Cloning can also be used to add more of the same element (e.g., more leaves onto a branch) to the final picture.

Color Temperature. A measurement of the color of any given light source provided in degrees Kelvin. "Warm" light, such as the light at sunset, has a low "temperature," whereas "cool" (bluish) light, as on a heavily overcast day, has a high color temperature on this scale.

Compositing. In digital imaging, combining two or more images into one, or parts of several images into one.

Contrast, Contrasty. 1. The range of brightness of a subject; the difference between the lightest and darkest parts of an image. A scene with high contrast range includes both extreme highlights and very dark shadows. 2. With film, the ability to record tonal differences from highlight to shadow areas. A high-contrast film is less able to hold detail in both areas but increases the visual impression of sharpness. In general, a low-contrast film is preferable in high-contrast situations, whereas a higher-contrast film is often desirable in flat lighting.

Depth of Field. The zone or range of apparent sharpness in a photograph. Although only the focused subject (and others at the same distance) is actually truly sharp, the range of acceptable sharpness extends in front of and behind the focused point.

Depth of Field Preview. A control found on some cameras that allows for the aperture to be stopped down (before the exposure is made) to the f-stop that may be used to take the picture. This allows the user to visually assess the range of apparent sharpness at several f-stops. (Also called stop down control, an older term.)

Diaphragm. The mechanism inside a lens that controls the size of the aperture using overlapping metal leaves.

Diffuser. 1. A translucent material generally held between the subject and the light source to soften the illumination. 2. A filter for producing a softer effect, as in portraits. 3. An accessory for electronic flash that can be used to scatter (soften) the light.

Distortion. An optical flaw that causes straight lines near the edges of an image to be bent, either inward (pincushioning) or outward (barreling). 2. When the perspective in a photograph appears very unusual, some will refer to this as "distorted perspective."

dpi (dots per inch). A term most commonly used to specify the density of information produced by a device. The dpi defines the resolution level that a scanner or printer should produce. The more dots per inch, the higher the resolution.

Dye-Sublimation. A type of printer that uses gaseous color dyes to produce a continuous-tone image much like a traditional photograph.

Exposure Compensation. A control found on most cameras with automatic mode that allows the user to overexpose (+ factor) or underexpose (- factor) from the metered value.

Extension Tubes. Hollow mechanical spacers that fit between the camera body and the lens, used to increase the lens focal length and magnify the subject; for close-up work. Automatic Extension Tubes maintain the camera/lens automation, though often not autofocus.

Fast. 1. A lens with a very wide maximum aperture, or 2. a very light-sensitive film. Both allow for faster shutter speeds (than their "slow" counterparts) to make a correct exposure.

Fill-In Flash. Extra light added by electronic flash to soften hard shadows, but without becoming the primary light source. Generally used in sunny conditions, fill-in flash is less bright than sunlight, producing a subtle effect while maintaining soft shadows.

Film Speed. A numerical value assigned to each film type, denoting its relative sensitivity to light. High numbers denote very sensitive film, often called "fast," as it allows for fast shutter speeds for a correct exposure. Low numbers denote less light-sensitive film, often called "slow," as it requires slower shutter speeds for a correct exposure.(See also ISO).

Filter. A piece of coated or colored glass or plastic, placed in front of the camera lens, which alters the light reaching the film. Filters can modify the color or quality of the light or the relative rendition of various tones, reduce haze or glare, or create special effects.

Flare. A degradation of picture quality by stray light that does not form the image, but reduces contrast or forms patches of light. Caused by reflections inside the lens and between the many lens elements, it is particularly problematic in backlighting, and most severe with lenses containing high numbers of optical elements (more air-to-glass surfaces). Can be reduced by multiple coatings of all elements, other internal technology, and the use of a lens hood to prevent light from striking the front element.

Flash-Exposure Compensation. A control on some high-tech SLR cameras and/or flash units that allows the user to increase or decrease flash output in an automatic flash mode. Most often used to reduce flash intensity for gentle fill-in flash.

Flash Meter. An exposure meter designed for measuring the intensity of light produced by electronic flash. Information from the meter is used to set an appropriate aperture-sync-speed combination.

F–Stop. A numerical value to denote the size of the lens aperture. The focal length divided by the diameter of the lens aperture equals the f/number. Regardless of lens size or focal length, the same f/number allows the same amount of light to be transmitted to the film. Wide apertures are denoted with small numbers such as f/2, small apertures with large numbers such as f/22. (See also Aperture and Diaphragm.)

GIF (Graphics Interchange Format). A common digital file type used on the Internet for graphics—because of small file sizes—but less than ideal for photos because it has a limited color palette and discards color information when compressed.

Grain, Graininess. Images on film are registered by light-sensitive silver halide particles or dye molecules, and their pattern (grain) is visible under high magnification. The higher the magnification, the more noticeable they become, as in oversize prints or slides viewed under a magnifier. Slow films generally have a much finer grain pattern than fast films.

Guide Number (GN). Numerals that indicate the relative power output of electronic flash units. These may be in feet or meters or both, and must be quoted with a certain film speed, generally ISO 100. With manual flash units, the GN is used to determine what lens aperture should be used, depending on subject distance. However, since most flash units today are automatic, the GN is primarily used as a means for comparing the maximum power of various models.

Hot Shoe. An accessory on the camera intended for mounting a flash unit; contains electronic contacts that mate with the contacts on the "foot" of the flash unit. These contacts are required for transmitting data between the camera and flash unit, and automatically trigger flash when the shutter is released.

Incident-Light Exposure Meter. An accessory that measures the light falling onto the subject. Its recommended aperture/shutter speed combination is then set on the lens/camera.

Interpolation. Increasing digital-image file size by adding pixels; also increases resolution.

ISO. 1. Abbreviation for International Standards Organization, which sets a standard for film-speed rating. ISO replaces the previous term "ASA" (American Standards Association). 2. A series of numerals expressing the sensitivity of any film to light. Common film speeds range from ISO 25 to 1600. ISO 200 is twice the speed of ISO 100 film, for example, indicating that it is twice as sensitive to light. ISO 50 film is half the speed of ISO 100 film, indicating that it is half as sensitive to light. (See Film Speed).

Inverse Square Law. When you double the distance from the light source (flash) only a quarter of the original amount of light will reach the subject.

JPEG (Joint Photographic Experts Group). A file format used by most current digital cameras for storing images in a compressed form to keep the files small. Also a standard format on the Internet for photos due to small file size and full-color palette. Variable degrees of compression can be used. Compression discards data, but minor compression has little effect on image quality, whereas high compression degrades it.

Latitude. The ability of a film to produce an image with an acceptable exposure even if it is overexposed or underexposed. Negative films have fairly wide latitude so a satisfactory print can be produced even if the negative was overexposed or underexposed by one or two stops. Slide films have a very narrow latitude, requiring much more accurate exposure metering for satisfactory results.

Lens-Shutter Cameras. A term used to describe the compact 35mm point-and-shoot cameras in which the shutter mechanism is built into the lens.

Macro. A term used to denote close focusing and the close-focusing ability of a lens. By a strict definition, the term is employed when a subject is reproduced lifesize (or larger) on the film frame. (Nikon uses the term "Micro.")

Megapixel (MP). One million pixels. The higher the number of pixels, the greater the resolution of a digital image.

Mirror Lens. A special type of lens that offers a long effective focal length in a very compact barrel. By employing mirrors to fold the light path, the length of the barrel is substantially shortened. Also called "cat" for catadioptric—the technical term for the most common design used in such lenses—it has a fixed aperture that cannot be changed.

Mirror Lockup. A control found on some cameras that allows the reflex mirror to be raised—and held in the "up" position—before the exposure is made. This prevents internal vibration from mirror action but is necessary only in high-magnification photography at certain shutter speeds, usually around 1/4 to 1/15 second.

Multi-segment Metering (also called multizone, evaluative, matrix, multi-pattern, and honeycomb pattern). A metering system with artificial intelligence that reads light reflected from several subject areas and makes calculations based on algorithms. This type is intended to automatically produce more accurate exposures in a broader variety of conditions than other types of metering systems.

Perspective Control (PC). The movements of special lenses, or parts of a camera, intended primarily to place the film plane parallel to the subject in order to prevent apparent distortion of perspective. Such movements may be up/down or sideways and are most commonly used to prevent the "falling over backward" look in architectural photography or to maximize depth of field in landscape photography. (Also called shift lens.)

Pixel. Abbreviation for picture (PIX) elements (EL). These are the smallest bits of information that combine to form a digital image. The more pixels, the higher the resolution.

Predictive Autofocus (Tracking Focus). High-tech AF system that continuously tracks a moving subject. Because there is a delay (time lag) between the moment when the shutter release button is pressed and the actual exposure, such systems predict the probable location of the subject at the instant of exposure, and set focus to that point.

Pushing Film. Intentional underexposure of film, corrected by extended processing time for a properly exposed image. This technique is generally employed when faster shutter speeds are needed when using slow film. If you expose an ISO 100 film at 200, for example, specify a one-stop push at the lab.

Rangefinder. A system that determines the distance from camera to subject by viewing it from two positions. Both images can be seen in the viewing screen of such cameras when the subject is not in focus. When it is focused, the two overlap and the image appears sharply rendered. (This term is also often used with simple point-and-shoot cameras without a true rangefinder system; see Lens-Shutter Cameras.)

Rectilinear. Term applied to ultrawide-angle lenses that are corrected to render lines accurately, without the bending (barrel distortion) common with fisheye lenses.

Reflected-Light Exposure Meter. A device that measures light reflected by the subject. Can be an accessory or an in-camera meter. (See Incident-Light Exposure Meter.)

Resolution. A measurement of ability to resolve fine detail. With digital cameras, a measure (in pixels) of the amount of information included in an image.

Resolving Power. A measure of the ability of a film or lens to reproduce intricate detail with high definition. Film manufacturers often denote this ability in lines per millimeter—the higher the numeral, the higher the resolution. Slower films generally have higher resolution than fast films.

Silica Gel. Crystals that readily absorb moisture; used to keep photo equipment dry in humid conditions.

Shutter. The mechanism built into the lens or camera that regulates the length of time that light reaches the film to produce an image. It opens to expose the film to light entering through the lens aperture. After the exposure has been made, it closes.

Shutter Priority AE. A semiautomatic camera operating mode where the photographer sets the shutter speed and the system sets the f-stop required for a correct exposure. This is based on information from the in-camera exposure meter. (Also called shutter-preferred AE.)

SLR (Single Lens Reflex). A camera design that allows the user to view the scene through the same lens that is used to take the picture. This type employs a reflex mirror to reflect the image to the viewing screen. A pentaprism is generally used, so the photographer sees the scene right side up.

Spherical Aberration. Optical flaw most common in wide-angle lenses at wide apertures, where not all wavelengths of light focus on a common point. This is most visible as reduced sharpness near the edges of the frame. Can be corrected by various optical methods, including the use of aspheric lens surfaces, and by stopping down to smaller apertures.

Spot Meter. A metering system that reads only the intensity of light reflected by a very small portion of the scene. May be built into the camera or an accessory device. Requires experience in the judgment of tonal values for predictable exposures.

Substitute Metering. Taking a meter reading from a known mid-tone, such as a gray card, and holding that exposure value (aperture/shutter speed) when recomposing to take the picture.

Sync Speed. The fastest shutter speed of a camera that can be used to ensure that the burst of flash is synchronized with the time that the shutter is open.

Teleconverter. Also called tele-extender, lens converter, or lens extender, a device mounted between a camera and lens to increase the effective focal length. Today, 2x (doubler) and 1.4x are most common.

Telephoto. A specific lens design that offers focal lengths longer than the standard, but this term is now used for any long lens. In the 35mm format, we generally refer to any focal length longer than 65mm as a telephoto.

TIFF (Tagged Image File Format). A universal format that can be read with imaging software on most computers. Highly suitable for photos, because it has 16.8 million colors. If the file is compressed in its "lossless compression" mode, the image does not degrade. Some digital cameras can record images in uncompressed TIFF format, in substantially larger files, to eliminate the loss of information that occurs during JPEG compression.

TTL. Abbreviation for through the lens, generally indicating that the camera's light meter cell reads the amount of light that has passed through the lens and will actually expose the film. This is most beneficial when lens accessories that reduce light transmission are used (filters, teleconverters, extension tubes, etc.).

Tungsten Lighting. Continuous light provided by bulbs with tungsten filaments. Such lights make a subject appear yellow-orange in a photograph, unless a pale blue filter or a special tungsten balanced film is used.

Unsharp Mask. In digital imaging programs, a common tool for increasing the apparent sharpness of an image. Generally used to bring scans up to the sharpness of the original image. If a photograph is out of focus, this tool cannot make it sharp.

USB (Universal Serial Bus). A computer port that accepts cables for attaching accessories such as a printer, camera, memory-card reader, or disk drive.

Viewfinder. An optical system that allows the user to view the image area that will be included in the final picture. Types vary significantly. Some allow for viewing through the lens that will take the picture, whereas others are near the lens and offer only an approximate view of the actual image area.

Wide-Angle. Lenses with a focal length shorter than the normal for the format. This varies depending on the format, but in 35mm any lens shorter than 40mm is referred to as a wide-angle. (This term is also used for lenses whose angle of view is wider than about 50 degrees.)

Zoom. A term commonly used for lenses that allow the focal length to be varied, shifting between longer and shorter focal lengths.

INDEX

CREDITS

National Geographic Photography Field Guide
Peter K. Burian and Robert Caputo

Published by the National Geographic Society

John M. Fahey, Jr.	*President and Chief Executive Officer*
Gilbert M. Grosvenor	*Chairman of the Board*
Nina D. Hoffman	*Executive Vice President*

Prepared by the Book Division

Kevin Mulroy	*Vice President and Editor-in-Chief*
Charles Kogod	*Illustrations Director*
Marianne R. Koszorus	*Design Director*

Staff for this book

John G. Agnone	*Project Editor and Illustrations Editor*
Charles Kogod	*Editor for 2nd Edition*
Rebecca Lescaze	*Text Editor*
Cinda Rose	*Art Director*
Melissa Farris	*Assistant Designer*
Anne E. Withers	*Researcher*
Bob Krist	*Consultant*
Rob Sheppard	*Digital Consultant*
R. Gary Colbert	*Production Director*
Lewis R. Bassford	*Production Project Manager*
Richard S. Wain	*Production Manager*
Janet A. Dustin	*Illustrations Assistant*
Johnna Rizzo	*Staff Assistant*
Mark Wentling	*Indexer*

Manufacturing and Quality Control

Christopher A. Liedel	*Chief Financial Officer*
Phillip L. Schlosser	*Managing Director*
John T. Dunn	*Technical Director*
Alan Kerr	*Manager*

Library of Congress Cataloging-in-Publication Data
Burian, Peter K.
 National Geographic photography field guide : secrets to making great pictures / Peter Burian and Robert Caputo.
 p. cm.
 Includes bibliographical references and index.
 ISBN 0-7922-7498-9 (reg.). -- ISBN 0-7922-7496-2 (dlx.)
 1. Photography. I. Caputo, Robert. II. National Geographic Society (U.S.) III. Title: Photography field guide.
TR146.B948 1999
771--dc21 99-23595
 CIP

2nd Edition
ISBN 0-7922-6270-0
ISBN 0-7922-5676-X PAPER

One of the world's largest nonprofit scientific and educational organizations, the National Geographic Society was founded in 1888 "for the increase and diffusion of geographic knowledge." Fulfilling this mission, the Society educates and inspires millions every day through its magazines, books, television programs, videos, maps and atlases, research grants, the National Geographic Bee, teacher workshops, and innovative classroom materials. The Society is supported through membership dues, charitable gifts, and income from the sale of its educational products. This support is vital to National Geographic's mission to increase global understanding and promote conservation of our planet through exploration, research, and education.

For more information, please call 1-800-NGS LINE (647-5463) or write to the following address:

National Geographic Society
1145 17th Street N.W.
Washington, D.C. 20036-4688
U.S.A.

Visit the Society's Web site at
www.nationalgeographic.com.

Front cover: Sunsets and sunrises alone can make lovely photographs. Adding this figure to the scene makes it more memorable.
Robert W. Madden, NGS Staff

Composition for this book by the National Geographic Society Book Division. Printed and bound by R.R. Donnelley & Sons, Willard, Ohio. Color separations by Digital Color Image, Pennsauken, New Jersey. Cover printed by Miken Companies, Incorporated, Cheektowaga, New York.

Peter K. Burian is a widely published photo-equipment expert and photographer, and the past editor of *Outdoor and Nature Photography* magazine. A regular contributor to *Shutterbug* and *Photo Life* magazines in North America and *Australian Photography,* Burian wrote the "Guide to 35mm Cameras" for *Outside* magazine's Buyer's Guide for 1998 and 1999; he is also the co-author of ten *Magic Lantern Guides* to 35mm-camera systems. He lives in Milton, Ontario.

Robert Caputo has been photographing and writing stories for NATIONAL GEOGRAPHIC since 1980. His award-winning work has also appeared in numerous other magazines and has been displayed in international exhibitions. Publisher of two children's wildlife books and two photo-essay books, *Journey up the Nile* and *Kenya Journal,* Caputo appeared in and wrote the narration for the National Geographic Explorer film *Zaire River Journey,* and wrote the story for and was associate producer of the TNT Original film *Glory & Honor,* about the discovery of the North Pole. He is a resident of Kennett Square, PA.

The Book Division is grateful to many individuals and organizations who contributed to the National Geographic Photography Field Guide. Our special thanks go to: Lyn Clement; Dave Howard; Andrew Hudson; Diane Kane; Jim Lyon; Robert W. Madden; Bob Shell; Brian Strauss; Anne Schwab's Model Store; Arion Corp.; Bogen Photo Corp.; Calumet Photographic; Canon U.S.A., Inc.; Eastman Kodak Company; Epson America, Inc.; the F. J. Westcott Co.; Flexfill; Fuji Photo Film U.S.A., Inc.; Hakuba U.S.A., Inc.; Lee Filters; Leica Camera, Inc.; Lexar Media; Lowepro; LumiQuest; Mamiya America Corp.; MGI Software Corp.; Minolta Corp.; NGS Image Collection and Sales; NGS Photo Engineering; Nikon, Inc.; OP/TECH USA; Olympus; Pentax Corp.; Photoflex; Rollei RTS; SanDisk Corp.; SIGMA Corp. of America; THK Photo Products, Inc.; Tamrac, Inc.; Tamron Industries, Inc.; Tiffen Company; Vivitar; and Wisner Classic.